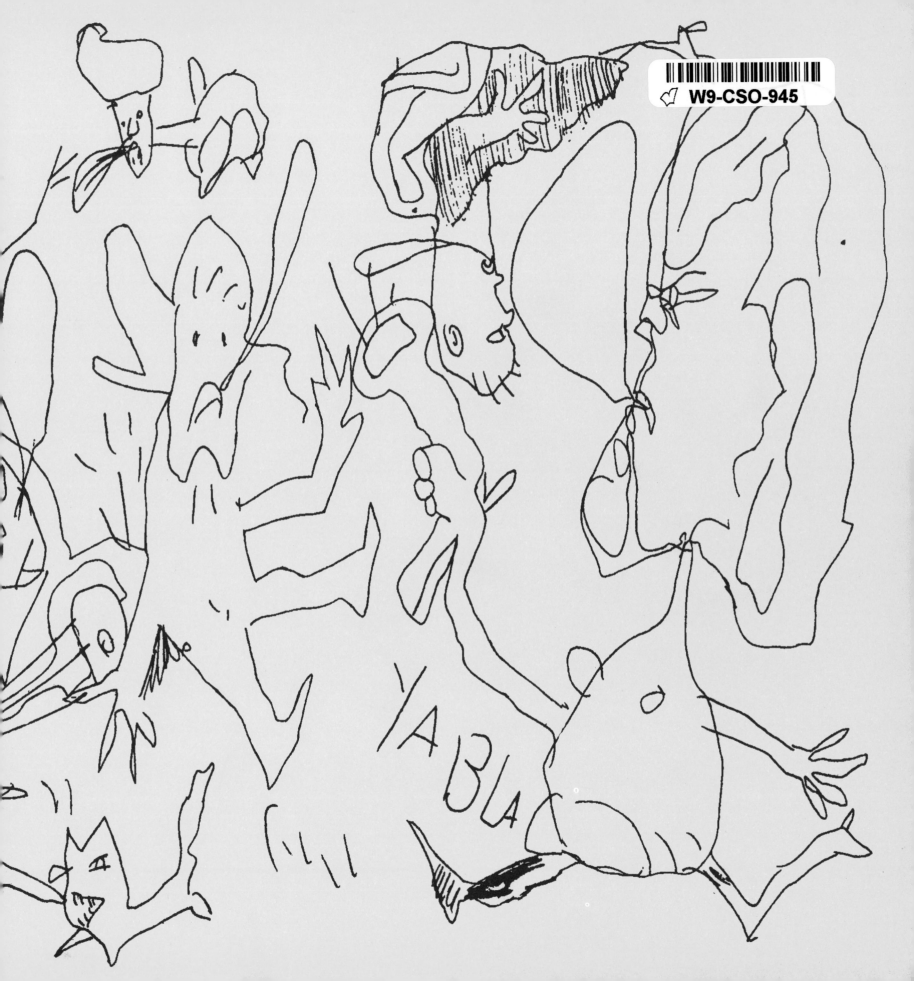

Claes Oldenburg: The Sixties

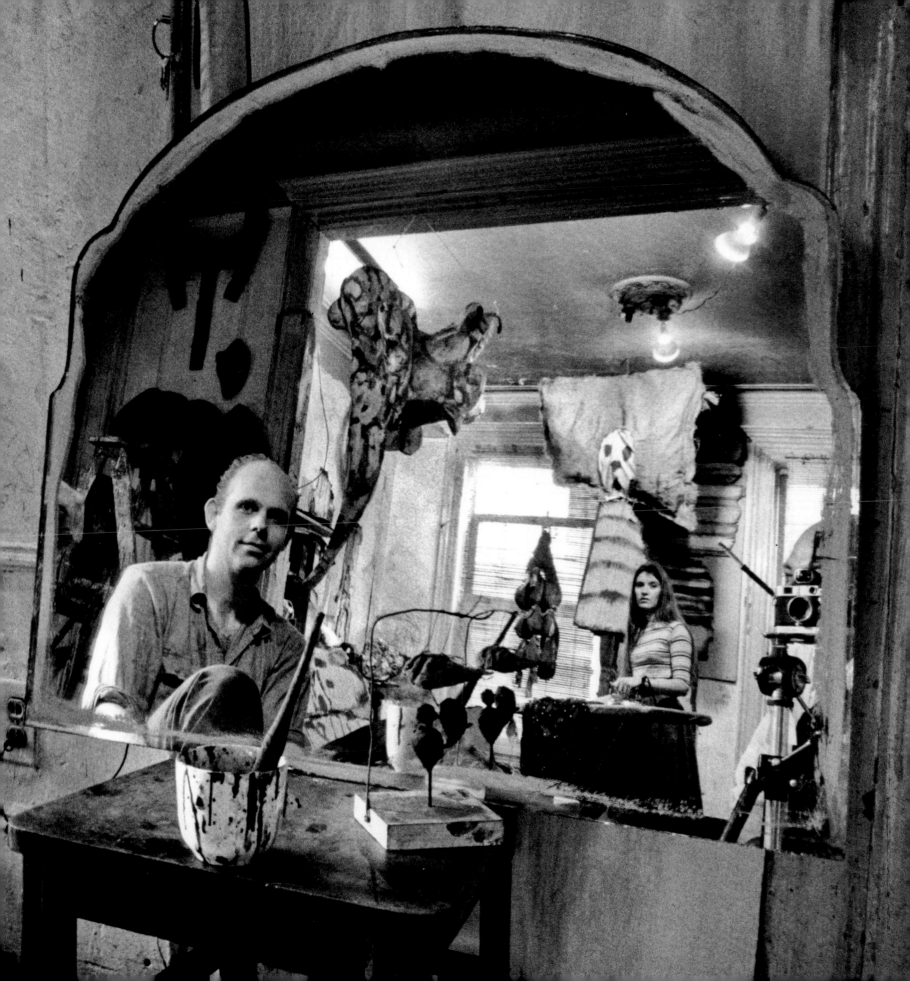

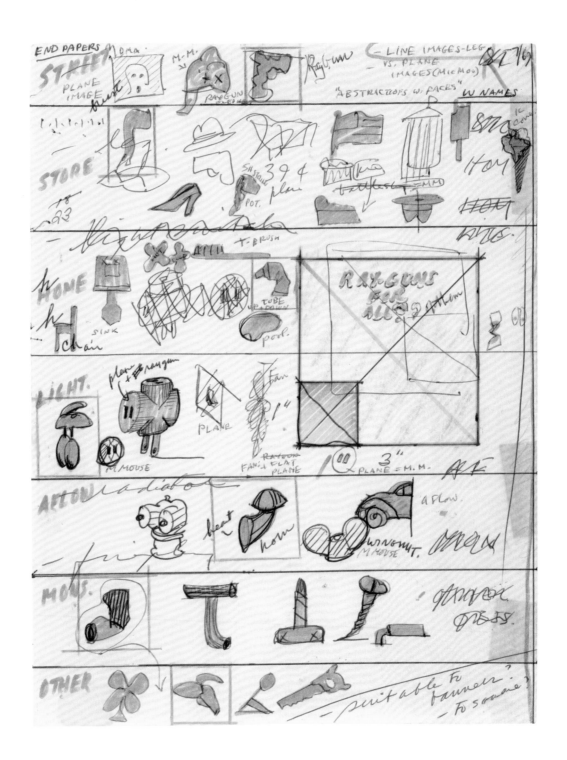

Claes Oldenburg: The Sixties

Edited by Achim Hochdörfer with Barbara Schröder

DELMONICO BOOKS • PRESTEL
MUNICH LONDON NEW YORK

This book was published on the occasion of the exhibition "Claes Oldenburg: The Sixties," organized by the Museum moderner Kunst Stiftung Ludwig Wien, curated by Achim Hochdörfer

The exhibition "Claes Oldenburg: The Sixties" is made possible by Terra Foundation for American Art and Peter und Irene Ludwig Stiftung.

Additional support is provided by Commerzbank-Stiftung, Verkehrsbüro Group, Dorotheum, U.S. Embassy Vienna, *Der Standard*, *Profil*, and Wien live.

Book design by Joseph Logan, New York

Edited by Achim Hochdörfer with Barbara Schröder

Editorial coordinator German edition, Nina Krick
Research assistant, Tonio Kröner
Manuscript editor, Karen Kelly
Proofreaders, Sam Frank and Karen Jacobson
Factchecking by Sarah Kovach
Translation by William Wheeler (preface)

This book was published with cooperation from Claes Oldenburg's studio, New York.

Library of Congress Cataloging-in-Publication Data

Claes Oldenburg : The Sixties / Edited by Achim Hochdörfer with Barbara Schröder.
 pages cm
Exhibition itinerary: Museum moderner Kunst Stiftung Ludwig Wien, February 3-May 27, 2012, Museum Ludwig, Cologne, June 22-September 30, 2012, Guggenheim Museum, Bilbao, October 30, 2012-February 17, 2013, The Museum of Modern Art, New York, April 14-August 5, 2013, Walker Art Center, Minneapolis, September 14, 2013-January 12, 2014.
 Includes bibliographical references and index.
 ISBN 978-3-7913-5205-3 (hardback)
 1. Oldenburg, Claes, 1929---Exhibitions. I. Hochdörfer, Achim. II. Schröder, Barbara, 1969- III. Museum Moderner Kunst (Austria) IV. Museum Ludwig. V. Museo Guggenheim Bilbao. VI. Museum of Modern Art (New York, N.Y.) VII. Walker Art Center.
 N6537.O4A4 2012
 709.2--dc23
 2011053120

Works by Claes Oldenburg © 2012 Claes Oldenburg

© 2012 Museum moderner Kunst Stiftung Ludwig Wien

Published by Museum moderner Kunst Stiftung Ludwig Wien, in association with DelMonico Books, an imprint of Prestel.

Museum moderner Kunst Stiftung Ludwig Wien
Museumsplatz 1
A-1070 Wien
T +43 1 525 00
F +43 1 525 00-1300
www.mumok.at

Prestel, a member of Verlagsgruppe Random House GmbH

Prestel Verlag
Neumarkter Strasse 28
81673 Munich
Germany
Tel 49 89 41 30 0
Fax 49 89 41 36 23 35
www.prestel.de

Prestel Publishing Ltd.
4 Bloomsbury Place
London WC1A 2QA
United Kingdom
tel 44 20 7323 5004
fax 44 20 7636 8004

Prestel Publishing
900 Broadway, Suite 603
New York, NY 10003
tel 212 995 2720
fax 212 995 2733
sales@prestel-usa.com
www.prestel.com

ISBN 978-3-902490-90-2 (mumok)
ISBN 978-3-7913-5205-3 (Prestel)

Printed and bound in Italy by Conti Tipocolor S.p.A

Cover:
Moveyhouse, performance at the Forty-First Street Theatre, New York, 1965 [front]
Claes Oldenburg on Broadway, 1964 [back]
Photos by Ugo Mulas

Endpapers:
Street Scene #1 (PWEET), 1960 (extended version) [front]
Mimeograph
Street Scene #2 (YABLA), 1960 (extended version) [back]
Mimeograph
Claes Oldenburg and Coosje van Bruggen

Page 3: Claes Oldenburg and Patty Mucha in their apartment studio at 330 East Fourth Street, New York, 1960

Page 4: *Notebook Page: "Ray Guns for All?,"* 1969
Ballpoint pen, felt-tip pen, colored pencil, and crayon on paper
11 x 8 ½ inches
Claes Oldenburg and Coosje van Bruggen

Contents

Preface

Claes Oldenburg's humorous and profound depictions of everyday objects have earned him his reputation as one of the most important artists since the late 1950s. A leading proponent of Pop art, performance art, and installation art, he has been in addition a determining influence on art in public space with his monumental "Large Scale Projects," realized together with Coosje van Bruggen, his late wife and partner of more than thirty years. The future of the industrially manufactured object—as a vehicle for and symbol of our fantasies, desires, and obsessions—is a central theme explored in Oldenburg's work through ever-new metamorphoses.

The Street, the Store, the Home, the Monument, and the Museum—thematic blocks into which the exhibition provides a comprehensive look—trace the development of Oldenburg's multiform artistic oeuvre of the 1960s: from the graffiti-inspired depictions of modern big-city life in his 1960 *Street* installation, to the expressionistically sculpted consumer goods in his 1961 retail space *The Store*, to his modern-day domestic utility objects from 1963 onward. With these works, Oldenburg defamiliarizes our seemingly natural environment by manipulating an object's scale ("giant version"), by altering its materiality and texture ("soft version"), by questioning its status as real ("ghost version"), or by putting it through a process of abstraction ("hard version"). Another segment of the exhibition is dedicated to Oldenburg's early designs for Colossal Monuments, which reposition his consumer objects within public spaces. The exhibition culminates with the *Mouse Museum* from the Museum moderner Kunst Stiftung Ludwig Wien's permanent collection, a walk-in miniature museum in the form of a Geometric Mouse housing 385 objects selected by Oldenburg since the late 1950s. With its souvenirs, kitsch objects, and small-scale studio models, the *Mouse Museum* displays the immense cultural diversity—but also the mysterious underside—of capitalist society.

Focusing anew on the early work, the exhibition "Claes Oldenburg: The Sixties" offers a look back that reveals, more than ever, the extent to which our canonical notion of Pop art fails to properly represent Oldenburg's achievement. When fully surveyed, the Happenings and sculptures—as well as the conflict between consumer object and expressionistic painting staged therein—actually contradict what has become a clichéd rendering of Oldenburg as a cynical, at times overly affirmative advocate for consumerism and the market.

It is a special privilege to have realized the exhibition and the design of this catalogue together with Claes Oldenburg. As a result, rarely or never-before shown materials and work can be presented and published for the first time. The catalogue functions, therefore, not only as documentation of the exhibition; it has been made in hopes of stimulating thought and developing new perspectives on Oldenburg's work of the 1960s. In his examination of the novel schemes laid out by the artist in his early installations *The Street* and *The Store*, Achim Hochdörfer shows how Oldenburg actuated a play, as analytic as it was humorous, on the conditions and presentational forms of the 1960s modern exhibition: his early exhibitions have the effect of a carnivalesque theater piece, performed by the objects of our everyday lives. Conversely, in discussing Oldenburg's "theater of objects," Branden W. Joseph demonstrates the influence of the Happenings on Oldenburg's sculptural practice. His analysis of the often-deployed concept of fetishism also reveals the hidden, uncanny, and at times dark aspects of Oldenburg's expressionist version of Pop art. Ann Temkin devotes her discussion to an unprecedented, extensive study of Oldenburg's clippings, a collection of advertisements he regularly cut and tore out of magazines starting in the early 1960s. The understanding of form demonstrated in the clippings, which correspond at times to individual sculptures, allows insight into Oldenburg's astute thought processes, revealing how he appropriated the fashions and obsessions of an increasingly media-informed public. Gregor Stemmrich analyzes the "softness" of Oldenburg's everyday objects as a major contribution to the history of modern sculpture and sheds light on the extent to which Oldenburg expanded his reading of the industrially manufactured object of the mid-1960s, moving it toward a new and highly original conception of the modern public monument. Benjamin H. D. Buchloh recapitulates the narrative arc of Oldenburg's early career—beginning with the establishment of his "legend" of the Ray Gun and culminating in his *Mouse Museum*, which was first realized in 1972 for Documenta 5—and places these works in relation to historical developments in modern art and society. And, finally, Maartje Oldenburg's in-depth chronology offers an indispensible account of the evolution of the artist's work in parallel to his biography. We extend our most heartfelt thanks to each author.

We are extremely pleased that we were able to gain some of the world's leading museums as partners in this endeavor.

Following its presentation in the Museum moderner Kunst Stiftung Ludwig Wien, the exhibition will be shown at the Museum Ludwig, Cologne, the Guggenheim Museum in Bilbao, the Museum of Modern Art in New York, and finally the Walker Art Center in Minneapolis. Because the museums in New York and Minneapolis each house major works by Oldenburg, numerous artworks integral to the exhibition were assembled from the participating institutions' collections. Two important sculptures, *Freighter & Sailboat* (1962) and *Soft Pay-Telephone* (1963)—an early soft sculpture and one of the first vinyl sculptures—are part of the Guggenheim's collection, and two of the most important Oldenburg collections in the United States are held by the Museum of Modern Art and the Walker Art Center. In addition to *"Empire" ("Papa") Ray Gun* (1959), MoMA holds several outstanding *Store* pieces, the soft sculptures *Floor Cone* and *Floor Cake* (both 1962), and the 1967 *Giant Soft Fan*, to single out just a few significant examples. The Walker Art Center's collection contains a sculpture that originated in a Ray Gun Theater Happening: *Upside Down City* (1962), itself of great significance to an understanding of Oldenburg's soft sculptures. Other major works on display are the spectacularly cascading *Shoestring Potatoes Spilling from a Bag* (1966) and the almost four-meter-high *Three-Way Plug* (1975).

Thanks to Irene and Peter Ludwig, the most extensive collection of early Oldenburg works in Europe can be found in the Ludwig museums in Cologne, Vienna, and Budapest. The collectors' prescient enthusiasm for American Pop art—they had initially been active as collectors of antique and medieval art—started as early as the late 1960s: *Soft Washstand* (1965) and *Giant Soft Swedish Light Switch* (1966) can be counted among their earliest acquisitions in this area. In the years that followed, the couple purchased several *Store* pieces: leading the way were *Big White Shirt with Blue Tie* (1961) and the ensemble *Lingerie Counter I* (1962), which was displayed in the window of the Sidney Janis Gallery, as part of the legendary "New Realists" exhibition in 1962. The latter made its way from Cologne via Vienna, and ultimately to the Ludwig Museum—Museum of Contemporary Art Budapest, which was founded in 1989. As early as 1970, *Street Head II (Pear)* became the first object from *The Street* to enter the Ludwig Collection in Cologne; it was followed by the 1960 sculpture *Street Chick* and *Street Head I* from 1959, the first *Street* object, located today in Vienna. In 1984,

Peter and Irene Ludwig acquired the majority of the surviving *Street* objects. Two more of the artist's major works from the Ludwig Collection made their permanent home in the Museum moderner Kunst Stiftung Ludwig Wien: the *Mouse Museum* and the *Ray Gun Wing*, a "museum wing" of the *Mouse Museum*. We are therefore especially pleased that both institutions have taken part in this important and elaborate exhibition project. As the exhibition's most generous lender, the Museum Ludwig affirms the importance of Oldenburg's early works within the Cologne collection.

Preparing and conserving these objects for the tour of this exhibition posed an enormous challenge to the Museum Ludwig. Thanks to the painstaking work of Kathrin Kessler and her colleagues, it became possible for the extremely fragile pieces loaned by the Cologne collection to embark on this journey.

We offer our sincerest thanks to the Peter and Irene Ludwig Stiftung, whose generous financial support of the exhibition's Cologne and Vienna venues testifies to the significance that Oldenburg has assumed within the Ludwig Collection. Our earnest thanks go to curatorial chairwoman Isabel Pfeiffer-Poensgen and executive director Walter Queins. We are certain that this exhibition would have been a momentous occasion for Mr. and Mrs. Ludwig.

Very special thanks must be extended to the Terra Foundation for American Art and its president, Elizabeth Glassman, for the faith they have shown in this exhibition project. Without their substantial financial support, the exhibition tour would not have been possible.

We are very much obliged to the directors and curators from our partner institutions: Stephan Diederich from the Museum Ludwig Cologne; Juan Ignacio Vidarte and Lucía Agirre from the Guggenheim Museum Bilbao; Glenn D. Lowry, Ann Temkin, and Paulina Pobocha from the Museum of Modern Art in New York; and Olga Viso, Darsie Alexander, and Siri Engberg from the Walker Art Center in Minneapolis. Special thanks go to Ann Temkin for her advice and support, which have had a determining influence on the project since its inception.

Many institutions and lenders have provided this exhibition with indispensible artworks, despite difficulties presented by the fragility of the pieces; this trust is very much appreciated. Adam D. Weinberg, the director of the Whitney Museum for American Art, one of the exhibition's most generous lenders, receives our gratitude, as do his coworkers Dana Miller and Carter Foster.

For their insight and faithful cooperation, we express deep indebtedness to our colleagues Richard Armstrong (Solomon R. Guggenheim Museum, New York), Christoph Becker (Kunsthaus Zürich), Barnabás Bencsik (Ludwig Museum Budapest), Daniel Birnbaum (Moderna Museet, Stockholm), Bernhard Mendes Bürgi (Kunstmuseum Basel), Consuelo Círcar Casabán (IVAM Institut Valencià d'Art Modern), Sjarel Ex (Museum Boijmans Van Beuningen, Rotterdam), Susanne Gaensheimer (Museum für Moderne Kunst Frankfurt), Ann Goldstein (Stedelijk Museum, Amsterdam), Josef Helfenstein (The Menil Collection, Houston), Richard Koshalek (Hirshhorn Museum and Sculpture Garden, Washington, D.C.), Alfred Pacquement (Centre national d'art et de culture Georges Pompidou, Paris), Earl A. Powell III (National Gallery of Art, Washington, D.C.), Martin Roth (Victoria and Albert Museum, London), Nicholas Serota (Tate Modern, London), and Evert van Straaten (Kröller-Müller Museum, Otterlo).

Wholehearted thanks are due to the private lenders Douglas Baxter, the Peter Brant Foundation, the George Economou Collection, Gail and Tony Ganz, the Collection of Samuel and Ronnie Heyman, the Helman Collection, Carroll Janis, Patty Mucha, Ad Petersen, Robert F. and Anna Marie Shapiro, the Locksley Shea Gallery, the Pace Gallery, and the Cy Twombly Foundation for the loan of key works. We would also like to acknowledge those private lenders who wish to remain anonymous.

The exhibition, as well as the catalogue, are the result of an immense concerted effort, and we thank each participant for their engaged commitment. Our deepest thanks are due to Claes Oldenburg not only for his assistance throughout the development and realization of the exhibition and the catalogue but also for his generous loan of precious—and in some cases previously unshown—works. While for him the manifold and elaborate preparations for our project represented an excursion into his own past, for every other participant they evolved into a spectacular expedition into one of the most interesting artistic explorations of the 1960s.

We would also like to extend our profound gratitude to Maartje Oldenburg, whose passion and engagement facilitated the conception of both the exhibition and the catalogue. The late Coosje van Bruggen's extensive knowledge

and scholarship continue to be vital as well. We would also like to thank the staff members at Oldenburg's studio, Carey Ascenzo and Alexandra Lane, for their enthusiastic collaboration and their thoughtful, professional coordination.

Wilfried Kühn, Thomas Güthler, and Johanna Hoth's sensitive exhibition architecture thoughtfully accommodates the complexity of the presentation's content; we are thankful for their care toward and devotion to this endeavor.

Manuela Ammer, Susan Davidson, Peter Freeman, Carmen Giménez, Alexander Katzkow, Stefanie Kitzberger, Susi Klocker, Edelbert Köb, Paul Messner, and Nicola Del Roscio stood at our side as advisers throughout the exhibition's progress and made a significant contribution to its realization.

We would like to express our deep gratitude to Barbara Schröder, who played a crucial role in conceiving and realizing this publication; her expertise and vigilance have contributed substantially to defining this venture. Joseph Logan developed a design that manifests an attentive response to Oldenburg's ideas and sensibility. We thank him for his intellectual acuity and for his interest in dialogue. We would also like to thank Karen Kelly for contributing her editorial skills and critical eye, which were essential for the success of this book. Sarah Kovach meticulously factchecked the texts with the aid of Oldenburg's studio. We would also like to thank Nina Krick for supervising the German edition and for her skillful coordination of the catalogue within the museum. Tonio Kröner compiled the extensive bibliography and exhibition history with attention to detail and persistence.

Sincere thanks goes to the staff members at mumok who nurtured this project with considerable dedication. We are particularly indebted to the conservation department, especially Christina Hierl, for their conscientious and exemplary maintenance of the artworks, as well as the care of the works during exhibition's tour. To all those who could not be named here, we express our genuine appreciation.

Our production manager and assistant curator, Claudia Dohr, who worked with incredible fervor on the realization of this touring exhibition, merits our admiration and most sincere appreciation. We thank Katharina Schendl for her impeccable exhibition production.

Our most heartfelt gratitude must be extended to curator Achim Hochdörfer, who with caring commitment and remarkable precision dedicated himself to this exhibition and publication from the inception. His close relationship with Claes Oldenburg was decisive in the success of this ambitious project. It is also, in particular, his dedication that we have to thank for enabling the cooperation of such eminent international museum partners in the exhibition tour.

Karola Kraus, director
Museum moderner Kunst Stiftung Ludwig Wien

Kasper König, director
Museum Ludwig, Cologne

From Street to Store: Claes Oldenburg's Pop Expressionism

ACHIM HOCHDÖRFER

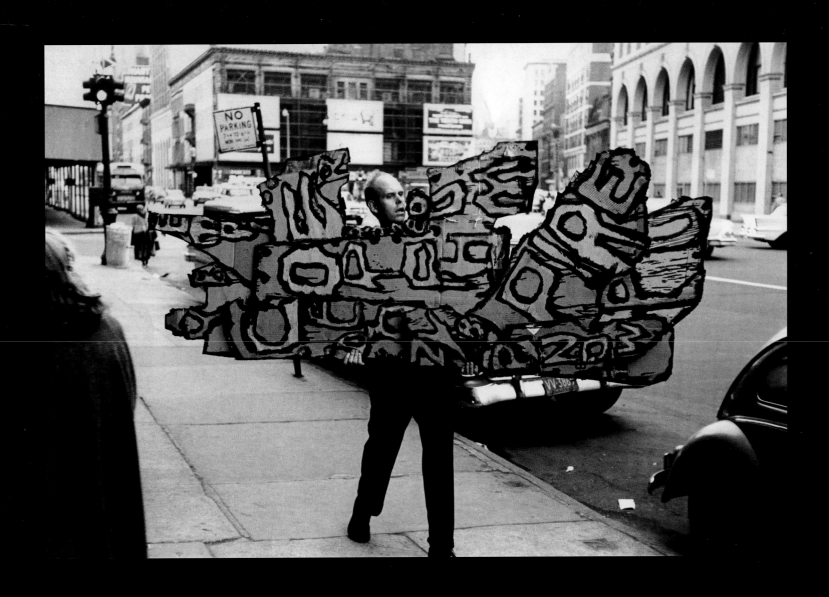

Oldenburg carrying *Street Sign* (1960) to the
Reuben Gallery, New York, 1960

Photographs by Claes Oldenburg,
New York, late 1950s

Photographs by Claes Oldenburg,
New York, late 1950s

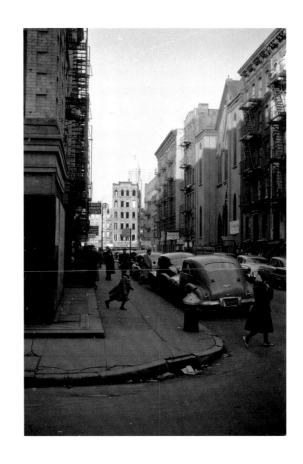

Ray Gun Poster, 1961
Spray oil wash on torn paper
24 x 18 inches
Claes Oldenburg and Coosje van Bruggen

From Street to Store: Claes Oldenburg's Pop Expressionism

ACHIM HOCHDÖRFER

A work of art is a ray gun. Like those in science-fiction movies and comics, it sends out immaterial rays. Its intangible power is transformative. The energy emitted by the ray gun materializes inside its target, if it strikes properly, thereby altering its target's constitution. The history of art, then, can be seen to consist of an enormous collection of ray guns, which populate museums and living rooms and are mass-reproduced in books and on the Internet. But ray-gun works of art do not coexist peacefully. Quite the contrary, they move within a highly contested terrain and are products of competing group formations, strategic maneuverings, mutual animosities, and self-assertions. Creation and destruction go hand in hand, and not infrequently the decision about victory and defeat takes on existential dimensions: "We are behaving as if a battle is being fought," noted Claes Oldenburg in autumn 1959: "An aesthetic battle but we may find ourselves in a real fight."[1]

It is surely no coincidence that Oldenburg developed the fantasy of the Ray Gun while establishing himself as an artist in the late 1950s—a time when the New York art world found itself bitterly debating the legacy of Abstract Expressionism. There were discussions of reintroducing figurative painting, arguments for launching an "Abstract Impressionism," and calls for renewing humanist painting in order to depict an alienated modern humanity. In addition, Robert Rauschenberg and Jasper Johns blurred the boundary between the picture plane and the viewer's space by integrating everyday objects into their paintings. Allan Kaprow countered, in his article "The Legacy of Jackson Pollock" published in 1958, that painting in general was outmoded, and he unceremoniously went on to replace painting with real actions.[2] These attempts to outdo painting were taken up programmatically in the exhibition "New Media—New Forms I" at the Martha Jackson Gallery in 1960, to which Kaprow contributed a text and for which Oldenburg designed the poster.[3]

At least two other factors caused the years circa 1960 to become a turning point for a neo-avant-garde or postmodern art. First, in the 1950s, there began a far-reaching reappraisal of the historical avant-gardes. Numerous exhibitions and publications made rising young artists familiar with the ideas and works of Expressionism, Dadaism, Surrealism, and Constructivism, so that the evolution of modern art could be depicted as a series of "revolutions": Dadaism replaced Expressionism, Surrealism replaced Dadaism, and Abstract Expressionism replaced Surrealism. Alfred H. Barr Jr., the

director of the Museum of Modern Art in New York, drew diagrams in which art movements are positioned like troop formations on a strategic map. Abstract Expressionism marked the last step in this progression to the summit of modernism, toward which artistic evolution since Manet had been inexorably moving.[4] The new generation of artists thus found itself in a paradoxical situation: the march of progress expected and openly demanded a new revolution, despite the historiographical dominance of Abstract Expressionism. The search for the new, the aesthetic shock, had become a common formulation. For example, at a discussion at the Artists' Club in New York in 1958, Barr called out to young artists from the podium: "Should there have been a rebellion by 1958? I looked forward to it, but I don't see it. Am I blind or does it not exist? Are painters continuing a style when they should be bucking it?" Barr's provocation met with heavy resistance, and one voice from the public countered that the concept of a permanent revolution was itself getting old: "I think the trouble with revolution is that it has become too fashionable . . . an academy of rebellion. I am surprised that a respectable head of a respectable museum calls for revolution."[5] Such discussions at the Artists' Club, which also circulated within art journals, became didactic plays on the logic of post-avant-garde art. The art critics Thomas Hess and Harold Rosenberg, who sat at the same podium at the Artists' Club, would soon vary their theories on this: Hess established the term "Soft Revolution," and in 1959 Rosenberg published a selection of his writings under the title *The Tradition of the New*.[6]

Moreover, the economic upswing of the late 1950s had immediate effects on art discourse. In the climate of an exploding art market—with prices for works by Pollock, Willem de Kooning, Mark Rothko, and Barnett Newman, among others, multiplying within just a few months—most of the rhetoric of alienation and authenticity associated with this painting lost credibility. Soon decisive rifts between art critics emerged: a whole generation of critics—Rosenberg, Hess, Frank O'Hara, Hilton Kramer, et al.—suddenly lost influence because their existential pathos was no longer persuasive. New journals such as *Artforum* and *Art International* were founded; a phalanx of new galleries conquered the scene to serve new collectors from the rising middle class. Current events in the arts piqued the interest of the fashion and gossip press, a fascination that increased by leaps and bounds: openings were stylized as big social events; neo-avant-garde scandals transformed into

carefully staged media spectacles (for example, when Jean Tinguely had a gigantic machine destroy itself in the sculpture garden of the Museum of Modern Art in New York in his *Hommage à New York* of 1960). These factors led to an extremely overheated situation within the art field: Neo-Dada, Junk art, Happenings, New Image Painting, New Realists, Pop art, Cool art, ABC art, Color Field. During the turn of the decade, new styles and sensibilities were proclaimed nearly on a monthly basis. "Artists do everything," Oldenburg noted with astonishment; "it is a rage for involvement with the world about them after the drought and denial of abstraction."[7]

Oldenburg's "Notes," an inexhaustible collection of biographical, art-theoretical, and philosophical ideas, as well as everyday observations keyed on a typewriter on a pedestal in his studio, show how attentively he followed these struggles in 1959 and 1960.[8] He divided the art scene of the time into various "leader[s] and camps" and extensively reflected on his own agenda—who could be his comrades in arms and who would be the theorists of the group:

> "we are theatrical and we are humorous, and loudmouthed. . . . We are not cool, we are not beat. Our behavior is offensive to business and to artists who are quieter. . . . We will find more artists, but our basic group is OK, plus Red [Grooms], and whoever else wants. . . . If we do bring techniques of sensationalism to art we do it in parody sense and in a sense of opposition. . . . I want to make camps, write manifestoes. [Bud] Scott must be given confidence to become our theoretician. . . . We are not Dada because we see ourselves as making progress in painting, extending the limits of painting, redefining it. We are post post Dada."[9]

Such descriptions ultimately led to the founding of his Ray Gun myth, with which he launched his own large-scale attempt to prevail within this scene; a "new synthesis," in which different artistic concepts were to dovetail, would lay the foundation for a new art to be known as "CITYPOP."[10] The numerous activities and projects Oldenburg united under the Ray Gun trademark amounted to a *neo*-avant-garde myth, in which involvement in a culture of the spectacle was openly discussed.[11] It culminated in two presentations of the installation *The Street* at the Judson Gallery and the Reuben Gallery in 1960 and in his legendary *Store*, which opened in 1961 under the name Ray Gun Manufacturing Company, and where a series of Happenings—the Ray Gun Theater—took place.

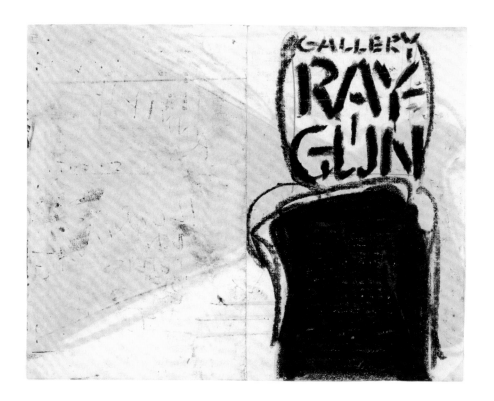

*Suggested Design for a Brochure
Announcing the Ray Gun Show
at the Judson Gallery*, 1960
Recto: pastel, wax crayon,
black typewriter ink, and pencil
on paper; verso: pastel and
wax crayon on paper
8 ⅜ x 10 ¾ inches
Whitney Museum of American Art,
New York; purchase, with funds
from The Lauder Foundation,
Evelyn and Leonard Lauder Fund
for the Acquisition of Master Drawings
and the Drawing Committee

THE BIRTH OF FORM

Oldenburg's Ray Gun myth, however, began not with the *Street* installation but rather with a group of sculptures first shown in November 1959 in a joint exhibition with Jim Dine in the Judson Gallery run by the Judson Memorial Church and its associate minister, Bud Scott. With the works in this exhibition, Oldenburg launched a program—technically, thematically, and formally. In the decades that followed, he would no longer exhibit any of his earlier, figurative paintings and drawings.

He executed all the sculptures in this new series using the same technique. Strips of newspaper soaked in glue were placed over chicken wire and then painted with thin black paint, flowing down in long streaks over bumpy surfaces. Oldenburg's diaries and "Notes" reveal that *Street Head* was the first sculpture created in this group. This formless chunk hangs from the ceiling. The title refers to the human head, and the viewer might try to relate the work's blots and irregularities to one another to recognize facial features, as with the man in the moon. Indeed, at the time he created it, Oldenburg referred to the form of the sculpture in the same breath as "City Head" and "Moon Head."[12] Only on closer inspection does an alternative perspective reveal itself: its contours trace facial features in profile; slight curves follow in and out of the mouth, nose, and eyes, then proceed over the sloping forehead to the bend at the hairline and up to the sweeping back of the head. Viewed from the side, this face becomes extremely planar, recalling Alberto Giacometti's famous portrait sculpture of his brother Diego, whose jutting profile is also thwarted by a flat frontal view. Thus *Street Head*, marking the beginning of Oldenburg's Ray Gun myth, is an ur-form, a highly conflicted form, which like an egg cell constantly splits into new pairs of opposites, into a profile and a frontal view, line and volume, drawing and painting, figuration and abstraction. *Street Head* also oscillates between two temporal extremes: on the one hand, it recalls a meteorite excavated from a prehistoric era; on the other, its skin, made from scraps of newspaper, testifies to the information flow of the contemporary world. In his "Notes," Oldenburg wrote: "the birth of form . . . the history of form." And, referring to the presentation of these first *Street* objects, he notes: "My sculpture to be free in space PLANETARY."[13]

In a group of sculptures from 1959 that hang from the ceiling like planets, Oldenburg created a constellation of the different aspects of his concept of ur-forms: a plaque, a building, a woman's leg, and two Ray Guns.[14] Each of these sculptures can be understood as a fundamental statement on a "history of form." *Woman's Leg*, for example, embodies the fetishizing (male) gaze. Desire is directed not at the whole body of a person but only at its detail. The viewer's idea all but palpates the curving contours of this fragment of a body in all its nuances—from the sweeping thigh over the knee to the slender ankles and the filigreed high-heeled shoes. This planetary ur-form brings up associations with shopwindow mannequins and the sexualized subjects of advertising. With *Woman's Leg*, Oldenburg insists that artistic form does not permit a return to supposedly authentic perception. The parallel he draws between fetish and art suggests that there is no way to distinguish clearly between (false) appearance and (true) essence: aesthetic form is always fetishized. The ambivalence between fragment and whole in *Woman's Leg* also corresponds to the dual nature of the work of art, the leg is cut off at the thigh, like a prosthesis, but at the same time the sculpture is a formal unity. In rhythmic sequence, the volumes of the body taper to the tip of the high-heeled shoe. "The erotic," wrote Oldenburg in his "Notes," "is to me obviously tied up with aesthetic. . . . [It] is a chief source of power."[15]

Oldenburg's fantasy of a new beginning is revealed most strikingly in the phallic ur-form of *"Empire" ("Papa") Ray Gun* (1959), whose title refers to New York's ostentatious self-characterization as the Empire State.[16] The sculpture was modeled on a simple toy pistol that is now part of the *Ray Gun Wing*—an addition to Oldenburg's *Mouse Museum* realized in 1977, which houses his collection of 258 Ray Guns. The basic configuration of the Ray Gun is the right angle; based on the

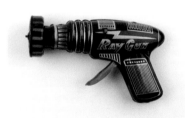

Blue Ray Gun, object from the *Mouse Museum*

variations and permutations that can be derived from it, *every* form can potentially be developed from a Ray Gun, and conversely every form can be broken down into one or more Ray Guns. It is a creative, productive form, from which two "baby ray guns" grow out between the two sides and at the tip of the right angle—namely, the trigger and the hammer.[17] *Ray Gun Rifle* (1960), by contrast, establishes an arc from a prehistoric club, the most primitive form of weapon, to the futuristic ray gun. An astonishing correlation can be made between *Ray Gun*

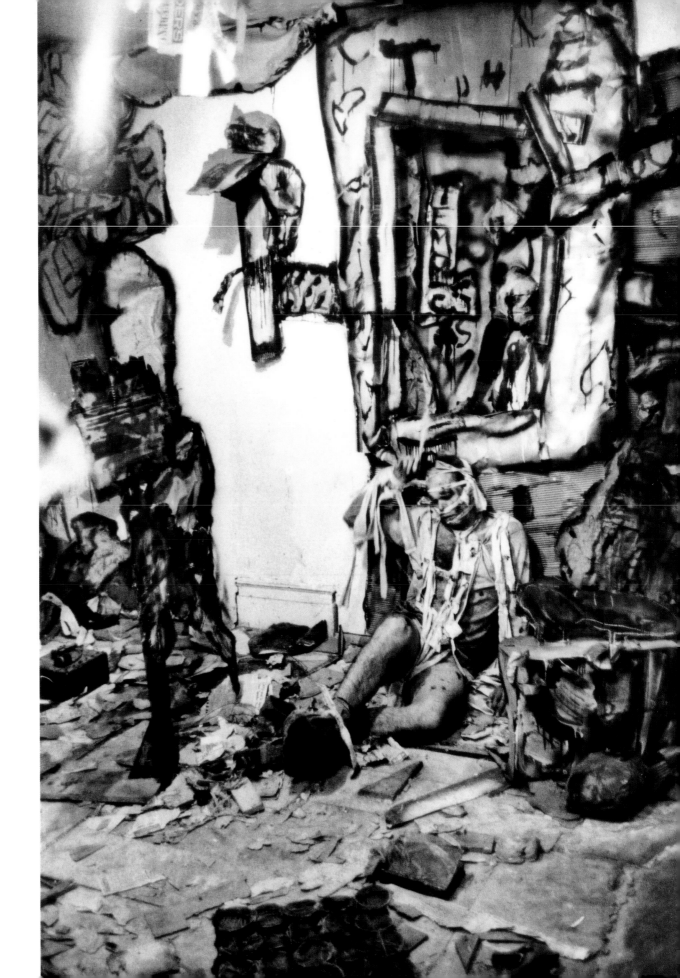

Pages 26–29:

Installation views of *The Street*,
Judson Gallery, Judson Memorial Church,
New York, 1960

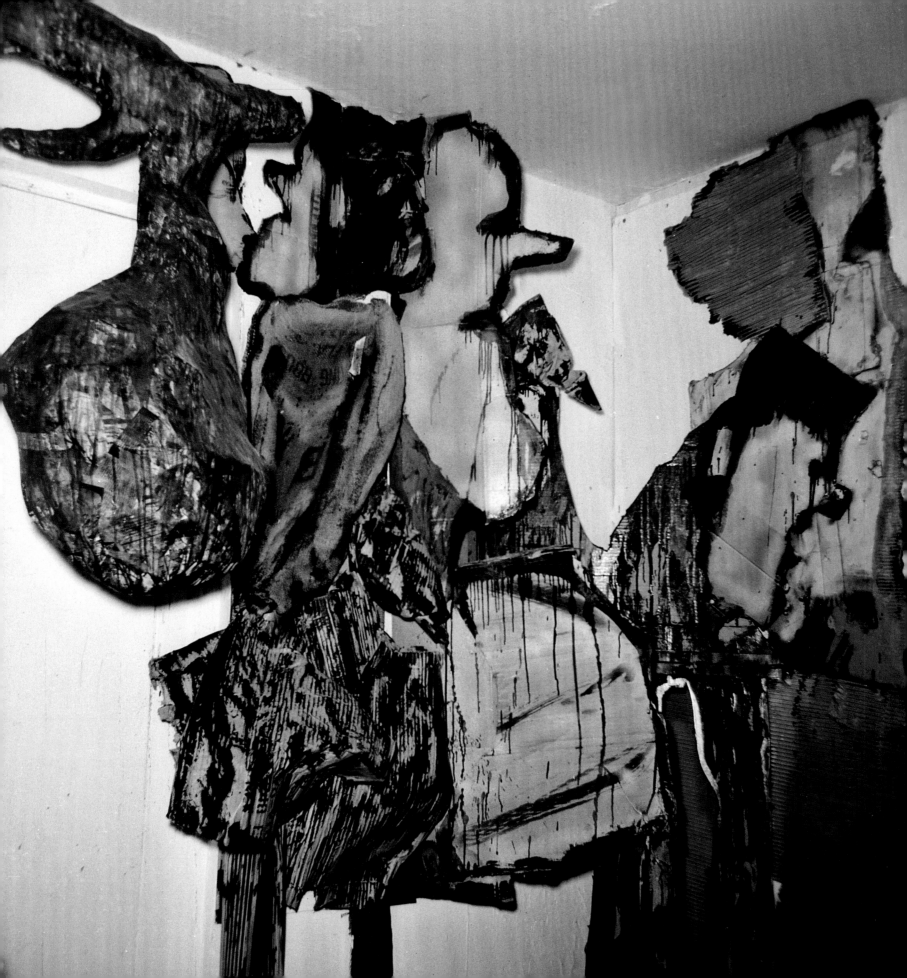

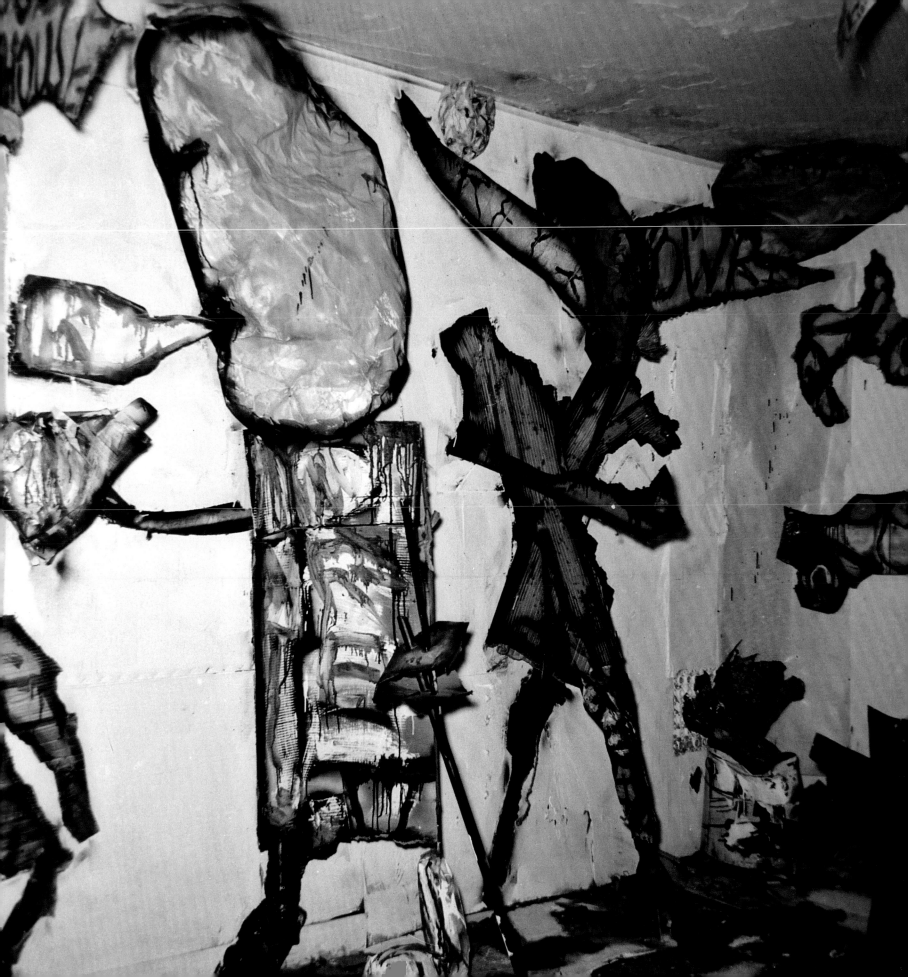

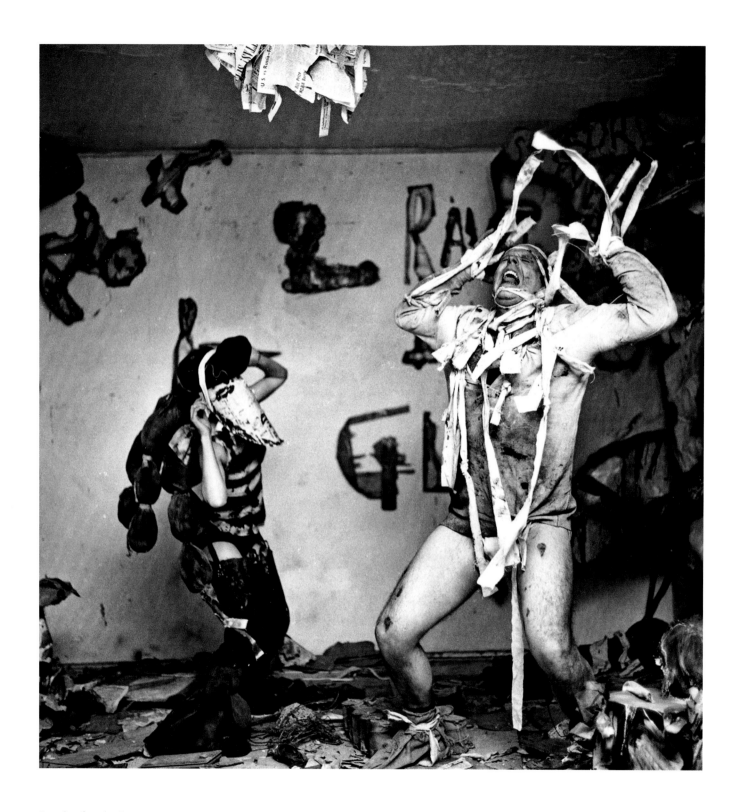

Snapshots from the City,
performance at the Judson Gallery,
Judson Memorial Church, New York,
February 29–March 2, 1960

place (*Duet for a Small Smell* by Robert Whitman, *The Smiling Workman* by Jim Dine, and performances by Al Hansen and Dick Higgins). From there, one continued into a third space, the gymnasium of Judson Church. During "Ray Gun Spex," Allan Kaprow performed his *Foot Dance* there as part of his installation *Coca Cola, Shirley Cannonball?* During the intermission, while the collected debris was sold in exchange for the *Ray Gun Money*, Oldenburg read from a balustrade a passage from a Swedish translation of Baroness Emmuska Orczy's *The Scarlet Pimpernel*. Published in 1905, it is an adventure novel whose hero is a historical precursor to such figures as Superman, Zorro, and Batman.[25]

The *Street* installation itself consisted of a chaotic accumulation of objects made of cardboard, wrapping paper, scraps of newspaper and fabric, bottles, and all sorts of debris. A panorama of contemporary urban life unfolded along the walls: there were cars, an airplane, passersby, heads, signs, a barking dog, a display window, a shoeshine man squatting on the ground, a bicyclist, a man with a walking stick, and, scattered throughout, a number of figures armed with ray guns. The clearly visible words *RAY GUN* promoted Oldenburg's myth like a store sign.[26] The scenery resembled snapshots of fleeting moments of modern life in a big city. The seemingly incidental motifs of the *Street* installation, when isolated from the events, caused grand themes from the world of capitalism to pass in review—traffic, work, the money economy, poverty, alcoholism, isolation, and lack of communication. They were scenes from daily life on the Lower East Side, where Oldenburg was living at the time, and in Greenwich Village, where the Judson Gallery was located.[27] Numerous photographic snapshots Oldenburg took of this area in the late 1950s reveal several inspirations for *The Street*: signage, the ruin-like aspects of urban space, and the random movements of passersby.

Cutting, tearing, and crumpling—these were the artistic techniques Oldenburg used to create the objects in his *Street* installation. Sheets of paper and cartons were cut to size, but entire sections were also torn off by hand, piece by piece. And so the outlines are peculiarly irregular, as if distorted or chopped off, and several of the figures have clearly been assembled from individual parts that do not really go together. Their painted black edges make them appear as if charred and damaged. They do not form an organic whole; on the contrary, their forms result literally and metaphorically from the effects of violence. The contours of a girl whooshing through the foreground—her form based on a photograph Oldenburg took of a young woman in the street in 1958 (see page 17)[28]—are completely frayed. She expresses something of the nervous tension and "intensification of emotional life" that Georg Simmel described as the psychological basis of the individual in a big city.[29] Moreover, in several places Oldenburg placed paper, crumpled by hand—as if trash had been thrown into the street. In that the objects last only for the duration of the exhibition, the treatment of the materials in this way signals the fleeting, amnesiac modern experience of time.

All the scenery is covered with expressionistic touches of paint and black and white sprayed lines. Letters and scraps of words, hearts, stick figures, and exclamation points recall the graffiti that flows through the streets of big cities like the flotsam of a stream of consciousness; it is as if a quiet protest against the mechanization of daily life stirs within the painting. At the same time, however, the spatters of white and black paint unify *The Street*—the "organic" quality of the city thus seems like a parallel world. An irregular bulge that transforms into a treelike, vegetal form borders the store window. The whole looks like an urban dream landscape in which legibility is muddled by a constant shift in scales and levels of reality: "About the Street. First it is clear to me now that it is a nightmare, my personal nightmare. . . . Interpenetration of dream and reality."[30] A melancholic contemplation on the subject represents the flip side of the active bustle. Crouching on the floor, dressed in scraps of paper and strips of fabric, a bottle of spirits in hand—that is how Oldenburg appeared to the audience of his performance *Snapshots from the City*, which took place in the middle of the *Street* installation. In his "Notes," Oldenburg wrote about this role: "The man sleeping against the wall is winter. It is also the allegory of a man retreating into himself to be alone with his obsessions."[31] His wife at the time, Patty Muschinski (later Patty Mucha), was dressed up like a clumsy caricature, as if she were one of the "Street Chicks" in Oldenburg's drawings: with a mask, long hair, leggings, and clumsy high heels. She performed a ritual dance with Oldenburg. At the end of the performance, Oldenburg, exhausted, sank to the floor. Lucas Samaras controlled the lighting during the performance, sporadically turning it on for one or two seconds. The resulting sequences of images, separated stroboscopically, so to speak, rolled out in nightmarish slow motion. The scraps in which Oldenburg was scantily wrapped were reminiscent of bandages.

Claes Oldenburg and Anita Reuben
in *The Street*, Reuben Gallery,
New York, 1960

As noted above, the "new synthesis" Oldenburg was striving for in the *Street* installation, following the predominance of Abstract Expressionism, was not simply stylistic. He associated humanistic figuration, whose advocates were the focus of the Delancey Street Museum, with his own preoccupation with returning to the great themes of modernism and with centering his art on the depiction of (alienated) human beings. Oldenburg's *Street* installation also represents a transgression of traditional painting and sculpture in favor of spacious environments and Happenings. In addition, however, in the overall structure of his Ray Gun activities, Oldenburg presented on a metalevel, as grotesque spectacle, the struggles to prevail in the New York art scene; self-promotion and protest went hand in hand, and recourse to avant-garde strategies combined with the launch of a pseudomyth. Thus Oldenburg wrote in his notes of deploying a "hysterical bellingerent obsessive tone or style" and hoped "to convert, publicize, embarrass."[32] His reflections on the art scene circa 1960 are among the most apt characterizations of the ambivalent logic of the neo-avant-garde: "Like Bud [Scott] says it is better to confuse, to play jokes on the critics than try to talk straight to them. Hire a balloon. Now for example Did Bud say this? So the whole art scene becomes a dramatic creation in the mind of one man who 'brainwashes' others into his creation. This is 'history.'"[33]

ALL STUFF MADE PERMANENT, SAVE FOR REUBEN SHOW

Just six weeks after the proclaimed "END OF RAYGUN" at the Judson Gallery, Oldenburg opened a second version of his *Street* installation at the Reuben Gallery. The institutional context was different this time. The Reuben Gallery, which had been founded in autumn 1959, soon advanced to become one of the leading galleries of the New York art scene.[34] This contextual shift corresponded to an aesthetic one: the space of the second presentation of the *Street* installation was incomparably cleaner than that of the Judson Gallery; the objects were more isolated and could be seen as autonomous works of art. The extremely fragile groups of objects in the installation at Judson were destroyed, apart from five relatively small objects.[35] In addition, Oldenburg included *Street Head I* and another of the ur-forms of 1959 that has not survived. All the other works were produced especially for the Reuben exhibition and today form the bulk of the surviving *Street* objects.

At the Judson Gallery, *The Street* opened up to viewers like a theatrical tableau—not closed off, yet in reality inaccessible because of the many objects on the floor. By contrast, its counterpart at the Reuben Gallery was conceived as a quasi-museum environment; the flat objects were distributed individually across the space, and viewers could move freely between them. Views changed according to one's position from the front or behind, whereas they compressed into vertical lines from the side. This formal isolation corresponded to one of motif. Akin to game pieces in an abstract order, the representations of people took no notice of one another whatsoever. The woman hanging in the back stared at the wall without any focus; several of the figures were painted with uniform horizontal stripes, and the speech balloons coming out of their mouths were empty. The head of *Street Chick*, hanging in the center of the room, was like a death mask. The scenery uncannily resembled a ghost town with the signs of abandoned stores and marionettes aimlessly running around.

Oldenburg's "Notes" reveal that the two installations were planned in parallel. For example, even before the Judson installation opened in January 1960, he wrote: "All stuff made permanent, save for Reuben show."[36] It is therefore a fundamental misunderstanding to play the two versions of the *Street* installation against each other, as has sometimes been done—that the Judson *Street*, as the original, was the more radical, and the Reuben exhibition was a remake for the market.[37] In fact, the two versions of *Street* are conceptually and aesthetically related. Whereas Oldenburg sought to present all the facets of his Ray Gun myth in the experimentally oriented art space at the Judson Church, for the Reuben Gallery he designed an institutional version conceived to last. Hence there were no performances or other activities at the Reuben exhibition. Oldenburg thus shifted the experimental performativity of the Judson's *Street* to the form of the objects' installation at the Reuben's *Street*; they hang, lie, sit, loom like store signs out of the wall, and change their scale and texture. He planned a number of display possibilities in which viewers strolling through the space would become integral components of the installation. The drama and theatrical directness of the Judson *Street* were thus subjected in the second version to a systematic formalization: "as I walk through my show [at the Reuben Gallery], I take positions which I then change by changing my position . . . parts join other parts or separate to form new parts and it is just that sense of metamorphosis through the relation

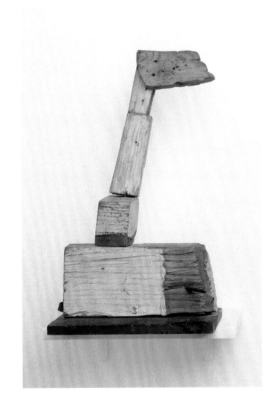

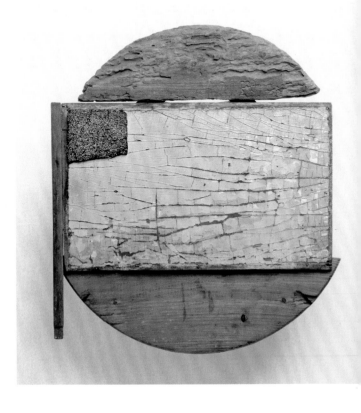

Big Cardboard Flag, 1960
Ink on cardboard
22 ½ x 38 x 1 ½ inches
Private collection

Cemetery Flag, 1960
Scrap wood
14 ½ x 8 x 6 inches
Musée National d'Art Moderne—
Centre Georges Pompidou, Paris

Kornville Flag, 1960
Scrap wood
19 ¼ x 17 x ¾ inches
Musée National d'Art Moderne—
Centre Georges Pompidou, Paris

Study for a Dance Announcement—Flag,
Moon, Ball-Man, ca. 1960
Crayon on paper
17 ⁵⁄₈ x 11 ¹⁵⁄₁₆ inches
Claes Oldenburg and Coosje van Bruggen

Flag, Store Objects, and Street Figure, 1960
Ink on paper
9 ¾ x 7 ⅞ inches
Staatliche Museen zu Berlin, Kupferstichkabinett

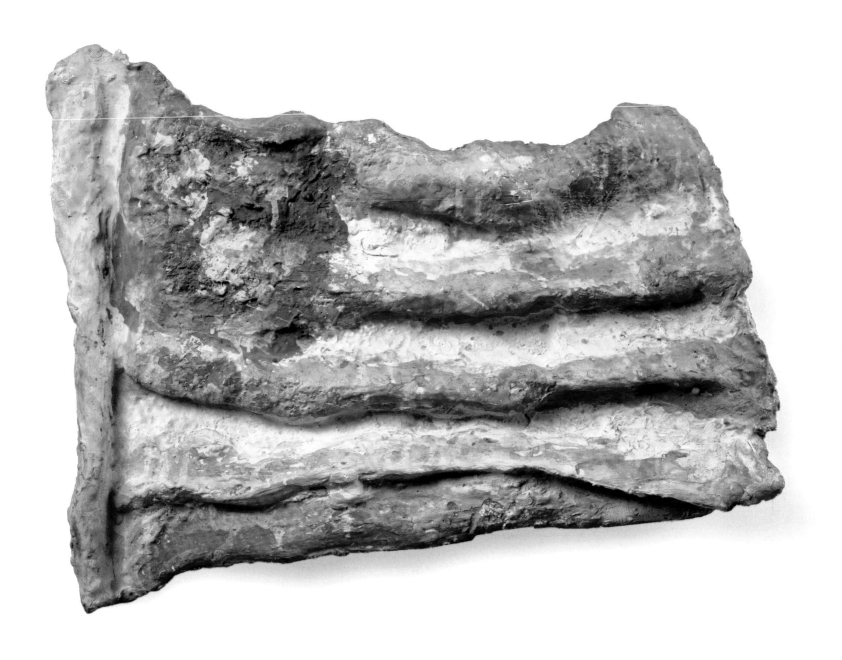

U.S.A. Flag, 1960
Muslin soaked in plaster over wire frame,
painted with tempera
24 x 30 x 3 ½ inches
National Gallery of Art, Washington, DC;
Gift of John and Mary Pappajohn

of form in open space that I experience when walking down the street."[38]

Oldenburg reflected in detail on the contextual potential of the two exhibition spaces—experimental art space versus commercial gallery. In November 1959—that is, before the opening of *The Street* at the Judson Gallery—he wrote: "There is no point in having a gallery outside the established ones unless it is in itself unique and for the presentation of group p[oin]ts of view etc. A 'creative' Gallery."[39] And he continued: "The Reuben or any other commercial gallery has its function, which is to make money, establish reputation for this purpose etc. This is not the aim of the Judson, other aims, cultural significances are more important. . . . They are not incompatible. X could belong to one and be active in the other."[40] Oldenburg structured the relationship of his two *Street* installations as a process of mutual conditioning and stimulation; the one can become "active" in the context of the other and vice versa. Referring to the Reuben installation, he thus spoke of an "environmental counterpart" to the Judson *Street*.[41] Oldenburg pursued this transgressive double movement in the years and decades to follow. As it happened, the concept for *The Store* was also planned as both an experimental setting in a rented storefront and an institutionalized exhibition in the Green Gallery, which was directed by Dick Bellamy.

I AM FOR AN ART THAT IS POLITICAL-EROTICAL-MYSTICAL

Recently married, Oldenburg and his wife, Patty, spent the summer of 1960 in Provincetown, Massachusetts, a colony of writers, artists, and tourists. The contrast between life in Provincetown and life in New York City could scarcely have been greater. Oldenburg felt he needed to escape the heated art scene of New York after the recent success of the two *Street* installations while still keeping an eye out for new directions. He has often pointed out that the place where he was living and the associated cultural context directly influences the art he produces. This is particularly apparent in the group of works he created in Provincetown whose theme is the United States flag. They are simple assemblages, cobbled together from pieces of driftwood Oldenburg collected on the Atlantic beach. As early as April 1960, he wrote in his "Notes": "I will present my world view in a series of 'grand symbols' first the street, then perhaps the garden, or the beach etc. etc."[42] In

Provincetown Flag, for example, the star-spangled banner is integrated into a landscape with the moon; in the freestanding *Cemetery Flag*, it becomes a quiet monument to the transitory. An almost lovely naïveté, even sentimentality, replaces the alienation embedded in the scenes of *The Street*. Oldenburg's interest was not in the cosmopolitan products of mass culture but rather a "folk art," in which the neo-Dadaist assemblage enters into an ironic rapport with American handicrafts. The beach stands in a contrapuntal relationship to the street: the flotsam and jetsam of civilization on the Lower East Side served his depiction of big-city life under capitalism, whereas the flags evoke a rural, unspoiled quality. For Oldenburg, then, the flag symbolizes the interweaving of culture and nature that constitutes the national identity of the United States. The flag as an overarching theme of Oldenburg's Americana might be seen as a bridge, and not just in a chronological sense, from *The Street* to *The Store*, the project he took up on returning to New York in the autumn of 1960. It is therefore no coincidence that the first *Store* piece was *U.S.A. Flag* (1960).

The Store is to *The Street* as the fragment is to the whole. Moving from the scenery of urban life, Oldenburg focused in on the detail in his *Store*: the fate of the industrially produced object—the object as commodity, which in its ever-new metamorphoses of media and form becomes the supporter of culture and the symbol of imagination, desire, and obsession. In order to explore the idea of a real store with art wares in all its facets, Oldenburg rented a store on Second Street in Manhattan in June 1961, using it as a studio during the summer and autumn and opened—thanks to the financial support of the dealer Dick Bellamy—*The Store* on December 1.[43]

Like the early ur-forms of *The Street*, the *Store* pieces were supported by chicken wire, on which Oldenburg placed strips of muslin soaked in plaster, which he then painted. This produced an abstract interior structure with numerous folds, unevenness, and lines. Sometimes the strips of muslin resemble broad brushstrokes, so that it is often all but impossible to decide whether the vibrating movement of the surface results from the unsteady surface or from the gestures of the painting. Oldenburg used enamel paint directly from the can, letting each layer of paint dry before applying another. Thus he avoided the undesired effects of paints running into one another, which would have deprived their colors of radiance. Each *Store* piece was intended to be identifiable—like a logo—by a color chord that was as memorable as possible. The bright contrast in the dress (*Mu-Mu*)

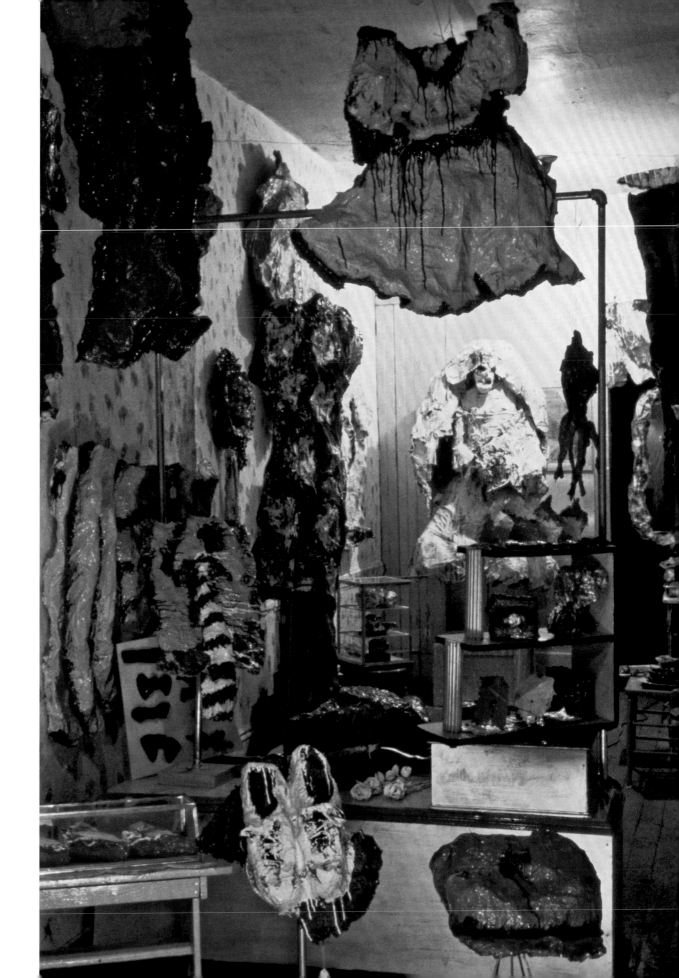

Installation view of *The Store*
at 107 East Second Street,
New York, 1961

Jacket and Shirt Fragment,
1961–62
Muslin soaked in plaster over wire
frame, painted with enamel
42 ⅛ x 30 x 6 ½ inches
Musée National d'Art Moderne—
Centre Georges Pompidou, Paris

Opposite:

Two Girls' Dresses, 1961
Muslin soaked in plaster over wire
frame, painted with enamel
44 ¾ x 40 x 6 ½ inches
Private collection

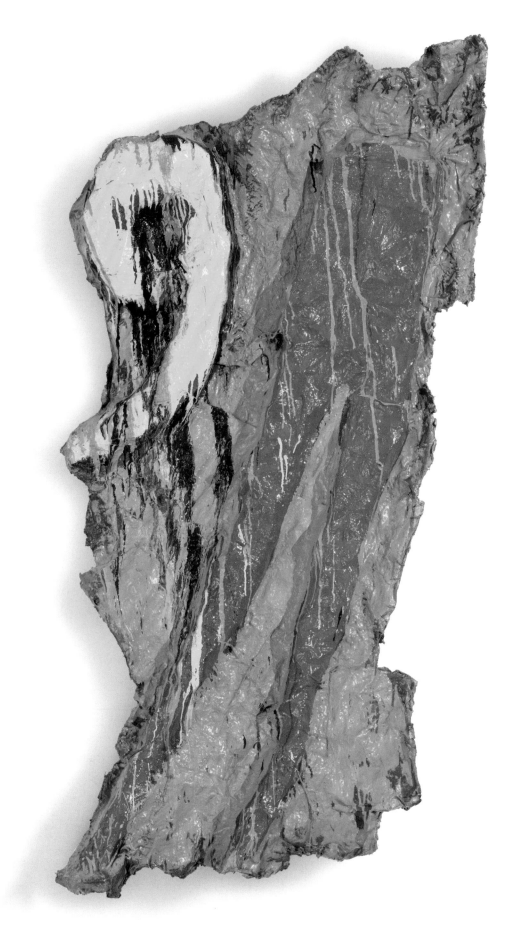

Red Tights with Fragment 9, 1961
Muslin soaked in plaster over wire
frame, painted with enamel
69 ⅝ x 34 ¼ x 8 ¾ inches
The Museum of Modern Art, New York.
Gift of G. David Thompson, 1961

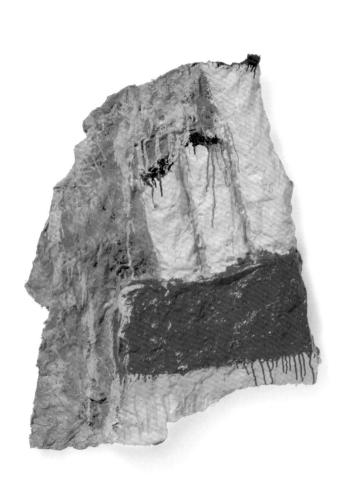

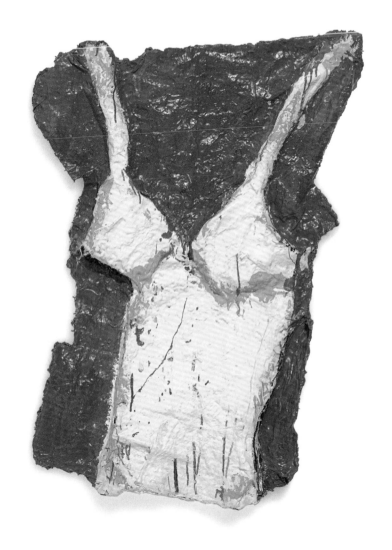

Cigarettes in Pack (Fragment), 1961
Muslin soaked in plaster over wire
frame, painted with enamel
32 ¾ x 30 ¾ x 6 ¾ inches
The Museum of Contemporary Art,
Los Angeles, The Panza Collection

Braselette, 1961
Muslin soaked in plaster over wire
frame, painted with enamel
41 x 30 ¼ x 4 inches
Whitney Museum of American Art, New York.
Gift of Howard and Jean Lipman

between dabs of yellow and red lines has a decorative appeal that undermines the dividing line between painterly sensitivity and market-friendly visuality. Oldenburg fetishistically reevaluates the traditional topos of "sensuous color" (versus "ideal line") in his *Store* pieces. So the enamel paint remains glossy, as if the *Store* pieces have just been painted and the paint is still wet. The resulting highlights are classic examples of visual fetishization. One example of this is found in *Braselette* (1961), a depiction of a woman's undergarment in which the sexual connotation of the motif is signaled by a bright red background, to symbolize the carnal and the sensuous.

Stylistically, Oldenburg introduced a number of art-historical references when painting his *Store* pieces, alluding, for example, to the post-Cubist style of de Kooning with virtuosically applied short brushstrokes (with no traces of drips) in *Big White Shirt with Blue Tie* (1961)—an Abstract Expressionist painting in the guise of a wrinkled shirt. In the evolution of modern art, the increasing abstraction of the objective world went hand in hand with a neutralization of social content, which to a certain extent retreated into formal design. By applying modernist stylistic means to "real commodities," Oldenburg reopens the experiential content that had been encapsulated formalistically, to revive life, as he clearly expressed it in the famous, manifesto-like "Statement," which he wrote for the Martha Jackson Gallery show "Environments, Situations, Spaces" in 1961: "I am for an art that is political-erotical-mystical, that does something other than sit on its ass in a museum. . . . I am for an art that takes its form from the lines of life itself, that twists and extends and accumulates and spits and drips, and is heavy and coarse and blunt and sweet and stupid as life itself."[44] This guiding principle is particularly striking in *Cash Register* (1961), as abstract formal idioms become narrative; for the cash register is identified as the "cold heart" of every store. The silvery ground corresponds to the color of money; otherwise, Oldenburg concentrated on the three primary colors, red, yellow, and blue. This reduction can be seen as a parallel to the equalizing reduction of the world of objects to their exchange value in the capitalist money economy. *Cash Register* is in that sense an object that objectifies all other objects—Oldenburg's sculptures and the things they depict—because they all become money without distinction. But Oldenburg dripped paint on the cash register in a Pollockian gesture that runs counter to the sober collection of money in exchange for commodities. It remains uncertain whether an affront to the modern money economy reverberates in this chaotic painting or whether the drips rectify the irrationality of desire that motivates every act of acquisition—including that of art as commodity.[45]

In his *Store* pieces, Oldenburg also varied the design of the motif, the background, and the contours. Hence the pieces oscillate peculiarly between painting and objecthood. As with the *Street* pieces, the outline is usually so undefined and frayed that it is not perceived as a boundary at all—"no outline," wrote Oldenburg in his "Notes."[46] Sometimes the *Store* pieces seem as if they have been torn out of a newspaper ad. And indeed, since the late 1950s Oldenburg has systematically collected advertisements and archived these clippings as preliminary studies. The wall piece *Red Tights with Fragment 9* (1961) is a shriveled canvas that looks as if it could be pulled on all four corners and adapted to a rectangular format. To put it the other way around, *Red Tights* suggests that it is a painting in the process of transforming into an ordinary object. Other *Store* pieces seem to be further along in their process of "becoming an object." In *Two Girls' Dresses* (1961), the sweeping dresses—which recall antique torsos—separate from the remnants of the background that delimits them; and in *Men's Jacket with Shirt and Tie* (1961), the outline coincides completely with the object depicted. The *Store* pieces are consequently ambiguous as to their status as painting, sculpture, or the intermediate form of relief. Rather, they constitute a hybrid: they describe different aggregate states of a *movement*. For in his overall concept for *The Store*, Oldenburg paid careful attention to assigning each piece a specific "role" in terms of the choice of motif, the form of presentation, and the status of the medium. Each of the *Store* pieces is, on the one hand, an autonomous work and, on the other hand, decisively coexistent with the other pieces, marking a specific "phase" in a transformative process: "My work is always on its way between one point and another. What I care most about is its living possibilities."[47]

This performative extension of painting is aimed at a process of reviving the functionally enclosed world of objects. The offerings of *The Store* correspond less to a stock of identical mass-produced commodities in a supermarket than to a collection of random things in a secondhand store, where a commodity begins a second life, as it were; the traces of use turn a mass-produced commodity into a casually designed form. Each *Store* piece is based on an industrial model but is also handmade and thus insists on its relationship to a subject.

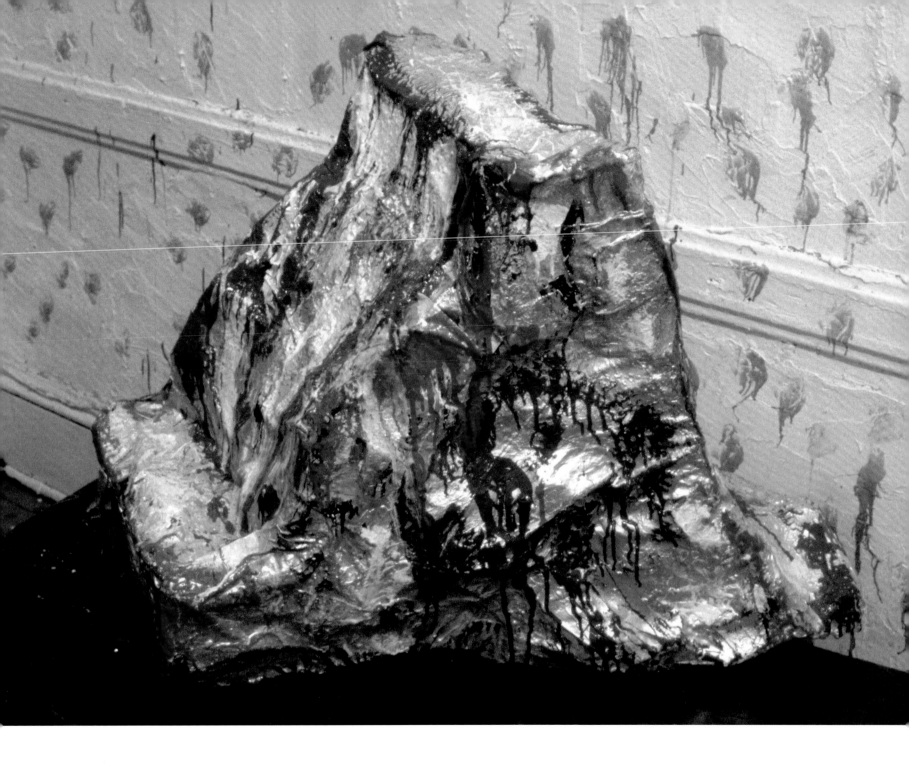

Cash Register, 1961, at *The Store*, 1961
Muslin soaked in plaster over wire frame,
painted with enamel
25 x 21 x 34 inches
Private collection

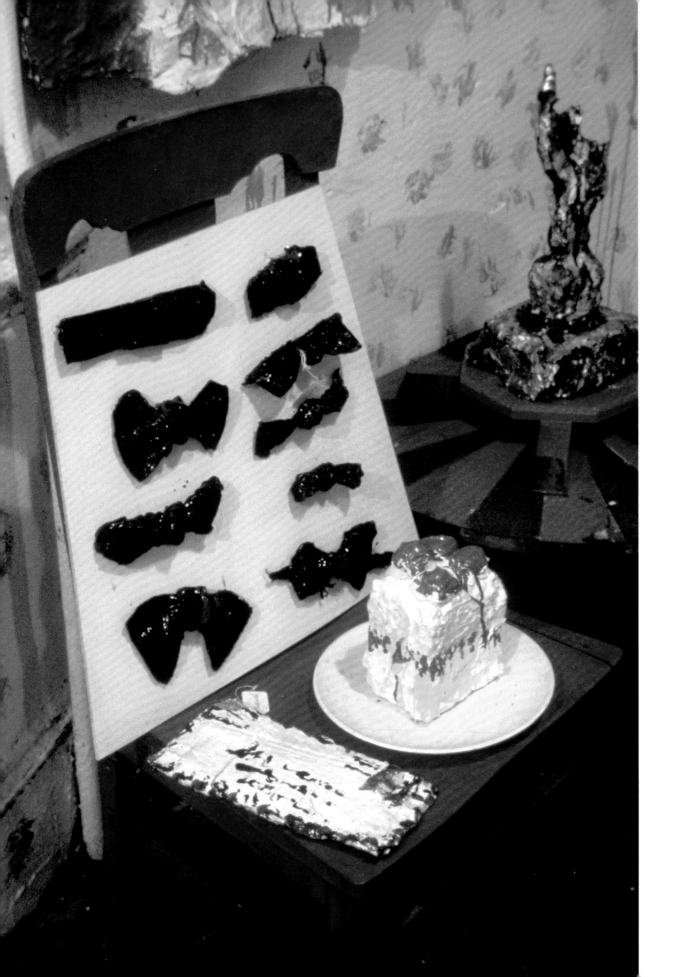

Various objects at *The Store*, 1961

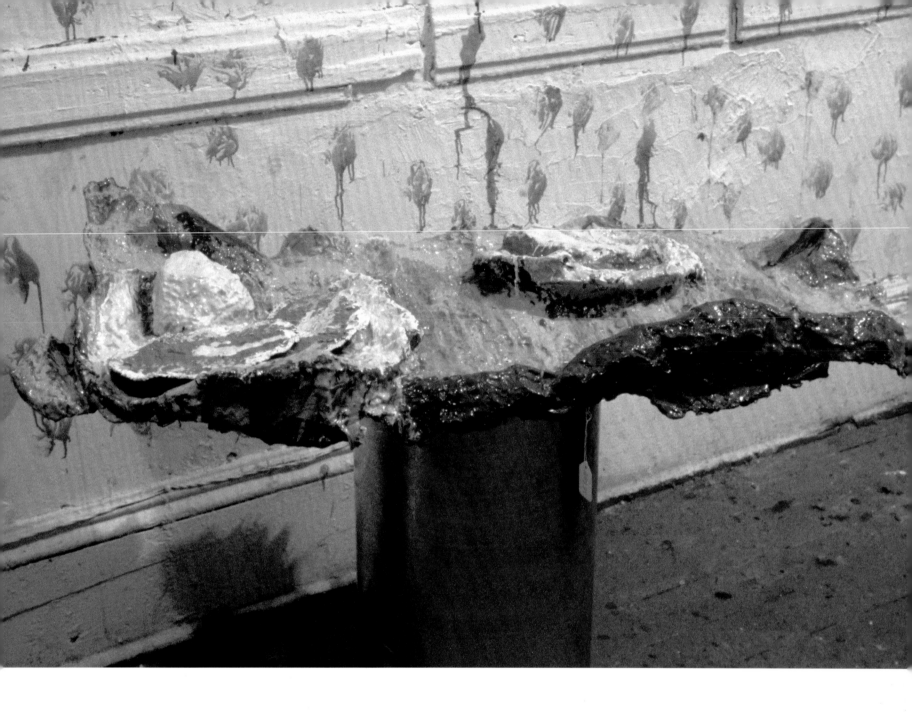

Counter and Plates with Potato and Ham, 1961,
at *The Store*, 1961
Painted plaster
4 ⅝ x 42 ¼ x 22 ¾ inches, overall
Tate. Presented by E. J. Power through
the Friends of the Tate Gallery 1970

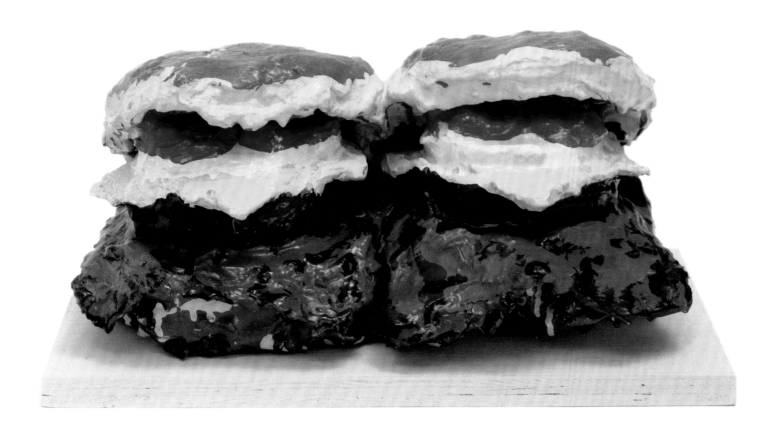

*Two Cheeseburgers, with Everything
(Dual Hamburgers)*, 1962
Burlap soaked in plaster, painted with enamel
7 x 14 ¾ x 8 ⅝ inches
The Museum of Modern Art, New York,
Philip Johnson Fund, 1962

Opposite:

Pastry Case, 1961
Painted plaster sculptures in glass-and-metal case
14 ½ x 10 ¼ x 10 ⅝ inches
The Museum of Modern Art, New York.
Mary Sisler bequest

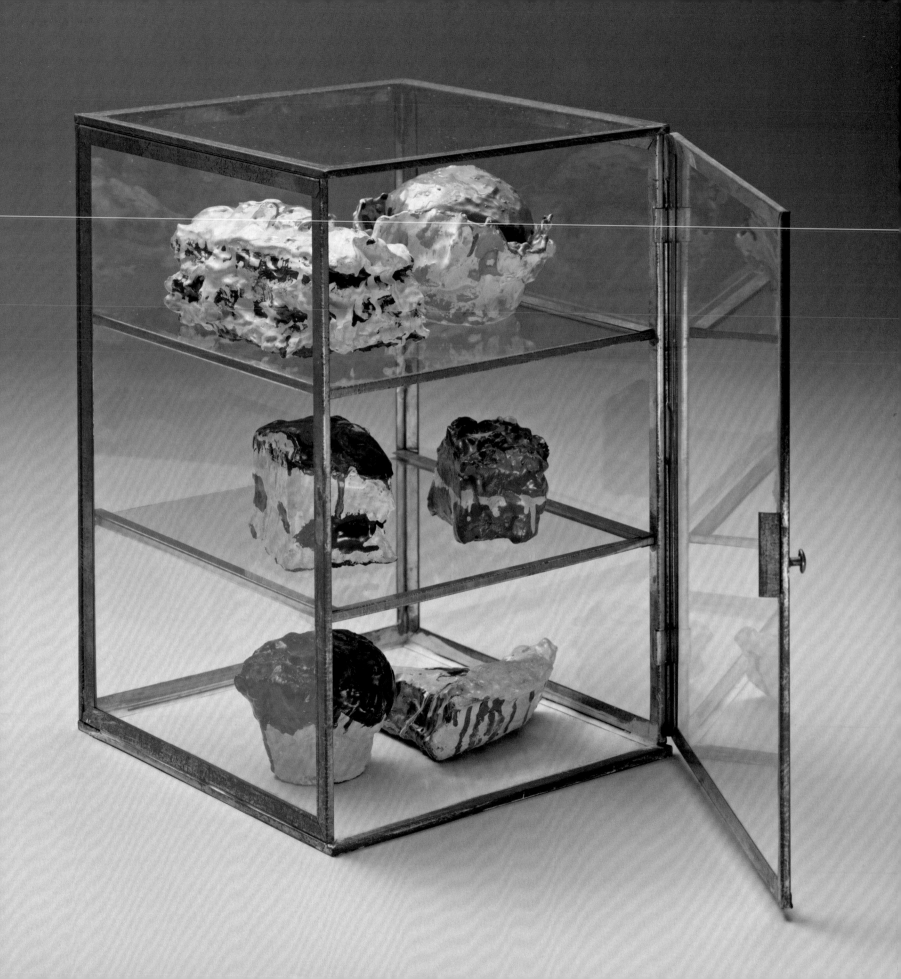

It possesses an individuality, its own "character," which can stimulate as does a fetish: the burgers in *Two Cheeseburgers, with Everything (Dual Hamburgers)* (1962) open up like two hungry maws, and blue paint drips from the collars of *Two Girls' Dresses*, as if its attendant heads had just been cut off. The animistic vulnerability of the world of objects is even clearer in *Jacket and Shirt Fragment* (1961–62). At the intersection where the jacket is fragmented, a bloodred wound gapes. Only on closer inspection do we identify it as a tie.

Oldenburg's *Store* dramatizes not only the vivification of painting but also the reverse process. The individual pieces seem paralyzed and frozen, as if life had suddenly been halted and the objects torn from their immediate life context—as in a photograph. It is as if the life in them had literally been reified. This interplay between bringing to life and mortifying the world of objects results in the uncanny quality of *The Store*. Everything human has shifted to objects, which now begin their own lives. Like a ghost among an absurd collection of objects brought back to life by death, *Bride Mannikin* (1961) is surrounded by prosthetic fragments of the capitalist world.

MY STORE HOWEVER IS HIGHLY EXPRESSIONIST

Pop art's rapid takeover of the New York art scene had already begun in the early 1960s. It was orchestrated as a fundamental break with Abstract Expressionism, with its "look," its rhetoric, and its social networks. "Cool" surfaces replaced wild brush-strokes, mechanical reproduction replaced the authenticity of the act of creation, and the overtly affirmative embrace of the market and mass consumption replaced the existential gesture of protest. These simplistic oppositions were soon so solidified that alternative artistic approaches either became clichéd or were completely banned from the art-historical canon.[48]

Oldenburg's concept for *The Store*, however, cannot easily be reconciled with the established notion of Pop art as "cool" and cynical. *The Store* has often been called the beginning of American Pop art, but that observation is usually meant in the simplistic sense that Oldenburg parodically presented the ideals of modernism. In this view, the actionist painting of the *Store* pieces is not much more than a relic of a style, a style in fact that Oldenburg would finally leave behind in 1963 with his first vinyl sculptures. In this reading, a historical rift runs through *The Store*: conceptually, his work is already "true" Pop art *avant la lettre*; aesthetically, however, he remains

indebted to Abstract Expressionism. Numerous passages from Oldenburg's "Notes" that would have made it possible to associate his art all too closely with an expressionist approach were, with astonishing consistency, abridged or deleted upon publication.[49] An expressionist version of Pop art did not jibe with the canon of art criticism after the mid-1960s. Reading Oldenburg's "Notes" in full, by contrast, paints a very different picture. Take, for example, the first time he mentions his idea for Ray Gun: "Proposal—A museum of American Expressionist Art. . . will terrify and embarrass the artist and also wound and terrify and embarrass the audience / it must grow out of scatological and masochistic impulses and all those impulses which produce the real power the real motivations."[50] And in December 1961, when Oldenburg opened his *Store*, which also operated under the name Ray Gun Manufacturing Company, he wrote of the reaction of the critics: "My store however is highly expressionist. . . . The distortion in critisism re the store is just that it is not understood as expressionistic."[51]

In the late 1950s, expressionism was usually characterized as an art of stark oppositions, in terms of both its means of aesthetic expression and its social references. All the parameters of the work of art—such as color, form, and composition—are in constant conflict, and every one of them is, in the words of Theodor W. Adorno, "polarized according to its extremes."[52] To state it concisely, the more conflicted, the more expressionist. In that spirit, Oldenburg wrote in his "Notes": "Expressionist art is a war between form and anti-form, between order and disorder, between reason and anti-reason, between taste and propriety and bad taste and impropriety etc."[53] These antitheses were, however, usually carried out along an axis of inside-outside relationships: inner freedom versus outward conformity, psychological irrationalism versus capitalist rationalization, actionist vitality versus mechanized industrial production. And when first reflecting on a "Ray Gun Museum of Expressionist Art," Oldenburg also envisioned an oppositional museum of oppressed art, whose approach should be antibourgeois, "primitive," and critical of consumerism: "my dream is actually to be running something like a museum a noncommercial institution to promote my ideas on culture. . . . The commercial has always disgusted me, it always destroys. This dream is naturally foolish."[54] For all the irony, in 1959 he still expressed his ideas in a quite combative tone. Expressionism here is synonymous with social protest, liberating irrationality, and artistic experiment.

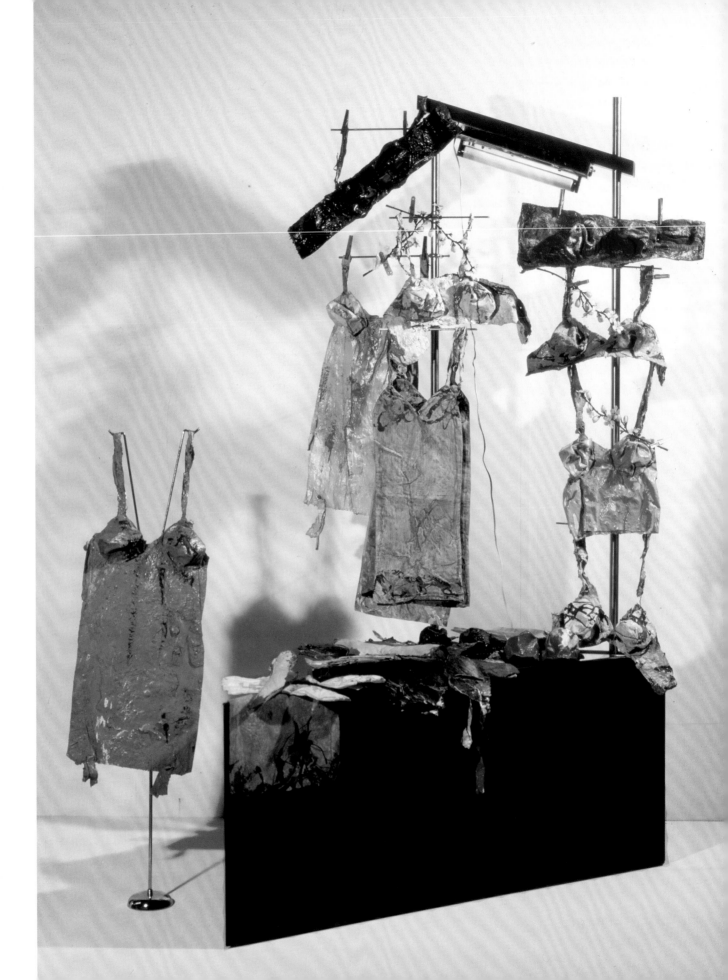

Lingerie Counter, 1962
Cloth soaked in glue and
plaster, painted with enamel,
with metal, Formica, glass,
and fluorescent light fixture
53 ⅛ x 70 ⅞ x 8 ⅞ inches
Ludwig Museum—Museum of
Contemporary Art Budapest

At the moment when Oldenburg's Ray Gun myth took concrete form, however, his concept of expressionism changed as well. In a sense, he turned the internalized psychological conflicts outward, projecting them onto the world of consumerism: "The Expressionist element in ALL SORTS OF THINGS will be revealed." It is as if he wanted to equip the world of commodities and the media with sensitive nerve cells and reveal the potential for conflict hidden within it—its existential abysses—"the fathomless corruptions"—especially where they appeared to have been softened: "Show business is expressionist. . . . RAYGUN—Scientific reality is now expressionist, popular is now expressionist. An expressionism of neon and spaceships, a mechanical expressionism."[55] This sort of Ray Gun expressionism aims to reveal the emotionalism of social conflicts—the capitalist unconscious.

As he established his Ray Gun idea, Oldenburg consistently moved further and further from Abstract Expressionism: "The profundity of pop art, we must emphasize this. THIS IS GETTING NEXT TO IT . . . and not faky like the abexs [Abstract Expressionists] giving titles, Dick Tracy etc. to their absolutelyhavingnothingtodowithpopsy paintings."[56] Oldenburg's criticism of Abstract Expressionism could be summed up thus: whereas the Abstract Expressionists subjected internal stylistic means to a principle of contrast, the status of the individual work of art as an autonomous unit remained untouched by the "fathomless corruptions" of the culture industry. When Oldenburg referred to his *Store* pieces as "highly expressionist," he did so to confront the conflict between artistic creation and fetishized commodity form in all its parameters. Oldenburg viewed his objective as follows: "In the face [of] contradictions etc. to depict dilemmas and state of mind."[57]

The evolution of Oldenburg's Ray Gun concept can be traced, from *The Street* to *The Store*, through an aesthetic of transformation. The confrontation and assimilation of consumption and the market occurred in *The Street* as caricature with distorted undertones, on the one hand, and in the quiet critique of melancholy, on the other. Thus, while still working on his *Street* installation, he wrote: "An art of greys and subdued color, of tonality, reflecting a pessimistic attitude. A melancholy, brooding art."[58] This articulates a certain solidarity with the dirt of the street as the social irrational, which is aimed against the "system," as well as a sympathy for bohemian motifs, which suggests a closeness to the poetics of the Beats. In fact, a photograph of Oldenburg's performance *Snapshots*

from the City was selected for the cover of an anthology of Beat poems titled *Beat Coast East: An Anthology of Rebellion*, which also includes a text contribution by him.[59] In his "Notes," as late as 1959, Oldenburg called the Beat poets a "great inspiration" and continued: "Formally and in every way of behavior to set an example for freedom."[60] The closer Oldenburg came to his concept for *The Store*, however, the more clearly he distinguished himself from the Beat aesthetic. Numerous statements emphasize that he no longer wanted to get out of the way of the capitalist lifestyle but instead wanted to directly *approach* the problems it causes: "the beats fail to see the enemy in them too, tend to externalize it."[61]

X COULD BELONG TO ONE AND BE ACTIVE IN THE OTHER

In September 1962, Oldenburg opened an exhibition at the Green Gallery in New York in which he combined different groups of *Store* pieces. Bellamy, the director of the Green Gallery, had founded it in 1960 on Fifty-Seventh Street in Manhattan. This move by a progressive young gallery into the midtown neighborhood of established galleries, such as Betty Parsons and Sidney Janis, was perceived as a strategically clever chess move to create a springboard for the careers of rising artists from the experimental downtown scene. Analogously, with the two versions of his *Street* installation, at the Judson Gallery and the Reuben Gallery, and now with *The Store*, Oldenburg presented his concept in all its facets, first in an experimentally oriented exhibition situation and then in an institutionalized framework. Even the poster for *The Store* referred openly to the Green Gallery: "In cooperation with the Green Gallery."

At the exhibition, Oldenburg systematized his *Store* concept and provided an overview of the first group of works.[62] He thus established a presentation model for his art that initiated a play on the conditions and presentation modes of modern exhibition and that was as analytic as it was humorous. Even in his use of pedestals, Oldenburg tried out a wide variety of possibilities: they had very different heights and forms, from a flat slab on the ground to a wall mount for a selection of Ray Guns and ice creams; some were deliberately too small, so that sculptures such as *Lunch Box* (1962) and *Umbrella and Newspaper* (1962) hang limply over the sides. A radiator and a bench served as plinths, and several of the sculptures were placed directly on the floor. Clearly Oldenburg

Patty Mucha and Claes Oldenburg with
Soft Calendar for the Month of August at
the Green Gallery, New York, 1962

Pages 54–55:

Claes Oldenburg preparing the exhibition
"Claes Oldenburg" at the Green Gallery,
New York, 1962

was concerned no longer with the modernist logic of integrating the pedestal to emphasize the concrete reality of the works of art but rather with the pedestal as ideological construct, which permitted a variety of questions and narrative allusions. In the process, he quite consciously made "mistakes" in the presentation: sculptures were placed too low or hung too high; the "classical" axes of orientation and spatial symmetries were not respected; sculptures and their pedestals were placed directly on the wall; and the positioning of objects hanging on the wall like paintings varied in perplexing ways.

In the course of exploring diverse modes of presentation, Oldenburg imbued the exhibition space with a performative charge. The viewers were literally set in motion: they were forced to bend down to see *Two Cheeseburgers*, to make their way through objects placed close together, and to confront differences in scale, texture, and color combinations. The realism of the sculpture also varied; whereas the oversize *Floor Cake* and the hanging *Giant Ice Cream Cone* are legible at first glance, Oldenburg scattered mysterious other forms that could be deciphered only on reading their titles, such as *Battleship* (all 1962), which hung from the ceiling with a red undercoating, soaring above the whole scene. In terms of subject matter, he evoked references to a wide variety of social levels: one saw secondhand clothes; a breakfast table; a shirt draped over a chair, as if someone had removed it after work; kitchen cupboards; and a chest of drawers. Hence the individual works were not "for themselves"—autonomous and self-contained— but rather they conditioned one another. The meaning of each was constituted only in relation to the meaning of another.

Because Oldenburg employed the conventions of modernist art exhibitions in critical and humorous ways at the Green Gallery, the exhibition still had something of the provisional character of *The Store*. Moreover, many of the sculptures were created in the gallery, so they retain their experimental, processural character in the exhibition setting. And indeed, Oldenburg had the creation and installation of the exhibition documented by Robert McElroy in more than four hundred photographs, as if it had been a Happening. One can see Mucha sewing several of the soft pieces while Oldenburg paints them—usually while lying on the floor—and the two of them, along with Bellamy, carrying the works back and forth through the space. Even after the exhibition opened, the sculptures were repositioned several times. When the Happening *Sports* was performed in the space, several of the objects were simply

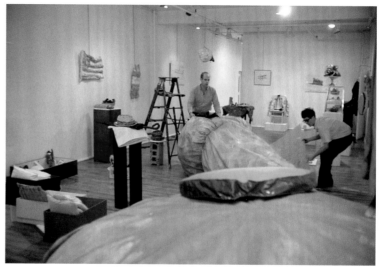
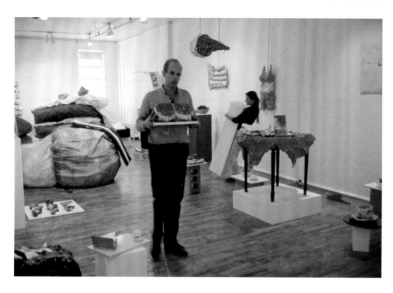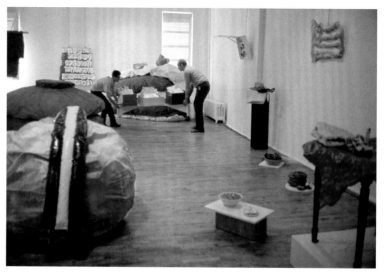

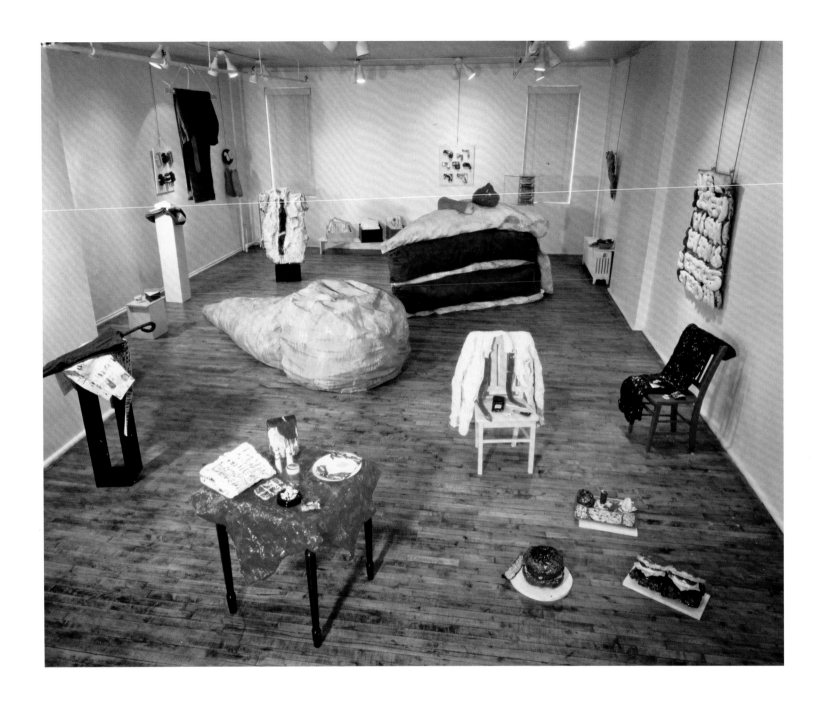

Exhibition view, "Claes Oldenburg," Green Gallery,
New York, 1962

Opposite:

Installing the exhibition at the Green Gallery, 1962

Pages 58–59:

Exhibition view, "Oldenburg,"
Dwan Gallery, Los Angeles, 1963

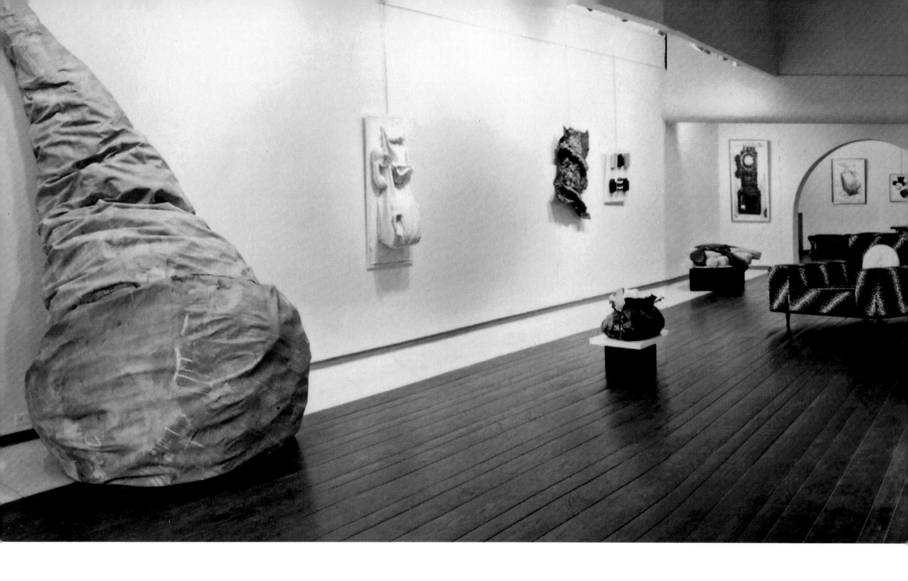

shoved aside and thus took on a new role: "the larger pieces took on a minor role and reverted back to being mere props," as Mucha put it in retrospect.[63] During the Happening, the pedestals served as supports for standing visitors. Close inspection of the published photographs of the installation reveals that no version is like the others; objects are constantly changing pedestals—on a tall pedestal in one photograph and on the floor in the next—appearing in ever-new groups, shifting from one side to the other, or simply disappearing, as in the case of *Floor Burger* (1962) in several of the best-known photographs of the installation. This was not about testing and experimenting to find an ultimate solution; the shoving back and forth was a principle. It is the key to understanding the overall effect of the exhibition: the whole scene resembles a carnivalesque stage play, in which everything could be grouped in different ways, and the individual pieces could change places at any time.

Oldenburg's presentation at the Green Gallery was the first to include sculptures that displaced the performative play with display situations to the object itself, as it were. The two suspended soft objects of *Freighter & Sailboat* (1962), for example, which were attached to the entrance of the Green Gallery, were both from one of the Ray Gun Theater Happenings, where they were literally integrated into a performative event. They formed—together with *Upside Down City* (1962), the second surviving "sculpture" from Oldenburg's Happenings—the point of departure for the monstrously enlarged "soft sculptures" at the center of the exhibition at the Green Gallery, whose forms changed depending on their placement.[64] For example, *Floor Cone* reappears in an exhibition at the Dwan Gallery in Los Angeles in 1963, but there it was placed on its head. The scoop of ice cream lay on the floor, and the cone loomed up vertically, leaning on the wall. Together with Dennis Hopper, Oldenburg

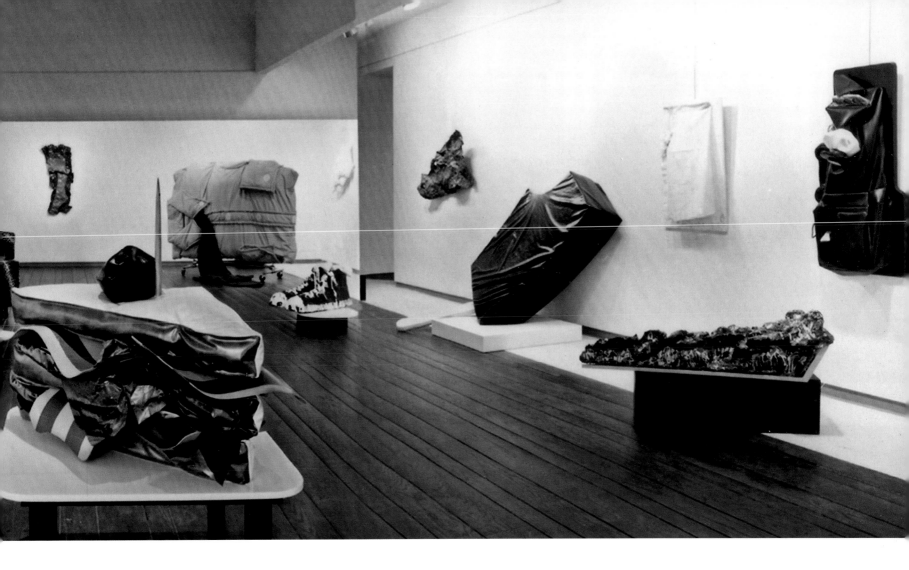

had *Floor Cone* photographed in striking locations in the city of Los Angeles: on the hood of a junked car, on the runway of an airport, and between the legs of a giant dog—one of those Los Angeles buildings shaped like animals, which in this case housed a record store in the early 1960s.[65]

This combination of a flexible model for presentation with the variable status of the work is one that Oldenburg would consistently refine throughout the 1960s. Once again, he chose an environment—a bedroom—to initiate a new group of works. *Bedroom Ensemble I* (1963) alludes to an apartment with modernist furnishings, of the sort that would be offered in the showrooms of a department store.[66] Designing it for the group exhibition "Four Environments by Four New Realists" at the Sidney Janis Gallery in January 1964, Oldenburg carefully adapted the details of *Bedroom Ensemble* to the loft-like room of the gallery; the windows, the painting of the walls,

the carpeting, even the door with the "Private" sign became part of the environment. Beginning with this in situ installation, he produced, in the years that followed, sculptures of household appliances and things from the average American home: light switch, bathtub, fan, mixer, toilet. Some of the motifs appear in different versions: as a "soft version" in stuffed vinyl that hangs down limply, as a "hard version" in precisely cut cardboard, as a "giant version" on a larger-than-life scale, and as a "ghost version" in white canvas. Oldenburg heightened the metamorphic transformability of the objects even further by producing the versions not only in their pure forms but also as hybrids.[67] Strictly speaking, there are also "soft/ghost versions," "soft/hard versions," "soft/giant versions," "ghost/giant versions," and so on. Moreover, Oldenburg related the drawings of his Home series directly to his sculptures, since the drawings after 1963 similarly follow

the principle of "versions."[68] He also reflected on this parallel between his drawings and sculptures when choosing the form of presentation for his exhibitions at the Sidney Janis Gallery in 1964, 1966, and 1967. While in the *Street* installations and in *The Store* the medium of drawing had played a secondary role, it was integral to his exhibitions after 1964. The drawings entered into an extensive dialogue with the sculptures, functioning as preliminary studies and as imaginary extensions of the three-dimensional forms, appearing alone or in series; at times, through their arrangement in the space, they translated the analytic play of the sculptures into a two-dimensional medium. In his three exhibitions at the Sidney Janis Gallery, Oldenburg perfected a model for institutional presentation that can be traced back to the *Street* installation at the Reuben Gallery by way of his exhibitions at the Green Gallery and the Dwan Gallery. Each piece now stood in all its parameters—form, motif, color, texture, size, and mode of presentation—in a systematic relationship to all the other works in the exhibition. And hence the aesthetic experience literally occurred *between* the things, in a constant alternation between subject and object and in a claim to reality and imagination.

It is thus not without a certain logic that in the late 1960s Oldenburg sought a way out of the institutional setting for his art. To put it pointedly, the dovetailing of the concept of the work and the mode of presentation had been so thoroughly exhausted by Oldenburg in his three exhibitions at the Sidney Janis Gallery that a turning point must have seemed inevitable. Indeed, already by his 1967 exhibition, he had integrated drawings and models of monuments in public spaces that would show him the way out of an institutionalized context. When he produced the final exhibition at Sidney Janis three years later, Oldenburg limited himself to projects that were no longer intended for the gallery space. So, whereas in his exhibitions from 1960 to 1967 he had drawn his performative revitalizations from a direct dialogue with models from everyday life—the street, the store, and the home—in the hope that one would become "active" in the other, after 1967 he took the opposite path: he sought to relocate his practice of art, which had since become institutionalized, into public spaces, thus pursuing the same neo-avant-garde dialectic between gallery space and the real world but under new circumstances.

NOTES

1. Claes Oldenburg, "Notes, August to December 1959," Oldenburg van Bruggen Studio Archives, New York, n.p.
2. Allan Kaprow, "The Legacy of Jackson Pollock," *Art News* 57, no. 6 (October 1958), pp. 24–26, 55–57.
3. Allan Kaprow, "Some Observations on Contemporary Art," in *New Forms—New Media I* (New York: Martha Jackson Gallery, 1960), n.p.
4. The first version of Alfred H. Barr's "Chart of Modern Art" appeared on the jacket of his catalogue for an exhibition at the Museum of Modern Art in New York, "Cubism and Abstract Art," in 1936. He revised the diagram, which was explicitly not intended to have a definitive form, several times over the years.
5. "Has the Situation Changed the Content?," transcript, early January 1958, Irving Sandler Papers, Getty Research Institute, Research Library, box 46, folder 8. Participants included Alfred Barr, Thomas Hess, and Harold Rosenberg. A number of young artists apparently were in the audience, among them Michael Goldberg, Paul Brach, Nicholas Marsicano, Sidney Gordin, and Allan Kaprow, who spoke later in the proceedings.
6. Thomas B. Hess, "Mixed Mediums for a Soft Revolution," *Art News* 59, no. 4 (Summer 1960), pp. 45, 62; Harold Rosenberg, *The Tradition of the New* (New York: Horizon, 1959). In his *Artworks and Packages* of 1969, Rosenberg wrote in retrospect: "Oldenburg is the liveliest artist intelligence to emerge in the United States in the last ten years. In an environment that to many is overwhelmingly monotonous, he has discovered objects familiar to all that contain seemingly inexhaustible sources of illusion and irony." Harold Rosenberg, "Object Poems," in *Artworks and Packages* (New York: Horizon, 1969), p. 87.
7. Claes Oldenburg, "Notes, January to June 1960," Oldenburg van Bruggen Studio Archives, New York, n.p.
8. Oldenburg's "Notes" remain largely unpublished. Small selections may be found in "Claes Oldenburg: Extracts from the Studio Notes, 1962–1964," *Artforum* 4, no. 5 (January 1966), pp. 32–33; and in Barbara Rose, *Claes Oldenburg* (New York: Museum of Modern Art, 1969), pp. 183–98.
9. Oldenburg, "Notes, August to December 1959."
10. Oldenburg, "Notes, January to June 1960."
11. On the dovetailing of the avant-garde and the culture of the spectacle, see especially *New Realisms, 1957–1962: Object Strategies between Readymade and Spectacle*, ed. Julia Robinson (Cambridge, MA: MIT Press, and Museo Nacional Centro de Arte Reina Sofía, Madrid, 2010).
12. Oldenburg, "Notes, August to December 1959."
13. Ibid.
14. Five of these first groups of sculptures have survived: *Street Head I ("Big Head"; "Gong")* (1959) and the slightly later *Ray Gun Rifle* (1960) in the Museum moderner Kunst Stiftung Ludwig Wien; *"Empire" ("Papa") Ray Gun* (1959) in the Museum of Modern Art in New York; *Woman's Leg* (1959) in the Centre Georges Pompidou, Paris; and *C-E-L-I-N-E, Backwards* (1959) in the Glenstone. Four additional ur-forms have been documented in photographs: a phallic sculpture titled *Building*; two sculptures in the back corner of the installation of *The Street* at the Reuben Gallery, projecting horizontally from the wall, one of which has a small head and a long speech balloon; and finally *Elephant Mask*, which had, however, been created earlier

Family with Orpheum Sign, 1960
Crayon on paper
13 ¹⁵/₁₆ x 16 ¹¹/₁₆ inches
Claes Oldenburg and Coosje van Bruggen

Graffiti Comics, 1960
Ink on paper
11 ¹⁵/₁₆ x 17 ⁹/₁₆ inches
Claes Oldenburg and Coosje van Bruggen

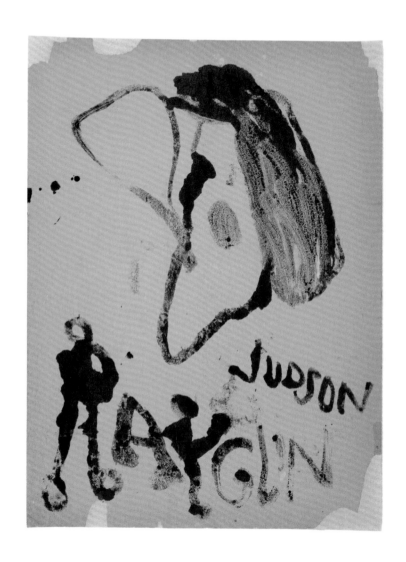

Ray Gun Poster—Woman's
Profile with Talk Balloon, 1960
Monoprint
23 13/16 x 17 15/16 inches
Private collection, New York

Bending Female Figure, 1960
Monoprint
17 3/4 x 11 7/8 inches
Private collection, New York

Ray Gun Poster—Dog, 1960
Monoprint
20 ⅞ x 17 ⅞ inches
Claes Oldenburg and Coosje van Bruggen

*Store Window—Man's Shirt, Mannekin Torso, 39—
on Fragment,* 1961
Wax crayon, pencil, and watercolor on paper
18 x 20 ⅞ inches
Whitney Museum of American Art, New York;
Gift of The American Contemporary Art Foundation,
Inc., Leonard A. Lauder, President

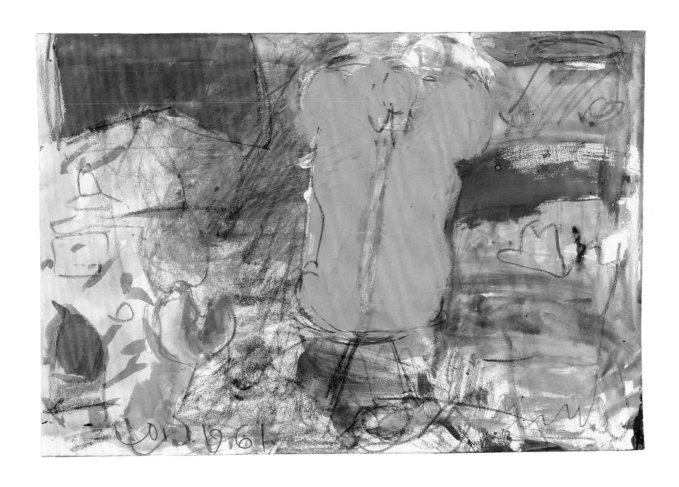

Store Window—Yellow Shirt, Red Bow Tie, 1961
Wax crayon, colored pencil, and watercolor on paper
11 ⅞ x 17 ½ inches
Whitney Museum of American Art, New York;
Gift of The American Contemporary Art Foundation,
Inc., Leonard A. Lauder, President

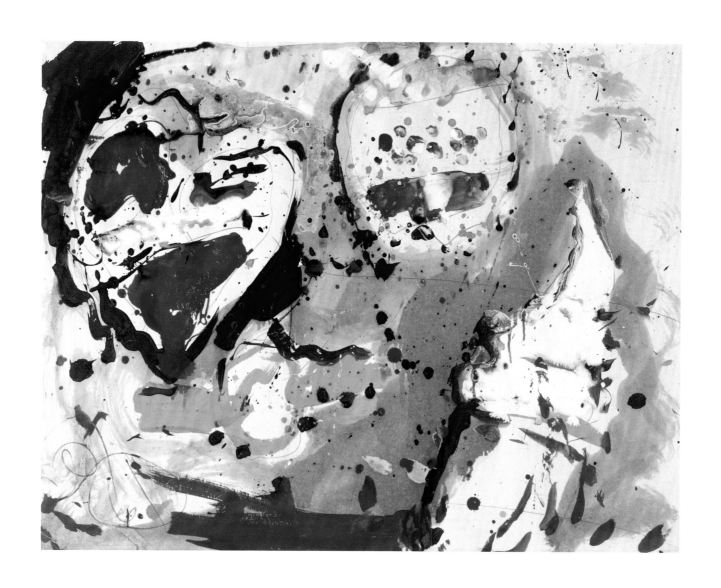

Store Goods, 1961
Enamel, ink, and watercolor on paper
20 x 26 inches
Victoria and Albert Museum, London

Studies for Store Window, 1961
Crayon and collage on paper; recto and verso
11 ⅝ x 9 inches
The Menil Collection, Houston; Gift of Claes
Oldenburg and Coosje van Bruggen, 2009

Psychological Expressionism:
Claes Oldenburg's
Theater of Objects

BRANDEN W. JOSEPH

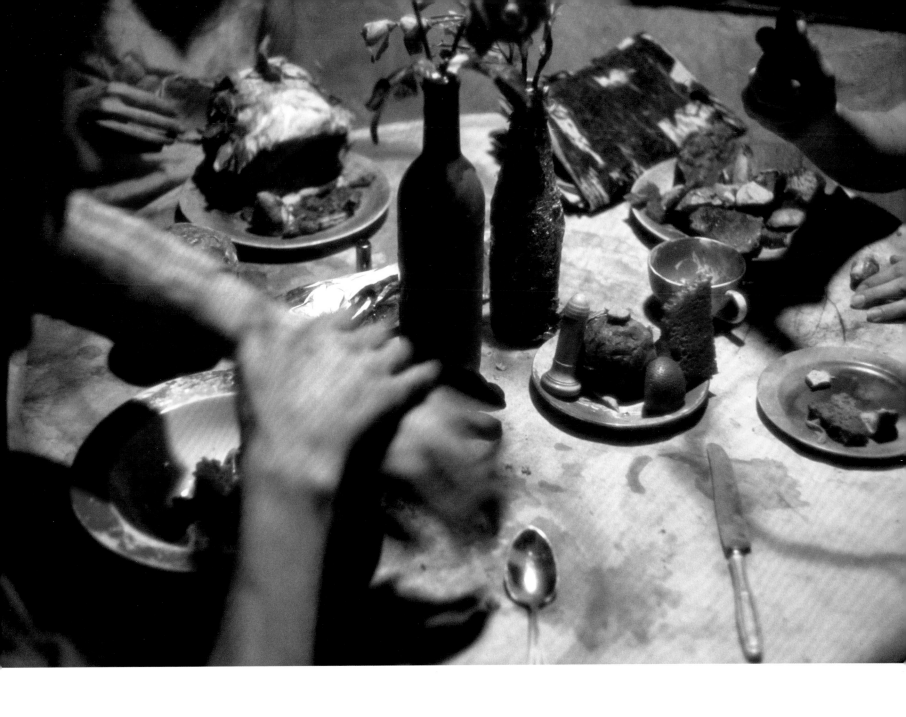

Nekropolis II, Ray Gun Theater performance
at *The Store*, New York, March 16–17, 1962

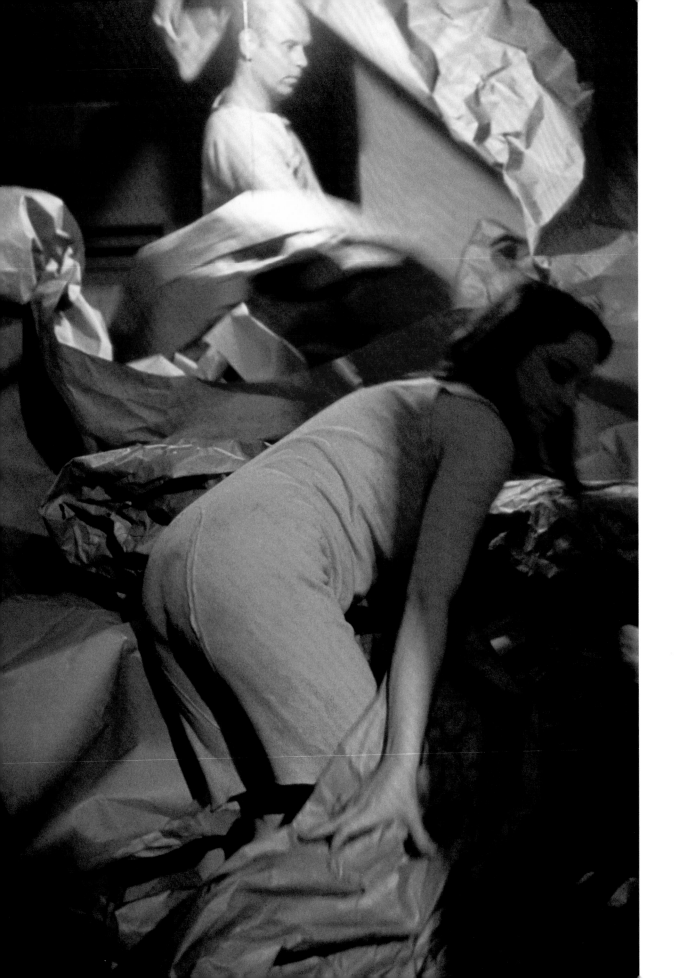

Voyages I, Ray Gun Theater
performance at *The Store*,
New York, May 4–5, 1962

those as happenings (theater)," he noted, "the distinction as to motion or absence of motion cant be made. The 'static' images (as f.ex. those in plaster), tend by their materials and by their subjects to exist in time. The 'moving' tend by the restrictions imposed on them towards staticity. An image that is as close to being *both dead and alive* is what I want."[40]

ROOM 2

Events in the second room of *Store Days I* revolved around the manipulation of dishes and food by the Woman (Gloria Graves) and the carving and examination of a small wooden ship model by the Man (Jean-Jacques Lebel), who occasionally pastes magazine images of women to the wall, while another Spirit (Mucha) inhabits the rafters. Graves, who was per the script to have worn a wetted apron and T-shirt through which her breasts would partially have been revealed, washes the dishes, ostensibly produces a pie (for pushing into the man's face) and ice cream (to end up on her stockings), washes her hair, and serves soup, before frantically chopping vegetables and finally passing out. (The Man, according to the script, was also to have passed out into his soup.)

In the script's first version, the scene was to have been more violent. After the Woman "bites a capsule in her mouth so that her mouth floods with what appears to be blood, which runs down her chin" (an action retained, although subdued, in the performance), both the woman and the man were to appear to die: "The man falls over sideways. A sort of boring a[nd] terrible slapstick scene."[41] Room 2 was labeled "The Kitchen-Butcher Shop," a description more apt for the more overtly violent *Store Days II* (March 2–3, 1962), in which Samaras, as the butcher, stuffs sausages and carves up various cuts of meat, made of canvas filled with sawdust, amid red paint that serves as blood. (His "butcher's" apron is actually a painter's, complete with paint-company logo.) His victim (Cora Baron), costumed in the same colors as the faux meat, is repeatedly lifted onto the table, as though to be carved, and drops to the floor as the paint-blood flows ever more ominously. Samaras "puts up Cora again. Swears, she falls off again. Hangs up phone in a pool of blood. Pushes her up but she falls, up but falls. Trips over a bucket of blood which splashes, Cora falls off, [he] leaves it all and starts to shave."[42]

Violence and death were central, recurrent motifs throughout Oldenburg's performances. A little later in *Store Days II*, Henry Geldzahler "suddenly . . . stiffens, his eyes roll and

his head hangs back (dead)."[43] In *Nekropolis I*, the very title of which means "city of the dead," Mucha is bound and drowned at the hands of Samaras, who is subsequently shot and killed by Oldenburg. At the end of the dinner-party sequence in *Nekropolis II*, all the eaters feign death before two "bears" come to destroy everything.[44] At the culmination of *Voyages I*, brown butcher's paper pulled from long rolls completely fills the scene, incarnating Oldenburg's memory of discovering, as a junior reporter in Chicago, a woman who had died surrounded by collected newspapers.[45] The vast bulk of the action in *World's Fair II* consists of rifling through the pockets of the "dead" Dominic Capobianco. Yet Oldenburg's thinking about death and, equally important, the question of how to bring dead objects and materials to life motivated his work well before his first performances. As early as spring 1959, Oldenburg expressed as his central concern a "violent need to make fantasies *live*," to "*give life*" to them.[46] Until the production of his *Store* reliefs, however, he failed to see how painting, as a two-dimensional representational plane, could serve that function: "what matters most to me is to give existence to a symbol / no matter what I do I cannot give existence by painting / which refuses to become a living object but remains / an operation of space an illusion. its own space not / real space."[47]

In a little-noted draft press release for his first Judson Gallery exhibition, the "white" show of May 1959, Oldenburg presented himself in the seemingly paradoxical position of being a painter (touting the exhibit as the "arrogant debut of a young painter") whose message was, in part, "Time has suddenly ceased for painting": "Who anymore can stand to see painting which refuses to look new refuses to be in the present. Only in the dead world of the nonpresent is there painting. But now the aim is the creation of the universe object in the forms of sculpture chiefly and in poetry and in the disgusting confusion of the two."[48] The first part of Oldenburg's statement can be unpacked fairly easily: the "nonpresent" is the (merely) representational realm, space depicted on the (other side of the) picture plane; "a painting," he noted to himself, is "in my opinion *not an object*, but a space (flat or deep, continuous or confined)."[49] Evincing his awareness of Robert Rauschenberg's three-dimensional Combines, Jasper Johns's collage reliefs, and Kaprow's assertion, in "The Legacy of Jackson Pollock," of Pollock's "near destruction" of the pictorial tradition in favor of "painting [that] comes out at us . . . right into the room," Oldenburg characterized painting's "cessation" as the move

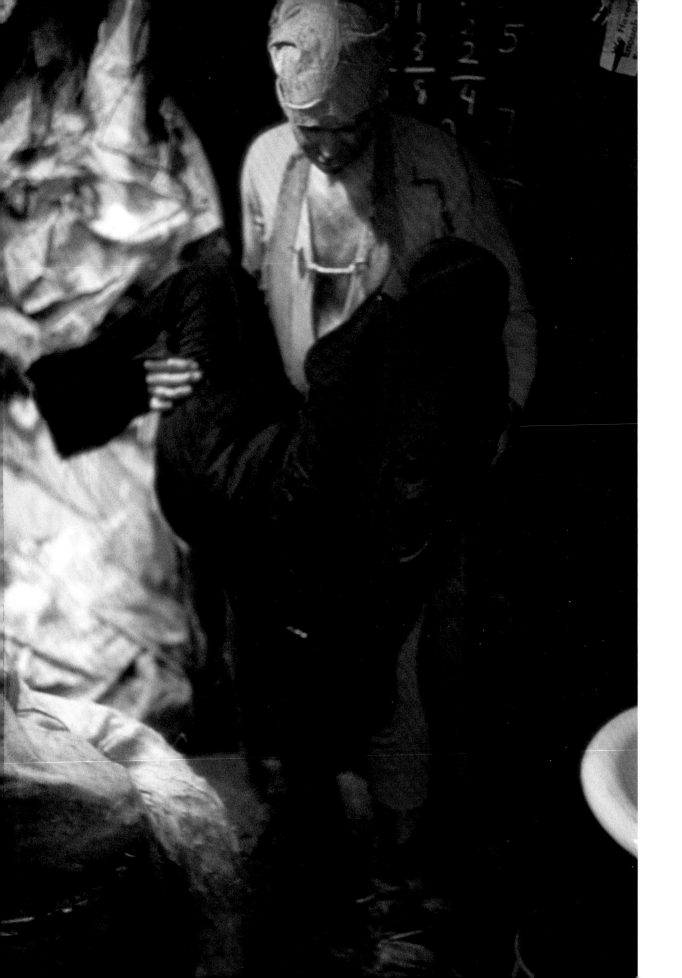

Nekropolis I, Ray Gun Theater
performance at *The Store*,
New York, March 9–10, 1962

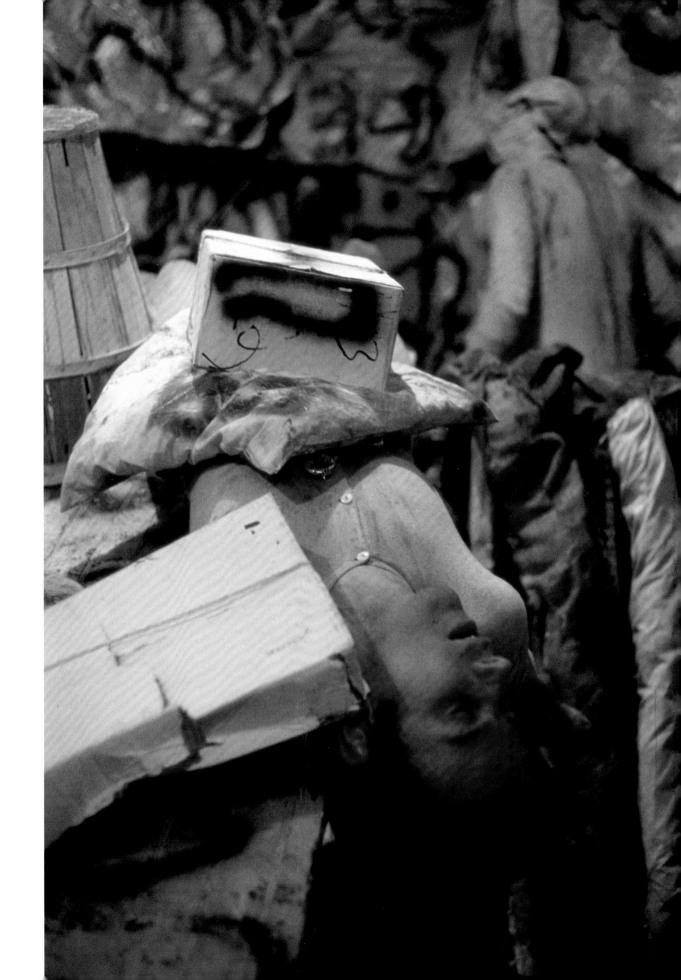

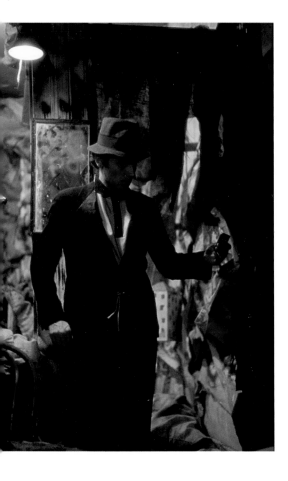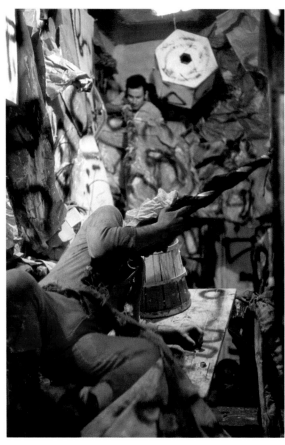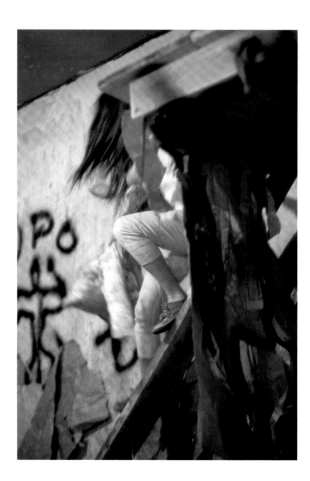

Nekropolis I, 1962

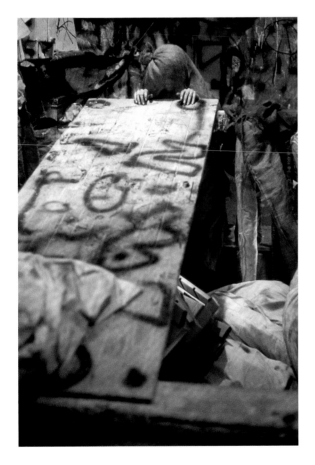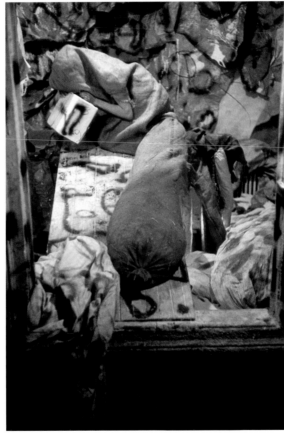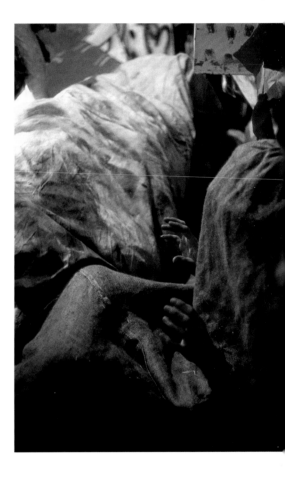

from representational space into three dimensions.[50] Sculpture is thus in the "present," both in terms of representing an up-to-date, contemporary direction of artistic practice, even for "painters," and in terms of being *there*, before the observer as a physical presence, in the real space and time of observation.

Oldenburg's efforts in this direction, which culminated in his painted plaster-over-muslin-and-chicken-wire *Store* objects and reliefs, coincided with his interest in fetishism. As Pietz makes clear, an essential element of the fetish's operation concerns its "irreducible materiality," which separates it from the order of the icon that characterizes the traditional representational function of both painting and sculpture. "The truth of the fetish," writes Pietz, "resides in its status as a material embodiment; its truth is not that of the idol, for the idol's truth lies in its relation of iconic resemblance to some immaterial model or entity."[51] In addition to the objects' existence within real space and actual time, Oldenburg found that the life of his *Store* reliefs came about by the incorporation of somewhat unpredictable materials, which offered resistance to the artist and partially confounded his intentions, "materials which, like [chicken] wire, seem to have a life of their own—socking you back when you sock them. I like to let the material play a large part in determining the form. With material, as with the object, what I seek is a personal exchange."[52] (We will come to see the importance of this last strategy for Oldenburg's performances.)

The second half of Oldenburg's "white"-show press release put forth poetry as a partner in the manifestation of physical presence, both singly and in its "disgusting confusion" with the sculptural. Oldenburg immediately expands on this relation: "Language has suddenly come into wild life metamorphosing taking on existence. From Kerouacs briliant ear to the latest Rhythm and Blues record the living sound is the thing. all formz Of expression twist and cry to serve the new sensation to tear themselves free of the old."[53] Poetry's newfound presence thus resides in its transmission of language's oral character and in intimations of felt, almost musical, rhythm, from Jack Kerouac's "spontaneous bop prosody" to the actually musical rhythm and blues.[54] Oldenburg's understanding of poetry already leans toward the performative; one means of animating "modern/genuine/magic objects" was to impart to them a living rhythm, perhaps even a beat.[55] As Oldenburg noted soon afterward, "rhythm (music) is the magic of time,"[56] hence his idea of staging a public procession to the Judson ("We will parade the sculpts to the gallery Wed.") that would literally

have animated his work, perhaps in emulation of the many Catholic processions that still occur across the Lower East Side. Oldenburg's interest makes particular sense when considering that his *Elephant Mask* (1959), a sculpture in the form of a tribal mask, was included in the exhibition and, according to Barbara Rose and Ellen Johnson, periodically worn about the streets by Oldenburg or Mucha.[57]

Oldenburg explicitly connected his performances to his search for the living object in "Actual Art," another statement from 1959:

> The Judson detects a revolutionary change in art in the direction of MAKING REAL or MAKING ACTUAL the image or object in the artists imagination. The plane with its limitations is no longer tolerable to the artists who feel this necessity, this strong desire. The results of their experiments is neither theater nor sculpture (which it resembles, or suggests) but definitely the projection of a painter's ambition. So we have objects or concrete images that seem to live, actually live, to contain a living quantity, and we have the presentation of living actions in time.[58]

Three years later, after having staged his first performances, *Snapshots from the City* (Judson Gallery, February 29–March 2, 1960) and *Blackouts* (Reuben Gallery, December 16–18, 1960), Oldenburg harked back to his earlier statement in the simple caption "Material Theater and Actual Art."[59]

By this time, Oldenburg understood the crux of the matter to be not simply the pursuit of life, liveliness, existence, or animation, but rather the dialectical interrelation within a single artwork of life and death, a dynamic he characterized as a "struggle" or "battle" between the "life and death impulse."[60] Oldenburg's properly psychoanalytic understanding of the life and death drives as Eros and Thanatos was already indicated by his connection of language's "living" rhythm to Beat writing and rhythm and blues, both strongly allied with the desublimation of sexual desire. As Oldenburg later explained to Barbara Haskell, "Any art that is successful in projecting positive feelings about life has got to be heavily erotic."[61] Oldenburg soon extended these examples to include rock 'n' roll (even more redolent than R&B with unleashed adolescent libido within a white public's imagination) and burlesque striptease.[62]

The interaction of life and death—figured by the opposition and interplay of motion and stasis, activity and passivity (the body as deadweight), eroticism and destruction—serves as the thematic

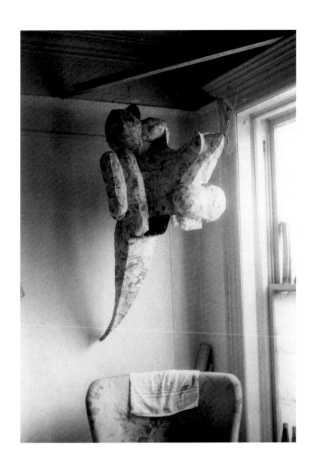

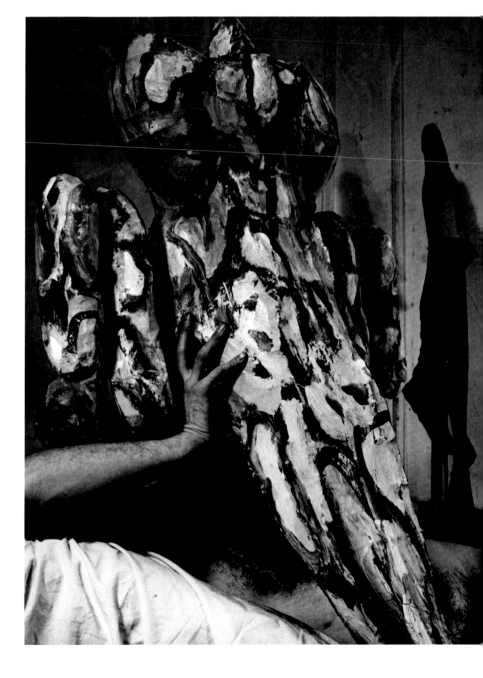

Left and right:

Elephant Mask, 1959
Newspaper soaked in wheat paste
over wire frame, painted with latex
48 x 35 x 27 inches
(destroyed)

and formal principle on which all of Oldenburg's performances play out. In *Nekropolis II*, Mucha plays a dead or sleeping bride, undressed by a groom as she lies on the wedding bed. In *Injun II*, three women—mostly inert but sometimes languidly writhing or crawling around the "bed" as though in fitful sleep, their disheveled dresses rising over their legs and undergarments with a distinct sensuality—are crawled over and eventually pulled off the bed by Oldenburg, before coming to life (as Oldenburg suddenly appears to be dead). Jill Johnston, who quickly "tired of the girls half-dressed or undressing" in Oldenburg's performances, nonetheless clearly noted the poles of sex and death, "perversion" and "violence," that persistently ran throughout his work.[63]

FOTODEATH

In *Circus (Ironworks/Fotodeath)*, presented at the Reuben Gallery from February 21 to 26, 1961, Oldenburg explicitly related the stillness of death to photography. A photographer, in nineteenth-century costume, with tripod-mounted camera, repeatedly takes a group portrait of three individuals who, at the click of the shutter, expire in a heap on the floor. While invoking a more general thanatographic consideration of photography—what led André Bazin to describe the uncanny "charm of family albums" in terms of "the disturbing presence of lives halted at a set moment in their duration"—Oldenburg had a much more specific (and chilling) association in mind: Los Angeles serial killer Harvey Murray Glatman.[64]

Sometimes identified as the first of the "signature killers," Glatman located most of his victims through photo-studio modeling agencies.[65] Engaging them to pose as though for "true crime" detective magazines, Glatman bound his victims in sadomasochistic poses before photographing, raping, and strangling them, and depositing their bodies in the California desert. The nature of Glatman's crimes serves as particularly brutal support for Roland Barthes's contention that photography is allied with "a kind of abrupt dive into literal Death. *Life/Death*: the paradigm is reduced to a simple click, the one separating the initial pose from the final print."[66] Oldenburg further associated Glatman's modus operandi with the nuclear tests then taking place in the Nevada desert (with which the Glatman case shared headlines), both involving the convergence of a flash of light and the moment of death.[67]

Although *Ironworks/Fotodeath* is in no way illustrative of the Glatman case, Oldenburg's mention of the incident is multiply suggestive. It not only makes a gruesomely literal connection between death and photography but also links both to eroticism (albeit of a particularly deviant form). Glatman represents a pathological version of what film theorist Laura Mulvey calls "the fetishistic spectator, driven by a desire to stop, to hold and to repeat . . . iconic images."[68] For Glatman, the arrest of temporal progress became shockingly literal, extending from photography to the human body itself, only to be reanimated in his use of the photo as an erotic fetish. That Oldenburg's curiosity would be piqued by Glatman's crimes, if only fleetingly, attests to his more general investigation of types of sociopathic (this time in the strictly clinical sense of the term) fixation that go beyond attentive norms, in this instance with regard to the commercial circulation of erotic images of women (which the studio-modeling industry accommodated).[69]

Surprisingly, given such an overdetermined connection to the photograph, foremost on Oldenburg's mind while conceiving *Ironworks/Fotodeath* was not photography, but rather cinema. Indeed, he initially thought to present the performance as though it were a film, even going so far as to sketch out rudimentary announcements in the form of marquee posters:

<div align="center">

A

MOVIE

by

Claes

Oldenburg

1. The Ironworks

2. At the Photographers

A

MOVIE[70]

</div>

As early as 1959, Oldenburg had turned toward cinema as a logical, perhaps inevitable, extension of his quest to bring the artwork to life, writing to himself that November: "Isnt film living painting (and drama too). An interest in these."[71] The following year, he described as self-evident an affinity between "the performances and the movies which will grow from them," although noting soon afterward, "even if cinema later, this is not the time for it."[72] In 1963, he even contended, "I sometimes feel . . . the happening is not a natural possibility for me. *Images in time* seem better realized in film, and I gravitate to this medium."[73]

In her 1970 monograph, Barbara Rose would go so far as to state that "if one seeks a connecting theme for the happenings

Poster for *Fotodeath*, 1961
Monoprint
30 ¼ x 23 ⅞ inches
The Menil Collection, Houston; Gift of Claes Oldenburg
and Coosje van Bruggen, 2010

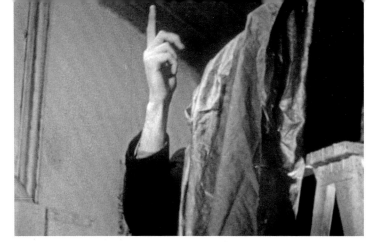

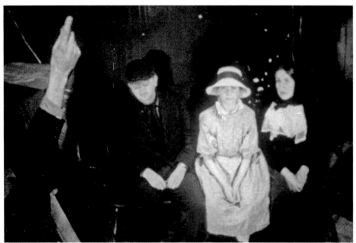

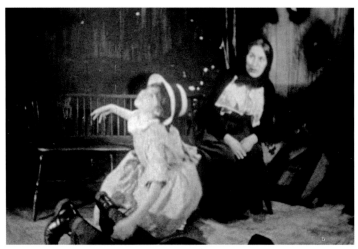

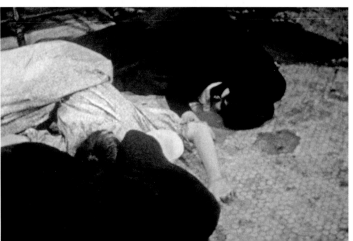

Stills from *Fotodeath*, 1961, a film of the
performance *Circus (Ironworks/Fotodeath)*
(1961), by Al Kouzel
16 mm, black-and-white, silent, 12 minutes

Pages 98–99:

Circus (Ironworks/Fotodeath), performance
at the Reuben Gallery, New York,
February 21–26, 1961

from *Snapshots from the City* through *Moveyhouse* (1965), one might say that it is the invention of the movies, or their development from the original still photograph through the multiple-image motion picture."[74] Nevertheless, neither she nor any other commentator has dealt with the issue of cinema in much detail.[75] In Oldenburg's films, as in his performances, his hopes revolved around an almost obsessive attention to the simplest of objects and actions, a concentration aided by mechanical reproduction that would allow, as he wrote in a 1960 plan for "Seven Films of Close Inspection," "The same action, a very simple action [to be] seen from many different viewpoints, in space and in time, over and over, slowly and rapidly, all that can be gotten from it physically & metaphysically is extracted, from this very simple thing."[76]

Aside from the 8 mm movies he shot as a child and the performance documentations he commissioned from Saroff, Stan VanDerBeek, and others, Oldenburg's first foray into filmmaking was *Pat's Birthday*, shot in Palisades, New York, in the summer of 1962 by the experimental filmmaker, painter, and sculptor Robert Breer. Although the explicit aim was to translate his performance aesthetic into cinema, Oldenburg, by his own account, quickly lost control of the project, ultimately ceding to Breer authority over its completion. Despite several activities reminiscent of those in Oldenburg's performances, only one passage in the completed work reflects his stated cinematic objectives: a close-up traveling shot of an ice-cream cone, followed from its extrusion from a soft-serve machine to Mucha's somewhat stylized dropping of it onto the ground. More pertinent is what attracted Oldenburg to Breer in the first place: Breer's mastery of "tempo/rhythm," a factor that connects Oldenburg's cinematic interests to his earlier thoughts about a living art.[77]

With the exception of *Le Mouvement* (1957), a documentation of the 1955 kinetic art exhibition of the same title at the Galerie Denise René in Paris, Breer's film work consists primarily of experimental stop-motion animations. His first two films, *Form Phases I* (1952) and *Form Phases II* (1953), were attempts to make abstract modernist paintings that would, to use Oldenburg's terms, "live" in time. Others—such as *Recreation* (1956), *Eyewash* (1959), and *Blazes* (1961)—incorporate a great deal of single framing by which images, whether hand drawn or filmed by the camera, flash across the screen in a rapid stutter step. The basic unit of Breer's rhythm, then, is that of the still, keyed to the projector's speed of twenty-four frames per second, against which slightly longer shots are occasionally contrasted. "The realms between stillness and motion," P. Adams Sitney

explains, "remain the object of almost all of Breer's explorations in cinema."[78] Although *Pat's Birthday*, a Jean Vigo–like travelogue, seems a conspicuous exception, Breer maintained that "it's really a still picture and time is not supposed to move in one direction anymore than it does in the other."[79]

Oldenburg grasped Breer's fundamental aesthetic concern, noting how for the filmmaker "action resolves itself into a succession of stills. The stills as unit. Successive stills, not movies."[80] Whatever the results of their collaboration, Oldenburg's initial attraction to Breer's work returns us to the formal and thematic relations between life and death fundamental to Oldenburg's production. The evident stop-start motion of Breer's single framing causes or allows cinema's photographic substrate—its predication on the single, still image, with all of its associated resonances with death—to erupt into the visual flow, disrupting cinema's illusion of "live" motion.[81] As Raymond Bellour has written about the not unrelated technique of the freeze-frame, such evidence of "the photogram surging up from photography, the overwhelming proof of the photographic immersed in the film, forcing itself into the meaning and the thread of its story," causes "cinema [to] lean in the direction of photography, toward its power to inscribe death."[82] For Oldenburg, then, film, like painting and performance, must also be understood as a site for the struggle between the life and death drives, explored via an aesthetic that contravenes the normative temporality of mainstream cinema (the moment's prevailing mode of industrialized attentive regulation), in which evidence of moving film's inert photographic underpinning is habitually repressed.

Ironworks/Fotodeath represents a significant transformation in Oldenburg's manner of addressing such cinematic issues. In *Snapshots from the City* and *Blackouts*, he had used periods of darkness to isolate the different scenes exposed to the audience. In *Snapshots*, the intervals of light are brief enough to connote photography (an idea reinforced by the title), while in *Blackouts* the intervals are of sufficient length to bring cinema explicitly to mind.[83] In *Ironworks/Fotodeath*, by contrast, all the action occurs in the light, and the different "images" (discrete miniature scenes) are separated by means of their spacing across the stage, a lack of interrelation between them, and a temporal isolation signaled by period costumes of the nineteenth century through the present. Among the image-scenes are those that show Mucha standing on a ladder, as two parasol-carrying women in nineteenth-century polka-dot dresses (reminiscent of the women pointillistically portrayed

in Georges Seurat's *A Sunday on La Grande Jatte* [1884–86])
traverse the stage behind her; a burlap-clad man dropping cans
as two other men in burlap flop about on their own; Graves,
in bowler hat, handling various "patriotic" objects (all labeled
"USA") before covering them with glue; Samaras, dressed as a
wounded World War I soldier, attempting unsuccessfully to sit
on a chair; and a woman, back-projected onto a scrim so that
she is a larger-than-life-size shadow, marching and saluting.

Whereas the earlier performances ultimately proved too
much like a film or a photograph, in the sense of being flat-
tened into an implicitly planar, (merely) representational
realm, *Ironworks/Fotodeath* generated images that were more
insistently physically present. "Time," as Oldenburg noted,
would be "slowed down in order to really dwell on action &
the images," and the result would be a "pseudo-cinema or
much more of an analysis and attention to detail and lingering
on an image than cinema can provide, with its slushy time."[84]

Ultimately, Oldenburg allowed for image analysis in
Ironworks/Fotodeath both by slowing time (a technique he
would deploy to virtuoso effect in *Nekropolis II*, in which
Samaras, as a waiter, serves a table of international diners in
excruciatingly slow motion to the accompaniment of a 33 ⅓ rpm
record playing at 16 rpm) and by staging each action in a
strictly repetitive manner.[85] As described in the *Village Voice*,

> each piece is slow and repetitive and appears to go on a very
> long time. Actually this exposure is necessary, because it takes
> that amount of time for the things that are set in motion to run
> down: The drum majorette saluting, the products demonstra-
> tor, the pornographic film sequence, the famous people shak-
> ing hands. These things, which have always bugged us, really,
> are allowed to run down gradually like mechanical toys.[86]

The result not only allowed for an increased physical pres-
ence and sufficient time for more detailed visual scrutiny but
also established a means to condense a past (via the period
costumes) and a present (made palpable through repetition), a
concentrated temporality structurally analogous to that of the
fetish. Oldenburg's explanation of the "eye clusters" by which
he would organize *The Store* well conveys the effect achieved in
Ironworks/Fotodeath:

> The clusters are a gathering together in an arbitrary way of
> sense impressions, without regard to unity of time or place
> or scale. Each impression is naively realized as a ragged piece

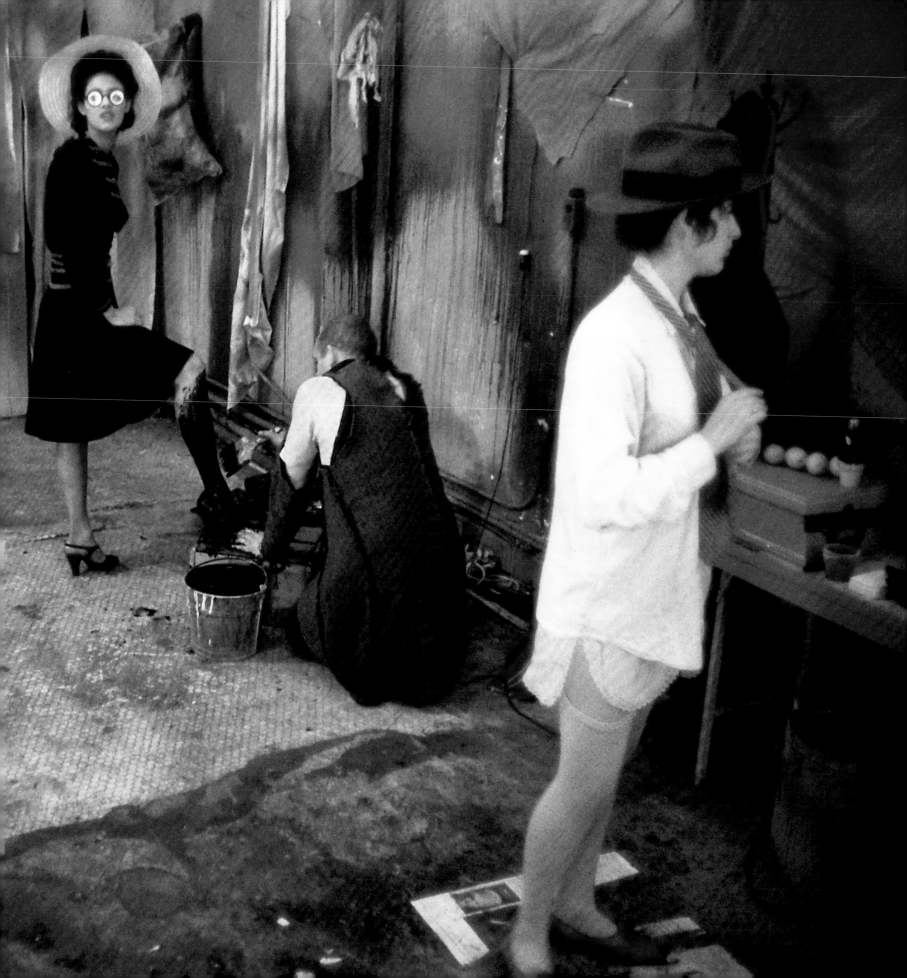

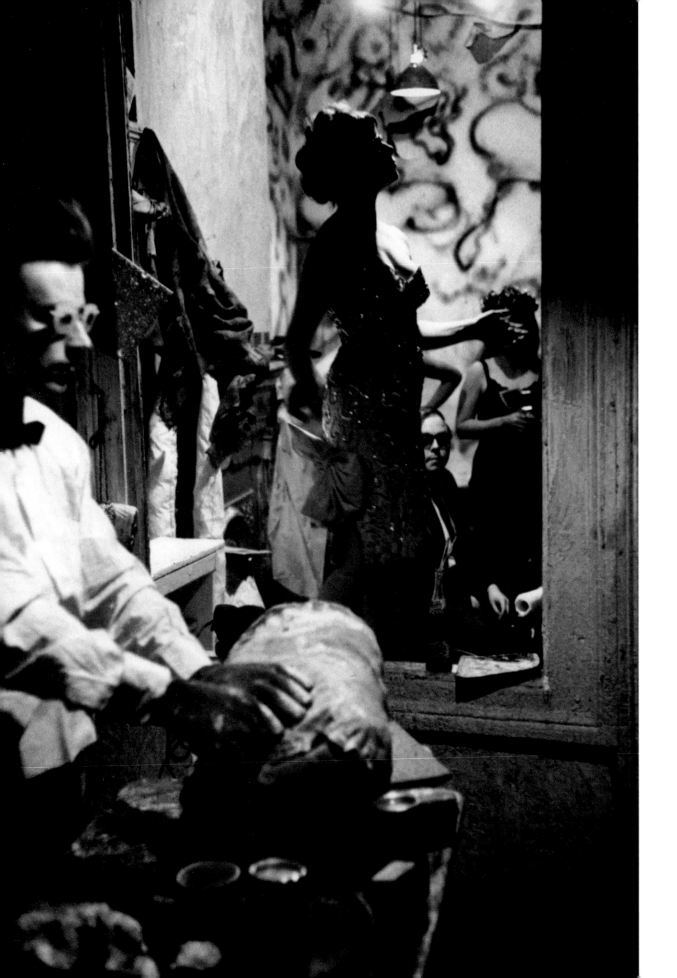

Store Days II, Ray Gun Theater
performance at *The Store*,
New York, March 2–3, 1962

torn out of space, including both object and space, the latter realized as concretely as the first. . . .

It is a matter both of simultaneousness in the present, and of simultaneousness in combining past and present.[87]

Ironworks/Fotodeath similarly presents a cluster of distinct visual animations, forever spinning and replaying their scenes like a collection of magic lanterns or, as Johnston perceptively described it, "the *extended exposure of a picture*. The elements of the picture move, but they seem to have been frozen in *one* character for the place they must assume in the frame."[88]

Ironworks/Fotodeath is not analogous to a continuous narrative film, then, but instead resembles the "cinema of attractions" characterizing film prior to 1906 (a tradition carried forward into Oldenburg's time by the cinematic avant-garde), which put forth a variety of intriguing spectacles to solicit viewers' curiosity in a manner akin to "low" theatrical genres such as the circus (title of the performance), amusement park, vaudeville, and magic shows.[89] Even as Oldenburg rejected the more explicit illustration of movies, he cited early cinema— the "influence of the Edison films" and "when vaudeville converted"—as a precedent for his performances.[90] In *Store Days II*, Oldenburg referenced the transformation of popular entertainments into film more directly, as he and Mucha alternate performing as a movie audience (watching a blank screen, a motif expanded in *Moveyhouse*), as vaudeville entertainers, and as a magician and his assistant. *Injun II* was organized as a series of carnival-like side shows, each separated by a curtain, as Oldenburg moves from one to the other as a novelty-spectacled viewer. Although thematically distinct, the actions in *Ironworks/ Fotodeath* were organized according to a similar structure, "revue style / no overall 'plot' or theme."[91]

In the *Store* performances, Oldenburg further developed the innovations of *Ironworks/Fotodeath*, organizing activities according to different temporal "periods" ("The Sock," "The Shirt," and so on), visually overlapping but thematically unrelated scenes he called "stations," and physically distinct "rooms." *The Store*'s back section, where all the performances other than *World's Fair II* took place, featured a ready-made architectural division into three partially enclosed chambers, complete with windowlike openings.[92] Oldenburg directed the audience's attention from one "room" to another by sequential lighting, the lights in each room coming on only when action was taking place, being extinguished before events began in the

next room. This visual progression owed much to Kaprow's *18 Happenings in 6 Parts* (1959), in which activities occurred simultaneously in three areas partially separated by walls of semitransparent plastic sheeting, but it also called to Oldenburg's mind the type of protocinematic interrelations of motion and stasis that formed a media-technical basis for much of his work. As he explained to Robert Pincus-Witten in 1963:

> I used the succession of rectangles with action in it as the model for a Happening I did in February, 1961, when I went back to New York. It had, let us say, one square of action, followed by another square of action, followed by another square of action, not necessarily developing. It's similar . . . to Muybridge's books—you know, animals in action—in which you see the action move from one square to another—see it develop. I used it as a kind of model. Of course, the action in my pieces doesn't really develop; it's simple action that repeats itself in relation to another simple action that in turn, repeats itself.[93]

In the *Store* performances, these squares became literalized into a succession of architecturally distinct rooms.

In *Death 24x a Second*, Laura Mulvey discusses cinema's capacity to interweave multiple levels of life and death: on a narrative level, as the tropes of desire (Eros) and death propel the story; on a material level, in the stillness that often initiates narrative beginnings and endings or in the freeze-frame, which evokes the stasis of moving film's photographic substrate; and on a psychoanalytic level, not only in the thematic interactions of death and desire but also in a compulsion to repeat that either renews or blocks the movie's narrative development. Writing about Alfred Hitchcock's *Psycho* (1960; based, in part, on the era's most notorious serial killer, Ed Gein), Mulvey notes how the infamous shower death scene of Marion Crane (Janet Leigh) exceptionally

> mobilizes the imagery of movement and stillness that had taken Marion from Phoenix onto the road into the imagery of the transition from life to death that is so central to the film. The homology that connects "stillness," "death" and "ending" takes the fiction film, which generally conceals its material base, back to the secret stillness that lies concealed within it. . . . The stillness of the "corpse" is a reminder that the cinema's living and moving bodies are simply animated stills and the homology between stillness and death returns to haunt the moving image.[94]

With the static shot of the dead Marion's eye that seems to arrest the motion picture, a "stillness . . . so deathly that it almost seems as though Hitchcock had substituted a still photograph for the living actress," Hitchcock places the audience in the uncomfortable position of the fetishistic viewer, driven to stop and thereby possess the image on the screen.[95] Yet, as Mulvey makes clear, such scopophilic investments in the image can open onto their more meditative and thoughtful dialectical counterparts. "The process of repetition and return," she writes, "involves stretching out the cinematic image to allow space and time for associative thought, reflection on resonance and connotation, the identification of visual clues, the interpretation of cinematic form and style, and, ultimately, personal reverie."[96]

Oldenburg had something similar in mind when developing *Ironworks/Fotodeath*; he described the slowed and repetitive temporality and the enhanced attentiveness and visual scrutiny it allowed in terms of "a feast for the eyes, thats why this is a poem for the eyes."[97] Johnston came away from the performance describing an experience that relates remarkably closely to Mulvey's proposed turn from observation to personal reverie: "Each [scene] contains several simple actions which are established and repeated in strict isolation from each other. Thus the eye wanders from one 'event' to another, lingers here or there, soaks up the 'atmosphere,' of the scene as its uniqueness becomes defined, and turns inward to make private connections between the scattered pieces."[98]

Persistently, albeit surreptitiously, drawing on cinema as they do, Oldenburg's performances concatenate formal, thematic, and psychoanalytic properties in a manner similar to Mulvey's theorization. Largely eschewing narrative development for what Susan Sontag termed "a kind of gestural stutter . . . to convey a sense of the arrest of time," Oldenburg's pieces emphasize and exacerbate beginnings and endings by means of their episodic character and internal repetition (the motion beginning and ending over and over again).[99] This complements the performers' constant interplay between motion and stillness, activity and passivity, life or liveliness, and sleep or death, all of which are combined with the exchange or alternation between the erotic and the deadly violent, which constitutes the "thematic" nuclei of all of his productions.

ROOM 3

The third room in *Store Days I* contained the greatest number of visually overlapping but otherwise disconnected "stations."

These included a Woman in a red dress (Johanna Lawrenson), who undertakes various acts of personal grooming (cutting her toenails, loosening her hair, removing false eyelashes, and taking off her clothes before delving into a closet); a Man (Milet Andreyevich), who was originally to eat a sandwich and unwrap a person bound up like a package (but who appears, in extant photographs, to have remained largely immobile); a second Woman (Carolee Schneemann), who paces back and forth atop a mantelpiece while smoking and eating a banana (or a pear), donning and removing a pair of gloves, menacingly flipping a knife, and taking photographs; a female Spirit (Mickey Henrion), who resembles nothing so much as Oldenburg's *Store* object *Bride Mannikin* (1962) reclining on a shelf, more two-dimensional painting than three-dimensional sculpture (when she is not shooting a toy gun); and, finally, a Man and a Woman (Billy Klüver and Lette Eisenhauer), who interact with a ceramic pig before Klüver strips down to an athletic supporter (a bit of role reversal compared with what Rose labeled Oldenburg's persistent "peekaboo" voyeurism of female flesh).[100] After Klüver finishes modeling (part of the time with a brown paper bag over his head) and redons his overcoat, he and Eisenhauer alternate wearing and cutting a shredded-newspaper wig pulled from his pocket before, in the performance's final action, he violently grasps Eisenhauer, places her leg in a sling, and hoists her upside down against the wall like an animal carcass. The resulting exposure of her undergarments helps produce what we now recognize as a typical Oldenburg image combination of violence, death, and eroticism.

Eisenhauer's hoisting is merely one of many instances in which the gravity-bound inertness of Oldenburg's players (forced upon Eisenhauer in this case) leads to their manipulation as though they were objects. In this, the butcher's victim in *Store Days II*, the bedridden women in *Injun I*, and the bride, unwrapped and then undressed before being removed from the bed in *Nekropolis II*, join Samaras's drowning victim in *Nekropolis I* (a scene in which Mucha is literally replaced by a stuffed-doll version of herself), Mucha's being "tied" (actually taped) down by John Rublowsky's daughter in the manner of Gulliver at the hands of the Lilliputians in *World's Fair I*, and Dominic's "dead" body on the table in *World's Fair II* (eventually replaced by an object-filled suitcase stenciled with the letters "DOM"). In *Voyages I*, Samaras and Mucha perform a "dance" that exemplifies and redoubles this type of subject-object relation. Balancing atop a wooden gangplank extending into the audience, Samaras manipulates Mucha as though she were an object—grabbing her

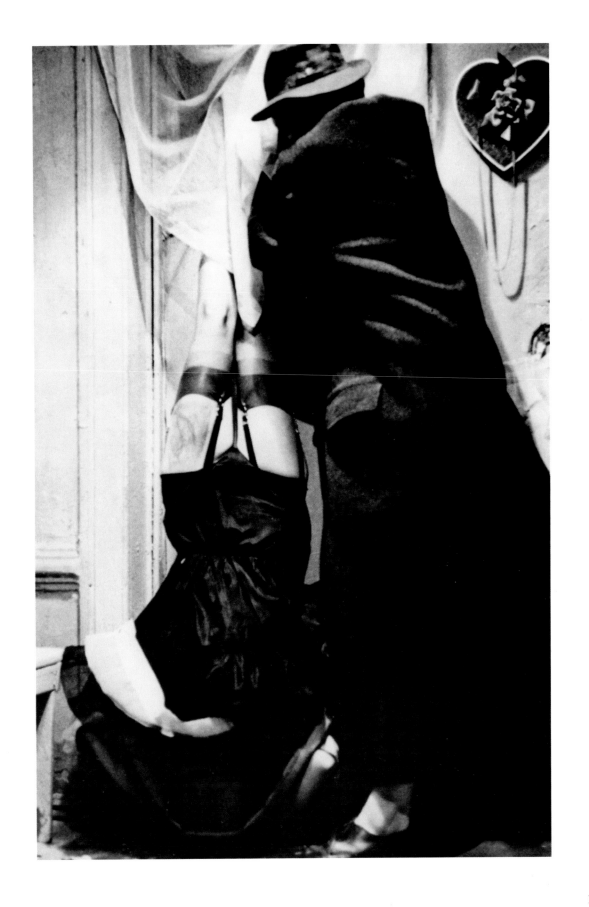

Store Days I, 1962

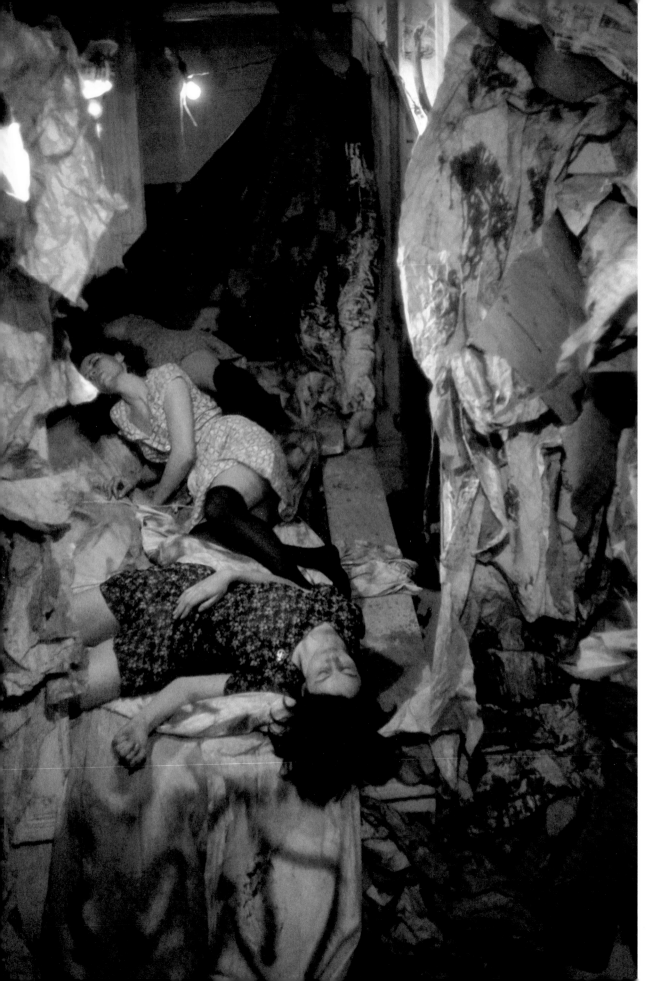

Injun I, Ray Gun Theater
performance at *The Store*,
New York, April 20–21, 1962

by the legs and lifting her, draping her over his shoulder, and so on—while she simultaneously manipulates other objects (reading a newspaper and eating a piece of challah bread) as though unaware of his actions. Sontag, who attended *Voyages I*, proposed as one of the Happening's general features "the use or treatment of persons as material objects rather than 'characters.' The people in the Happenings are often made to look like objects, by enclosing them in burlap sacks, elaborate paper wrappings, shrouds, and masks. . . . Much of the action, violent and otherwise, of Happenings involves this use of the person as a material object."[101]

Sontag effectively isolates the automaton-like nature of Oldenburg's performers' actions, a semimechanization that often lends them an uncanny air, not unlike that of the *Bride Mannikin*, "dressed in white with veil and corsage, but resembling a corpse more than a bride."[102] Since that time, the Happening performers' literal objectification has become an art-historical commonplace. Yet, despite certain of his own statements, Oldenburg did not merely use his performers as objects.[103] Although intended to be nearly mechanical components, they were also, and importantly, to introduce "a kind of unpredictable movement, which I like, to the machine that we have built." "I dont mean something narrow," he continued, "like a life model, taking one ridiculous position after another, to be cast + set wherever streets join. I mean the observation of the whole human being. . . . The form, that is, of his feelings as well as his suit of clothes, his mental processes as well as the shape of his big toe."[104]

In this more complex relationship of animate and inanimate, Oldenburg draws on the association of "living" and "dead" materials that is so fundamental to his work. When people take the role of objects, they do so in a manner analogous to that of the recalcitrant, semiautonomous paint, plaster, and chicken wire that answer back and thereby alter the production of his *Store* reliefs.[105] Oldenburg's players thereby inflect the performance, disallowing it from being merely an illustration of the ideas he gathers in the initial score. Indeed, Oldenburg has described his performances' evolution as the progressive dissolution of his original concepts:

> I find that on beginning a piece or a performance I have a lot on my mind none of which is finally true until it has collided with the facts of making. As I proceed all the thought that does not work is discarded but what is retained is so mixed with the facts of realization that it ceases to be expressible verbally. At

the completion of my work I'm afraid I have nothing to say at all. That is I have either thrown it away or used it up.[106]

In place of easily articulable meanings—what Oldenburg termed variously "symbolism," "sentimentality," and "corn"—his works revolve around "actions [that] are visually clear but ambiguous in meaning. It is the world without words, or actions seen through a telescope."[107]

Such a lack of articulable meaning coincides with facets of two of the overriding tropes by which we have approached Oldenburg's production: the photograph and the fetish. In the photograph (as well as the still within the visual flow of cinema), the image's inarticulable nature concerns the surging forth of the uncoded indexical trace, the direct impress of the rays of light reflected off the subject onto the photosensitive emulsion, that which led Barthes to distinguish the indescribable and ultimately subjective effect of the photograph, which he termed the *punctum*, from its verbally analyzable features, the *studium*.[108] In Oldenburg's performances, this aspect of the photograph finds its analogue in what might be called "actions without a code" (a goal sought by French playwright Antonin Artaud, who had a profound impact on Happenings and whom Oldenburg read at the time). These are what remain once Oldenburg's preliminary ideas are rendered from the performance (like fat during cooking) through the former's "collision" with his collaborators' adoption and enaction of them.[109] Hence Oldenburg's opposition to his fellow "Happeners'" recourse to schema, plots, and any kind of pregiven or traditional symbols:

> I want no part of the artificiality, the subjective symbology, imposed content, or the conscious aestheticism which characterizes the "happenings" of Allan Kaprow, Jim Dine, Robert Whitman, Geo[rge] Brecht or Red Grooms (which is not to say I do not appreciate their works). In my "theater of action" all meaning arises from the events themselves whch I have recreated, and not from any imposition of meaning by me. The objects and events are responsible for their own meaning— I simply allow them the opportunity to mean something.[110]

The result is that the content and meaning of the performance are obscure even to their author but are nonetheless able to touch him and others in a personal manner.

The encounter with the fetish, like that with the photograph, has also been characterized as inherently extralinguistic. "Such encounters," writes Pietz about Michel Leiris's speculations

about "true fetishism," "lack any adequate formal code to transform them into meaningful communications or coherent narrations. Such a singularly fixating encounter is 'stripped of all symbolic value' and, paradoxically because of this degradation from any recognizable value code, becomes a crisis moment of infinite value, expressing the sheer incommensurable togetherness of the living existence of the personal self and the living otherness of the material world."[111] In this instance, the fetish is associated not only with a radically individual reception but also with an equally intimate connection to the otherness of material existence, a momentary experience of the single material item as a collective object, a condensation and repositioning of a particular order of social relations.

That this aspect of the fetish may be at play in Oldenburg's work finds support in his insistence on his theater's simultaneously psychological *and* social significance. "I am taken by limitation and I should like the see the Happening defined in a limited way," he wrote in an unpublished 1962 text titled "Special character of RG Theater": "With me we have the psychological happening. Ray Gun is New York inside out (backwards) or psychoanalysed. New York being exotic US. Jim[Dine']s [performance] is selfanalytical. Mine is socialanalytical."[112]

As Pietz has convincingly demonstrated, the fetish comes into historical existence and functions as a point of transition between incommensurable cultures (originally, sixteenth- and seventeenth-century Portuguese traders and West African civilizations); it acts as a condenser of cultural otherness, which it allows to be perceived and engaged, even as it is displaced. The fetish thus evinces (as Freud's theory of it would come to encapsulate) a particular and peculiar "double consciousness of absorbed credulity and degraded or distanced incredulity" toward the cultural values it both addresses and condemns.[113] As Pietz explains, "It is in those 'disavowals' and 'perspectives of flight' whose possibility is opened by the clash of this incommensurable difference that the fetish might be identified as the site of *both the formation and the revelation* of ideology and value-consciousness."[114] In this dual role of the fetish to both participate in and reveal the social system in which it is formed, we reencounter the indecipherability that has art historically characterized Pop art, and Oldenburg's place within it, vis-à-vis its criticality toward or complicity with the values of commercial society. Yet, akin to the fetish at the time of its historical emergence, Oldenburg's objects, when woven into the nearly ritualistic actions of his performances, "distort [the commodity's]

relative exchange value."[115] By slowing, obsessively repeating, and otherwise thickening interactions with his objects, Oldenburg freights them with sexual, psychological, uncanny, and even religious qualities that appear, from the perspective of merchant rationality, as "a perversion of the natural processes of economic negotiation" and thereby repositions them "adjacent to" the commodity's normative material and temporal flow.[116]

• • •

With his opposition to meaning's subsumption under verbal articulation, Oldenburg approached a central trope within the aesthetic of Kaprow's teacher John Cage, himself often credited with having invented the Happening with his *Black Mountain College Event (Theater Piece #1)* (1952). For Cage, the paramount issue was indeterminacy, the production of significations that were not pregiven by artist or composer and that therefore could not be "correctly" decoded but only received in a unique and differential manner by each member of the audience. Beyond freeing both artist and audience from an authoritarian imposition of meaning, indeterminacy served as Cage's strategy of liberation from the controlling effects of desire and the attraction to objects (including, in some sense, other people) imposed by the system of consumer culture. Within the visual arts, Cage found Marcel Duchamp's *The Bride Stripped Bare by Her Bachelors, Even (The Large Glass)* (1915–23) an exemplary instance of indeterminacy: "There is nothing in it that requires me to look in one place or another or, in fact, requires me to look at all. I can look through it to the world beyond."[117] Cage explicitly sought to extend such transparency to Happenings. He explained to Richard Kostelanetz, "I would like the happenings to be arranged in such a way that I could at least see through the happening to something that wasn't it."[118]

Although the enigmatic nature of his performances invites indeterminate reception (that personal reverie noted by Johnston above), Oldenburg's position differed profoundly. For, as we have seen, he concerned himself with nothing so much as affective and psychological cathexes onto objects, the type of induced, anormative fixations that sexual fetishes can come to share with commodities. Oldenburg distinguished his work from the Cagean paradigm and those (such as Kaprow) who followed it through precisely such "psychological" factors: "Psychological expressionism. That why its so foolish to compare my hpgs with Cages or others. . . . They are psychological a thing an obstacle, not a thing to see through."[119]

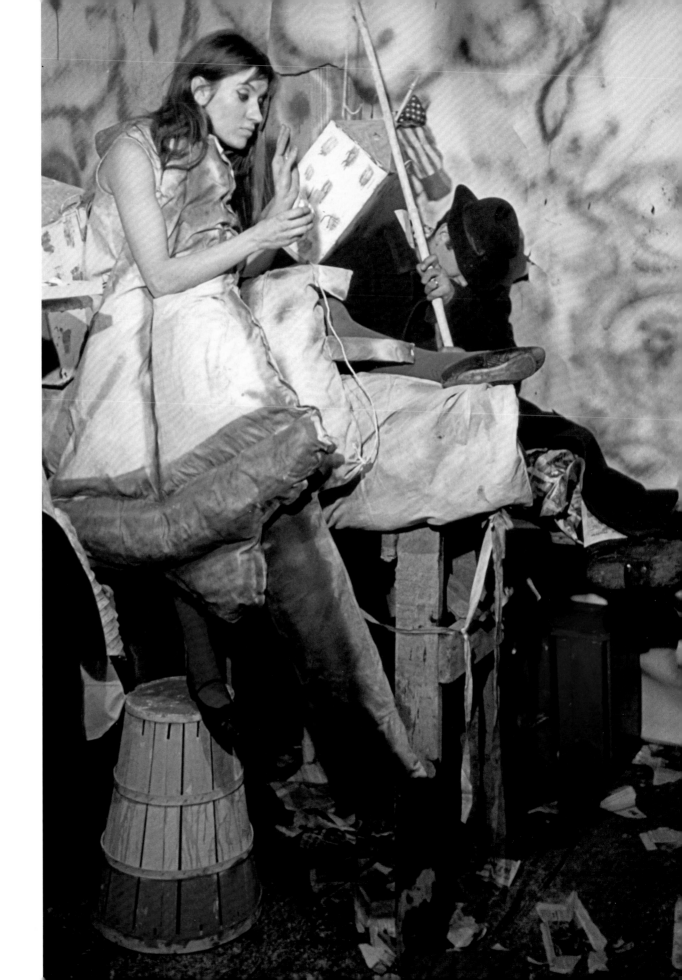

Store Days II, Ray Gun Theater
performance at *The Store*,
New York, March 2–3, 1962

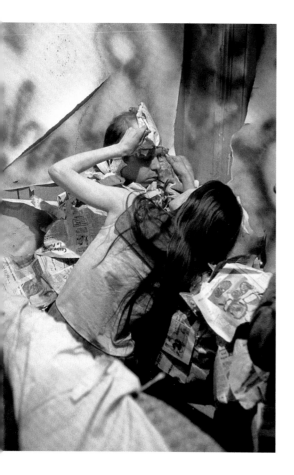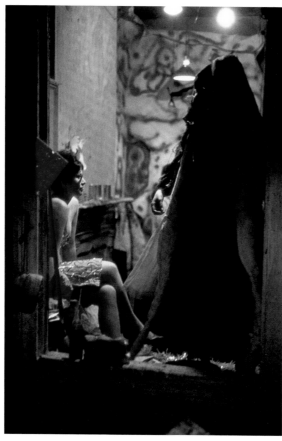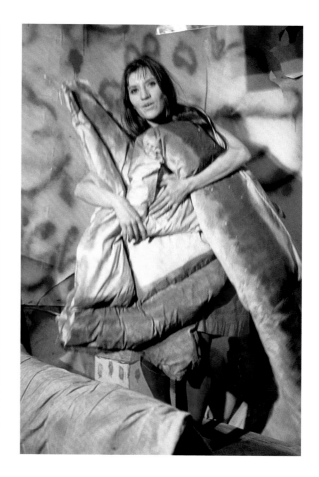

Store Days II, 1962

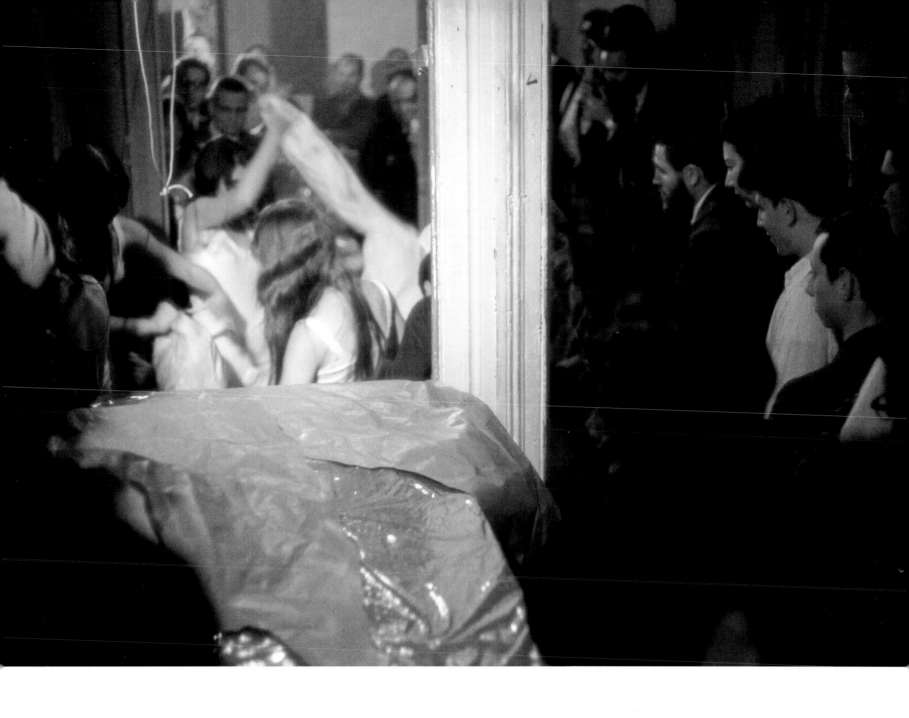

Voyages I, 1962

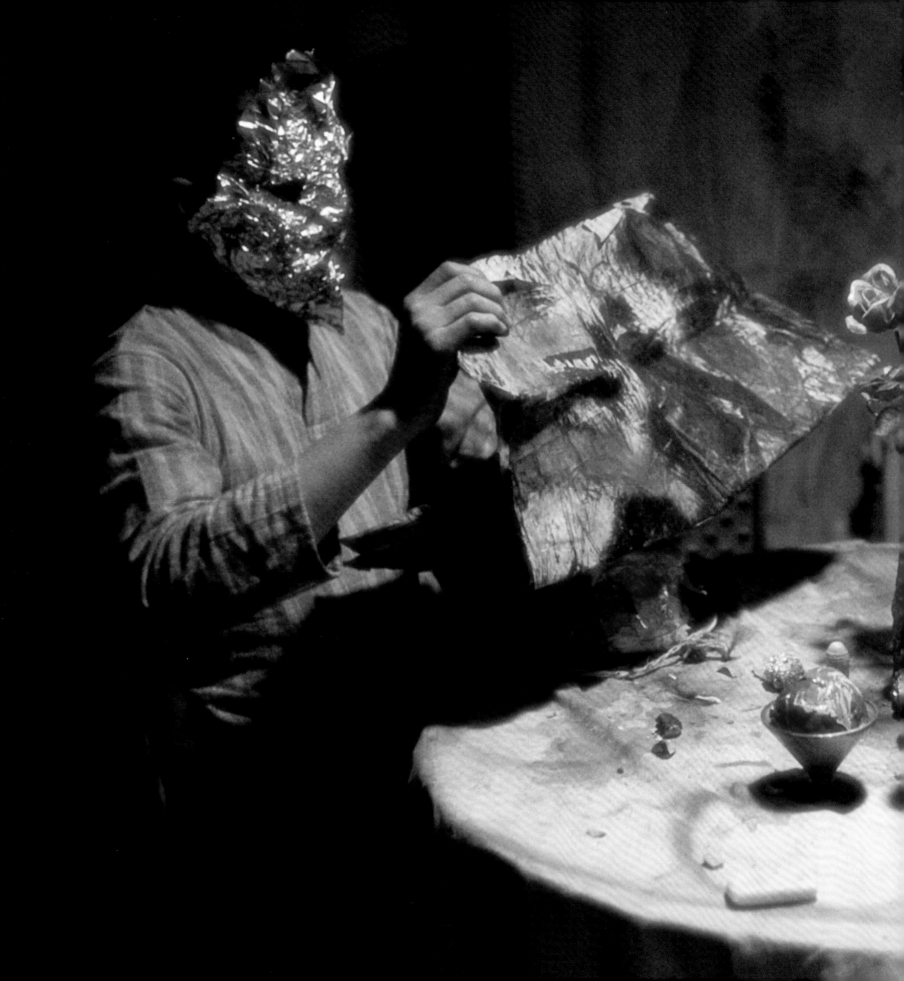

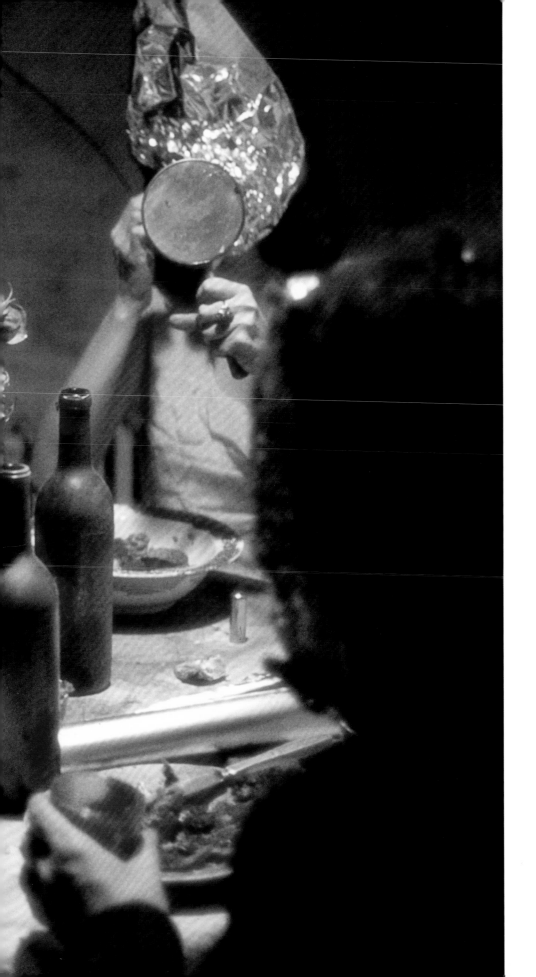

Nekropolis II, Ray Gun Theater performance at
The Store, New York, March 16–17, 1962

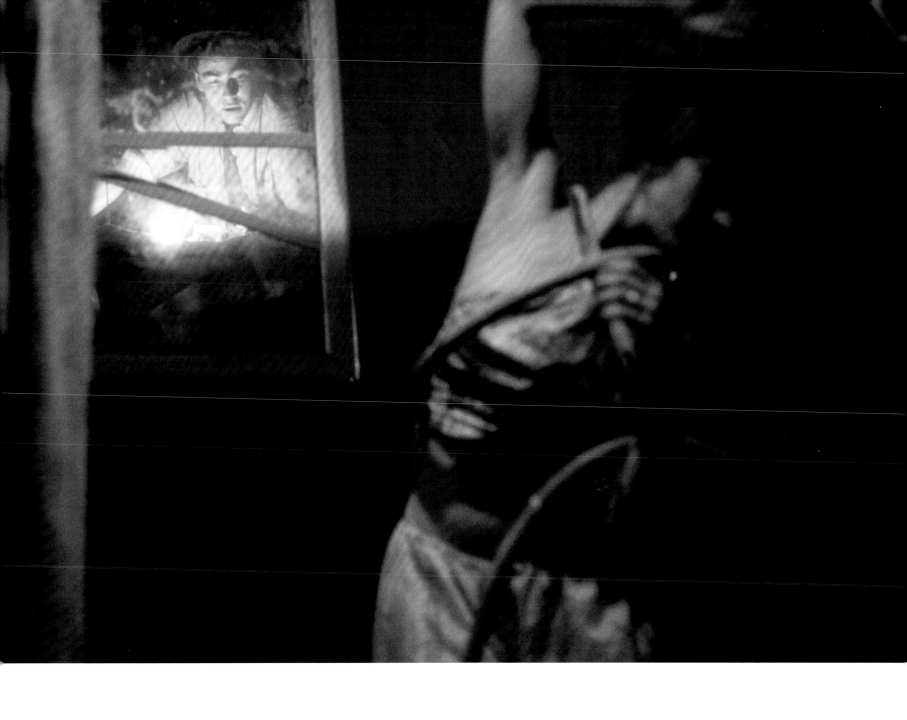

Injun II, Ray Gun Theater performance at *The Store*,
New York, April 27–28, 1962

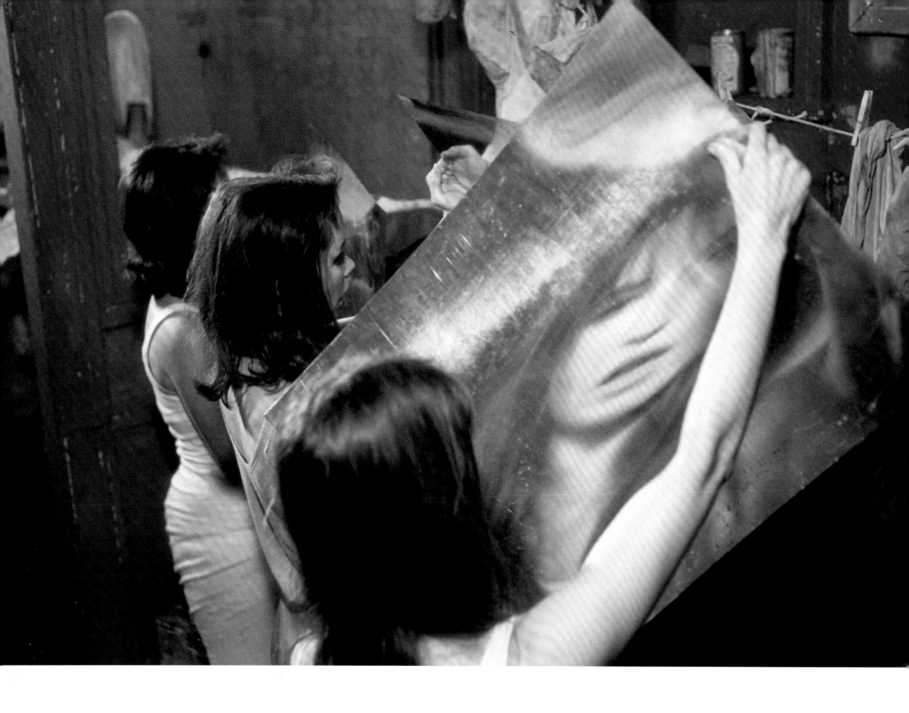

Voyages I, Ray Gun Theater performance at
The Store, New York, May 4–5, 1962

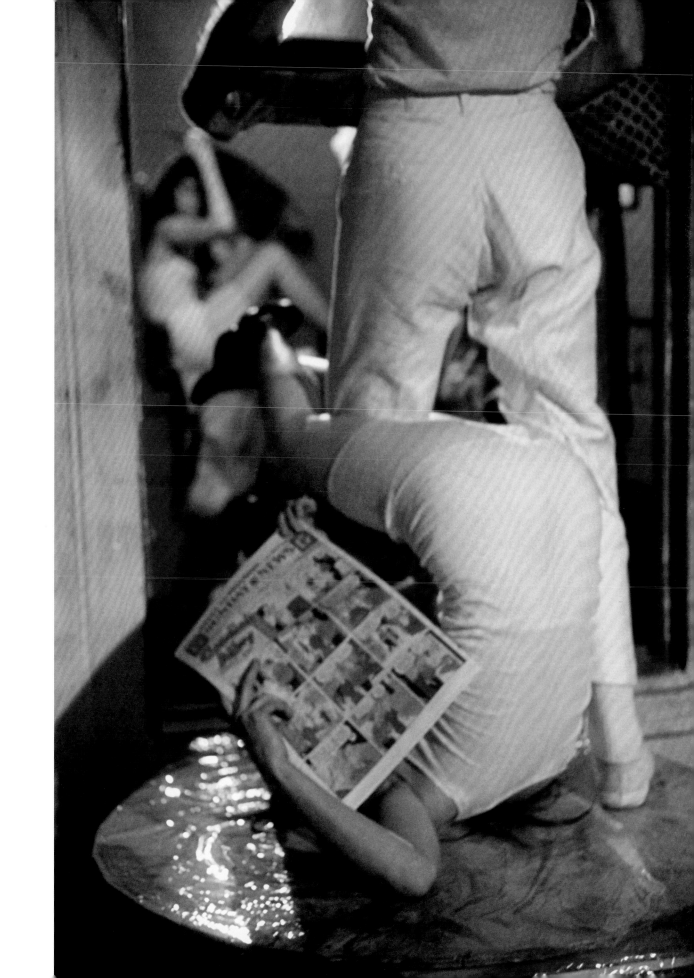

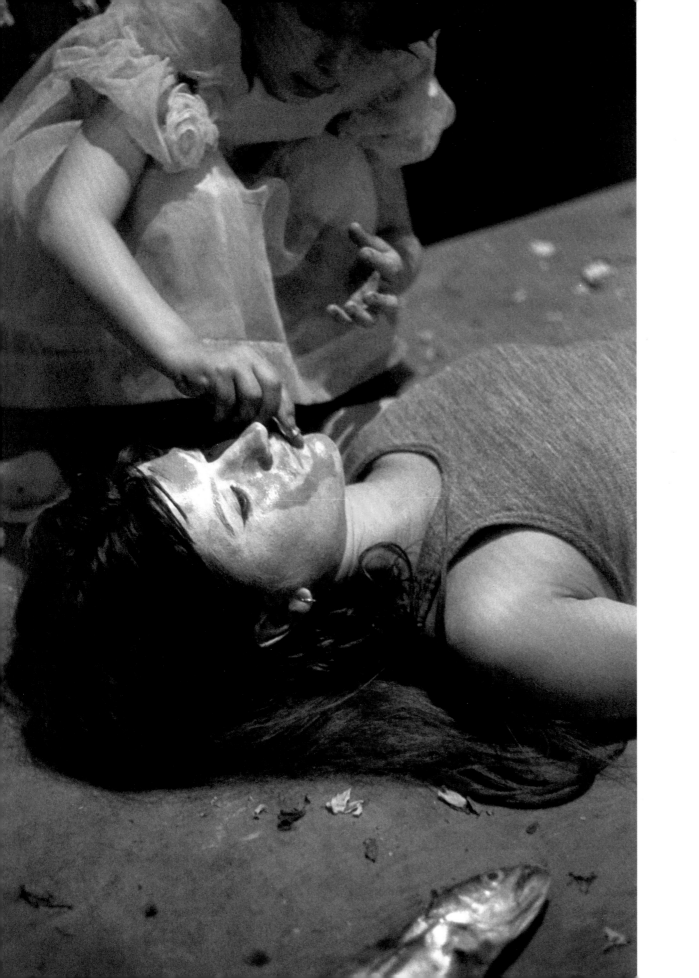

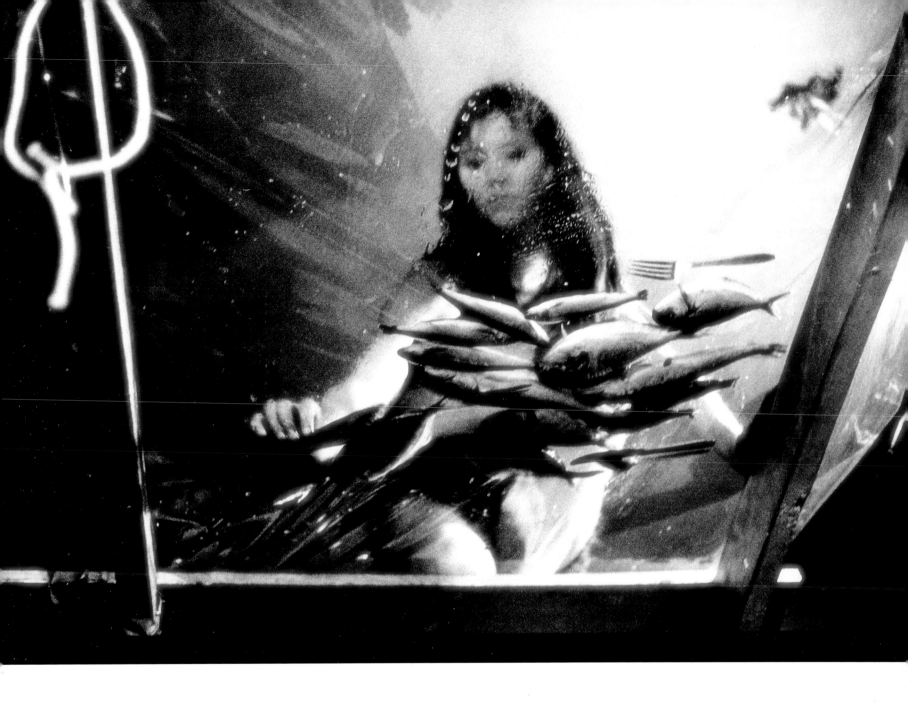

World's Fair I, Ray Gun Theater performance
at *The Store*, New York, May 18–19, 1962

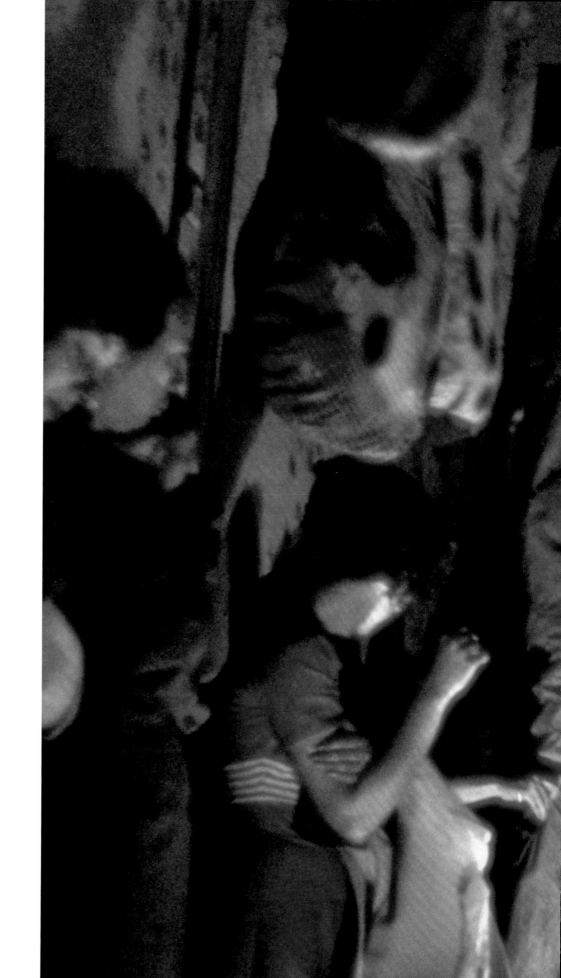

World's Fair II, Ray Gun Theater performance
at *The Store*, New York, May 25–26, 1962

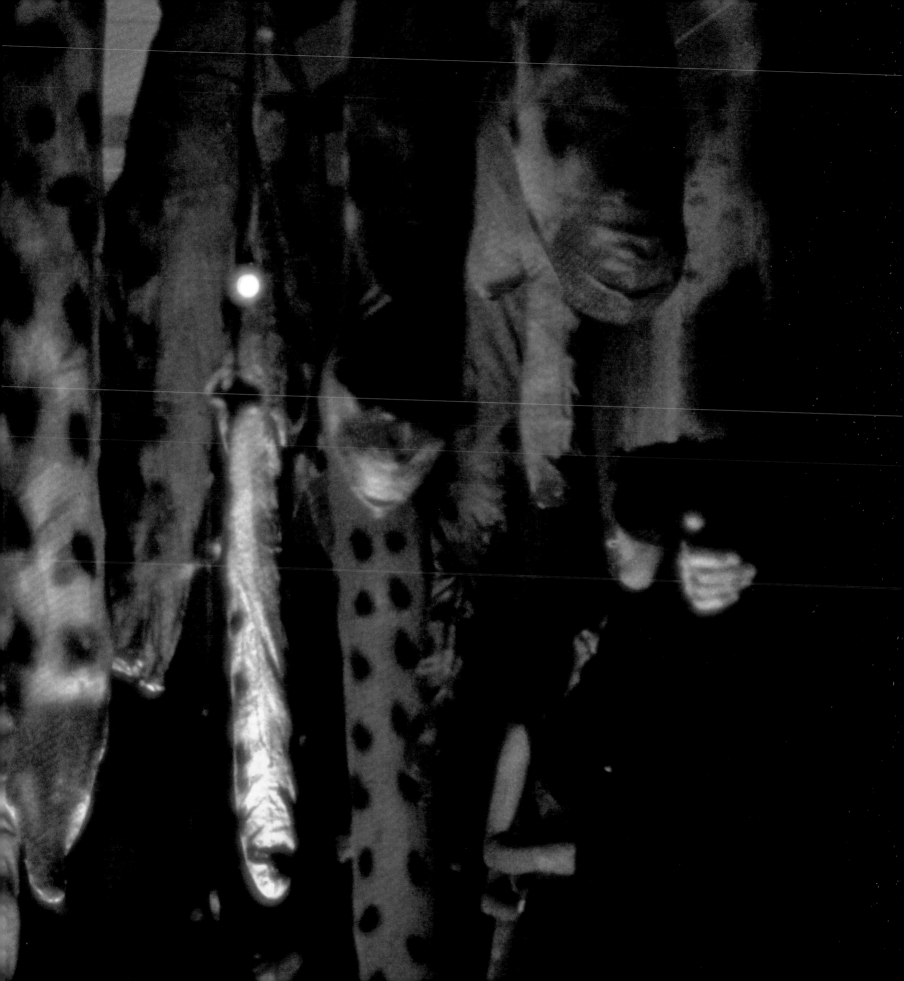

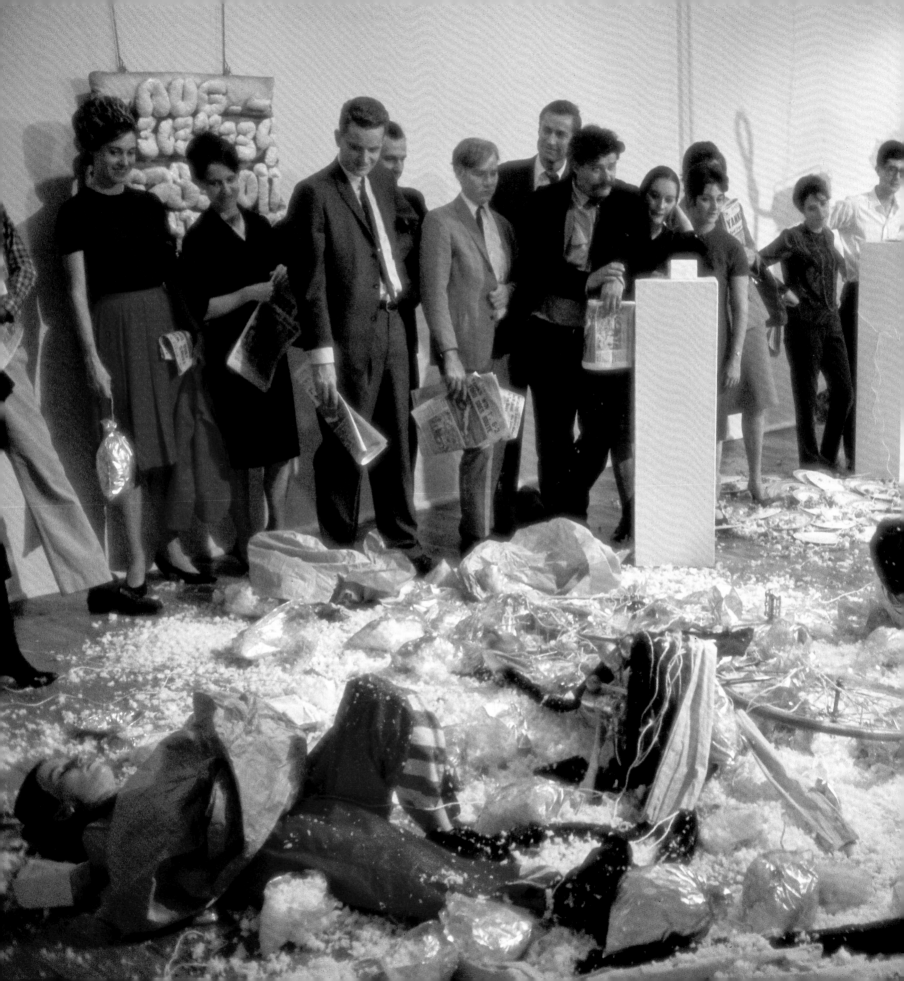

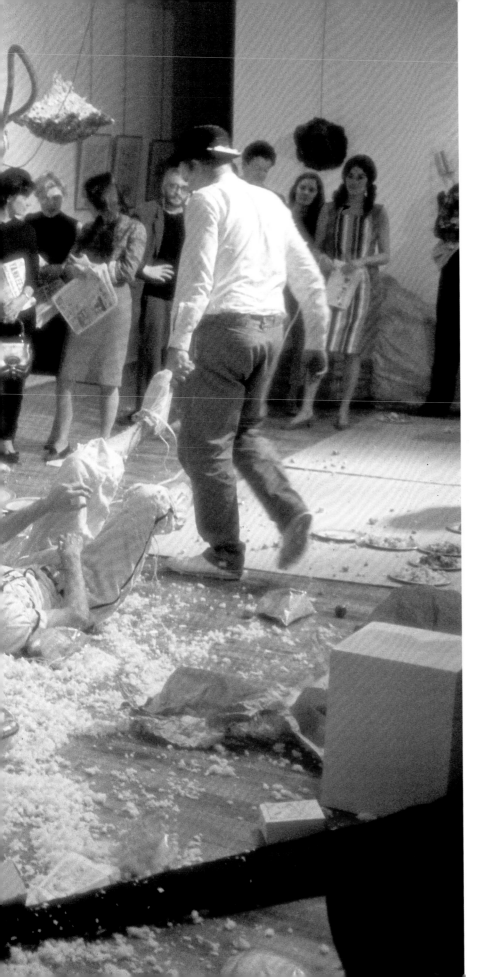

Sports, performance at the Green
Gallery, New York, October 5, 1962

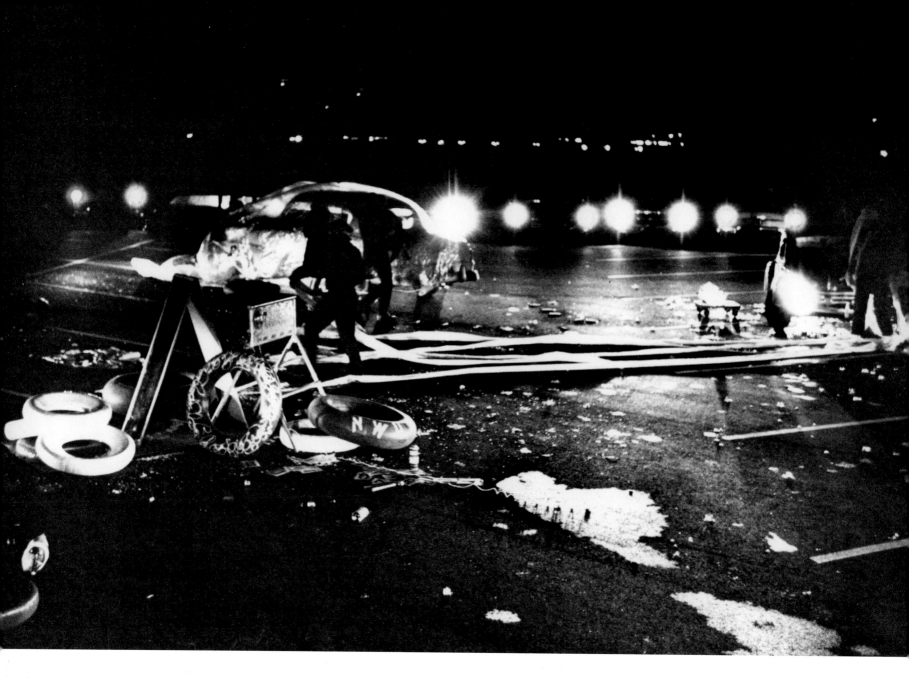

Autobodys, performance in the parking lot
of the American Institute of Aeronautics and
Astronautics, Los Angeles, December 9–10, 1963

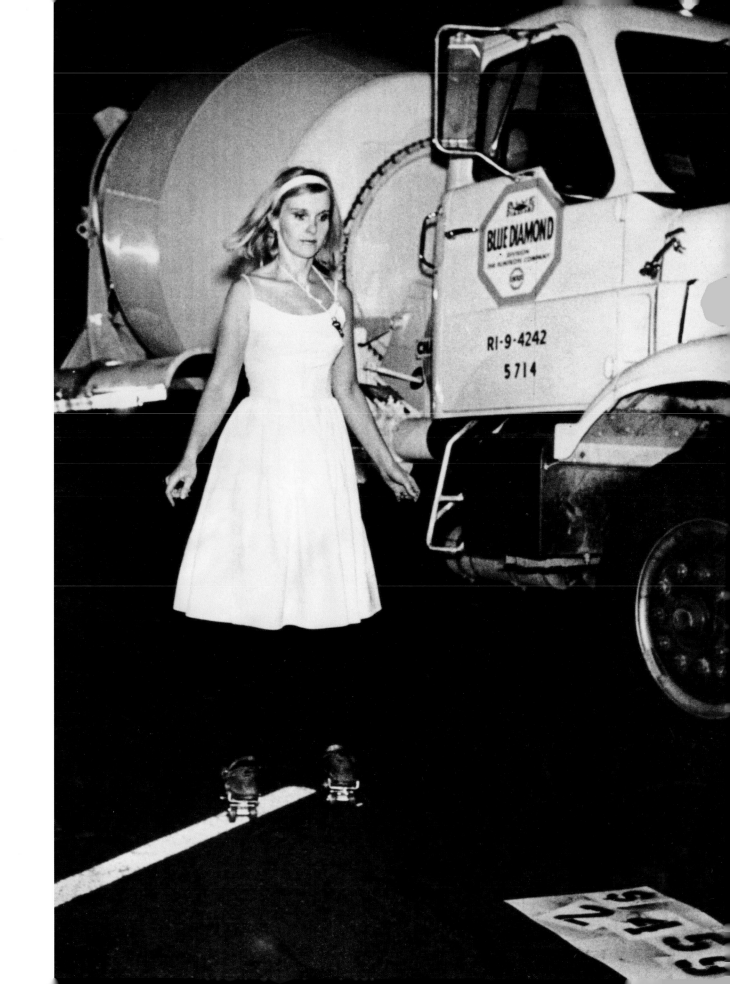

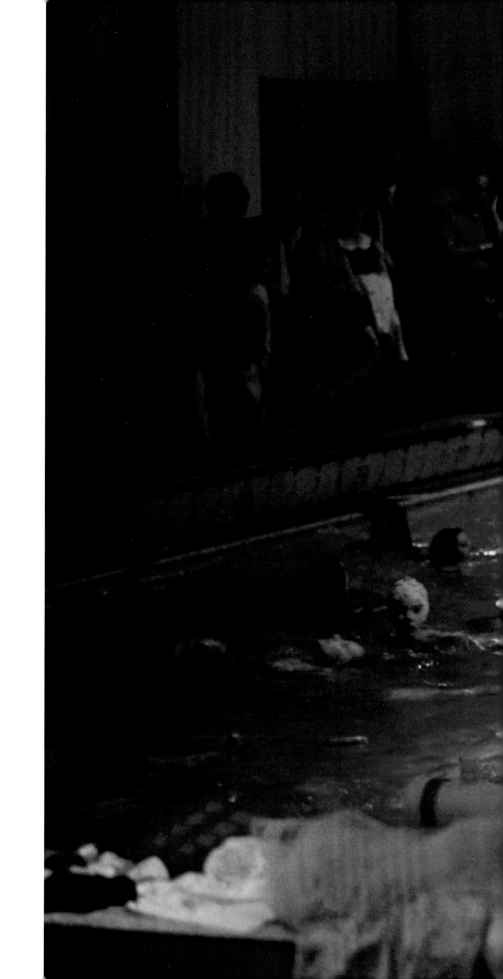

Washes, performance at Al Roon's Health
Club, New York, May 22–23, 1965

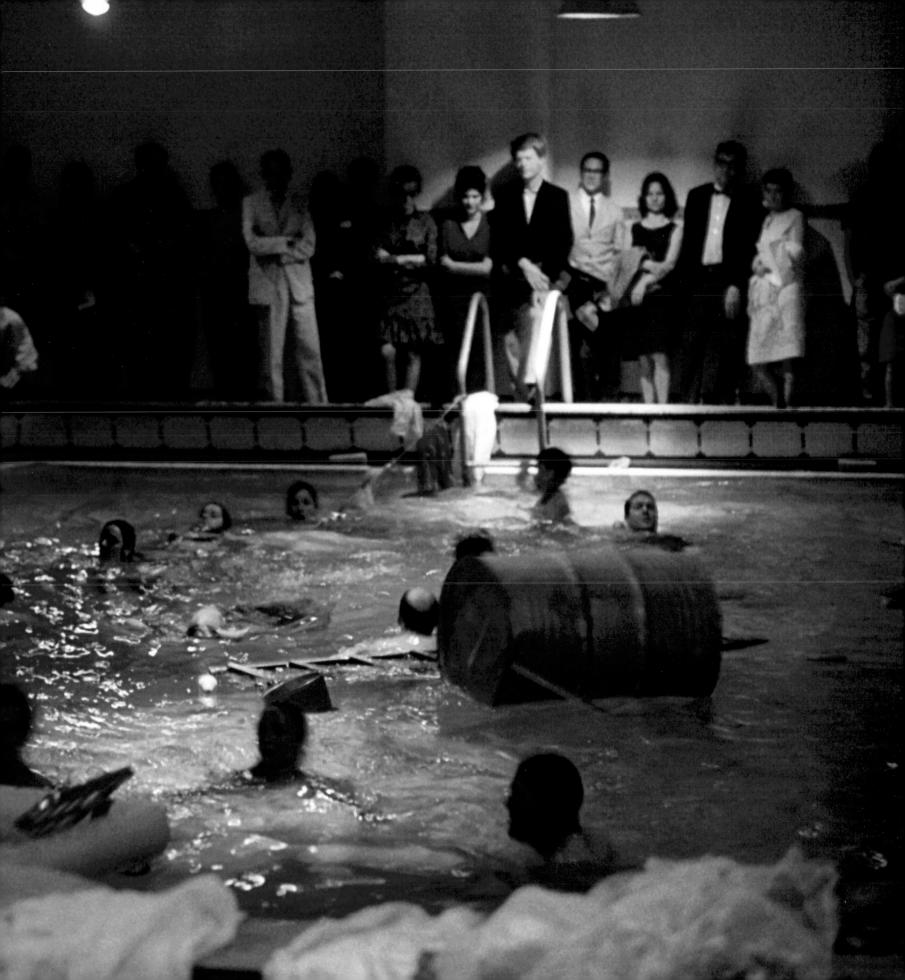

Claes Oldenburg's Clippings:
An Introductory Tour

ANN TEMKIN

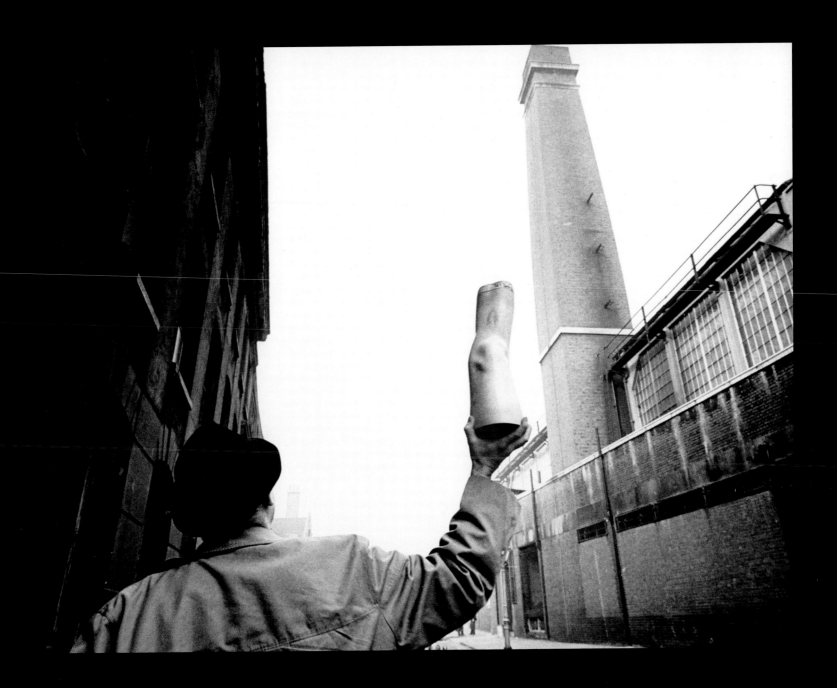

Oldenburg with cast of *London Knees* (1966), London, 1966

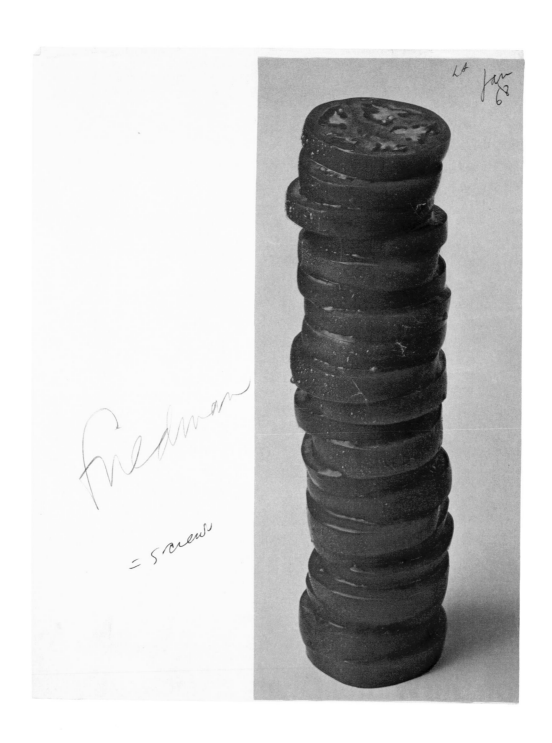

Notebook Page: Tomato Column; "= screw," Los Angeles, 1968

This and all following clippings:

Variously clippings, pencil, ballpoint pen, and felt-tip pen on paper
Approximately 11 x 8 ½ inches
Claes Oldenburg and Coosje van Bruggen

Claes Oldenburg's Clippings: An Introductory Tour

ANN TEMKIN

Like many important habits or preferences, Claes Oldenburg's way of keeping a sketchbook was born of a loss. As an aspiring artist in New York in the late 1950s, Oldenburg had maintained a conventional artist's sketchbook. But one day he left it on a bus, and suddenly all it contained was gone. And with it, forever, the gamble of recording and amassing his perceptions inside an object that could encounter a similar fate.

Oldenburg devised a practical alternative. He needed the immediacy a notebook provided but did not wish to be burdened with an object that became more irreplaceable with each passing day. So he began the practice of making drawings on loose sheets of paper or pages from a steno book or smaller spiral-bound notepad. Then, back in the safety of his home or studio, he would take the drawings and affix them with ordinary library paste to 8½ by 11 inch sheets of white paper. These pages would be tossed into a cardboard box and periodically culled and collected for insertion into spring binders.

Since 1960, parallel to keeping drawings that he has made, Oldenburg has used this tactic for a practice of clipping images that interest him from newspapers or magazines. For Oldenburg, ordinary mass-market publications offer a window onto a city or a culture not only through their stories but even, or especially, through their advertisements. These advertisements provide an invaluable source of inspiration for his own art, and for more than half a century he has made a habit of purchasing and perusing countless publications for material that catches his eye. Sometimes he has pasted the clippings to an 8½ by 11 inch sheet with no commentary or graphic additions; often they are annotated with drawings and/or words ("some day," "tornado dream," "plexi or styro"). The clippings sheets then get tossed into their own cardboard boxes to await occasional harvesting into spring binders.

Oldenburg's method for collecting the notebook pages of drawings and clippings—and he has applied the same approach to written texts—is entirely consistent with the real-life anchor that characterizes his work as a whole. All of his materials—notepads, 8½ by 11 inch sheets, library paste, ring binders—are items easily found in any stationery or five-and-dime store. The binders stand at far remove from the distinguished tradition of the fine artist's sketchbook that conjures visions of Leonardo and Cézanne. Oldenburg belongs to a generation of artists who, in contrast to their predecessors, the Abstract Expressionists, share a deep desire for a widely accessible art. Nothing conveyed that more than his decision

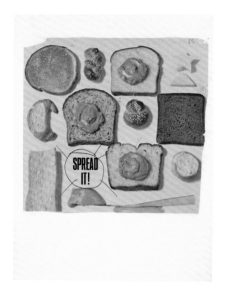

Notebook Page: Peanut Butter on Bread;
"SPREAD IT," New York, 1965

Notebook Page: Adding Powdered Milk;
"rainstorm at sea," New York, 1966

Notebook Page: Olive Close-up, Chicago, 1967

in 1961 to sell his art directly from his storefront studio on East Second Street. A working-class block replaced the tony locale usually associated with the art gallery, crowded walls and shelves supplanted elegantly spare installations, and recognizable objects took over from inscrutable abstraction. His notepads and binders maintain a similar distance from artsy pretense: the attraction to the everyday is evident as much in Oldenburg's relatively private choices of tools and methods of art making as in his sculptures and performances.

At their heart, Oldenburg's clippings as an entity offer the viewer the rare privilege of watching an artist *see*. They permit the visual equivalent of eavesdropping: it is as if he is allowing us to stand behind him and look over his shoulder as he perceives the world from his unique viewpoint. The clipping pages are arenas for the recurring obsessions that dictate how the artist extracts form from the surrounding chaos. With the detachment of the newspaper reporter that he had briefly been, Oldenburg chronicles himself seeing and

documents the process for the subsequent benefit of himself and others.

Advertising imagery has long served Oldenburg as fertile territory for visual exploration. As Donald Judd observed in 1966, Oldenburg's objects are "simplified to what's most desirable about them or to what's used most."[1] The photographs in newspaper and magazine ads provide ready-made sources for the sort of stereotyping that fascinates him. Commercial stylists and photographers have invented numerous strategies to exaggerate the identity of a given object and to maximize the impact of its pertinent characteristics. Oldenburg's clippings offer an encyclopedia of such devices. While the professionals responsible for the images collected in his clippings are not dignified by the term "fine artist," they are nonetheless the image producers who in large measure create our vision of the world. It is their strategies that Oldenburg's clippings expose and that he has chosen to harness for his own artistic purposes.

Notebook Page: Sliced Cake; Sesame Cracker,
New York, 1965

Notebook Page: Fountain in the Form of
Wet Bathing Trunks, Paris, 1964

Notebook Page: Sliced Cigarette; "Analysis,"
Los Angeles, 1963

THE AERIAL VIEW

The advantage of looking at something from above, as if watching from the window of an airplane, is that one can fully apprehend things too large to see from ground level. Objects that cannot be photographed in their totality from the ground can be captured from above, at a tiny scale. On the page, the act of looking down is transferred to looking across. The magic of the aerial view is that when it is applied to items that are not large, it fools a viewer into thinking that they are. The viewer instinctively reads them as he or she would the Empire State Building or the Brooklyn Bridge, even if they are just a bowl of corn flakes or dollops of peanut butter on slices of bread. At times, Oldenburg's clippings include a notation that alludes to the fantasies such scale jumps can generate. A mass of powdered cream invading the surface of a cup of coffee: "rainstorm at sea."

THE CLOSE-UP OR VIEW FROM BELOW

The ant's-eye view, unlike the bird's-eye view, directly transposes an object that is not very large into one that is extremely so. Scores of mundane items assume monumental status to a Lilliputian, attaining a grandeur they never would have possessed in a contextually accurate scale. This is true of a green olive stuffed with a bit of red pimento, a cheeseburger, and a layer cake whose frosted sides become as imposing as the stone walls of a fortress. Before a background vista of a magnificent coastline and sparkling sea, a pair of red bathing trunks clutched by two lovely female hands becomes positively heroic.

THE CROSS SECTION

The cross section simultaneously exposes interior and exterior form. We know infinitely more about something when we understand its inside as well as its surface. With the human body, this is only possible in the operating room and the pathology lab, but with objects it is conveniently achieved with a saw, a good knife, or, if necessary, a delicate instrument.

Notebook Page: "Encyclopedia AMERICANA,"
New York, 1965

Notebook Page: Slit Baked Potato, with Butter,
New York, 1971

Notebook Page: Spoon in Egg,
New York, 1965

Advertisers make sure that a potential consumer can appreciate the contents of a blueberry pie, a Lark cigarette, or a Chinese egg roll. An illustration of a Kenmore gas clothes dryer diagrams its inner workings to prove its superiority as a product. The concentric rings of an old tree indicate a vast number of years lived, and the spill of pages from an open encyclopedia presents knowledge to be absorbed.

FROZEN MOTION

The contradiction of representing something in motion with a static image has challenged artists since the beginning of time. Opposites, such as liquid and solid, collapse: flow becomes rigid but nonetheless is somehow convincing as flow. Paradoxically, the stillness of an image probably can sensitize a viewer to a subject's fluidity more than the actual experience of it. One recognizes this, for example, in images of cream sauce as it nears a head of cauliflower and (a particular hero within the clippings) a pat of butter as it melts.

HARD MEETS SOFT

This category also exploits the power of opposites. A clever way to sharpen a viewer's sensory awareness of a given object is to juxtapose it with something contrary. Textures, for example, are best understood as relative, a truth that has enlivened the still-life tradition for centuries. Contemporary demonstrations of this principle abound in magazine pages: a metal spoon stands upright in a soft-boiled egg, a silver knife slices into a brick of cheese, and a serving fork spears a slice of bacon. A squiggle of toothpaste balances on erect toothbrush bristles. More provocatively, the toe of a woman's high-heeled leather shoe nudges inside the edge of a man's trouser leg.

REMOVAL

An absent segment from an object can prompt a viewer to consider more acutely the wholeness of a particular shape. One instinctively understands the full roundness of a fruit pie or of

Notebook Page: Toe under Cuff,
New York, 1965

Notebook Page: Pizza with Cut Out Slice;
Two Men in a Tub, New York, 1965

Notebook Page: Assorted Slices of Cake,
New York, 1965

a pizza thanks to the triangular void left after a slice has been cut away. This is in part because the removal identifies the point in the center at which all the symmetrical segments meet. The effect holds even in nonsymmetrical removals, however. A missing bite of a Life Saver or doughnut forces the mind to complete the circle and therefore actively register the roundness of the object.

REPETITION

Repetition can surrealistically intensify an individual image, as is what happens on a page filled by a grid of kidney-shaped swimming pools. Related units might be piled or stacked to make, say, a tower of tomato slices. Repetition can also prove a useful technique for demonstrating possibilities of variation: another full-page sheet features a grid of cake-mix boxes in assorted flavors. A bevy of fancifully bestockinged legs takes a less symmetrical route to underscoring the pleasure that variety can provide.

Having identified images that repeatedly uncover these and other such devices for heightening viewers' sensory awareness, Oldenburg tears or cuts them out and attaches them to pages, either alone or in combination with other items. A quick survey of his binders of clippings indicates a range that extends from pages serving as utilitarian image storage to pages that are easily exhibition worthy—that is, compelling works on paper. Certain single-image clippings, for example, silhouette an item and so ceremoniously situate it on a page that one could easily believe it to be the image of a sculpture by Oldenburg. A yellow stick of butter on a china dish hovers two-thirds up a page with cool dignity. The precise articulation of the butter's abstract form suggests that Oldenburg's work can be discussed in the same terms as those of Minimalists Donald Judd and Tony Smith, as well as those of a Pop sensibility.

The realm of sheets that include multiple images demonstrates a wide variety of compositional approaches. Many pages house unrelated items that are situated together with no

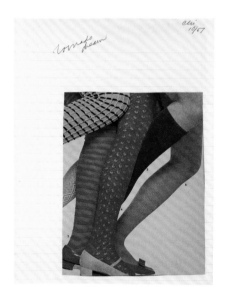

Notebook Page: Stockinged Legs, Running; "Tornado dream," Chicago, 1967

Notebook Page: Butter Plate, New York, 1963

Notebook Page: Floor Plan; Furniture; Food, Los Angeles, 1963

implied relations. This format accords with that of a newspaper page, which has made familiar the incongruity of proximate news items, photos, and ads. A clipping sheet might position a domestic floor plan beside an ad for a "valet chair" (on which clothes can be hung), above a toilet, an apple pie, and an open-faced sandwich. Such pages do not provide a field for formal experiment but are simply convenient repositories for items Oldenburg wished to hold onto.

Conversely and just as often, the unifying context of the 8½ by 11 inch sheet provides a base that prompts the artist to compose in terms of formal rhymes. The clipping pages provide a perfect arena for playing out the logic of analogy that operates within Oldenburg's imagination, offering a ready home for suggestive juxtapositions. Because Oldenburg works with what he calls a "stereotype image" of a specific thing, the formal equations become far more obvious than they would be with the objects themselves. In actuality, one just might overlook the connection between a salami and a pink Princess

telephone, but it seems perfectly obvious in images thereof. This comparative turn of mind rules Oldenburg's day-to-day way of perceiving and understanding the world. Absorbing the vastness of his new loft on East Fourteenth Street in 1965, for example, Oldenburg took to thinking of it as the island of Manhattan. What another occupant might have considered the back corner, he considered the Upper West Side; the center of the loft was Midtown; and so on. As he explained to an interviewer, "There's a kind of poetry in making comparisons that don't have any logical reason."[2]

The format of the clippings has been consistent since their inception, but their appearance and their role as a tool have a discernible evolution. The earliest clippings (years are noted in pencil in the upper right corner of each support sheet) are derived primarily from newspapers and feature low-cost ads that use illustrations rather than photographs. The gritty environment of the Lower East Side circa 1960 was an all-important influence on the look of Oldenburg's art of the time and was

Notebook Page: Pink Telephone; Sliced Sausage, Los Angeles, 1963

Notebook Page: "DOLL RIOT!," New York, 1961

Notebook Page: "WUCKER," New York, 1961

manifest in the clippings as clearly as it was in *The Store* or in his performances. Exploring a newspaper, Oldenburg's eye was drawn to advertising illustrators' sketches of prosaic items such as nylon stockings or a jumble of assorted hard candies. An ad for Wucker, "one of New York's largest furniture specialists for projects & homes," is as crammed as its store must have been: a torrent of illustrations, prices, and exclamations vie for attention. The perforated letters spelling WUCKER shrink perspectively from the W to the R, as if to fit under the elevated train line taking customers to the store and the housing projects it furnished.

A 1961 clipping bears the scribbled pencil notation "street = store = newspaper," an equation that unites the three sites as key sources for an artist attuned to the character of his environs. Many of the first clippings share the rugged appearance of the items in *The Store*, as their edges are usually torn rather than cut. When Oldenburg did use scissors for a clipping, the cutting seems to have been quick and efficient rather than

finely tailored to the subject; images and words are haphazardly interrupted (*EOUT, elestial*). Through such means, the artist emphasizes the status of the fragment: we are made to realize that this excerpted moment of perception occurred within a broader field of attention.

By 1963 the glossy color pages of magazines became more common to Oldenburg's collection of clippings, a development that was amplified when he moved to Los Angeles in the middle of the year. The production of clippings increased dramatically as the artist responded to the exuberance of that city's advertising culture. The poverty of the Lower East Side gives way in the clippings to the wonders of consumer culture as celebrated on the West Coast. The changing content of the clippings is mirrored by developments in Oldenburg's sculptural work. Magazine advertisements for bedroom sets fueled his thinking for *Bedroom Ensemble I* (1963), the installation sent to New York for Oldenburg's debut at the Sidney Janis Gallery in January 1964. The apparent distortions of the furniture in

Notebook Page: *Furniture in Vanishing-point Perspective, Los Angeles,* 1963

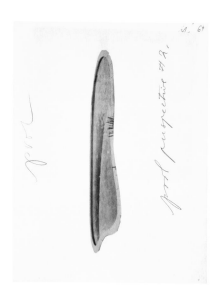

Notebook Page: *"pool perspective #2," Los Angeles,* 1964

Notebook Page: *Powdered Coffee; Lipstick; Cleaning Materials, Paris,* 1964

Bedroom Ensemble—such as the sharply angled slant of the foot of the bed—are literal transcriptions of the way in which furniture is two-dimensionally rendered in the advertisements.

Swimming pools joined home furnishings as items of interest once Oldenburg arrived in Los Angeles. This fascination is witnessed in several clippings that make manifest the variety of available models. These resulted in the sculpture *Pool Shapes* (1964), a work presented at the Sidney Janis Gallery the following year. This sculpture later became the striking cover for the catalogue of Oldenburg's 1966 exhibition at Moderna Museet in Stockholm. Even protracted obsessions do not necessarily produce such outcomes, however. Although the abundance of outboard motors and clothes dryers in the clippings would suggest attendant objects, none has ever materialized. Conversely, the clippings reveal that Oldenburg might identify a certain subject and finally produce a sculpture many years later. Lipstick had potential as early as 1964, in Paris, and continued as a subject of inquiry throughout the decade in several locales

before it became the motif of the artist's first outdoor monument in 1969.

In Los Angeles, the clippings assumed their enduring function as one of Oldenburg's methods for getting into the brain of a new setting. His months in Los Angeles initiated a steady stream of travel for the remainder of the decade, and everywhere he went—Paris, Rome, Stockholm, London, Chicago—Oldenburg made a point of flipping through a variety of newspapers and magazines. The production of clippings served as a way both to investigate a city's particularity and to provide the comfort of routine wherever he might be. The sameness of the habit illuminated the differences among locales.

Foremost among the subjects in which such differences loom large is that of food, a fundamental theme in the clippings. Food, of all kinds, is as ubiquitous in Oldenburg's clippings as in his drawings and sculptures. One need not be an anthropologist to know that the traditions and rituals surrounding food—everyday as well as special occasion—provide

Notebook Page: Dropped Tea Bag,
New York, 1966

Tea Bag, 1966
Laminated vacuum-formed vinyl,
screenprinted vinyl, felt, Plexiglas,
and rayon cord
39 x 28 x 3 ½ inches
Edition of 125 with 16 proofs

The clippings reveal that it was a familiar motif that reached back all the way to 1961 in New York, at which time a scribbled note beside two newspaper fragments of female legs in stockings suggested the legs be "cut fr. plaster." In London, Oldenburg's interest was magnified by the star turn for female knees occasioned by the advent of the miniskirt and go-go boot. After much experimenting, and with a nod to Duchamp's iconic *Box in a Valise (from or by Marcel Duchamp or Rrose Sélavy)* (1935–41), Oldenburg decided to make a *Knees* multiple in the form of a cloth-covered case containing not only two knees cast in flexible latex, painted the color of the Elgin Marbles in the British Museum, but a wealth of printed matter relating to the genesis of the object. An accompanying text narrates the absurdist story of the artist's quest to make a simple knee sculpture: the art school competition for photographs of beautiful knees, the decision to work from mannequins instead, the realization that new mannequins were not as good as older ones, the procurement of an older mannequin,

the inadequacy of the mannequin's right knee due to stance, and the ultimate creation of a right knee from a mirror image of the mannequin's left knee.

The documentation in the *Knees* valise includes a panoply of works in varied mediums and materials. Thus, the note pages make their debut on the public stage in the company of sculpture, drawings, and texts, as the artist shows the public how closely aligned these aspects of his practice are. The note pages (four, including three with clippings) appear as offset lithographs, at 16 by 10½ inches slightly larger than the original sheets. One presents a newspaper photograph showing two cooling towers of the sort that Oldenburg noticed on his flight into London. The two towers uncannily resemble . . . two knees. The fragment is torn and placed on the page as if a view through a peephole. Another print features a small collection of images, including a pair of drill bits, some very knee-looking synthetic logs on a fireplace ("fires without heat"), and an athlete poised on one of his knees. The clippings,

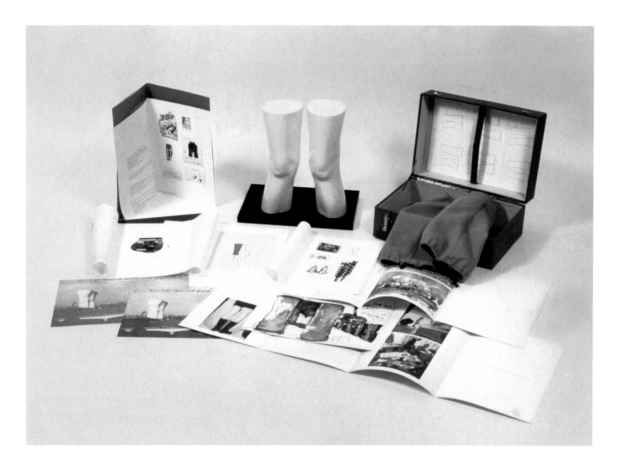

London Knees (1966), 1968
Cast latex painted with colored
polyurethane, felt, cast acrylic,
21 offset lithographs on paper,
and cloth-covered traveling case
Knees: 15 x 6 x 5 ½ inches, each
Stand: 1 x 16 x 10 ½ inches
Prints: 16 x 10 ½ inches, each
Case (closed): 11 ½ x 17 x 7 ½ inches
Edition of 120 with 10 artist proofs

sketches, and inscriptions are reproduced with the same precision that Duchamp applied to the *Green Box*. The types of paper, colors of ink, and torn edges of carelessly ripped scraps are faithfully preserved. The casual spontaneity of the notebook page necessitates ingenuity and painstaking labor in the printer's workshop.

By the time *London Knees (1966)* was published, in 1968, Oldenburg was in Los Angeles at work on a portfolio of color lithographs specifically dedicated to his notes. His preface to *Notes* explains that "this group of twelve 'notepages' is the first attempt to put into more permanent form the scribbles and scratches that occur on any handy fragment of paper during the day."[5] Here, Oldenburg replaced the goal of direct facsimile, manifest in *London Knees (1966)*, with the aim of heightening the visual intensity of the originals. He accomplished this by means of alterations imposed during the course of the photographic and lithographic processes, as well as by combining images from different sheets to organize their thematics.

Using as his basis the "hundred or so" pages made during his stay in Los Angeles early in 1968, the twelve lithographs retain the informal, even accidental, spirit of the originals. They are paired with pages of text that clearly and generously explain the source of each item and the context for the ideas with which it is associated.

Each printed sheet, roughly twice the size of Oldenburg's 8½ by 11 inch pages in the binders, houses a variety of virtuosic reproductive devices that faultlessly mimic the various papers affixed to a single note page. Yellow lined paper from a legal pad and graph paper are faithfully reproduced as backgrounds to drawings and clippings. Bits of masking tape that affix some images to the support sheet are reproduced as well. Snapshots are embossed to convey the relief of the original pages. Various textures and colors of pencils, crayons, markers, and ballpoint pen are accurately invoked. Although in the clipping pages the imagery generally appears on pasted fragments, here Oldenburg chose to directly transpose some

Notebook Page: Life Saver; Doughnut,
New York, 1965
Clipping, ballpoint pen, pencil, and collage on paper
Claes Oldenburg and Coosje van Bruggen

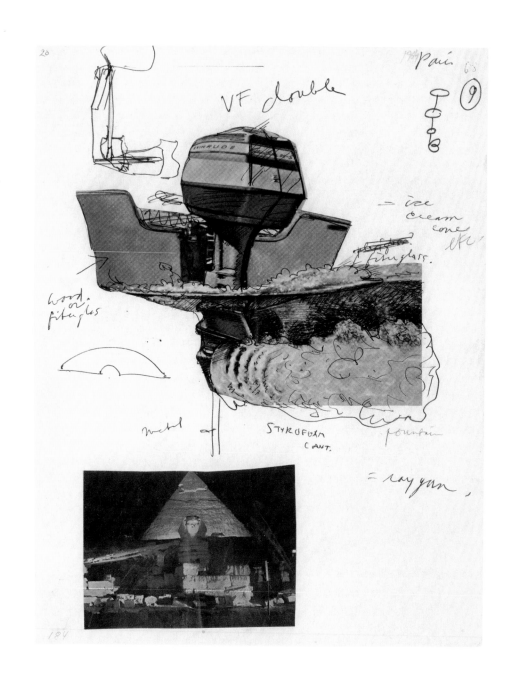

*Notebook Page: Study for an Outboard Motor in Action, on a
Fragment of Stern, with Notes on Technique and Materials,* Paris, 1964
Clippings, ballpoint pen, and pencil on paper
Claes Oldenburg and Coosje van Bruggen

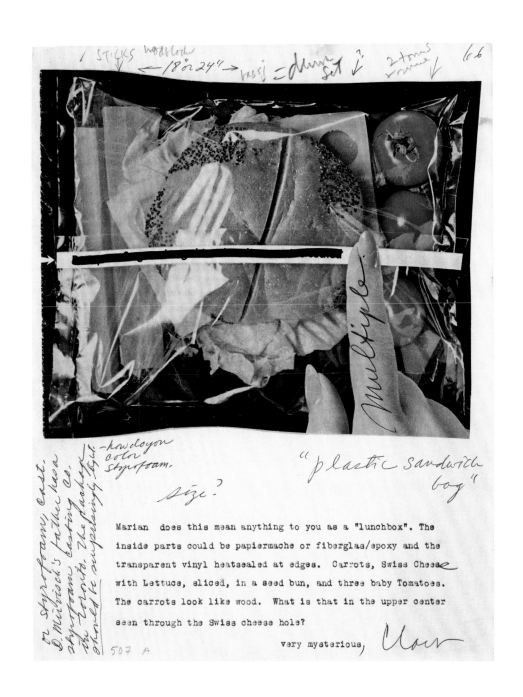

Notebook Page: Study for a Multiple in the Form of a
Sandwich Bag, 1966
Clipping, ballpoint pen, and typescript on paper
Claes Oldenburg and Coosje van Bruggen

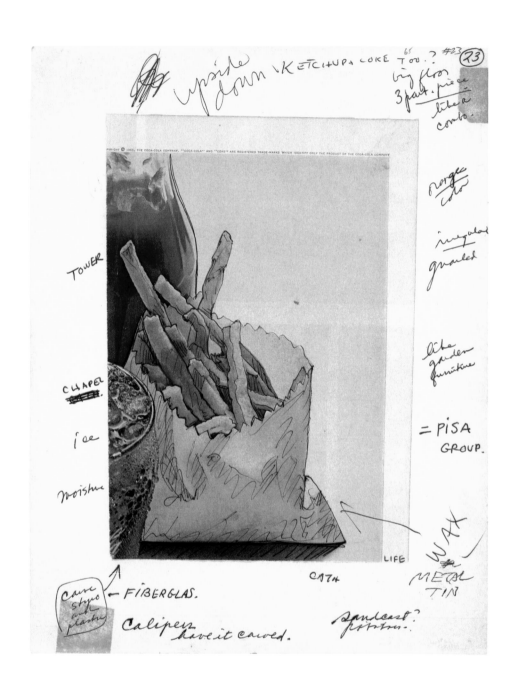

*Notebook Page: Shoestring Potatoes, Ketchup Bottle
and Coke Glass*, New York, 1965
Clipping and ballpoint pen on paper
Claes Oldenburg and Coosje van Bruggen

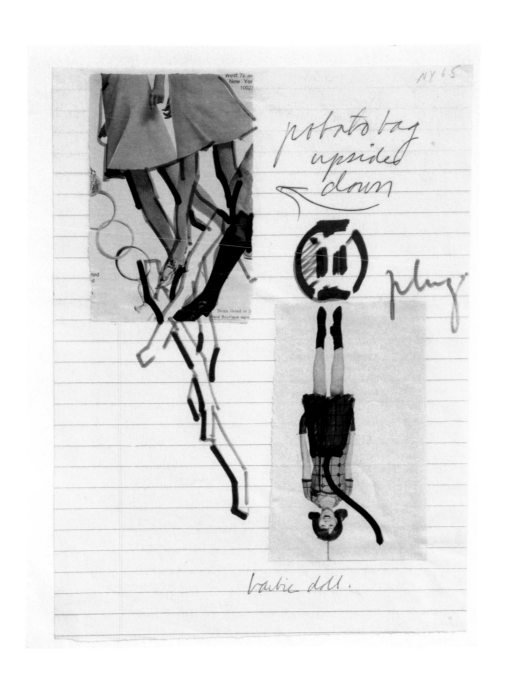

Notebook Page: Shoestring Potatoes in a Bag
Compared to Legs under Skirt, 1965
Clippings, ballpoint pen, and felt-tip pen on paper
Claes Oldenburg and Coosje van Bruggen

Hypertrophies, Trophies, and Tropes of the Everyday: Claes Oldenburg's New Definitions of Sculpture

GREGOR STEMMRICH

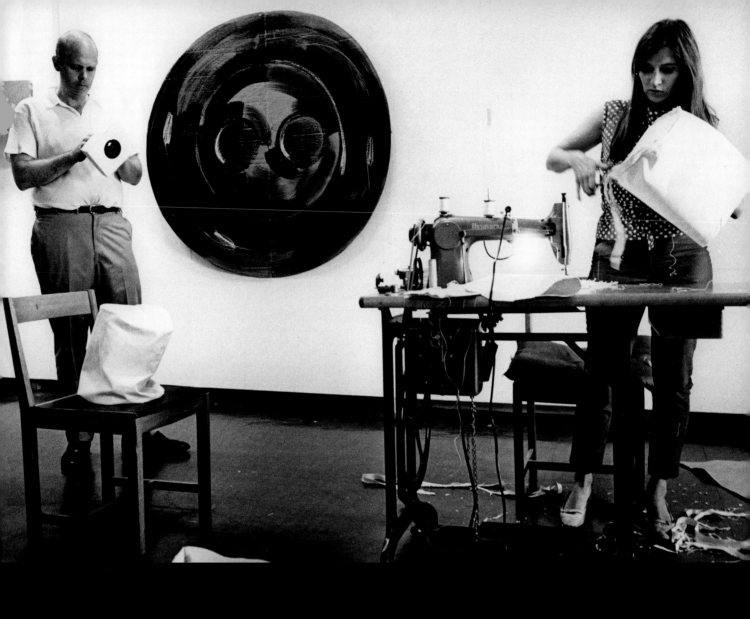

Oldenburg and Patty Mucha completing *Soft Giant
Light Switch (Ghost Version)* for the retrospective
exhibition at Moderna Museet, Stockholm, 1966

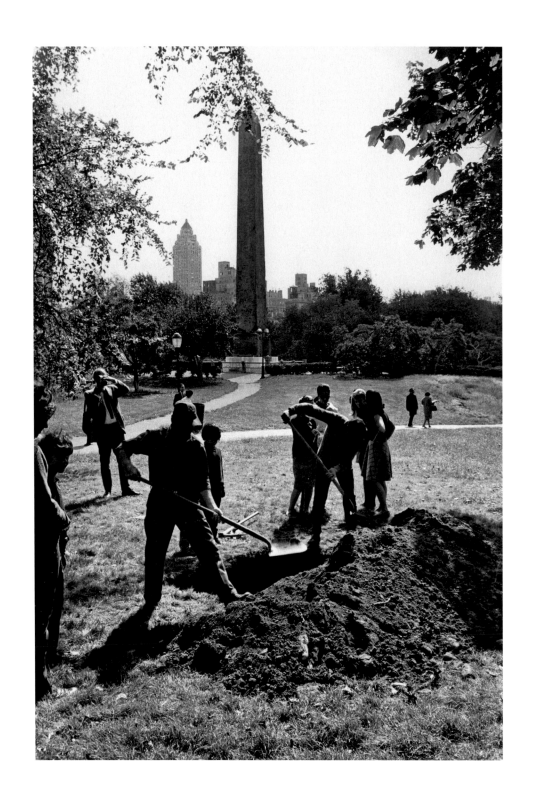

Placid Civic Monument, project for the exhibition
"Sculpture in Environment," in Central Park near the
Metropolitan Museum of Art, New York, October 1, 1967

Hypertrophies, Trophies, and Tropes of the Everyday: Claes Oldenburg's New Definitions of Sculpture

GREGOR STEMMRICH

Early in the twentieth century, artists and critics questioned the viability of the medium of sculpture. In his "Technical Manifesto of Futurist Sculpture" of 1912, Umberto Boccioni, for example, insisted that sculpture should draw its materials and themes from the contemporary environment, while Robert Musil, in his short prose text "Monuments," pointed out that public sculptures were virtually invisible in the urban landscape, since they could no longer compete with "developments in advertising" and swift and widespread human mobility.[1] This existential crisis resulted in a critical determination that even modernist sculpture could hardly live up to. As the century progressed, modernists deployed strategies of fragmentation, abstraction, construction, and the use of materials and objects not traditionally associated with art, yet sculpture remained traditional in the sense that longevity and universality endured as ultimate goals. Efforts to locate new forms and materials in an "idealist space"—that is, a space "cut off from the project of temporal and spatial representation," in the words of Rosalind Krauss—became dominant and were proclaimed to epitomize modernity.[2] But this paradigm, whose main proponents in the United States were David Smith and Alexander Calder, invited criticism from younger artists after World War II. New sculptural ideas and methods were developed in relation to or in correspondence with painting. It is hence revealing that Robert Rauschenberg, who in the 1950s championed the integration of paintings and materials from the lifeworld, called the sculptural companions to his Combine Paintings simply Combines, rather than Combine Sculptures. Claes Oldenburg, who in this same period conducted similar studies and experiments in painting and sculpture, referred to his early ventures into sculpture, with comparable restraint, as "constructions" and expressed uncertainty over whether they were "artistic enough."[3] These advances were followed by developments that will be examined here in terms of two guiding questions: first, that of how Oldenburg fostered, in reference to the contemporary "advertising business," strategies of sculptural fragmentation that excluded the idea of "idealist space" and, second, that of how he moved from sculptures created for presentation in interiors to "monuments" outdoors.

THE PSYCHO-LOGIC OF THE FRAGMENT

The complex artistic development of Oldenburg's early work began with countless forays through the urban environment. Although he wished to make use of the social situations he had

captured in sketches of the street in his paintings, they were portraits, landscapes, and depictions of individual figures, so any social theme could be applied only through some form of condensation. Influenced by artists such as Marcel Duchamp, Jean Dubuffet, Jackson Pollock, Willem de Kooning, and later Jasper Johns and Allan Kaprow, he became increasingly interested in materiality and the flexibility of media in painting, which he combined with an interest in vulgarity. His resistance to the association of painting with conventional understandings of "art" ultimately led him beyond the métier of painting and into the realm of sculptural assemblage, for which he employed materials he had picked up from the street.

In his first installation, at the Judson Gallery in 1960, titled *The Street*, he was finally able to bring together these disparate forms: the work (figures and objects) and the exhibition cannot be separated; rather, they constitute a unified whole. The "psycho-logic" of *The Street* pointed the way to his future explorations. Made from found cardboard and burlap, the individual works in *The Street* have irregular black borders, which make their forms resemble cell-like structures under pressure from inside and outside, so that the environment seems to penetrate them and vice versa. This transgression of the boundaries between object and surrounding space and between perception and its subjective interpretation corresponds to the blurring of the lines of artistic discipline (painting, sculpture, drawing, theater). Although the clusterlike fragments are flat and painted, the fact that Oldenburg used the borders to foreground the raw supports of cardboard and burlap picked up from the street makes the structures seem sculptural, especially since they can occupy different positions in space.[4] The effect is that of specters in a landscape, as fleeting as they are chaotic. Their figuration occurs within the mind, despite their concrete materiality—a quality that has led Oldenburg to consider these works "hallucinations": "I think of space as being material like I think of stage as being a solid cube or hollow box to be broken," he noted in 1965, "so a hallucination basic to my work is of the continuity of matter, that air and the things in it are one, are HARD, and that you can RIP a piece of air and the thing in it out of it, so that the piece of object and a whole object and just air, comes as one piece. This [is] in my hallucination accompanied by a RIPPING SOUND."[5]

The first exhibition of *The Street* comprised not only figurative assemblages but also graffiti-like writings on the wall, including the words *Ray Gun*. Oldenburg referred to the Ray Gun in countless notes and drawings, which together with diverse Ray Gun assemblages and culled found pieces form a large complex of works based on the urban environment's potentially aggressive nature. He reflected in these works on this nature sometimes in a melancholy way, sometimes in an ironic, refracted way. The Ray Guns are based on the idea that (nearly) every right angle, when framed and isolated as an object, can be interpreted as a ray gun. Oldenburg picked up apposite found pieces from the street, arranged them together in display boxes, and later dedicated the *Ray Gun Wing* of his *Mouse Museum* to them. They might have irregular outlines; they might be flat, linear, sculptural, and even perspectively distorted, but all are based on the idea of a "universal right angle" found in the city.[6] In contrast to the schematic figures and figurations in *The Street*, which emphasize planarity, the Ray Guns mythologize one-dimensionality—that is, the one-dimensionality of the ray, which is, however, accompanied by "hallucinations," of spatial volume and plastic form by way of the artifact itself.

Finally, in 1960, Oldenburg found a new way to position himself in the urban environment by establishing the Ray Gun Manufacturing Company and setting up *The Store* as an all-in-one production and sales location, studio, and gallery. In *The Store*, he replaced representations of an *imaginary* everyday object—the Ray Gun—with representations of *real* everyday objects. *The Store* was initially just an idea, but by the autumn of 1960 it had become literal as Oldenburg began a continuous production of artifacts, which were first exhibited at the Martha Jackson Gallery in 1961. Toward the end of the year, Oldenburg set up a real store at 107 East Second Street. Although he had already included representations of everyday objects (cards, store signs, bicycles, etc.) in *The Street*, they had there formed the parts of an overall setting. The shop window of *The Store*, by contrast, simultaneously separated and merged the interior and exterior environments, emphasizing their physical separation but visual and psychological interconnection.

Oldenburg thematized and materialized the semiotic objects found in ordinary store-window displays with standins, whose decidedly raw aesthetic suspended the idea of the use value of the everyday objects on display. His replicas, made of strips of fabric dipped in plaster and placed over wire frames that were then painted and doused with glossy industrial paints (alluding to Pollock's drips), can be associated

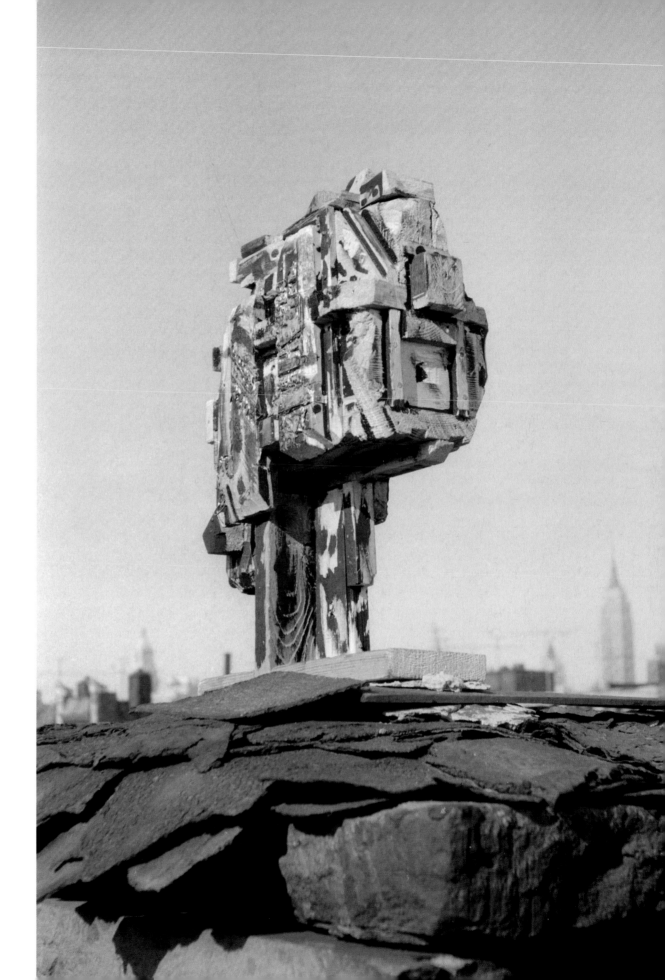

Head of a Woman, 1957 (destroyed)
Photo by Claes Oldenburg

Freighter & Sailboat, 1962 (props from *Store Days II*)
Muslin filled with shredded foam rubber, painted with spray enamel
Freighter: 19 ¹¹⁄₁₆ x 70 ¹¹⁄₁₆ x 5 ¹⁵⁄₁₆ inches
Sailboat: 45 ¹⁄₁₆ x 28 ¹⁵⁄₁₆ x 5 ⁵⁄₁₆ inches
Solomon R. Guggenheim Museum, New York;
Gift of Claes Oldenburg and Coosje van Bruggen, 1991

Opposite:

Upside Down City, 1962 (prop from *World's Fair II*)
Muslin filled with newspaper, painted with latex and spray
enamel, wood, clothespins, clothesline, and hangers
118 x 60 x 60 inches
Walker Art Center, Minneapolis; Purchased with the aid of
funds from the National Endowment for the Arts and Art Center
Acquisition Fund, 1979

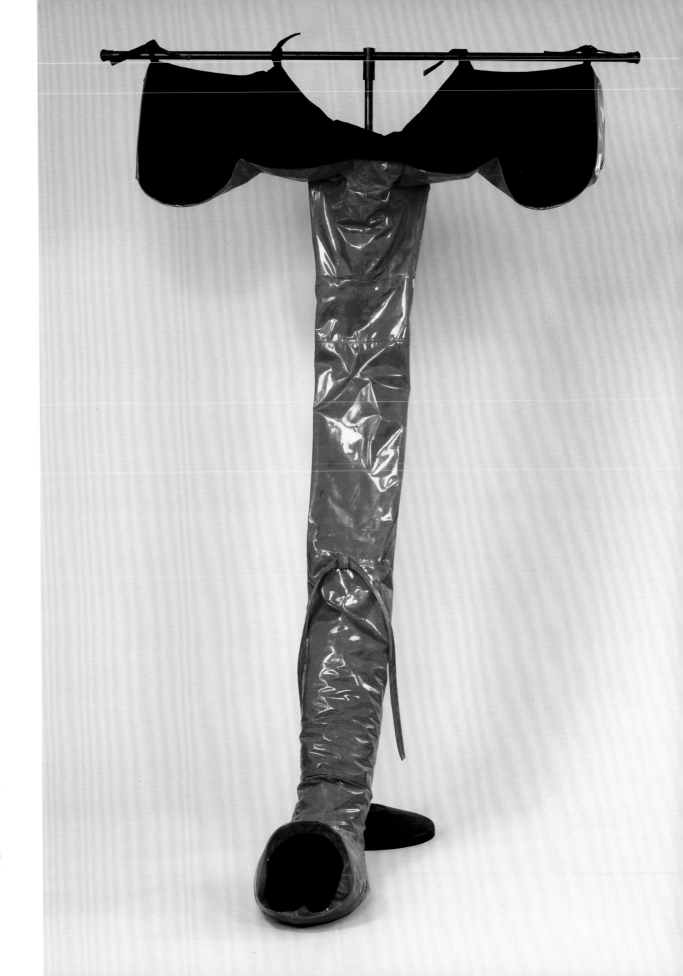

Soft Drainpipe—Red (Hot) Version, 1967
Vinyl filled with expanded polystyrene
chips, on painted metal stand
Drainpipe: 120 x 60 x 45 inches
Stand: 96 inches
National Gallery of Art, Washington DC;
Collection of Robert and Jane Meyerhoff,
Gift in Honor of the 50th Anniversary of
the National Gallery of Art

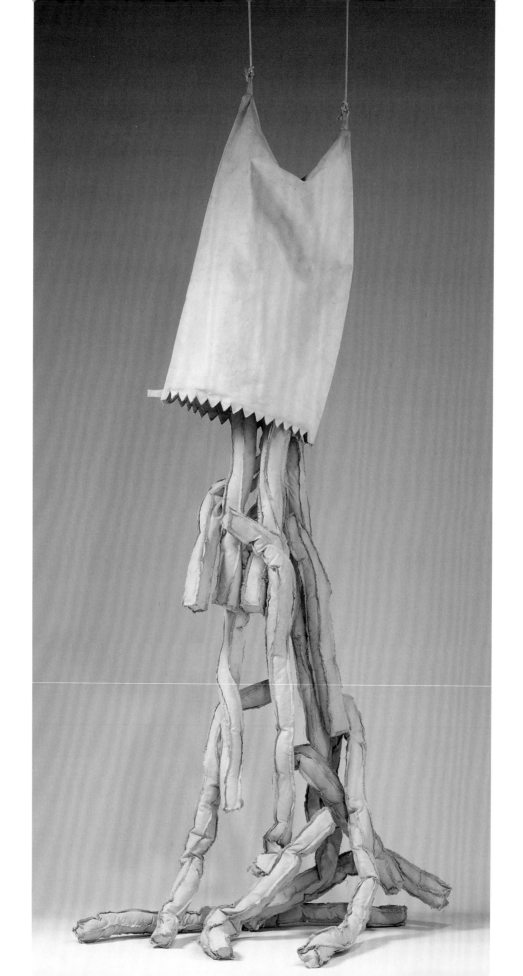

Shoestring Potatoes Spilling from a Bag, 1966
Canvas filled with kapok, stiffened with glue and painted with acrylic
Dimensions variable; approx. 108 x 46 x 42 inches
Collection Walker Art Center, Minneapolis. Gift of the T. B. Walker Foundation, 1966

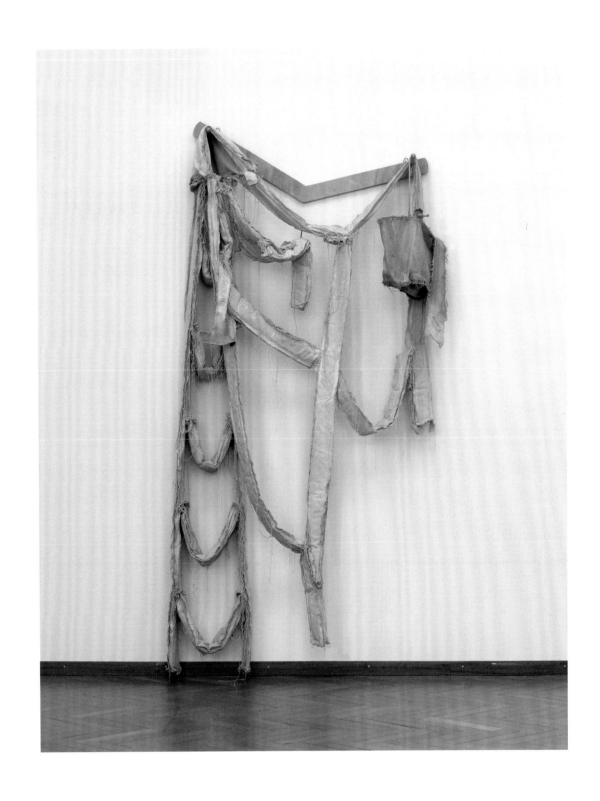

Soft Ladder, Hammer, Saw and Bucket, 1967
Canvas filled with polyurethane foam, stiffened with glue and painted with acrylic
7 feet 10 inches x 4 feet 6 inches x 2 feet
Stedelijk Museum, Amsterdam

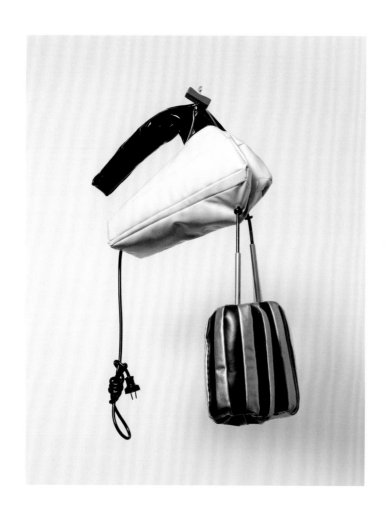

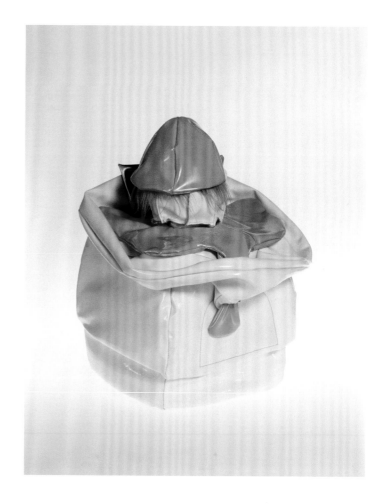

Soft Dormeyer Mixer, 1965
Vinyl filled with kapok, wood, aluminum tubing,
electric cord, and rubber
32 x 20 x 12 ½ inches
Whitney Museum of American Art, New York;
purchase, with funds from the Howard and Jean
Lipman Foundation

Soft Juicit, 1965
Vinyl filled with kapok, fake fur
20 ½ x 17 x 16 inches
Private collection

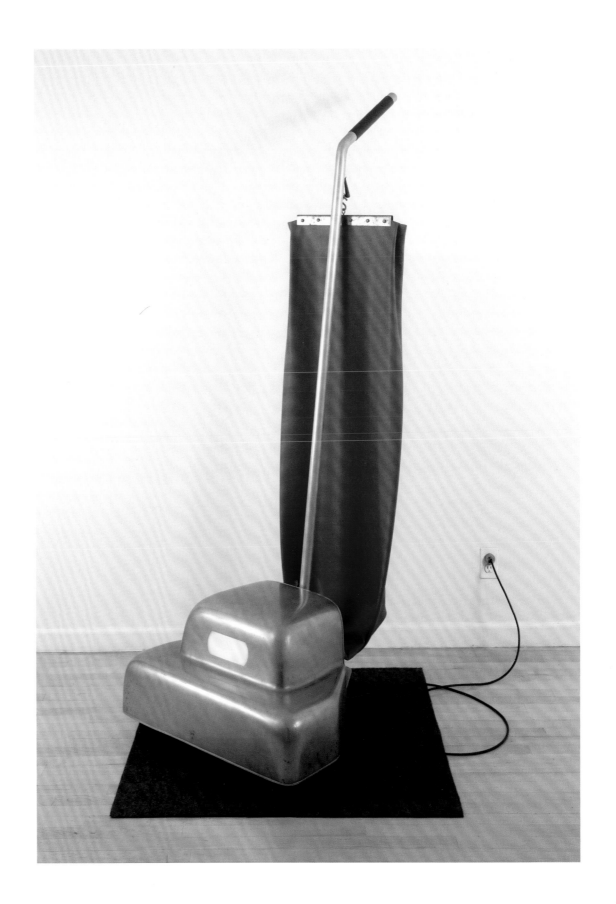

Vacuum Cleaner, 1964–71
Aluminum, vinyl, plastic, rubber,
lightbulb, and cord
64 x 29 x 29 inches
The George Economon Collection

Pages 176–77:

Bedroom Ensemble 2/3, 1963–69
Wood, Formica, vinyl, aluminum,
paper, fake fur, muslin, Dacron,
polyurethane foam, and lacquer
10 x 17 x 21 feet
MMK Museum für Moderne Kunst,
Frankfurt am Main

the perspectively oriented, sharp-edged objects prompt the viewer's imagination to project bodies only to fragment them at the same time.

Although *Bedroom Ensemble* exists only in a "hard version," Oldenburg produced both "soft" and "hard versions" of the bathroom furnishings. The "hard versions," made of painted cardboard, somehow seem even more ghostly than the soft "ghost versions." Just when we believe we can grasp the form of a ghost version unaffected by gravity, it dissolves into a ghost image, as a result of the white paint. This form is thus experienced as a mere hallucination, so to speak. Whereas the paint was applied with a brush in these works, with an almost pointed irregularity, the mass-produced fabrics in *Bedroom Ensemble* are regularly articulated. Nevertheless, they each convey an analogous effect, for we can neither directly perceive the strict regularity of the fabrics nor grasp the object through form. Both the painting and the complex patterning result in the virtual suspension of the boundaries of the object qua form by means of an "allover" effect. This effect is achieved in a different way in monochrome works, such as the "hard version" of *Light Switches* (1964). Although homogenization makes it easier to grasp the form, its effect is the dissolution of form, since it is impossible to distinguish the various parts of the sculpture (e.g., screws and switches) based on color and materiality.

In Oldenburg's Home, we confront omnipresent mass-produced everyday objects, which are at the same time singular artifacts that cannot be used in the ordinary sense.[11] Because the concept of reproduction presumes production, the artifact is presented as a virtual archetype or as a model based on a possible reproduction, and yet it also seems to present a reaction to mechanical reproduction and its effects in real life. It is thus necessary to understand Oldenburg's production of the artifact as an attempt to create an ode, one might say, to the often anonymous cultural activity that produced the everyday objects. Because Oldenburg often replicates in sculpture technologically outdated objects whose obsolescence casts doubt on their functionality, his reproduction makes the archetype visible in the first place; the object appears to be a "subject far enough away to be on the verge of disappearing from function into archetype, like the Switches and Plugs." This enables Oldenburg "to press style upon mere function"[12]—that is to say, to stylize and thus suspend technical functionality and to "form" a design that "rhymes" with the design of the archetype. On the whole, the works that Oldenburg brought together under the title

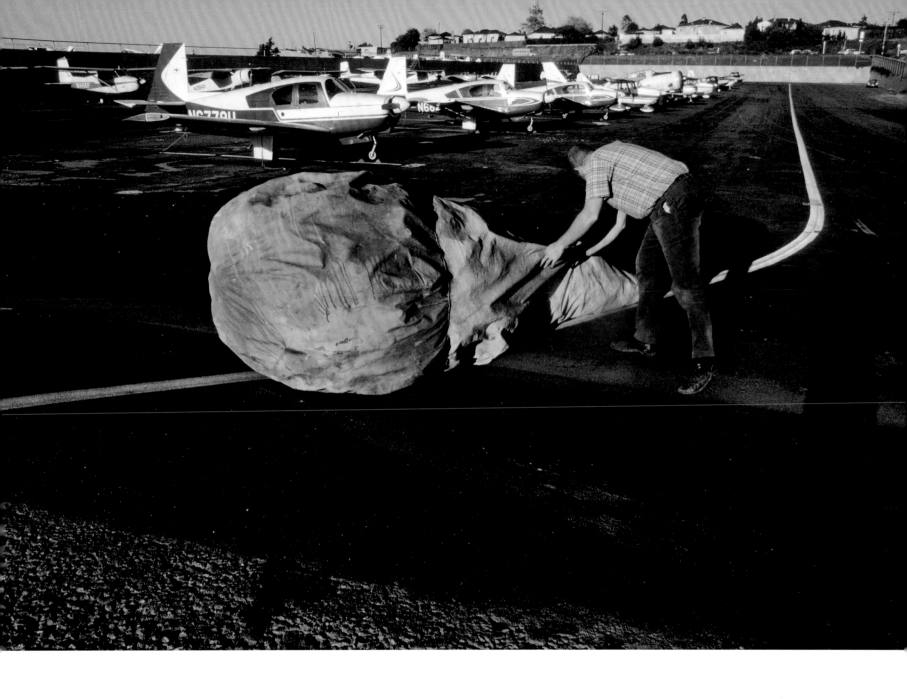

Claes Oldenburg with *Floor Cone* (1962),
at the Santa Monica Airport, CA, 1963

*Proposed Colossal Monument for Central Park
North, N.Y.C.—Teddy Bear*, 1965
Crayon and watercolor on paper
23 ⅞ x 18 ⅞ inches
Whitney Museum of American Art, New York

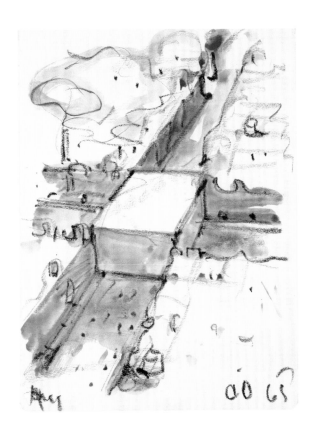

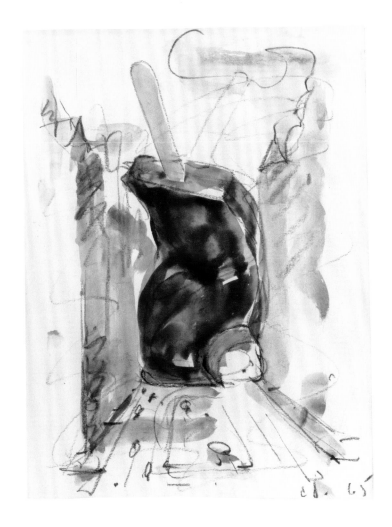

Proposed Monument for the Intersection of Canal Street and Broadway, N.Y.C.—Block of Concrete, Inscribed with the Names of War Heroes, 1965
Crayon and watercolor on paper
16 x 12 inches
The Museum of Modern Art, New York; Bequest of Alicia Legg

Proposed Colossal Monument for Park Avenue, N.Y.C.— Good Humor Bar, 1965
Crayon and watercolor on paper
23 ¾ x 18 inches
Private collection, New York

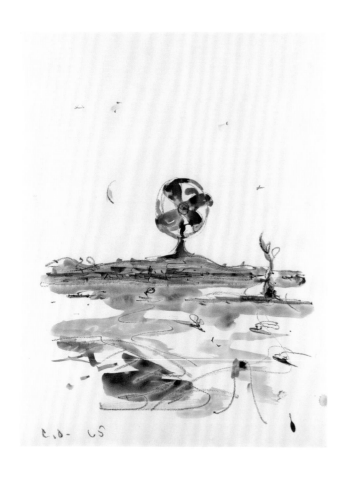

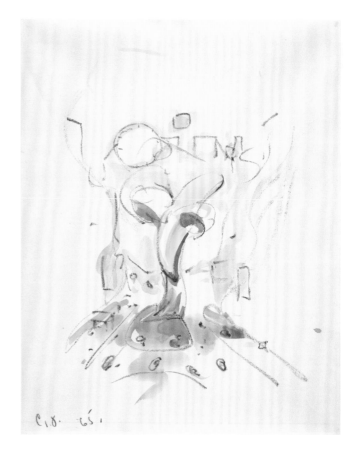

Proposed Colossal Monument for Staten Island, N.Y.C.—
Fan (Study for cover of Domus Magazine—not used), 1965
Crayon and watercolor on paper
23 ¾ x 18 ¾ inches
Private collection, New York

Proposed Colossal Monument for Times Square, N.Y.C.—
Banana, 1965
Crayon and watercolor on paper
24 ½ x 19 inches
The Museum of Modern Art, New York.
From the Collection of Laura-Lee and Robert Woods

*Late Submission to the Chicago Tribune Architectural
Competition of 1922—Clothespin, Version Two*, 1967
Crayon, pencil, and watercolor on paper
22 x 27 inches
Des Moines Art Center Permanent collections; Partial purchase
with funds from Gardner Cowles and gift of Charles Cowles

that he had already represented sculpturally in order to test their placement in the urban landscape. His choice of the teddy bear for the first design of a colossal object is hardly surprising, since, as a sewn-together and stuffed object, it directly relates to the "soft sculptures." However, most of these sculptural representations (with the exception of those of food and clothing) are "hard" objects, so the challenge was to imagine an object known for its softness as a hard sculpture placed "architecturally" in a landscape. In a watercolor proposal, air could function as a soft-focus lens, but if the sculpture was to be executed, one would have to reckon with the possibility that a sculpture of an oversize everyday object might look like a "painful eyesore," as Oldenburg admitted.[24]

A simple translation of a sketch's two dimensions into three was inconceivable, in part because the execution would require an administrative process that would bestow an official status on the sculpture. The proposals left the sculptures in the realm of the imaginary. In 1968 Herbert Marcuse felt compelled, given the popularity of Oldenburg's graphic monument designs, to highlight this problem: "If you could really envisage a situation where at the end of Park Avenue there would be a huge Good Humor ice cream bar and in the middle of Times Square a huge banana I would say . . . this society has come to an end. Because then people cannot take anything seriously. . . . But the trouble is you must already have the radical change in order to get it built and I don't see any evidence of that. And the mere drawing wouldn't hurt and that makes it harmless. But just imagine that overnight it would suddenly be there."[25] Oldenburg's drawings, which precisely delineate how these situations can in fact be imagined, are, therefore, by no means as "harmless" as Marcuse claimed. For in the drawings, the imagined is thrown back on itself and remains in the imagination, whereas Marcuse spoke of a *reality* that was to be imagined.

The challenge for Oldenburg became finding a way to mediate imagination and reality while neither subjecting the imagination to the actual nor blocking it out. He tackled this problem, from 1965 onward, by dividing his graphic designs into "feasible monuments" and "unfeasible monuments"— that is, he made reality a distinguishing criterion. In a second step, he rented a billboard in Stockholm in 1966 on which to present in graphic form six proposals for public monuments. This move can be understood as simultaneously promoting an idea and realizing it. As a billboard commonly promotes proposals for new buildings and parks to the public, so

Oldenburg's billboard likewise announced projects to be carried out—after all, the graphic depictions expressed his self-image: "My work is architecture . . . nothing is as important as the scale and relation of different volumes . . . planes, lines . . . my personal architecture."[26]

Architecture begins by excavating the earth and ends with exposing a facade to a critical gaze, and the following year Oldenburg applied this first stage, excavation, to sculpture and the second, exposure, to painting. His goal was to clarify the question of how art could assert itself under urban conditions. In the second instance, he created his mural *Pop-Tart* on the facade of a building in Chicago. Kellogg's had alluded to Pop art when it christened its toaster pastries Pop-Tarts. For Oldenburg, this move raised the question of whether a mural of a Pop-Tart would be perceived as architecture, painting, or advertising.

For the first instance, Oldenburg dug a trench in the earth in New York's Central Park and then filled it with soil again. Rather than erecting a monument, he examined the space that would have to be dealt with if erecting one. This sculpture, which Oldenburg called his "first public monument" and titled *Placid Civic Monument*, was realized on October 1, 1967, as part of the exhibition "Sculpture in Environment."[27] In a grassy area in Central Park behind the Metropolitan Museum of Art, the artist asked workers to dig a trench measuring 6 by 6 by 3 feet and then—after a brief waiting period during which, as he wrote, the workers could go have lunch—fill it back in with the same soil. Then this surface was raked, paying close attention to the edges. In his written notes, Oldenburg anticipated the administrative measures that would be required to make the work, the discussions and reactions of the press, and the fact that grass would eventually grow back over the raked soil.[28] As an "environmental," subterranean sculpture, the work referred to past, present, and future in equal measure.[29] He donated the work to the City of New York. It was not just a three-dimensional realization based on a preparatory drawing but an activation of the fourth dimension—time.[30] This act also raised questions regarding the public perception of the resulting field as sculpture, bed, construction site, and grave. On the one hand, the allusion to a grave leads to a reflection on the tradition of the monument as largely one of tombs. On the other hand, Oldenburg treated it like he did other everyday objects: the replica suspends its ordinary function. The "hardship" we attribute to a grave in a psychological sense is transferred to the experience of a soft material.

Photo of Macy's Thanksgiving Day Parade from 1972, from the Oldenburg van Bruggen Studio Archives

Photos by Claes Oldenburg, Los Angeles, ca. 1971

Placid Civic Monument, project for the exhibition "Sculpture in Environment," in Central Park near the Metropolitan Museum of Art, New York, October 1, 1967

It was not the only proposal Oldenburg submitted to the exhibition organizers. Lucy Lippard noted: "Claes Oldenburg is asked to participate in a city outdoor sculpture show; he (1) suggests calling Manhattan a work of art, (2) proposes a scream monument wherein a piercing scream is broadcast through the streets at 2 a.m., and (3) finally has a 6' x 6' x 3' trench dug behind the Metropolitan Museum by union gravediggers, under his supervision, and then filled up again."[31] His first proposal testifies to Oldenburg's awareness of the preferential treatment accorded to conceptual ventures in the late 1960s; the realization of the second would have theoretically been possible but was highly unlikely; the third proposal combined a conceptual ambition with the possibility of its realization and did not abandon a critical negation of the traditional monument. He was interested in a work that both engaged and commented on the administrative process. In his notes, he wrote of the "aesthetic bureaucratic structure of the big city" and of his work as "an aesthetic event turning the mechanism of the city into aesthetics, i.e., nonfunction (by some read as comedy)."[32] The concept of the aesthetic is ambivalently connoted here: on the one hand, the administrative structure presumed by the work does not function and so should be understood as "aesthetic"; on the other hand, this very nonfunctioning is made aesthetically visible. What links *Placid Civic Monument* to Conceptual art, and what caused Oldenburg to call it a "conceptual monument," is that what eventually is left to see seems insufficient.[33] The observer depends on linguistic and photographic documentation that explains that the only material used was earth, permitting Oldenburg to define it as an "earthwork."[34] It might thus be possible to characterize the work linguistically (*ante res*) or as a photographic or cinematic document (*post rem*), while it remains present and viable as material (*in re*).[35]

In relation to Oldenburg's previous sculptures, it seems noteworthy that this first public sculpture is made of material that has no definite form. In 1966, he had already created two soft sculptures of maps of Manhattan hanging on the wall as planar forms. In one case, "postal codes" are given a certain depth as separate, material parcels. And, in 1962, Oldenburg had created *Upside Down City* for a performance in *The Store*, for which he thwarted the soaring verticality of Manhattan's skyscrapers by hanging narrow, planar-looking, but sacklike forms close to one another like socks on a clothesline. He took the exhibition title "Sculpture in Environment" literally. The form of his sculpture emblematizes the urban structure,

and its material reconnects it to its environment entropically. Oldenburg's explanation—"a hallucination basic to my work is that of the continuity of matter," which in other works he related to the air surrounding the objects—refers not only to the air that penetrates the earth but also to the soil. Oldenburg also noted the work's association with a grave: "The hopes of a city lie buried there,"[36] and explained: "The artist is communicator, and from experience he knows how difficult it is to communicate the pure sense of being alive."[37]

Placid Civic Monument can be understood as a metareflection on Pop art's strategy of taking things that are alive and expressive in the world of advertising and commodities and making them seem dead and inexpressive by reproducing them as art objects. In the area of public sculpture, however, Oldenburg explored other strategies. Though as a drawing his *Teddy Bear* points to "society's frustrating lack of tools," the elevation of the idea into an enduring public sculpture would be unconvincing. So it is not surprising that Oldenburg acknowledged this in a humorous, antithetical way as he developed "feasible" monuments that were indeed executed. Rather than referring to "society's frustrating lack of tools," he monumentalized everyday tools in order both to generate opportunities for positive action and to undercut them ironically.[38] At the same time, he put the colossal into perspective. He did not create his monuments to seem colossal in relation to architecture and the landscape, but instead his enlargements were relative to the depicted objects. In the case of *Placid Civic Monument*, however, Oldenburg primarily emphasized that the scale of an outdoor sculpture, whatever else may determine it, is always tied to human scale: "It is modest because we need modesty. A nice contrast, I thought, to the pomposity that 'civic' sculpture always generates."[39]

The historical context of the Vietnam War was also critical to the development of Oldenburg's public monuments: even though the war was not his explicit theme, the tense domestic opposition to it tended to inflect its interpretation, like that of any public inquisition of institutions. Oldenburg's second outdoor sculpture, *Lipstick (Ascending) on Caterpillar Tracks*, despite its differences, can also be understood as institutional critique.[40] In his various critiques and engagements with institutions, Oldenburg operates with calm restraint as often as intense spectacularization.[41]

Marcuse's critical remarks about Oldenburg motivated several students at Yale University, where the artist himself had

studied, to approach him.[42] They knew that they were unlikely to get official funding to support the construction of a sculpture by Oldenburg on the university's campus, so they established a foundation. Such a donation could not be rejected, as the foundation would remain anonymous. Oldenburg conceived a Caterpillar vehicle, on which a monumental, extensible lipstick was mounted. Its tip consisted of an inflatable red vinyl sack. In comparison to the Caterpillar, the lipstick was outsize, which heightened the phallic reference. A platform could be ascended via a foldout ramp, from which people could

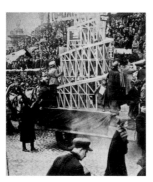

Simplified model of Vladimir Taltin's *Monument to the Third International* during a street demonstration in Moscow, May 1, 1926

speak. The tip of the lipstick could mechanically inflate and then collapse once the speech, likely a political outburst, had ended. The work alluded not only to the spiral form of Vladimir Tatlin's *Monument to the Third International* (1919–20) but also to the mobile platforms that had been deployed in parades in the newly founded Soviet Union.[43] Hence Oldenburg's *Lipstick* highlights at once the conditions under which a monument with a claim to political credibility is possible in the twentieth century and the unlikelihood that such a thing can be seriously considered in the present day.

Not all the ideas for the *Lipstick* could be realized as planned. For reasons of cost, the idea for a remote-controlled Caterpillar—indeed, for a vehicle at all functional—had to be abandoned. But Oldenburg did initially stick to the idea for an inflatable lipstick. At the festive opening, however, which, in keeping with the intention of its initiators, became a burlesque spectacle, it proved impossible, despite all efforts, to inflate the red vinyl sack. The parodistic quality of the situation thus intensified. Because it was supposed to be a permanent sculpture, Oldenburg replaced the vinyl top with a version in metal the following week. It then alluded ironically to the architectural rhetoric of the campus (porticoes, church towers, etc.). Only a few months later, however, the sculpture was so covered with graffiti that Oldenburg himself removed it. Several years later, with the spectacle of the opening ceremony still alive in the memories of many, the desire to reconstruct it was articulated. People wanted a souvenir, Oldenburg realized.[44] And so, in 1974, a third version was ultimately installed on

the grounds of Morse College, where the work was fenced in: "It had worked its way from a piece of useful art to a museum piece."[45] As a monumental souvenir of the parody of a monument, however, it nonetheless celebrated the parody itself and paradoxically fulfilled the memorial function of a monument, as it memorialized its own history.

Like *Placid Civic Monument*, *Lipstick (Ascending) on Caterpillar Tracks* also related to the U.S. involvement in the Vietnam War, even though again the work made no explicit reference to it and did not ask the viewer to take a political position. Oldenburg's lipstick, which looks like a missile standing upright on the Caterpillar, makes a military connotation undeniable, however. *Placid Civic Monument* made obvious Oldenburg's oppositional stance toward the claim to permanence associated with the idea of a monument, and the work's relationship to the grave likewise called to mind the military engagement of the U.S. in Indochina. Both works were created with an awareness that administrative prerequisites and the public reactions would be part of the process of the work. In both cases, the work's inauguration—which in the case of *Placid Civic Monument* coincided with its execution—became the focus of public interest. Initially, Oldenburg retained—in contrast to ordinary outdoor sculptures—the basic idea of his soft sculptures, as he chose materials whose form or state is subject to change. For example, he remarked of *Placid Civic Monument*: "The Central Park Monument is a softened piece of surface."[46] Oldenburg's monuments suggest an ambivalence and failure unfamiliar to conventional outdoor monuments. The red vinyl sack of his *Lipstick* was supposed to inflate and then collapse; and *Placid Civic Monument* was thought of by the artist both as a "grave" and as a "perfect (anti)war monument,"[47] as well as, paradoxically, a representation of a "pure sense of life." The mere association with a grave seemed just as problematic to the artist as the mere presentation of a limp lipstick. In both works, therefore, Oldenburg wanted to work with inverted or invertible signs, so to speak, and thus he critically distanced his monuments from their traditional equivalents, signaling the possibility for "positive" experience—albeit an ironic, refracted one.

"DROP ART" SCULPTURE AS POP ART SCULPTURE

When Oldenburg turned in 1967 to the conception, design, and execution of outdoor sculptures, no group of everyday objects claimed his interest with particular urgency (as had occured

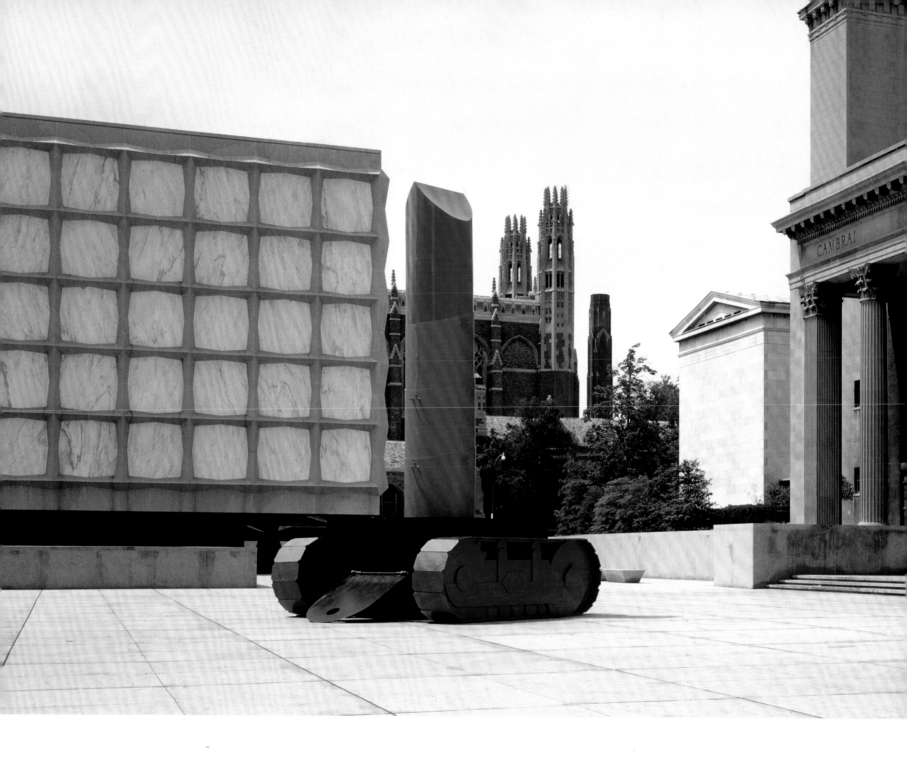

Lipstick (Ascending) on Caterpillar Tracks,
installed at Beinecke Plaza, May 1969–March 1970

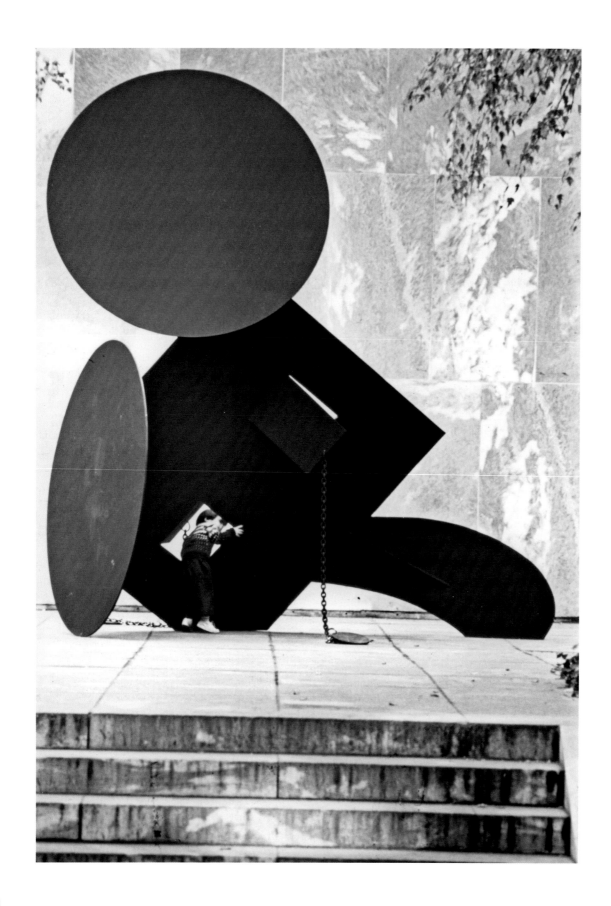

Geometric Mouse—Scale A, Black 1/6,
1965–75, installed at the Museum of
Modern Art, New York, 1969
11 feet 7 inches x 12 feet x 6 feet 2 inches
Painted steel and aluminum
Empire State Plaza Art Collection, New York

case of monumental sculptures, especially the choice of location. For though Oldenburg's "monuments" may *seem* like "dropped sculptures," they are in fact related both obviously and profoundly to their topographic and cultural context.[59]

The first works that could be labeled Drop art in this positive sense are the *Giant Three-Way Plug, Scale A* of 1970, located in an outdoor space belonging to the St. Louis Art Museum, and *Geometric Mouse—Scale A, Black*, the first version of which was placed in the sculpture garden of the Museum of Modern Art in New York in 1969; a much larger version, created in 1971, was installed near the shore for the exhibition "Monumenta: Sculpture in Environment" in Newport, Rhode Island, in 1974. In both cases, the sculpture thwarts the idea of its "erection." *Giant Three-Way Plug* has

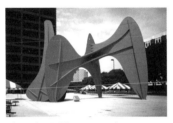

Alexander Calder, *La grande vitesse*, 1967, Grand Rapids, Michigan

neither a pedestal nor a plinth, nor does it lie on the lawn; rather, it looks as if it had been dropped from a great height and left lying half sunken into the earth. *Geometric Mouse* in Newport, composed of planar parts painted a red conjuring Calder's monumental

sculpture, stands on a square field built especially for its presentation.[60] This field, because it is painted white, invokes a "cinema" screen, but in this case the projected images depend not on an ideational visual "vanishing point" but instead on the material vanishing point of gravity, which, for earthbound beings, sits at the center of the planet. And, although the effect of this vanishing point can be geometrically calculated, it is, nevertheless, determined by mass. Because of the peculiar configuration of its parts, the sculpture equally evokes deformed projections of Mickey Mouse and a film projector. The eyes of the Mickey Mouse qua Geometric Mouse look like the windows of a projection room from whose flaps disks of tears attached by chains roll out and onto the floor. The mouse seems to have bumped its nose, which also looks like a piece of film looming out of the projector.

Both sculptures are made of steel (combined with bronze in the case of *Giant Three-Way Plug*), a material that Oldenburg first used for *Lipstick (Ascending) on Caterpillar Tracks*. It signals his turn from the soft sculptures, his "way out" of the 1960s. His earlier "hard versions" of everyday objects stood in a dialectical relationship with his soft sculptures. By contrast, the

"dropped" sculptures Oldenburg conceived during the early 1970s maintain a dialectical relationship with their place, to the ground on which they rest. The ground, for example, on which *Giant Three-Way Plug* rests, seems soft as the hard metal penetrates it. Conversely, the "hardness" of these works is softened by colorful paint and the deformations resulting from their "striking" the ground. Hardness and softness, no longer physical properties of the materials, are relativized and become symbolic indicators of the reciprocal transformation of the sculpture and the site.

With his outdoor sculptures, Oldenburg connected his work to other art from this historical and cultural moment—above all, to Earth art and Minimalist and Postminimalist works, which were wagering everything on the properties of materials to manifest phenomenologically the subjects of a sculptural praxis. But, as his early outdoor sculptures show, Oldenburg was also concerned with the administrative requirements for erecting a monumental sculpture outdoors. His rhetorical, symbolic use of materials contends that such requirements cannot simply be obscured through the phenomenological experience of a work. At the same time, however, rhetoric serves him not to achieve certain goals but rather to provoke a wide variety of perceptions and reactions. Any search for a specific inner core of meaning would be misguided. Illustrating rhetoric through rhetorical means effects a kind of hollowing out, since no personal stance is taken, as Oldenburg himself remarked: "If it was just a satirical thing there wouldn't be any problem. Then we would know why we were doing these things. But making a parody is not the same thing as a satire. Parody . . . is simply a kind of imitation, something like a paraphrase."[61] Parody can be recognized as a rhetorical form from its effect of dissolving form, including its own.[62]

The use value of an object, once turned into an Oldenburg sculpture, is simultaneously upheld and denied; the sculpture takes on a semiotic character that thwarts the sign value of commodity. Thus they combine the idea of an ordered structure with that of a "continuity of matter." Oldenburg's *Alphabet in the Form of a Good Humor Bar* of 1970, which depicted letters of the alphabet as if they were convulsing internal organs, demonstrates this programmatically. A humorous game that involves a "poetry of scale," and an exchange between the visceral and the tectonic, sign and thing, imagines that human beings—like Oldenburg's objects—could grow beyond themselves. The "continuity of matter" establishes not

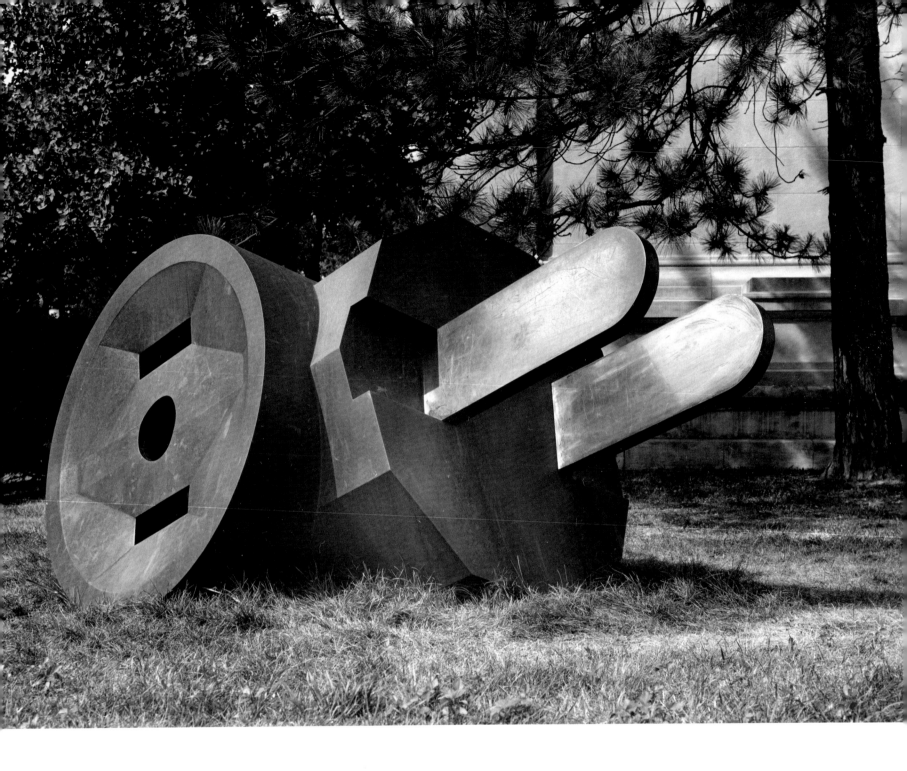

Giant Three-Way Plug, Scale A 2/3, 1970
Cor-Ten steel and bronze
60 ⅞ x 78 x 120 ⅝ inches
City Art Museum of St. Louis, MO
Gift of the artist and Fund for Contemporary Art, 1970

Page 205:

Giant Ice Bag, 1969–70, in the U.S. World's Fair
pavilion for Expo 70, Osaka, Japan, 1970
Vinyl over steel structure, with motors and blowers;
top: fiberglass painted with metallic lacquer
18 feet in diameter; 16 foot maximum height
Musée National d'Art Moderne—Centre Georges
Pompidou, Paris (acquired 1999)

a norm but rather an unbounded, formless unity that cannot be suspended structurally.[63] Oldenburg's proposals reveal the artist's need to find "the human" in a conformist culture.[64] But because he bestows on everyday objects anthropomorphic features, he presents conflicting amalgamations of the human and reified material, which makes our own search for the human all the more urgent.

Oldenburg's sculptures do not envisage a specific idea of humanity but rather warn of the reification that ensues. In assigning anthropomorphic features to everyday, reproducible objects, Oldenburg explores the conditions and effects of reification in quotidian social contexts. In connecting sculpture to these conditions and effects, he points beyond the "idealist space," in which sculpture is situated heroically, to the "continuity of matter" of a "materialist space," to which it belongs just as much as the viewer does. Orientation, we understand, occurs only through a dynamic and reciprocal relation of a work and its viewer.

NOTES

1. Robert Musil, "Monuments," in *Posthumous Papers of a Living Author*, trans. Peter Wortsman (Brooklyn: Archipelago, 2006), pp. 64–68, esp. p. 67.

2. The term "idealist space" has ambiguous connotations in the work of Rosalind Krauss. In her 1978 essay "Sculpture in the Expanded Field," published in *October*, no. 8 (Spring 1979), and reprinted in her *The Originality of the Avant-Garde and Other Modernist Myths* (Cambridge, MA: MIT Press, 1986), pp. 276–90, she applies the term generally to modernist sculpture to distinguish it from the *space* of postmodernist sculpture. However, in a study published a year earlier—*Passages in Modern Sculpture* (Cambridge, MA: MIT Press, 1977)—she distinguishes two strands in the evolution of modern sculpture, only one of which she characterizes as "idealist." This contradiction is, however, only apparently such. The 1978 essay refers generally to the placelessness of modern sculpture; the 1977 book, by contrast, refers to two fundamentally different types of semantics. Both arguments are relevant to Claes Oldenburg. He is not interested simply in practicing a nonidealist form of semantics but rather is interested in doing so in a way that also redefines the place of sculpture within culture.

3. Claes Oldenburg, interview by Paul Cummings, 1973, Archives of American Art, Smithsonian Institution, Washington, DC, p. 75.

4. Oldenburg noted: "I represent the object in *mind* which is an unpredictable illogical and inconsistent cluster. Because I am representing by concrete means, space (light) is naively realized as solid. The pieces are as if ripped out of a solid space which includes both the object and the 'air' surrounding it. I have made a deep mural in the air, a suspension of solids. The actual space between the solids can be thought of as potentially solid. There is present an amount of invisible material. The concretions are selective, the ellipses highly condensed, spatially and temporally. The edges (which are the edges of perception) do not necessarily correspond to the object. Scale is freely mixed." Claes Oldenburg, quoted in Barbara Rose, *Claes Oldenburg* (New York: Museum of Modern Art, 1970), p. 193.

5. Ibid., p. 69. In this context, Charles S. Peirce's remarks on "hallucination" are of interest: "Meantime, we know that man is not whole as long as he is single, that he is essentially a possible member of society. Especially, one man's experience is nothing, if it stands alone. If he sees what others cannot, we call it hallucination. It is not 'my' experience, but 'our' experience that has to be thought of; and this 'us' has indefinite possibilities." Peirce, *Collected Papers of Charles Sanders Peirce*, vol. 5 (Cambridge, MA: Harvard University Press, 1931–58), p. 259. When Oldenburg as an artist speaks of his hallucination, there is a pressing effort to make "his" perception the experience of "our" possibilities.

6. Oldenburg explained this in 1960 as follows: "I wish to destroy the rectangle and substitute the 'medium' of indefinite form." Oldenburg, quoted in Rose, *Claes Oldenburg*, p. 54.

7. In his book *The System of Objects*, Jean Baudrillard provided a systematic framework for an anthropomorphic interpretation of this premise, which must, however, be distinguished from Oldenburg's art; Baudrillard wrote: "In creating or manufacturing objects, man makes himself, through the imposition of a form (i.e. through culture) into the transubstantiator of nature. . . . So too, with the form perfectly circumscribing the object, a portion of nature is included therein, just as in the case of the human body: the object on this view is essentially anthropomorphic. Man is thus bound to the objects around him by the same visceral intimacy, *mutatis mutandis*, that binds him to the organs of his own body, and 'ownership' of the object always tends virtually towards the appropriation of its substance by oral annexation and 'assimilation.'" Jean Baudrillard, *The System of Objects*, trans. James Benedict (London: Verso, 1996), p. 28. Consequently, Baudrillard analyzed both the "phallic order" and the "fecal order" and referred to everyday objects and how we deal with them. But because Oldenburg presents in his art a "transubstantiation" not of nature but of *everyday objects* that reveals these "orders" not as social relations of order but as *schematas*, his objects thus can project *back* culturally determined projections. This becomes the experience of a complex structure of cultural forms and conditions to which the artifact is *not* subject, which does not mean that it stands outside the culture. Thus Oldenburg's sculptures produce a connection to materiality that fundamentally suspends the anthropomorphic idea of a transsubstantiation of nature.

8. The connection between Oldenburg's sculptures and the phenomenon of sleep was first noted by Ulf Linde, "Claes Oldenburg at the Moderna Museet, Stockholm: Two Contrasting Viewpoints," *Studio International* 172, no. 884 (December 1966), pp. 326–28.

9. Donald Judd, "Specific Objects," *Arts Yearbook*, no. 8 (1965), reprinted in Judd, *Complete Writings, 1959–1975* (Halifax, NS: Press of the Nova Scotia College of Art and Design, and New York University Press, New York, 1975), pp. 181–89, esp. p. 189.

10. See Rose, *Claes Oldenburg*, p. 193.

11. Oldenburg explains: "The pieces depend not only on the participation of the spectator but his frustration—which is really a technique of definition: this is not a *real* object." Oldenburg, quoted in ibid., p. 194.

12. Oldenburg, quoted in ibid., p. 97. In this context, it should be noted that Oldenburg described his production of sculptures in general as a "cemetery of objects": "An electric fan has more form than a television set or an air conditioner. It probably has to do with the history of industrialization. . . . In electronics, as things get smaller and smaller, and more and more refined, they lose their particular existence as objects and become transistors, conductors of some kind. Perhaps the object civilization is something that existed in an earlier time. Maybe it's characteristic of an antique civilization. At one point I said I was creating a cemetery of objects." Oldenburg, quoted in *Oldenburg: Six Themes* (Minneapolis: Walker Art Center, 1975), p. 11.

13. The Chrysler Airflow was designed in 1935 by Carl Breer, the father of a close friend of Oldenburg's, the sculptor and filmmaker Robert Breer; see Rose, *Claes Oldenburg*, p. 96.

14. Judd, "Specific Objects," p. 189. Judd discusses Oldenburg in greater detail than he does any other artist and, on the occasion of the essay's reprinting, noted that it was his editor's choice, not his own, to include a photograph of one of his works. It would seem that Oldenburg's structures can be considered paradigmatic of the "specific object," even though this term is applied in the literature almost exclusively to works of Minimalism, particularly Judd's.

15. Oldenburg, quoted in Rose, *Claes Oldenburg*, p. 105.

16. Ibid., p. 104.

17. Claes Oldenburg, "The Poetry of Scale," interview by Paul Carroll, August 22, 1968, in *Claes Oldenburg: Proposals for Monuments and Buildings 1965–1969* (Chicago: Big Table, 1969), pp. 10–36, esp. p. 18.

18. Ibid., p. 16.

19. Ibid., pp. 14–15.

20. Ibid., p. 14.

21. Ibid., p. 15.

22. Walter Benjamin, "On the Concept of History," in *Selected Writings*, vol. 4, ed. Howard Eiland and Michael W. Jennings, trans. Harry Zohn (Cambridge, MA: Belknap Press of Harvard University Press, 2003), pp. 389–97, esp. p. 392; Benjamin wrote: "There is a picture by Klee called *Angelus Novus*. It shows an angel who seems about to move away from something he stares at. His eyes are wide, his mouth is open, his wings are spread. This is how the angel of history must look. His face is turned toward the past. Where a chain of events appears before *us, he* sees one single catastrophe, which keeps piling wreckage upon wreckage and hurls it at his feet. The angel would like to stay, awaken the dead, and make whole what has been smashed. But a storm is blowing from Paradise and has got caught in his wings; it is so strong that the angel can no longer close them. This storm drives him irresistibly into the future, to which his back is turned, while the pile of debris before him grows toward the sky. What we call progress is *this* storm." Oldenburg himself related the teddy bear to the idea of a winged allegorical figure; he noted: "Fireplug equals Teddy Bear—seated and tumbled / Blunt form of—clumsy version of—the Winged Victory." Oldenburg, quoted in *Claes Oldenburg* (Düsseldorf: Städtische Kunsthalle, 1970), p. 39. Rose notes that Oldenburg related the design of the Chrysler Airflow, to which he devoted a separate complex of works, to the winged goddess of victory; see Rose, *Claes Oldenburg*, p. 97.

23. Oldenburg, quoted in Barbara Haskell, *Claes Oldenburg: Object into Monument* (Pasadena, CA: Pasadena Art Museum, 1971), p. 8.

24. Oldenburg, "Poetry of Scale," p. 27.

25. The quotation is from a discussion between Herbert Marcuse and Stuart Wrede, who at the time (June 1968) was a student at Yale; it is published in *Perspecta*, no. 12 (1969), n.p.; on this, see Hans Dickel, *Claes Oldenburgs Lipstick (Ascending) on Caterpillar Tracks: Kunst im Kontext der Studentenbewegung* (Freiburg im Breisgau, Germany: Rombach, 1999).

26. Oldenburg, quoted in Rose, *Claes Oldenburg*, p. 192.

27. On this, see Dan Graham, "Oldenburg's Monuments," in *Articles* (Eindhoven: Van Abbemuseum, 1978), pp. 32–38. (Originally published in *Artforum* 6, no. 5 [January 1968], pp. 30–37); Graham compared the work to works by Carl Andre and Sol LeWitt. In her monograph on Oldenburg, Rose calls the work "the first of Oldenburg's monuments" but does not give its title; see Rose, *Claes Oldenburg*, p. 107. She lists the work (without a title) in her chronology only as one of Oldenburg's artistic activities, while calling *Lipstick (Ascending) on Caterpillar Tracks* his "first 'feasible' monument," giving the impression that only the "realized" versions of those drawings he marked "feasible monument" should be included among his "monuments." Because *Placid Civic Monument* does not fit into this schema, it was often ignored. Benjamin H. D. Buchloh called *Lipstick (Ascending) on Caterpillar Tracks* "Oldenburg's first public sculpture"; see Buchloh, "Die Konstruktion (der Geschichte) der Skulptur," in *Skulptur Projekte in Münster 1987*, ed. Klaus Bußmann and Kasper König (Cologne: DuMont, and Westfälisches Landesmuseums für Kunst und Kulturgeschichte in der Stadt Münster, 1987), pp. 349–78, 377. Hans Dickel identified *Lipstick* as the "first work realized in an urban space" by Oldenburg; see Dickel, *Claes Oldenburgs Lipstick*, p. 9.

28. See Haskell, *Claes Oldenburg*, p. 61. On this, see Benjamin H. D. Buchloh, "From the Aesthetics of Administration to Institutional Critique," in *L'art conceptuel, une perspective* (Paris: Musée d'art moderne de la ville de Paris, 1989–90), pp. 41–64. Suzaan Boettger treats Oldenburg's *Placid Civic Monument* in the context of the Earth art movement, which was just beginning in 1967; see Boettger, *Earthworks: Art and the Landscape of the Sixties* (Berkeley: University of California Press, 2002), esp. the chapter "October 1967: A Corner of a Larger Field," pp. 1–22. Many important earthworks by other artists that could be compared to Oldenburg's "hole" in one way or another were not created or at least not completed until 1968, which is why I have chosen not to discuss his *Placid Civic Monument* in that context, since I wish to consider the work primarily from the perspective of his moving into the field of outdoor sculpture and the transition to his later "monuments." With regard to Oldenburg's "grave," on the one hand, and the beginnings of the Earth art movement, on the other, I refer the reader to the exhibition "Monuments, Tombstones and Trophies" in spring 1967 at the Museum of Contemporary Craft, Portland, Oregon. Dan Graham wrote about Andre's "conical pile of sand," shown in that exhibition, which can be understood as gravity materializing the cone of vision; see Graham, "Carl Andre," *Arts* 42, no. 3 (December 1967–January 1968), pp. 34–35.

29. Oldenburg, quoted in *L'art conceptuel, une perspective*, p. 219; quoted in English in Haskell, *Claes Oldenburg*, pp. 60–62.

30. In her essay "Sculpture in the Expanded Field," Rosalind Krauss attempted to sketch the "postmodernist space" of sculpture. To that end, she developed a schema that covers all the possible combinations of the terms *landscape* and *architecture* and their negations to produce four relevant

210

shirt on its side

C. O. 1963

Opposite:

Colossal Fagend—Dream State, 1967
Pencil on paper
30 x 22 inches
Museum of Modern Art, New York; Gift of Lily Auchincloss,
Charles B. Benenson, Ronald S. Lauder and Purchase

Visualization of a Giant Soft Sculpture in the Form of a Shirt with Tie, 1963
Crayon and watercolor on paper
14 x 16 ¾ inches
Los Angeles County Museum of Art, Michael
and Dorothy Blankfort Bequest

211

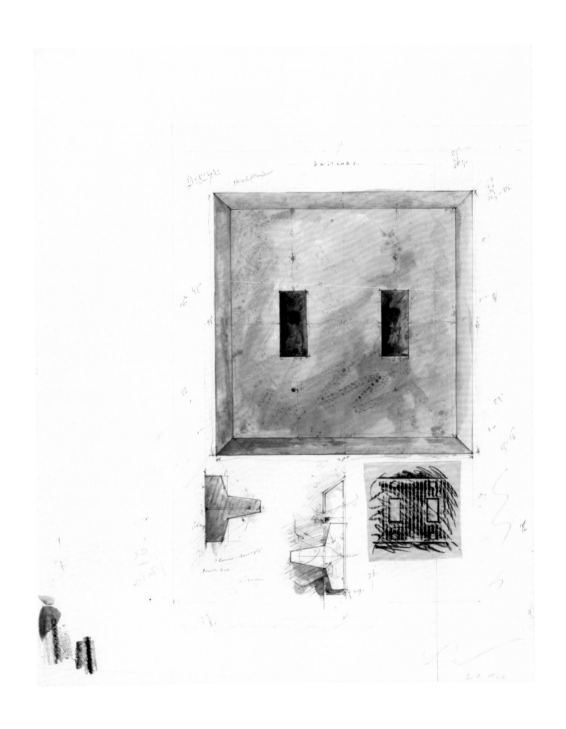

Plan for a Sculpture in the Form of Wall Switches, 1964
Pencil, ballpoint pen, crayon, wash, and newsprint on paper
29 x 23 ⅝ inches
Whitney Museum of American Art, New York. Purchase,
with funds from a Neysa McMein Purchase Award

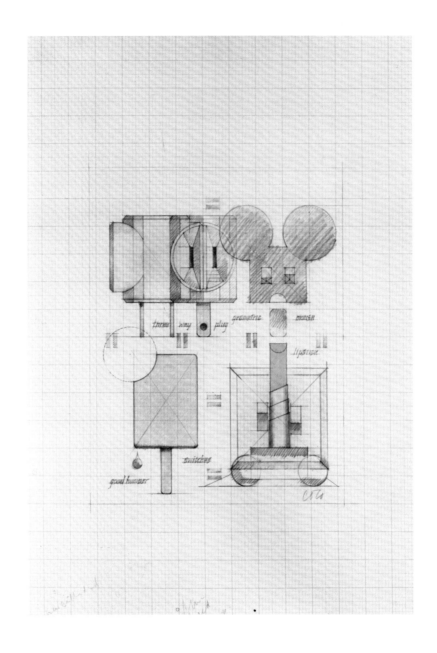

System of Iconography: Plug, Mouse, Good Humor
Bar, Switches and Lipstick—Version I, 1970
Pencil and crayon on paper
22 x 15 inches
Stedelijk Museum, Amsterdam

Annihilate/Illuminate:
Claes Oldenburg's Ray Gun
and *Mouse Museum*

BENJAMIN H. D. BUCHLOH

Oldenburg and Coosje van Bruggen
installing the *Mouse Museum* at the Whitney
Museum of American Art, New York, 1979

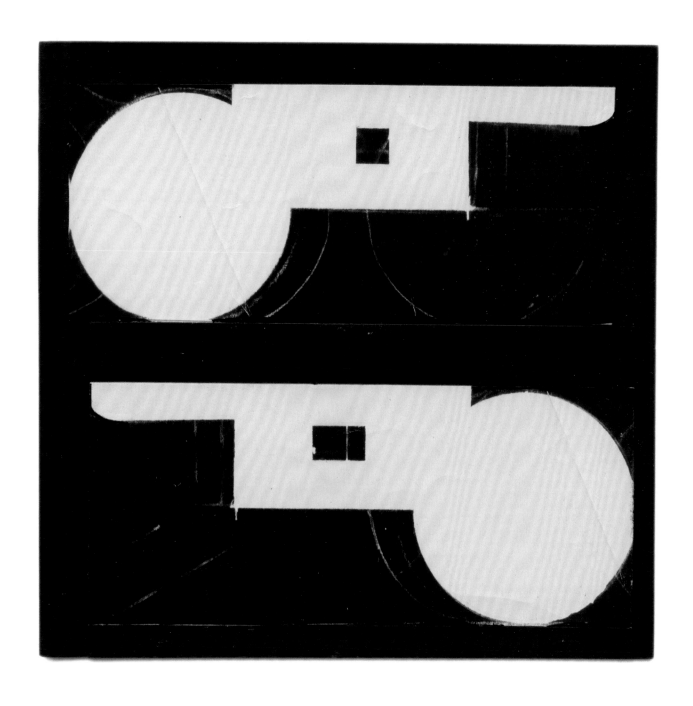

*Ray Guns Made by Dividing the Geometric
Mouse in Half*, 1969/79
Photostat on cardboard
8 x 7 ¾ inches
Claes Oldenburg and Coosje van Bruggen

216

Annihilate/Illuminate: Claes Oldenburg's Ray Gun and *Mouse Museum*

BENJAMIN H. D. BUCHLOH

For Rosalind Krauss, whose Passages *brought me to America*

My Dear Friend,
I send you a little work of which no one can say, without doing it an injustice that it has neither head nor tail, since on the contrary, everything in it is both head and tail, alternately and reciprocally. I beg you to consider how admirably convenient this combination is for all of us, for you, for me, and for the reader. We can cut wherever we please, I my dreaming, you your manuscript, the reader his reading. . . . Take away one vertebra and the two ends of this tortuous fantasy come together again without pain. Chop it into numerous pieces and you will see that each one gets along alone. In the hope that there is enough life in some of these segments to please and to amuse you, I take the liberty of dedicating the whole serpent to you.
—Charles Baudelaire, "To Arsène Houssaye," *La Presse*, August 26, 1862

RAY GUN AND RROSE SÉLAVY

There are very few instances in the twentieth century when an artist split the public self, seemingly doubling the subject's presence and the artist's impact and in that process revealing all the more the construction of author and subject. Marcel Duchamp's Rrose Sélavy is one such instance, and Claes Oldenburg's Ray Gun is another, perhaps not even plausibly comparable at first.[1]

Duchamp had initially invented his counterfigure and its pseudonym in an effort to bypass the fetters of traditional artistic identity. The shift to Sélavy signaled that Duchamp would be the first to recognize that socially guaranteed roles (like that of the artist as an exceptionally gifted and exquisitely talented genius and artisan) had reached the threshold of historical erasure.[2] The encroachment of industrial culture on artistic production pressed for a new public profile and social persona, and Duchamp's conception of his counterfigure was one of its early epiphanies. The name of his female alter ego, when enunciated in French phonemes, celebrated the desirable supremacy of Eros (at the very moment of its manifest destruction in collective public life). Similarly, Rrose called for a conception of the artist's subjectivity as androgynous in order to enact the emergence of a truly liberated post-Oedipal eroticism, while additionally adjusting to those historical processes that were shifting the subject's constitution from one of production to one of consumption. Venerable objects—such as abstract painting in 1912—that had performed entries into metaphysical dimensions, epistemological utopias, and aesthetic critiques were increasingly forced to compete with the impertinent

Marcel Duchamp, *Belle Haleine, Eau de Voilette*, 1921

banality of merely affirmative objects of consumption and the false alterities of fashion production. Rrose would pronounce this in her last readymade, *Belle Haleine, Eau de Voilette* (1921), a *détournement* of a found French perfume bottle here carrying Rrose's photographic portrait and a polymorphous perverse pun. Apparently, even the former privilege of an extreme singularity of artistic sublimation would have to be inextricably bound up with, if not mutually dependent on, the industrial schemes of systematic desublimation.

FRAMING FRAGMENTS: *STRANGE EGGS*

Photomontage was indeed also one of Oldenburg's points of departure, even before the artist called up Ray Gun, his own imaginary ally and counterfigure. In a series of eighteen collages, assembled in 1957–58 for a planned publication titled *Strange Eggs*, these images situate Oldenburg's early work at the center of that most intense debate of the twentieth century, the dialectics of modernism and mass culture. In the light of the newly emerging conditions of enforced consumption, unimagined and unimaged, this debate flared up again in the mid-1950s, making the Dada legacies newly plausible and triggering a subterranean flux that was increasingly critical of New York School painting.[3]

Given the perpetual flooding of everyday life with the mass-culturally produced objects of consumption, artists increasingly realized that the flood of automatist writing and painting, and its aspirations for the subject's emancipation from reification through the regression to prelinguistic processes, were neither credible nor possible any longer. By contrast, what seemed to be needed was a new type of automatism, making simulacral reification its standard and its point of departure. Rather than assuming that a psychobiologically and sociosexually driven political eroticism could detach the subject from its reified forms of experience and dissolve its libidinal investments in the mass-cultural fetishization of everyday life, the gestures of subversion now had to originate in the reified constellations themselves, the very fusions in which perception, cognition, desire, and representation were submerged by the constructions of false consciousness and artificially produced libidinal fixations.

In simultaneous strategies of mimetic adaptation and annihilation, Oldenburg's early collages for *Strange Eggs* reenact this fusion in a form of countersuture that traces the subject as it is forced to cathect onto the photographic representation of the commodity. Since neither object nor subject remains legible in Oldenburg's montage images, the reader-spectator consciously rehearses the processes of object cathexis that the consumer performs unconsciously when false needs and desires are instrumentally activated.

Oldenburg's montage operations in *Strange Eggs* are performed in two steps, and they differ dramatically from the classic principles of photomontage, whose primary modus operandi is to juxtapose abruptly heteronomous iconic representations of figures or objects. By contrast, the montage process here is twofold: the first step disfigures a photographic image into illegibility by literally cutting it from its referent, thus dissolving both its iconic origins and its mimetic intentions and annihilating the very ground of the photograph's denotational instrumentalization of seeing. As these photographic fragments emphatically circumscribe new absurd units, the cut of the image itself mimics the singularization that leads to the fetish object in its psychic enactment.

Then, in a second montage phase, the initial fragment is fused with one or more equally particularized and mostly illegible fragments. As the multiple fragments form an undecipherable new unit, they hover between a biomorphic and a mechanomorphic universe, a zone of animate and inanimate specters in full interaction.[4] The photographic advertising image is driven by the total instrumentalization of vision, in which every feature of the icon—its plasticity, its chiaroscuro, its depth and spatial illusion—serves to solicit the referent, to suture the subject and fetishize the object in the act of viewing. Oldenburg's fusions of fragments generate the opposite effect in their manifest reversal of the principles of specular signification. A somewhat enigmatic statement formulated by Oldenburg two years later, when he described the principles of production for *The Store*, becomes more lucid when read against the background of his earlier development of a collage/montage aesthetic in *Strange Eggs* (as much as some of the principles of manufacturing the reliefs of *The Store* become transparent): "There is present an amount of invisible material. The concretions are selective, the ellipses highly condensed, spatially and temporally. The edges which are the edges of perception, do not necessarily correspond to the object. Scale is

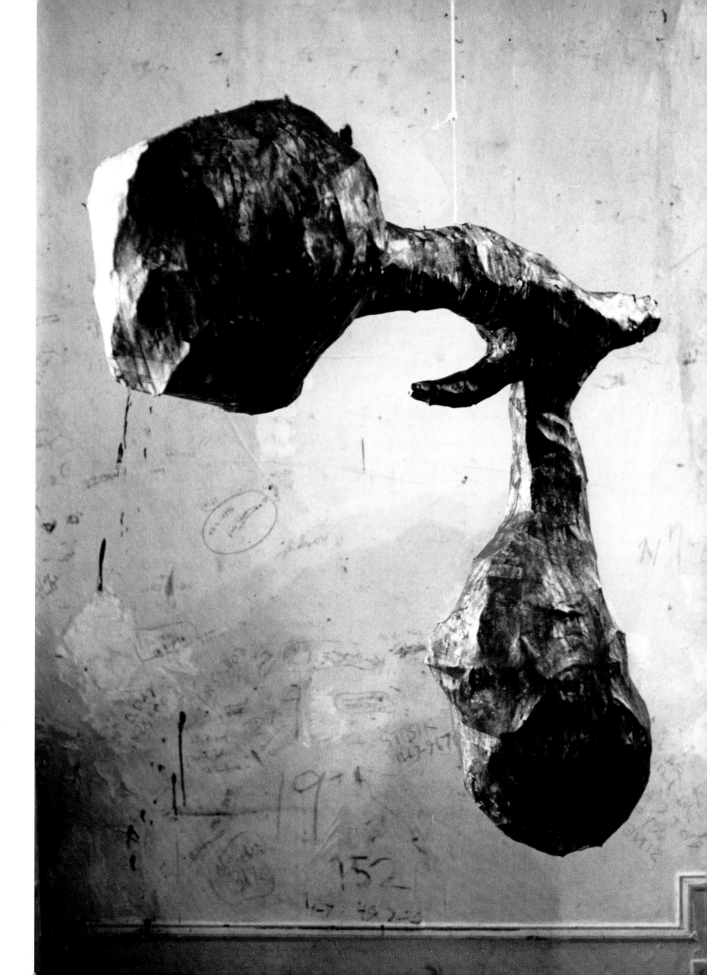

"Empire" ("Papa") Ray Gun, 1959
Newspaper soaked in wheat
paste over wire frame,
painted with casein
35 ⅞ x 44 ⅞ x 14 ⅝ inches
The Museum of Modern Art,
New York. Gift of the artist, 1969

Page 227:

Graffiti and posters by Claes
Oldenburg near the Judson
Gallery during the installation of
The Street, 1960

Model with Jackson Pollock's
Lavender Mist (1950),
photographed by Cecil Beaton
for *Vogue*, March 1951

performances of a liberated libidinal unconscious could remain credible at the very moment when the register of the unconscious itself had become the newly discovered territory for deeper invasions by commodity culture. Third, and—equally provocative for Oldenburg—what automatist painting could achieve when Pollock's gesture of libidinal resistance and liberation itself was about to be absorbed within the myth-churning apparatus of the culture industry, drifting involuntarily into the realm of its own spectacularization (after all, Cecil Beaton's photographs of models posing in front of *Lavender Mist* [1950] had already been published in *Vogue* in 1951).

Again, Oldenburg himself has signaled the key terms of how he approached the conflicted venerations and demands of that moment: "Lately I have begun to understand action painting, that old thing, in a new, vital and peculiar sense— as corny as the scratches on a NY wall and by parodying its corn I have (miracle) come back to its authenticity! I feel as if Pollock is sitting on my shoulder, or rather crouching in my pants."[16] The terms here seem to be, first of all, the observation that that "old thing," called action painting, had become "corny" by 1957. Second, that its corniness appeared comparable to the graffiti on a New York wall. Third, that only parody could restitute a sense of authenticity to the gestural and libidinal maneuvers of Abstract Expressionism. And last, in a renewed reference to Pollock, that a reversal of hierarchical orders would have to occur, one from the head, as the site of the subject's vision, to the guts and genitals to re-"embody" painting with the same radicality that Pollock himself had once performed. After Pollock's belated automatism had become acculturated, the question was how to retrieve the materiality and corporeality of his painting, its epistemological and social *bassesse* as a form of resistance against the control and coordination of vision in an increasingly aggressive culture of advertisement and spectacle.[17]

Almost all authors, since Barbara Rose's foundational monograph written for Oldenburg's first major retrospective at the Museum of Modern Art in New York in 1969, have argued for a peculiarly inexplicable sequence of dialogic relations that led Oldenburg's early works from Pollock to Jean Dubuffet, but

these contentions fail to recognize that it is neither in a gesture of mimetic assimilation nor in a developmental sequence but instead in a complex simultaneity of negative citations and devices of distantiation from Duchamp, Pollock, and Dubuffet that Oldenburg situated the beginnings of his work in 1957.[18]

READING GRAFFITI

Pollock's intense enactment of the post-Surrealist automatist grapheme had—perhaps involuntarily—induced an association between the libidinal liberation of the subject's unconscious and the speed of pictorial execution, signaling the imminent spectacularization of these gestures themselves.[19] Thus Oldenburg, in response to this performance of accelerated painterly execution, which ultimately constituted both the subject's enactment of and its subjection to spectacle, had to search for a painterly counterforce, which would sustain the *retardataire* and the recalcitrant. Dubuffet's conception of the unassimilable Art Brut offered him this spectrum of obstinacy, different citations of deviance and disability. The stunted and stuttering articulations of the graffito, suspended halfway between pure grapheme and caricature, between compulsive figure and pure gesture, must have appeared to Oldenburg more credible and authentic than automatism's manifestly failed liberations.

What Oldenburg's resuscitation of the graffito further recognized was the fact that a subject's projected libidinal force fields were always already implicated within the linguistic and enunciatory constraints of the symbolic order. Rather than claiming the pure rebellion of action painting, the graffito literally signaled for Oldenburg a matrix in which the social, the linguistic, the spatial, and the psychic restrictions were condensed, as they were imposed on the subject in the process of articulation. Oldenburg described his citational approach to graffiti in a text in 1968 in the following terms: "I turned my vision down, the paper became a metaphor for the pavement, its walls (gutters and fences). I drew the materials found on the street—including the human. A person on the street is more of the street than he is a human. The drawing at that time takes on an 'ugliness' which is a mimicry of the scrawls and patterns of the street graffiti. It celebrates irrationality, disconnection, violence and stunted expression—the damaged life forces of the city street."[20]

In other words, the authenticity so desperately sought after in "that old thing" called action painting could be found in

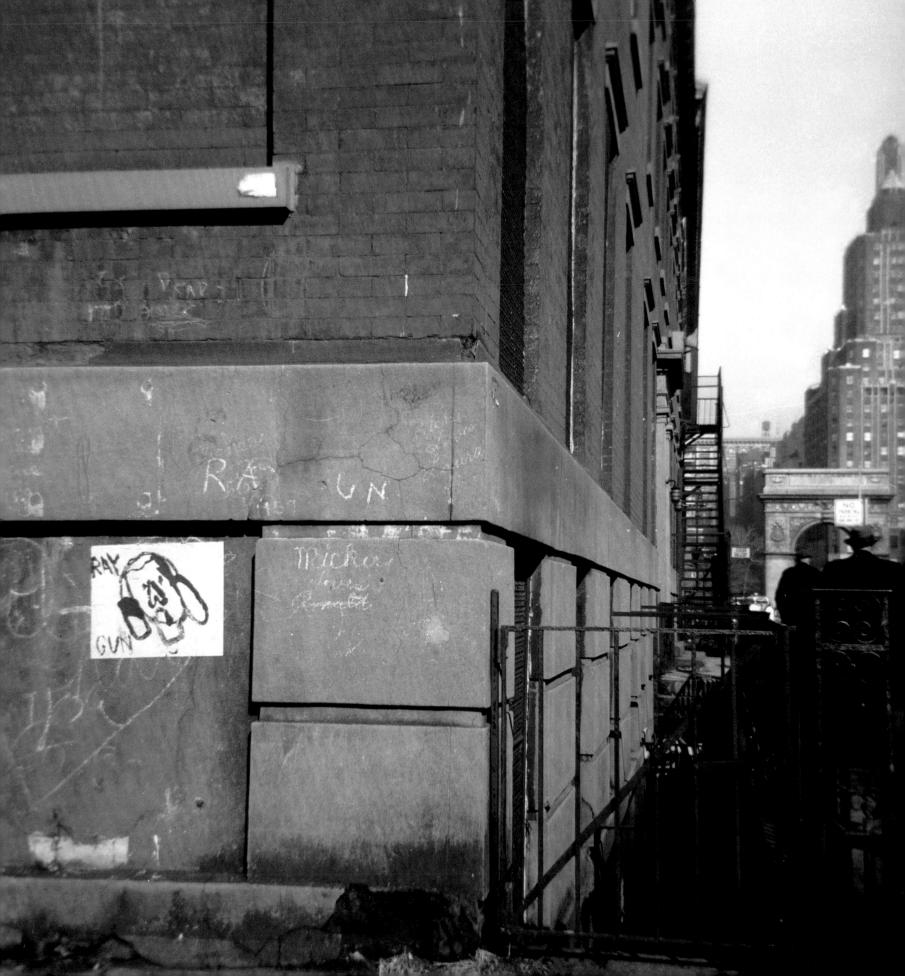

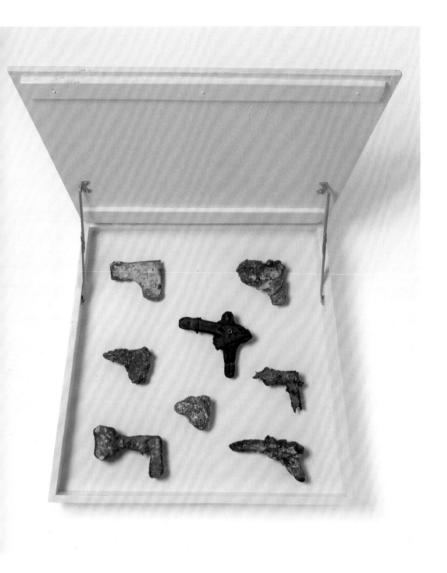

Street Ray Guns, 1959
Eight objects in plaster, glue, and leather,
painted with enamel and casein in wood box
Private collection

Ray Gun Advertisement for the Village Voice, 1959
Watercolor
8 ⅞ x 10 ⅞ inches
Claes Oldenburg and Coosje van Bruggen

Ray Gun Poster, 1959
Monotype with ink
17 ⅝ x 14 ¾ inches
Kunstmuseum Basel, Kupferstichkabinett

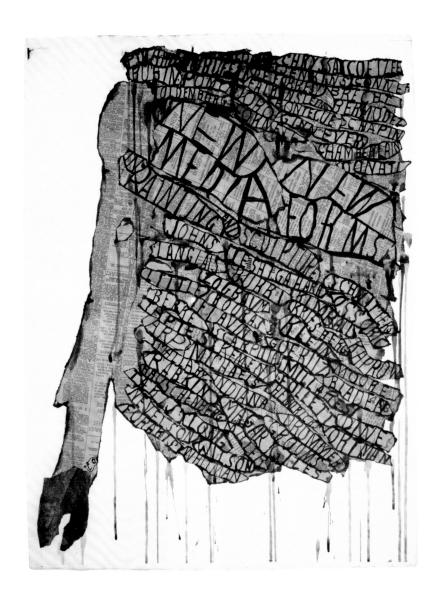

Poster Study "New Media—New Forms I,"
Martha Jackson Gallery, 1960
Newsprint, ink, and watercolor on paper
24 x 18 ½ inches
Private collection

Exhibition poster *New Media—New Forms*
in Painting and Sculpture, 1960
Offset lithograph
22 ⅝ x 17 ¾ inches

Street Chick—Too Tired to Love, 1960
Ink and newspaper on paper
13 ⅞ x 10 inches
Musée National d'Art Moderne—Centre Georges Pompidou, Paris

Street Chicks with Theater Sign, 1961
Ink, watercolor, and newspaper on paper
13 ½ x 10 inches
The Menil Collection, Houston. Gift of Claes Oldenburg and
Coosje van Bruggen, 2009

Opposite:

Original announcement for one-man show,
Reuben Gallery, 1960
Ink, watercolor, and newspaper on paper
13 ½ x 10 inches
Claes Oldenburg and Coosje van Bruggen

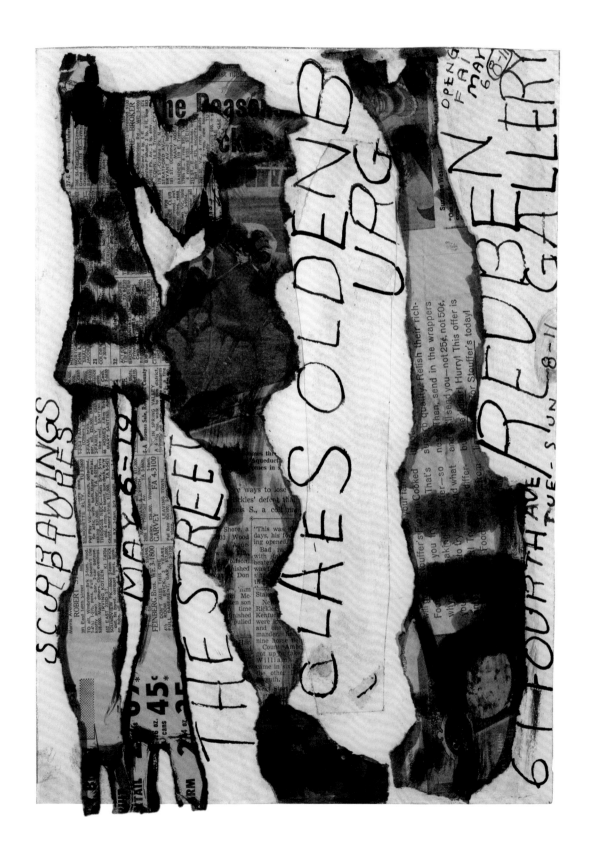

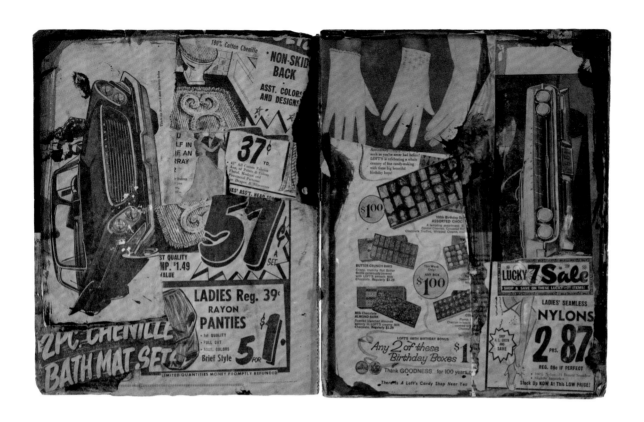

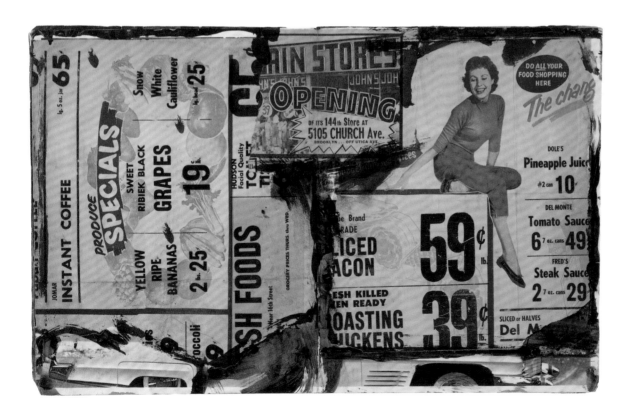

Pages from *Source Book: Newspaper Advertisements and Images Pasted in a Composition Notebook*, 1960–61
Ballpoint pen, crayon, enamel, pencil, plaster, watercolor, newspaper clippings, and collage
12 sheets, 24 pages including front cover (back cover discarded); approximately 10 ⅛ x 7 ½ inches, each
Claes Oldenburg and Coosje van Bruggen

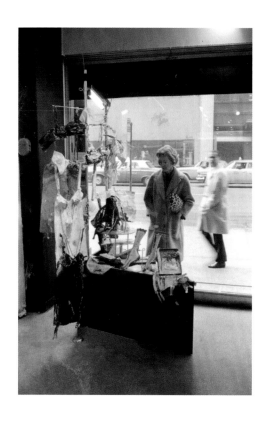

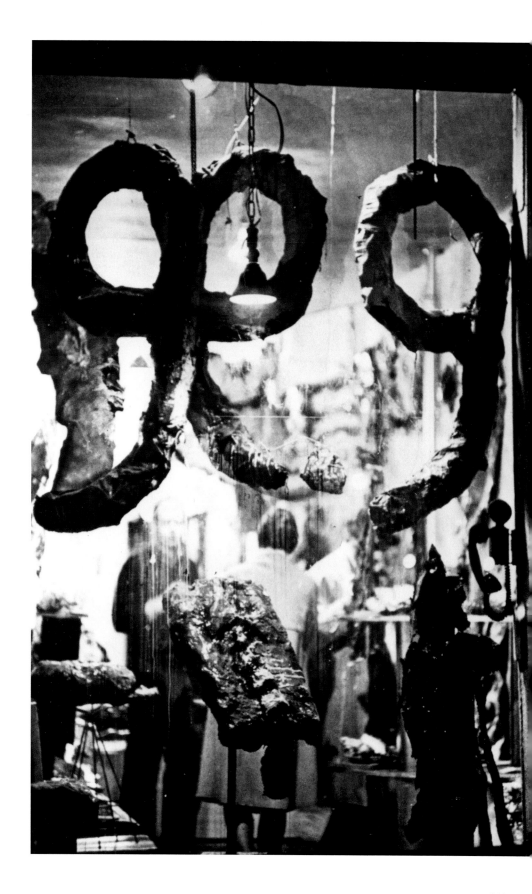

Lingerie Counter (1962) exhibited in "New Realists" exhibition at Fifty-Seventh Street, New York, 1962

View into *The Store* at 107 East Second Street, New York, 1961

Oldenburg shaving in his
bathroom at the Fourteenth
Street studio, New York, 1967

Pages 244–45:

Oldenburg in *The Store* at
107 East Second Street,
New York, 1961

bathroom here a sculptural thing by placing all the fixtures out from the wall so that they can stand free like sculptures, but I dont know how that's going to work when you take a bath. The bathtub is practically in the middle of the room. We've got a long six footer. And if I had more time and money I would try more of this in the home—try to make the home more functionless and more a thing in itself." Oldenburg suddenly sounds as though he had become a truly Duchampian artist or had been one all along. At first reading, the statement pretends that aesthetic production has taken its inevitable course merely qua artistic fiat ("the nominative act") and by shifting contexts in the transference of the object from the hardware store to the museum. And yet on second reading, Oldenburg's subtle destabilizing ambiguity again evolves, pitting a claim for an object's use value ("how that's going to work when you take a bath") against the absurdity of a purely aesthetic experience ("to make the home more functionless and more a thing in itself").

Oldenburg's actual production, in the transition from *The Street* to *The Store*, profiles these contradictions and their suspension as their foundational structure: neither their genre (readymade or painted sculpture) nor their category (painting or sculpture, relief or object), neither their processes of production nor their iconography, will be easily established, and Oldenburg scrambled the sculptural codes at that time more than anyone since Vladimir Tatlin (and, of course, Duchamp).[44] After all, what is the actual status of paint, gesture, and facture in the *Store* objects? They are suspended between a highly self-conscious, postautomatist factitious application and a mere matter-of-fact deposit of factory-made enamel lacquer (one could say, remembering Pollock and foretelling Donald Judd). And what is the actual status of the sculptural production process (with its antiaesthetic origins in the children's art class and its position between modeling and casting) and its resulting objects? And how else if not through this dialectic would we explain why the representation of the human figure, still prominent in *The Street*, disappeared forever from Oldenburg's iconography with the onset of the readymade emporium of *The Store*, whose only "figure," appropriately, is itself a manufactured object, a mannequin.

In his conversation with David Sylvester, conducted in 1965, the same year as the interview cited above, it is evident not only that critics at the time could not properly identify the genre and categories of Oldenburg's works but also that the

artist actually engaged actively in destabilizing all these orders. More important, perhaps, we realize that it was Oldenburg whose devotion to linking the experience of the process of production with the subject's bodily perception initiated a phenomenological conception of sculptural experience:

> CO: At the same time, the plaster surface created a certain amount of subjectivity because the paintings weren't flat, they were irregular, and, depending on where you stood in relation to the paintings, that resulted in valleys and you knew there would be difficulties for the eye which you don't find in the average sign board.
> DS: These were paintings not sculptures?
> CO: Well, I consider them paintings. I mean, the vision I had was of colour and space, that is to say, three-dimensional colour.[45]

THE DIALECTICS OF DISTRIBUTION

What needs to be explored . . . is how unreproducibility and reproducibility intersect with each other, transforming the conditions of autonomy in art as a consequence. For if autonomy cannot be secured solely through unreproducible forms of artefactuality the struggle for autonomy is not excludable from reproducible forms. . . . The hand moves not in response to sensuous representation of an external (or internal) object, but in response to the execution and elaboration of a conceptual schema, in the way a designer, architect or engineer might solve a set of intellectual or formal problems. The hand and the eye become linked through the selection, arrangement, superimposition and juxtaposition of materials, enforcing a shift in art's technical base from covering and moulding to the organization and manipulation of preexistent objects.

> —John Roberts, *The Intangibilities of Form: Skill and Deskilling in Art after the Readymade*, 2007

The artist disappears. No one knows where he went. He leaves his signs here and there. He is seen in this part of town and the next moment—miraculously—on the other side of town. One senses him rather than sees him—a lounger, a drunkard, a tennis player, a bicycle rider—always violently denying that he did it. Everyone gives a different description of the criminal.

> —Claes Oldenburg, "Guises of RG," 1961

Oldenburg, having confronted the crisis so well theorized by John Roberts—namely the disintegration of traditional artistic

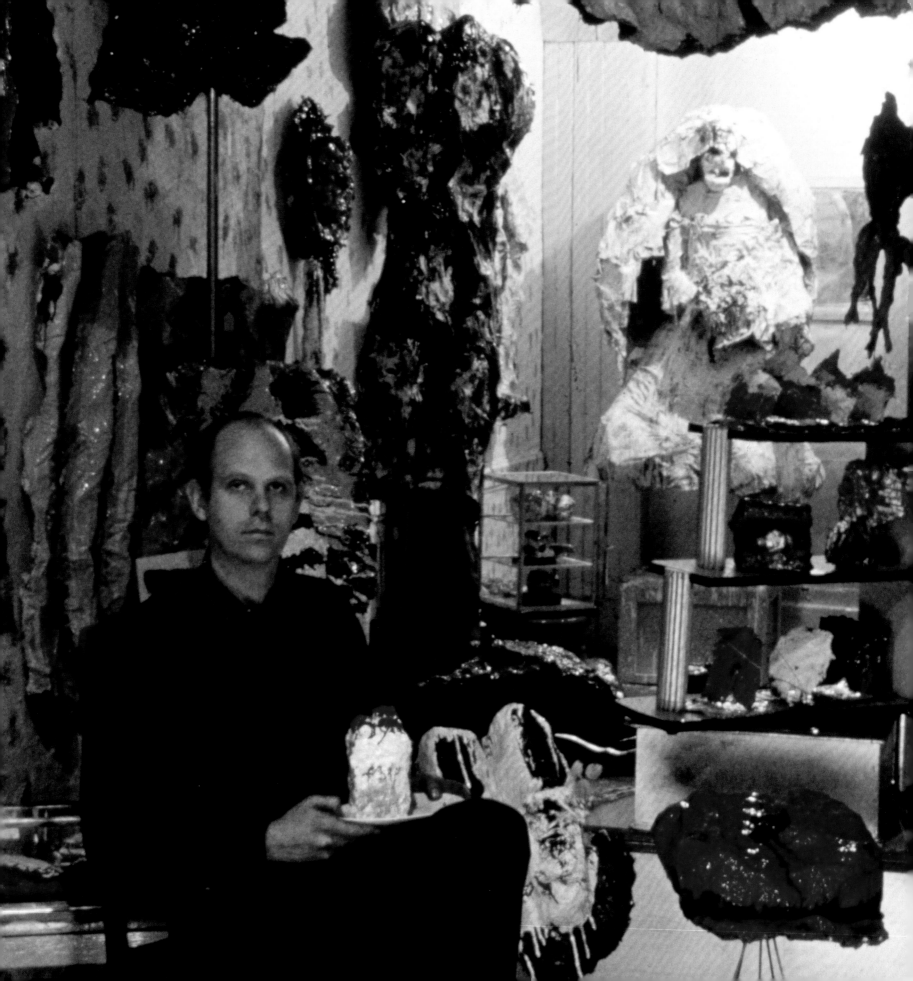

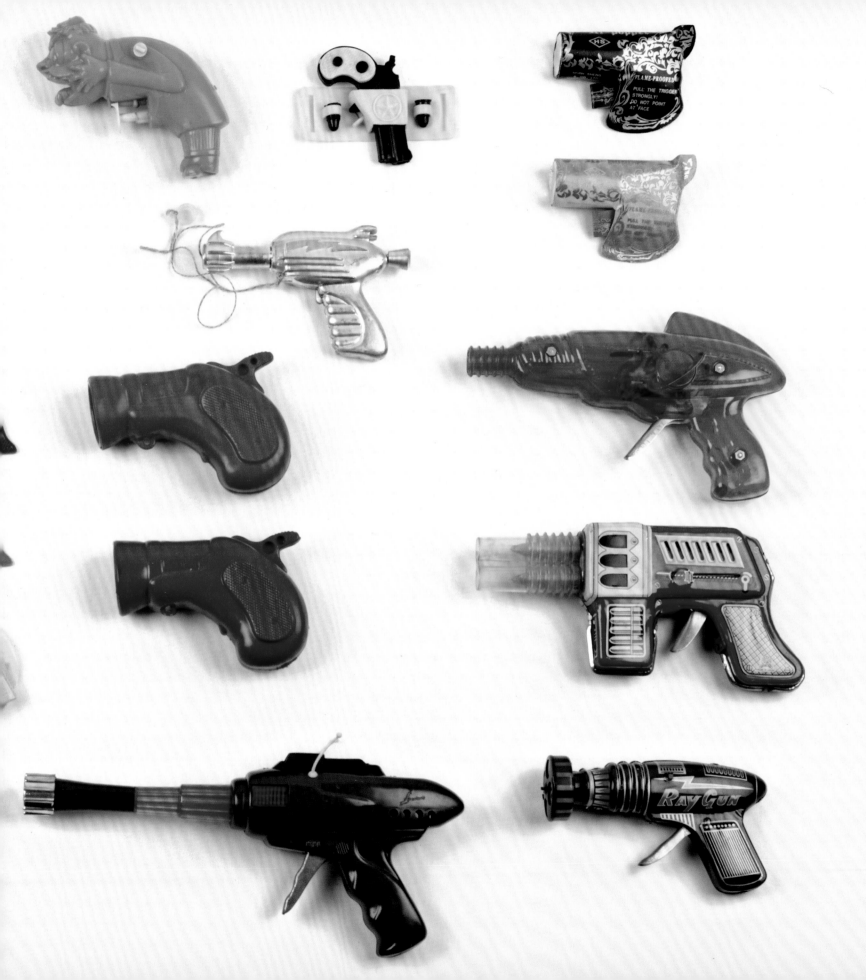

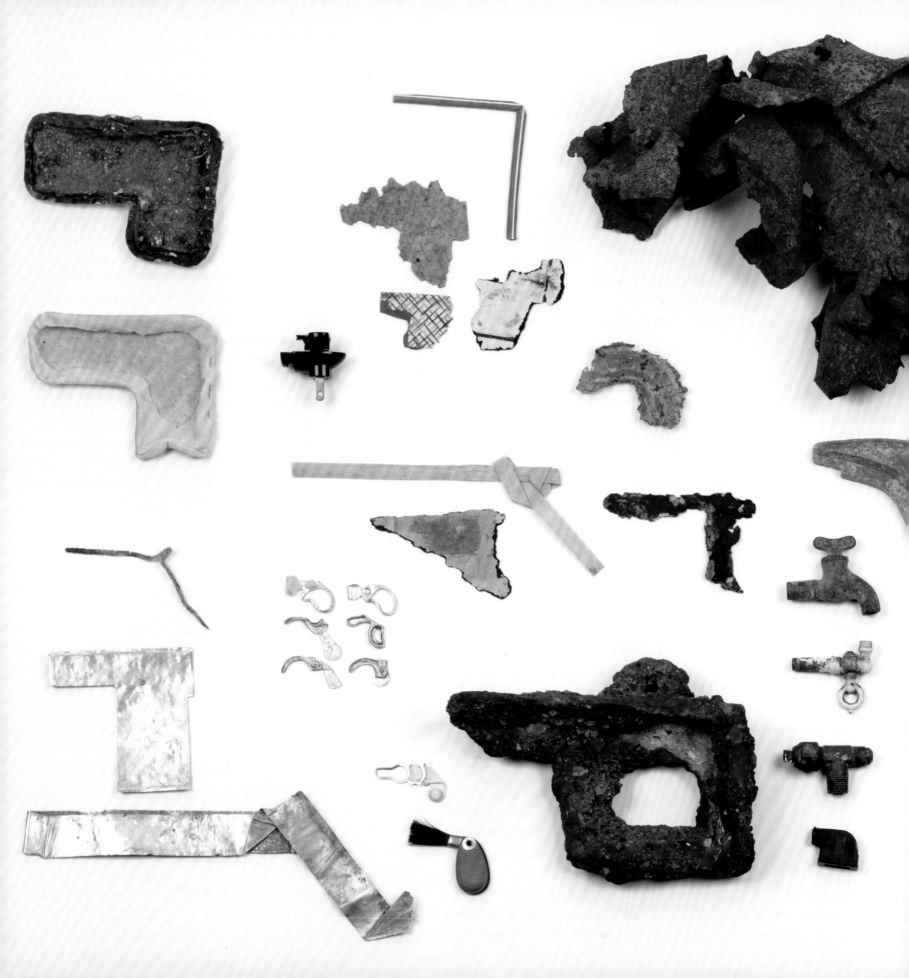

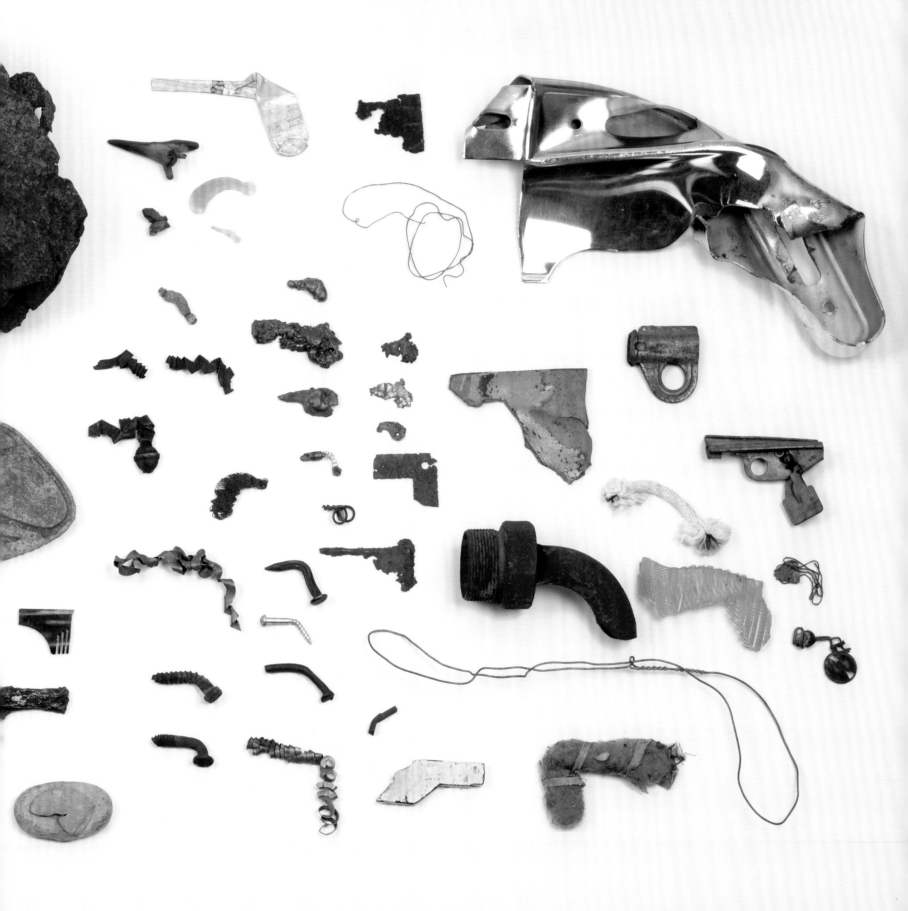

the Fluxus artists had been precisely that neither the readymade nor the cult of the *objet trouvé* could have purchase anymore under the conditions of an advanced consumer culture delivering wave after wave of obsolete objects. Yet for the Fluxus artists, as for their Situationist confreres in Paris, it was mandatory that the subject find ways and means to position itself within these controlled spaces and object regimes and to articulate its voices, to demarcate the places and practices of resistance.

Throughout the Ray Gun text, this subversion is invoked almost in the manner of a Situationist *dérive*: the pursuit of Ray Guns is defined as a game in public space in which one or more players can engage at the same time: "One ambles along on the alert for one thing only. It may take any form, any scale. . . . The game can be played alone or with two or more persons. The two may be considered equally qualified, or one may be considered the authority and the other the novice."[50] Oldenburg seems to suspend subjectivity between aleatory choices and chance encounters, on the one hand, and elusive criteria of selection, on the other. The Ray Gun's magic results from this oscillation: drifting, the subject will discover the voided object and will declare the Ray Gun in ludic opposition to the universal instrumentalization of object experience under the commodity regime: "Collecting Ray Guns can be practiced anywhere, on a beach for example, but New York is the most interesting place because of the extraordinary quantity and variety of trash in the streets and its movements. Every sidewalk is a Ray Gun Beach."

And Oldenburg's grotesque, comical descriptions of the details and differences of Ray Gun production confirm this: halfway between an animistic projection onto the world of everyday refuse and a magic redemption of objects destined for perdition, Oldenburg describes in great detail (sublime in its irony of the myths of Surrealist automatism) the shifting moods of the collecting subject and the conditions of objective chance that allow a Ray Gun to be retrieved and rescued: "I have noticed that some days there seem to be no Ray Guns on the streets and some days there seem to be too many. Some days one is embarrassed to be seen at the activity, other days proud. Some days one can pick them up easily, on other days one's decision is paralyzed. Some days a Ray Gun not picked up haunts the mind and on other days a Ray Gun passed up and still in the streets makes no difference at all."[51]

Paradoxically—and in manifest distinction to otherwise comparable attitudes in Fluxus—Oldenburg defines the Ray

Gun as a dialectical object resulting from a chance encounter with an anonymously formed object, voided of subjective intentionality, yet chosen by numinous yet hierarchical criteria of a (mock?) selection that after all had founded the culture and the authority of the museum institution.[52]

MUSEUM OF POPULAR ART, N.Y.C.

In 1965 when I moved into a new loft at 14th St in New York I collected all the residue from happenings and the many objects which had accumulated as a result from gifts and purchases into a shelf which I had found on the premises. The shelf had an architectural appearance, like a building, perhaps a department store. . . . One day I lettered on the top of it: "museum of popular art, n.y.c."
—Claes Oldenburg, "Notes," n.d.

I soon imagined a museum of popular material, perhaps encouraged by David Hayes' suggestion of buying a Woolworth store, closing it for twenty five years and reopening it as a museum.
—Claes Oldenburg, "Notes," n.d.

It seems that with the foundation of the "museum of popular art, n.y.c." in 1965 Oldenburg moved from the dialectics of the museum and the hardware store to that of the department store. Or, rather, the artist appears to have recognized that these discursive and institutional dimensions had superseded the old dreams of resuscitating objects of use value. While it was with the elimination of artisanal craft and artistic skills that the crisis of artistic identity had been brought about, the resulting crisis of judgment would inevitably take an equal if not higher toll on the museum, the very institution whose orders had been founded on hierarchical criteria of distinction.

With the arrival of the readymade as the central episteme of artistic production, the dissemination of genres, categories, and typologies, as much as the assignment of value, would now have to be fundamentally reconsidered. Given the new laws of a universal equivalence of all objects (handmade, machine made, hybrids of both, or antagonistic to either), equal attention and adequate evaluation must be given to all, bringing the museum structurally much closer to the order of the department store, in which all object types coexist in the universal equivalence of pure exchange value.

Oldenburg adopted this new law of equivalence for his museum, since he gave the found, the altered, and the artistically

Shelf with objects at Oldenburg's Fourteenth
Street studio, New York, 1967

Installation of objects at Oldenburg's Fourteenth
Street studio, New York, 1968

Pages 254–55:

Installation view of the *Mouse Museum* at the
Kröller-Müller Museum, Otterlo, 1979

made equal value and pride of place in the order of its display.[53] Thus he destabilized first of all the hierarchy of quality and significance in the order of production (that is, by collapsing the distinction between the sketch and the finished work or by effacing the contrast between the stroke of the master draftsman conceiving sculptures and the stutter of the minor dabbler designing tchotchkes). Manifesting an additional institutional affinity, perhaps even more subversive than the department store, and one already invoked by artists in the 1920s, the museum now functioned as an archive of documents, a space of specimens, and not as a hieratic site of cultic veneration of singular auratic objects.

The second level of destabilization occurs in the register of artistic agency and social participation: after all, an artist's collection of anonymously and industrially produced trinkets, endowed with the status of the museum object, renders collective desire in a manner rather different from Dubuffet's museum of Art Brut, which was explicitly acknowledged by Oldenburg as one of the models he had in mind when founding the "museum of popular art, n.y.c." Dubuffet's carefully selected samples of individual "brutishness" had still been crafted by individual subjects, by involuntary artisans distinguished by their lack or refusal of traditional artistic competence. That Oldenburg actually claimed that his museum was housing "popular" art is all the more surprising since the majority of objects were actually the opposite of the "popular"—anonymously and industrially produced disfigurations of collective desire that challenged any museum's precisely outlined boundaries of judgment and taste.

We should not assume that his usage of the word *popular* was simply a misnomer for "mass culture" (as we generally identify those industrial formations that had displaced the last forms of popular art in the nineteenth century). Rather, Oldenburg's insistence on the dimension of the popular bespeaks his deep commitment to an egalitarian principle of universally different and specifically valid nonhierarchical forms of desire. Unlike an authoritarian modernist, he recognizes a residual potential for the alienated subject's self-determination even in seemingly debased and desublimated forms of articulation. And Oldenburg again constructs the most provocative dialectical oppositions when he moves on to explain how the *Mouse Museum*, in which all these questions and dialectical oppositions will culminate, originated in the "museum of popular art, n.y.c."

As cited above, he states, on the one hand, that it was indeed the department store, the epicenter of the subject's

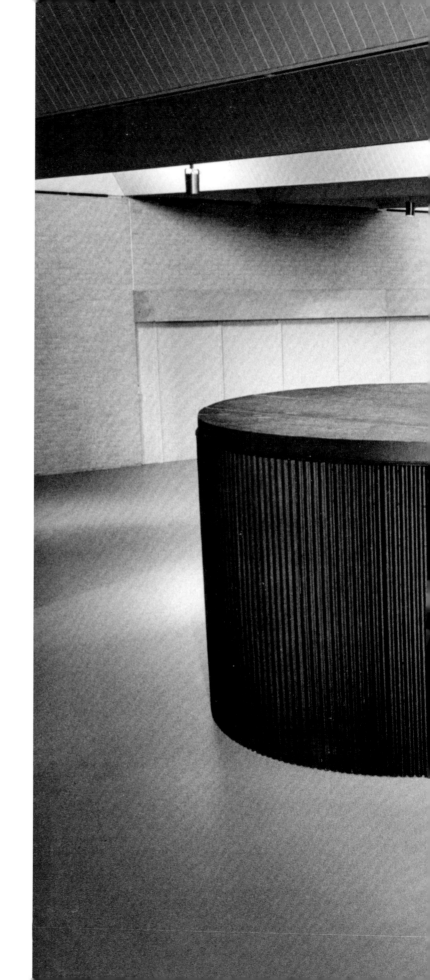

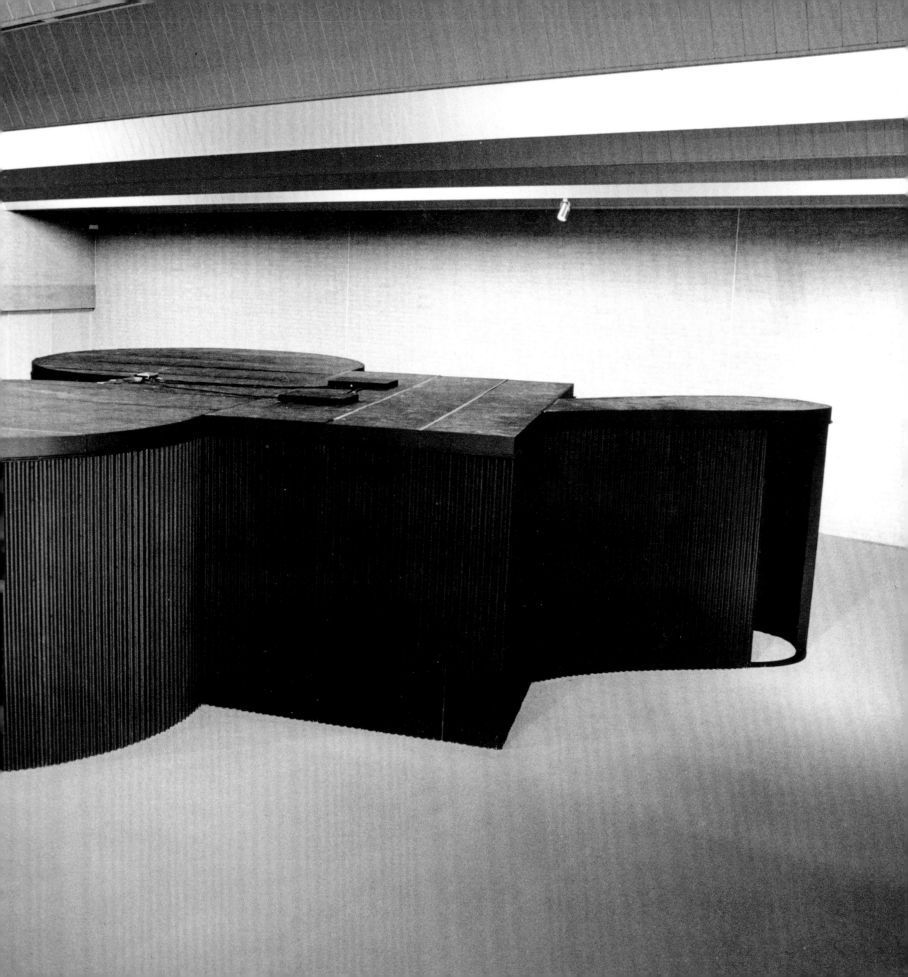

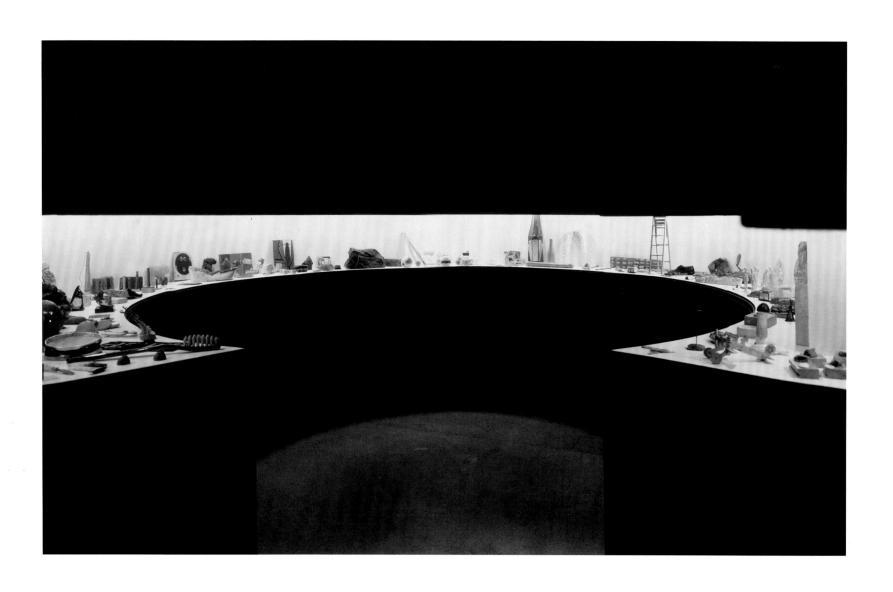

Interior of the *Mouse Museum*, 1965–77
Wood, corrugated aluminum, and Plexiglas display cases with 385 objects
8 feet 7 inches x 31 feet 2 inches x 3 feet 3 inches
Museum moderner Kunst Stiftung Ludwig Wien, on loan from
the Austrian Ludwig Foundation, since 1981

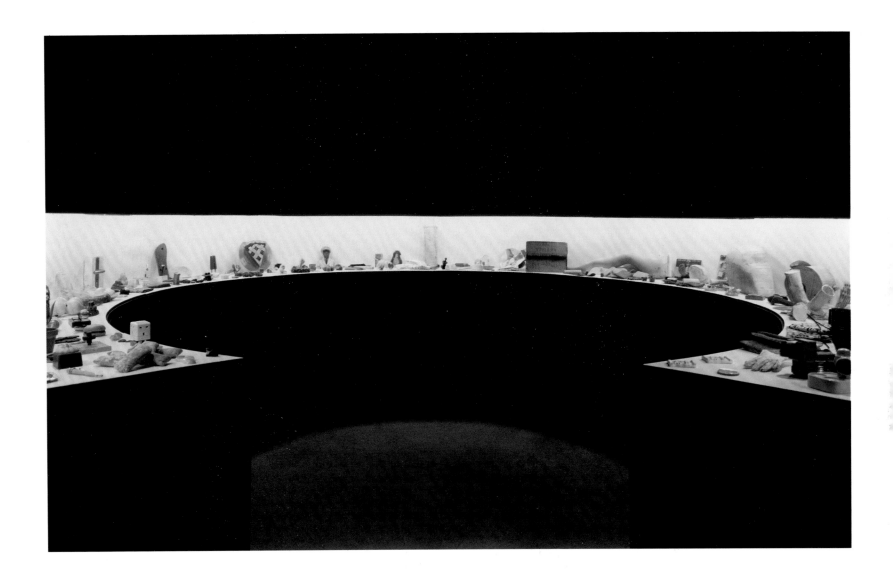

Pages 258–61:

Objects from the *Mouse Museum* arranged and
photographed by Balthasar Burkhard, ca. 1977

Page 262:

Moveyhouse, performance at the Forty-First Street
Theatre, New York, December 1–3 and 16–17, 1965

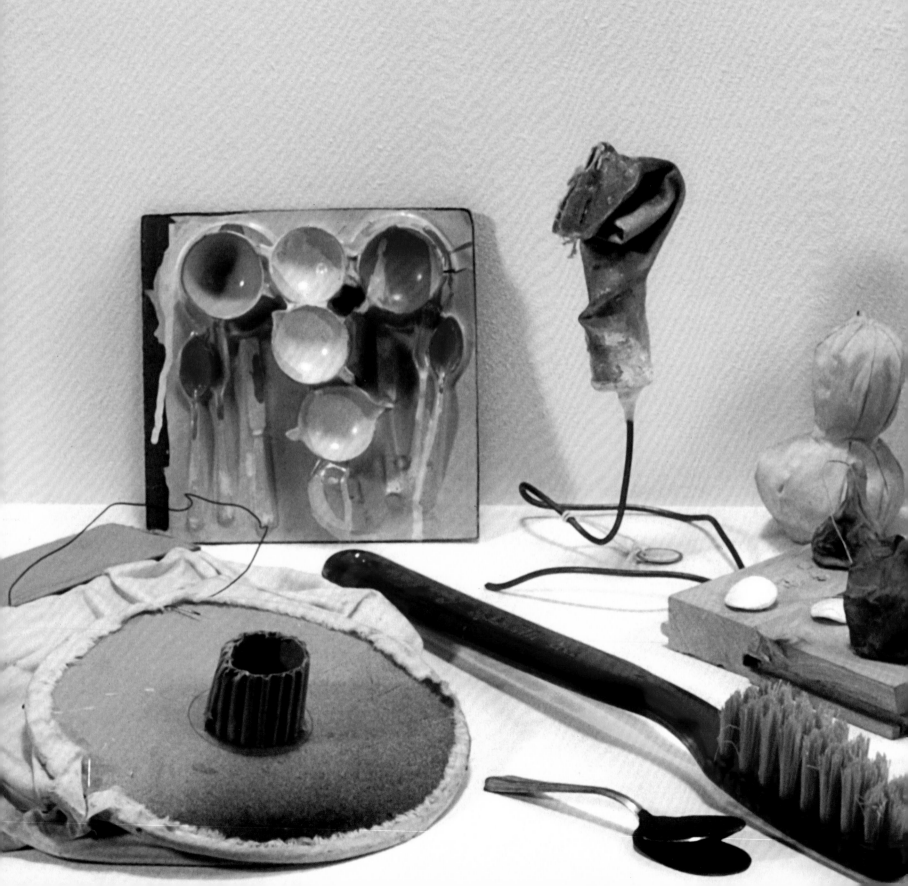

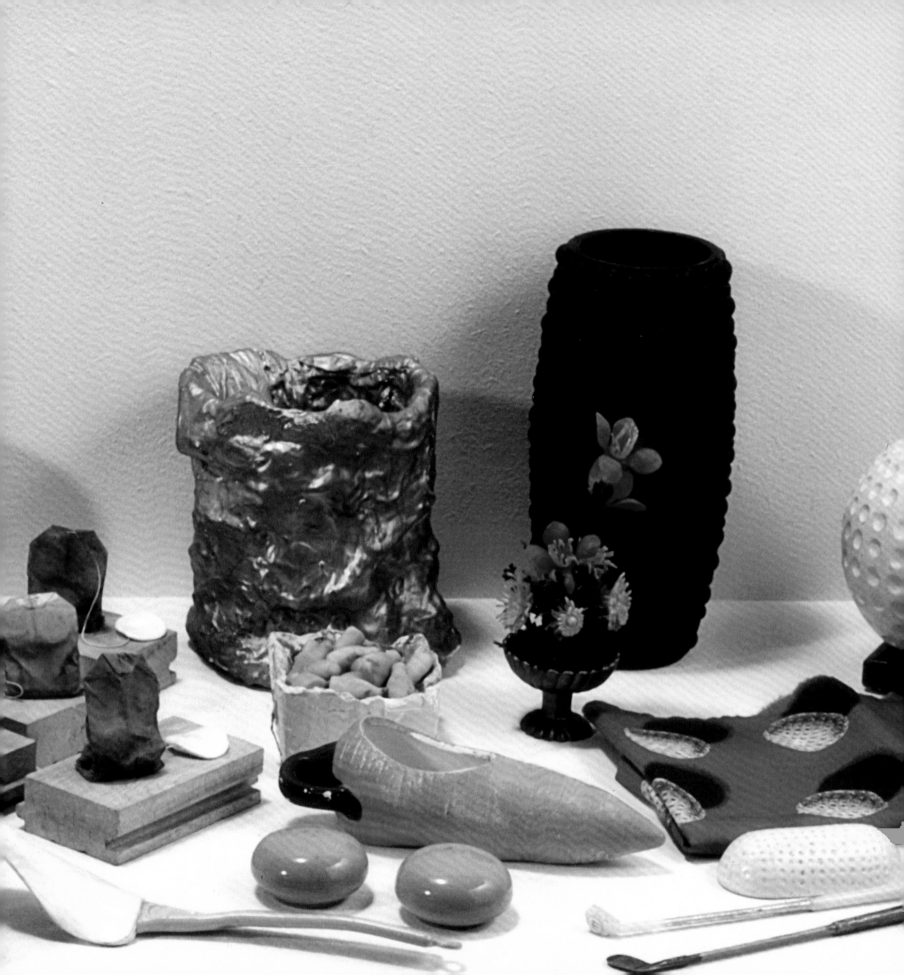

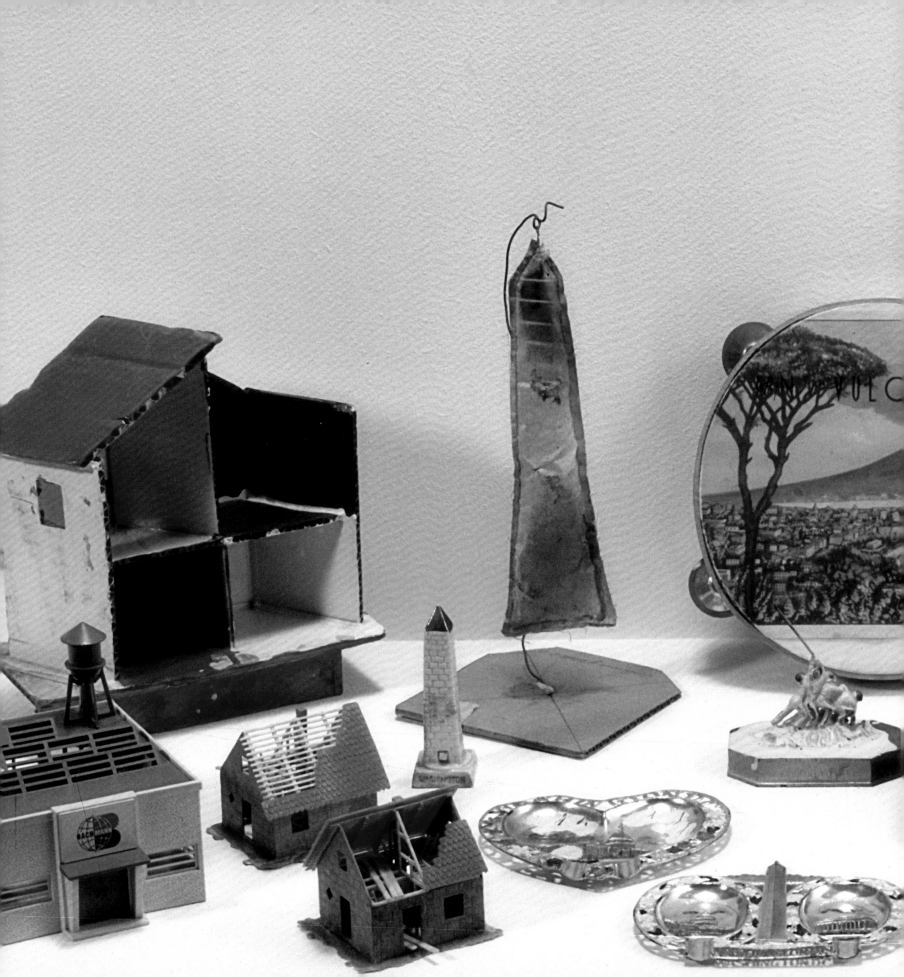

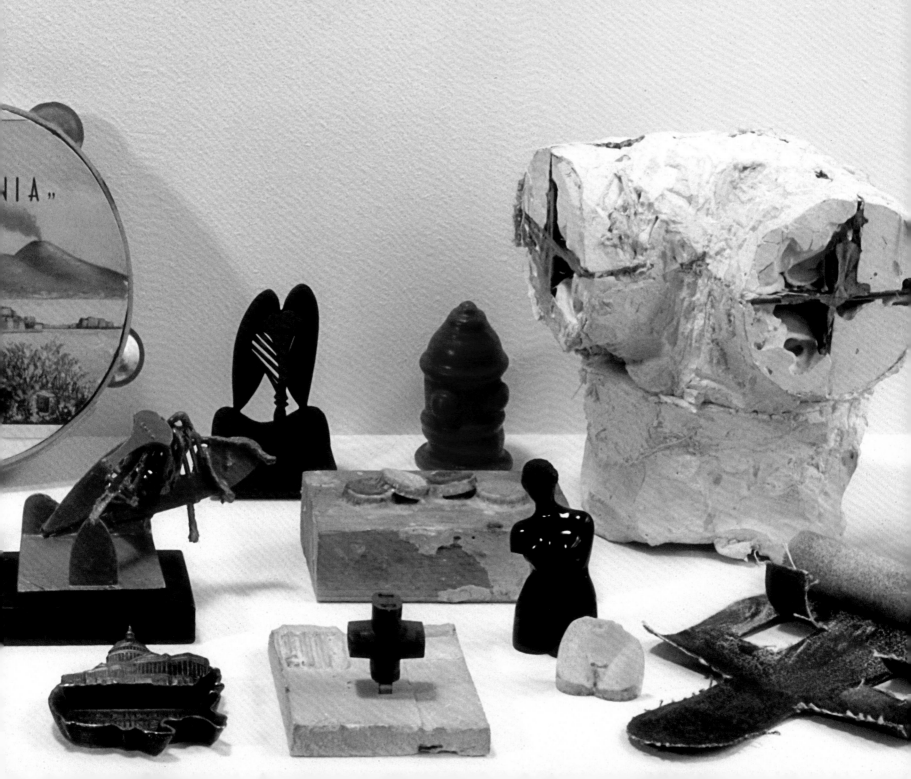

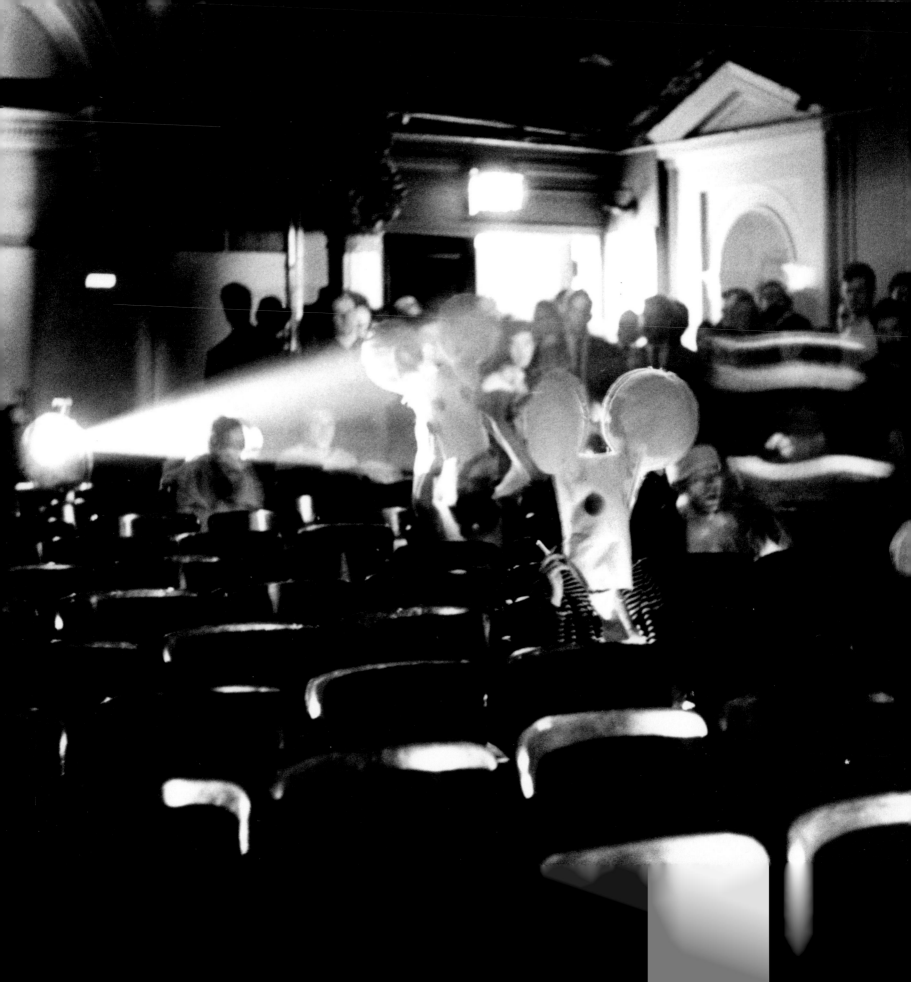

alienation and reification, that had served as the institutional matrix of his museum project. On the other hand, the artist suggests in the same text that the project attempted to recuperate the experience of children and their collection of toys, thus juxtaposing an image of the subject's extreme forms of alienation with the quintessence of an imaginary or actual developmental phase of subjectivity in which identity and subject-object relations are still presumed to operate in a state of prelapsarian bliss: "It may be compared to a child's collection of toys because a child chooses what he finds useful to him, and builds up a model of the 'outside' and larger world. . . . The result is a microcosm of my own art production and a view of the society that surrounds me."[54]

Oldenburg's contemplation of the contradictory structures of his collection, suspended as it is between an abject and alienated collectivity and an idealized infantile subjectivity, strikingly resembles the exquisite description of the collector by Walter Benjamin in his essay "Unpacking My Library," which Oldenburg did not know at the time of writing his notes on the formation of the *Mouse Museum*: "This is the childlike element which in a collector mingles with the element of old age. For children can accomplish the renewal of existence in a hundred unfailing ways. Among children, collecting is only one process of renewal; other processes are the painting of objects, the cutting out of figures, the application of decals—the whole range of childlike modes of acquisition, from touching things to giving them names."[55]

And a third dimension of the museum project is the fact that in various other statements, made in retrospect, Oldenburg referred to the museum as his "three dimensional notebook."[56] Yet the function of this notebook is not simply to record sketches and projects for the future execution of major works; it also fulfills the mnemonic tasks of retrieving and rescuing objects that are lost or "forgotten" or "misshapen," terms that Oldenburg uses repeatedly in his various texts on the *Mouse Museum*. Were it not for the redemption offered by the collector, those objects would be left to rejection and oblivion, since they would not likely live up to the general criteria of judgment and expectations for high artistic quality associated with the institution of the museum: "Studio objects, objects of curiosity, which have occurred in the manufacture of artworks . . . or partial stunted abandoned works which have called out to be saved. A certain pathos is evident and unavoidable in objects such as these and others like them, outside the studio . . . they are 'left

behind.' They say something so they are not thrown away, but they do not say it all, do not say enough, and so they are hidden, and neglected like an unbright child. Crippled in some way."[57]

And it seems once again that Oldenburg operates in the manner of the true collector here, not only redeeming the objects of his own making that did not quite grow to artistic maturity and eligibility for induction into the bourgeois art museum but also, in the manner of a true Benjaminian allegorist, rescuing the devalorized objects of the world at large, discarded by obsolescence, rejected from use value, disqualified as bad taste and low class. Once more, Benjamin's classic text on collecting illuminates Oldenburg's practice better than anyone's: "In this circumscribed area, then, it may be surmised how the great physiognomists—and collectors are the physiognomists of the world of objects—turn into interpreters of fate. . . . One of the finest memories of a collector is the moment when he rescued a book to which he might never have given a thought, much less a wishful look, because he found it lonely and abandoned on the market place and bought it to give it its freedom."[58]

As they disregard hierarchical orders of quality and the search for significant world-historical objects, neither one of Oldenburg's motivations conforms to the conventions of the bourgeois museum institution and its criteria. Thus the spectrum of Oldenburg's museum ranges from redeeming the unconscious desires embodied in mass-cultural objects to defining a child's motivation in constructing a collection, from archiving and recording the artists' private pursuits in notebook form to conceiving a countercultural museum institution and a critique of existing definitions of the functions of the museum.[59]

THE *MOUSE MUSEUM*: *ARCHITECTURE PARLANTE (SOURI-ANTE)*

The language of little children and of animals seems to be the same. The similarity between man and ape is thrown into sharp relief by the animal-likeness of clowns. The constellation of animal, fool and clown constitutes one of the most basic dimensions of art.
 —Theodor W. Adorno, *Aesthetic Theory*, 1969

From my point of view the Mouse Museum *is a situation (like* The Store*) where I imitate a certain established structure of presentation, in this last case,* The Museum, *and an absurd or makebelieve way, imitating what interests me in that pattern.*
 —Claes Oldenburg, "Notes," n.d.

The origin and iconography of the mouse and the *Mouse Museum* in Oldenburg's oeuvre have been extensively discussed and documented.[60] Yet we are still left with the task of clarifying how Oldenburg's citation of the mouse iconography responds to the transformation not only of artistic but also of collective subjectivity under the impact of a prototototalitarian culture of spectacle. After all, both Mickey Mouse (certainly not the sole reference for Oldenburg's mouse), and the Ray Gun date from 1928–29, and they are—from their inception onward—both deeply contradictory images: one of the dreams of the Buck Rogers Ray Gun universe was to transcend the Fordist instrumentalization and rationality of advanced technological modernity with utopian technology and cosmic imagination, while the animation of Mickey Mouse in its earliest phases practiced anarchist forms of resistance against the subject's fusion with the machine. But Oldenburg repeatedly cautions against a simplistic mapping of his mouse image onto that of the Disney mouse, stating, for example, during the second showing of the *Mouse Museum*, in 1977 in Chicago: "I want to make a distinction between my mouse and that other famous mouse. My mouse is more artistic."[61]

In her brilliant essay on the cultural debates triggered by Disney's figures in Weimar Germany, the late Miriam Hansen made these arguments compelling: "As is well known, Benjamin was not the only writer who perceived Mickey as an instance of the utopian imagination. And the early Mickey Mouse films . . . indeed contain glimpses of a playfully transformed nature, nature liberated from anthropocentric, phallocentric oppositions and hierarchies, a nature in which the boundaries between humans and animals, mechanical and organic, living and inanimate objects, master and slave, labor and play become fluid."[62]

The mouse made one of its first appearances in Oldenburg's Happening/performance *Moveyhouse*, staged in a movie theater in 1965, in which the artist asked several participants sitting in the audience to wear large mouse masks with protruding circular ears that cast shadows like those in a child's shadow play. Oldenburg commented on how the structure of *Moveyhouse* was determined primarily by the institutional site of the cinema, and one could indeed suggest that the performance amounted to a staged *détournement* of the experience and behavior of a conventional movie audience.[63] Oldenburg's audience, confronted with the theatrical transformation of some of its members into mouse heads and their shadows, could not possibly have missed the masks' uncanny associations: the con-

ditions of mimetic regression and animalistic assimilation to which spectators are subjected in the cinematic experience.

In two drawings from 1965 and 1966, respectively, Oldenburg shifts the mouse from a logotype to an architectural container, and from the cinema to the museum (initially still the "museum of popular art, n.y.c."). The first one is a sketch for a poster, announcing the performance of *Moveyhouse* organized by New York's Film-Makers' Cinematheque, which appears in Oldenburg's poster design as "Cinema Tick." The phrase "Expanded Cinema," referring to a concept that had considerable currency in the New York world of independent cinema at the time, has been erased and replaced with "Deflated Cinema."[64] But the main feature of the sketch undoubtedly is the drawing that fuses architecture with animation for the first time, and the industrial instrument of the film camera with the corporate logo. The inscription *Moveyhouse*, graphically disfigured in a way that makes it also read as "Mousehouse," refers to the design of an architectural pavilion in the shape of a mouse head, which, thanks to a large lens and a penile protrusion on its right side, also inevitably reads as a classic movie camera. The second drawing, of 1966, places the emblem of Oldenburg's "Geometric Mouse" as a corporate logo at the top of a design for the letterhead of his *Museum of Popular Art, N.Y.C.*, (now capitalized for the first time), a drawing, as Coosje van Bruggen pointed out in 1978, that was clearly derived from a study made by Oldenburg in 1966, comparing the mouse with the logo of the monumentalized letters of the 20th Century Fox Corporation.[65]

Thus, this mouse design—in its fusion of architecture, animation, and corporate logogram—even in its earliest instantiations traces the intersection of the corporate culture industry, the classical bourgeois art museum, and a once rebellious subculture in a miniature yet highly condensed emblematic structure that would generate an altogether different impact on the debates about the museum institution once it found its first architectural realization in 1972 at Kassel's Documenta 5.

Oldenburg assumed the manner of an ironic physiognomist when explaining what might have appeared at the time as a rather provocative choice for a museum architecture in the shape of Mickey Mouse, since Disney's former antihero had become the universal image of the industrially produced undoing of the subject. Claiming that he had deployed the mouse image initially because it resembled him, Oldenburg stated that he had finally settled on the design of the museum pavilion in the shape of a mouse head, when he discovered that there was

*Notebook Page: Buildings in the Shape of Geometrically Formed Mouse
Compared with the Logo of 20th Century Fox*, New York, 1966
Photostat of original ballpoint-pen and pencil drawing
11 x 8 ½ inches
Claes Oldenburg and Coosje van Bruggen

*Notebook Page: Letterhead MUSEUM OF POPULAR ART N.Y.C.,
with a Sketch of the Museum Building*, New York, 1966
Ballpoint pen, graphite, and collage on paper
11 x 8 ½ inches
The Menil Collection, Houston. Anonymous promised gift

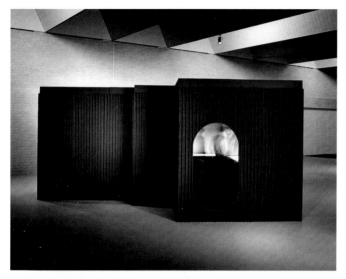

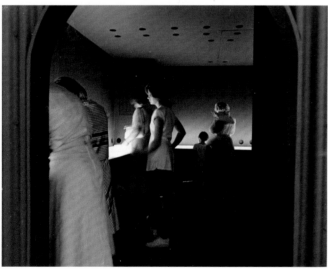

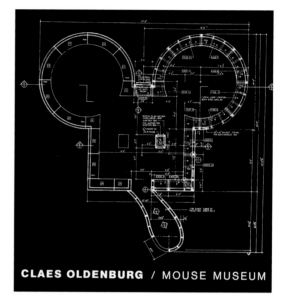

CLAES OLDENBURG / MOUSE MUSEUM

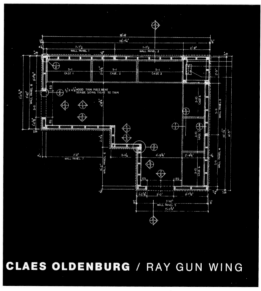

CLAES OLDENBURG / RAY GUN WING

Installation view of the *Ray Gun Wing* at the
Kröller-Müller Museum, Otterlo, 1979

Cover for the catalogue to the *Mouse Museum/
Ray Gun Wing* exhibition at the Museum of
Contemporary Art, Chicago, 1977, front and back

an additional physiognomic similarity between Mickey and the large ears of Kasper König, the curator who had advised him on this project and would eventually become the first director of the *Mouse Museum*. The reductivist physiognomist's ironic arguments were certainly meant to distract the amused readers from recognizing the full scope of Oldenburg's ambitious project.

The Ray Gun collection and the "museum of popular art, n.y.c." had already been suspended by the artist in a dialectical movement, as we have argued: an opposition between the hierarchical order of the museum and a collection of anonymous rebellious gestures at the very moment when popular art's rebelliousness was tamed into industrial production. A similar, if not more challenging, set of contradictions was formulated by Oldenburg in the *Mouse Museum* just as it seems to have dawned on everyone that not only had Disney's universe of a once rebellious unconscious been industrialized but the institution of the museum itself was shifting to a fully regulated and controlled space of corporate culture. Hansen formulates this dialectic of precariousness lucidly as it had evolved in the 1930s:

> The popular cousin of these "new barbarians" is Mickey Mouse, herald of an imagination that does not rely on experience, citizen of a "world in which it does not pay to have experiences." In the Disney films, Benjamin says in a fragment of 1931, "humanity prepares itself to survive civilization." . . . The problem was compounded with the more acute insight that these capacities, indeed the very concept of experience, were being held hostage by a bourgeois humanist culture that had tied them to the perpetuation of social privilege, to aestheticism, escapism, and hypocrisy. . . . The decline of experience is troped into an opportunity to abolish it altogether; the "new barbarism" of experiential poverty appears as the proletarian alternative to a moribund bourgeois culture.[66]

But Oldenburg's situation in the late 1960s entirely differs from that described by Hansen, since the very principle of hope for the emergence of a liberating barbarian had been fully contaminated, if not annihilated altogether, by the all-out incorporation of popular forms of resistance and rebelliousness into the cultural-industrial practices of control and oppression. That might explain Oldenburg's surprising distantiation from the Disney mouse in an interview in 1977, when the *Mouse Museum* was shown for the second time: "It's closer to Mondrian than to Disney. Perhaps it's somewhere in between."[67]

Yet, typical of the artist's infinitely subtle dialectical reversals, he challenges the aspirations with which artists had been traditionally endowed as the redeemers of these historical conflicts. By the early to mid-1970s Oldenburg formulated a critical perspective on the situation of the artist and the meaning of artistic practices, as much as on the centrality or lack thereof of the hierarchical institution of the museum, that positions him clearly as one of the central figures of that period to have analyzed in theoretical and practical terms the intertwining of architectural and institutional, of discursive, ideological, and artistic, operations and to have argued that an artistic project must simultaneously address all these to credibly claim any form of intervention in the otherwise monolithic structures of power. Yet, once the *Mouse Museum* had reached its public form, the early libertarian seemed to formulate a more generous, liberal position:

> It is kind of a encyclopedic view of the world. There is something in there of all scales, all shades of emotion. There is art, there is a lot of non-art. It is like a cross section of a certain time, a microcosm that raises all kinds of questions. . . . It is almost like an educational project to go into the museum and discuss, for example, what is art. You can point out examples of this and that. Examples of things that have no form, things that have form, things that are trying for form but dont make it.[68]

Hand in hand with the increasing doubts about the possibility of continuing the rabid rebellious projects of the Ray Gun of the 1960s and the realization that the merely iconographic shock value of mass-cultural citationality had run its course once these practices had been generalized and acculturated under the label of Pop art, Oldenburg's aesthetic critiques shift even further into the preoccupations with public spaces and architectural contexts and containers that had been at the center of his Ray Gun work from the beginning. These shifts began to situate his work on the *Mouse Museum* in a direct contextual relationship to that of some of his younger Minimalist and Postminimalist peers (from Robert Morris to Dan Graham) who had studied his work and had written about him early on. This shift into an architectural dimension of Oldenburg's sculptural work in general, and of the *Mouse Museum* in particular, takes on some of the central concepts of Minimalist and phenomenological thought, in which a increasingly emancipated and self-determined spectator was assumed

to operate more freely in bodily and spatial interaction with the spatial structures than previous object relationships had allowed. It is precisely along these lines that Oldenburg formulates his expanding preoccupation with form and architecture when discussing the *Mouse Museum*, from a different angle: "My work has been going in the direction of more and more architectural structure. . . . [It is] an indication of my interest in making buildings or things that are structural. And so, the idea of these two black forms sitting in that big white space is part of the show. Part of it is to follow the forms, walking around them, constructing their image in the mind."[69]

Eventually even the Ray Gun itself was neutralized and distanced from its originary association with an aggressive libidinal assault on all bourgeois conventions that had defined it so strikingly in the 1960s. Now, preserved in its own *Ray Gun Wing*—in what Oldenburg himself humorously called his *Mousealeum*—the Ray Gun, redefined in its purely formal rectangularity, has become more Mondrian than Disney, as Oldenburg had stated: "When I am speaking of Ray Gun, I am also speaking of the right angle, a very basic form. The collection begins with fabricated pieces I made. But the original shape gets more distant, having passed through store bought objects and other things composed of various materials, There the angle is just recognized or perceived as something that comes across as if by accident. The whole concept becomes rather purified. It really progresses away from the gun, and in the exhibition catalogue I am quoted as saying, it is a celebration of the right angle."[70]

Yet this shift, typical for Oldenburg, into an architectural dimension with an explicitly formalist drift that distances itself from the originary aggressive association with the mass-cultural conditions of experience, operates simultaneously as a ruse to redefine his own radicality and to make its effects more palpable in the actual public spaces of collective experience.

Oldenburg's silhouette of a mouse as an architectural facade associated itself directly with architectural practices of the French Revolution, resuscitating the projects of an *architecture parlante*, when a gigantic phallus signaled the housing of a brothel, for example. At that time, architects, in particular Claude-Nicolas Ledoux and Etienne-Louis Boullée, had wanted to transcend the presumably eternal codes of classicism in order to communicate with the newly emancipated population. In a similar gesture of renewed democratic and egalitarian fervor and in a critical challenge to the contemporary currency and orthodoxy of a presumably universal and transhistorical

modernism that had actually become debased into corporate architecture, Oldenburg bracketed the brand, the industry, and the architectural design—the unholy triad so carefully disguised in modernism's stereometric utopian neutrality—into a new *architecture parlante*.

It was Oldenburg's contribution to the utopian vision of a new subject-object relationship, in spaces in which subjects would interact and determine themselves within relationships, that made the *Mouse Museum* a lasting challenge to the conditions of architecture and to the future of the museum as an institution of the formerly public sphere. Thus, the artist should have the last word:

> As a container also it had a meaning to me in relation to the head, the collection being like the memory, and the head also has an autobiographical significance—it is a sort of portrait (sometimes). If the museum as conceived then had been built it would have been a giant head and at the same time a building standing somewhere on a hill in the countryside. What it was then was an architectural object from the museum enlarged to contain itself and other objects. . . . That is, from the beginning the shape of the Maus Museum was an object in itself, a form.[71]

NOTES

My gratitude goes, first of all, to Claes Oldenburg, for having allowed me to write on this chapter in the history of his oeuvre and for his unfailing generosity and good humor in answering questions that had been asked too many times before or that might have seemed at first unanswerable. Thanks are also due to Achim Hochdörfer, who invited me to contribute to this grand curatorial project on Oldenburg's early work, and to my dear friend Julia Robinson, whose comments and cues prompted me to get some things right at least on subjects she knows quite a bit more about. At the Oldenburg van Bruggen Studio Archives, Carey Ascenzo and Alexandra Lane were very friendly, professional, and helpful at all times. I owe major thanks to Barbara Schröder for all of her efforts on behalf of the manuscript, and to her team of editors— Karen Jacobson, Karen Kelly, and Sarah Kovach, who made the essay more legible than it would have been otherwise.

1. In one of the earliest definitions of the multiple facets of Ray Gun's identities, Claes Oldenburg seems almost to iterate some of Marcel Duchamp's principles, and he certainly signals their comparability: "Ray Gun is both a form of deception (to everyone incl. oneself) and a form of play. so important play is. i.e. only the comic is serious, only the offhand is effective. Therefore, Ray Gun is a series of contradictions, paradoxes. A form of dialectic. Ray Gun as Eros or life in its disguises. Its disguises are very often its opposites." Claes Oldenburg,

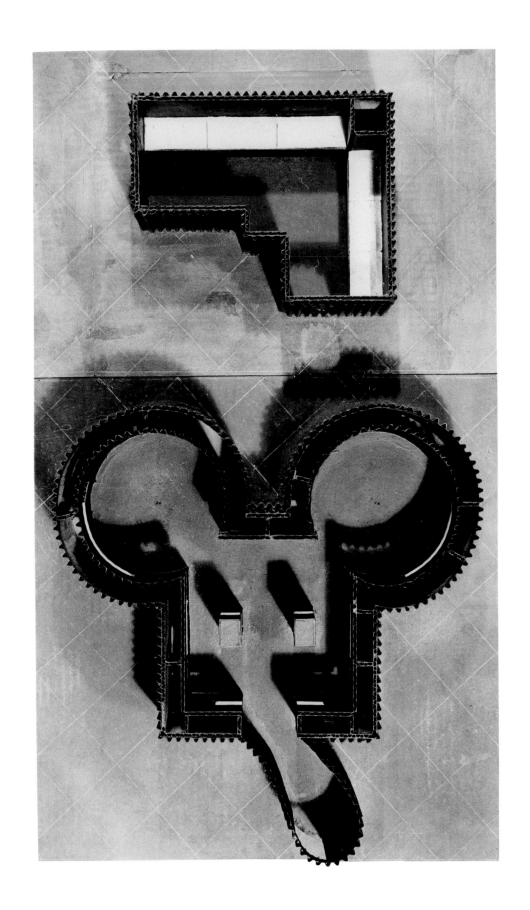

Model of the Ray Gun Wing and
Model of the Mouse Museum, 1977
Cardboard and wood painted with
tempera and spray enamel, pencil
6 1/8 x 12 7/8 x 18 7/8 inches and
6 7/16 x 18 7/8 x 18 7/8 inches
The Menil Collection, Houston,
Anonymous promised gift

"Guises of RG," Oldenburg van Bruggen Studio Archives, New York.

2. Oldenburg explicitly refers to this Duchampian story in 1964: "Now I am beginning to parody the scientist and the inventor (something like that is what Duchamp has done all along)." Claes Oldenburg, "Extracts from the Studio Notes 1962–1964," *Artforum* 4, no. 5 (January 1966), pp. 32–33.

3. Typically for the reception of Oldenburg's work, set as it has been in the groove from Jackson Pollock to Jean Dubuffet, constructed by Barbara Rose in 1969, there was no room for a comprehension of these photomontages that would both posit Oldenburg's project not only at the center of these debates and position him from the start in a complex relationship with the episteme of Duchamp's readymade and its various extensions into the indexical cast, the found fragment, and the photographic trace and record. Neither was it possible to recognize that Oldenburg's work, from the very beginning (just like that of Andy Warhol a few years later), engaged with the commodity form and advertising as the hegemonic industries of the image and their radical artistic contestation. Rose mentions these collages only in passing but recognizes their importance for the emerging morphology of the sculptures: "For a few months in 1957 in the course of attempts to elicit erotic fantasies, he also made collages: the irregular contours of unrecognizable single images were silhouetted sharply against the white background of the paper. Later the eccentric silhouette of these obsessive shapes was to find expression in the twisting outline of the *Empire (Papa) Ray Gun*." Barbara Rose, *Claes Oldenburg* (New York: Museum of Modern Art, 1970), p. 24.

4. The only predecessors that come to mind when studying *Strange Eggs* would be some emerging aspects within the photomontages by Hannah Höch, produced during the mid- to late 1920s (e.g., *From an Ethnographic Museum*), obviously unknown to Oldenburg, since they had not been published. In Höch's montages, we discover a focus on the intensity of the cut itself, over the iconic reference. Höch, however, never intensifies this principle to the point of a total erasure of iconic reference. In an uncanny parallel of pursuits in 1957 and 1958, Oldenburg shared the strategy, however, with some of the collaged fragments that Asger Jorn inserted into his two books, *Mémoires* and *Fin de Copenhague*, both produced in collaboration with Guy Debord. Especially in *Mémoires*, we find several photographic structures that are equally "illegible" in the way that Oldenburg's *Strange Eggs* produces the effect of radical defetishization, a restitution of the reader-spectator's polymorphous perverse fluidity of vision over and against vision's instrumentalized deployment in the process of fetishization in advertising. What makes the parallel even more compelling is the fact that throughout the two books, Jorn's collages and photomontages perform a manifestly polemical dialogue with the pursuits of Jackson Pollock's automatist gestural drip paintings. Just like Oldenburg at that time, Jorn clearly perceived the automatist legacies as historically disqualified and as failing the challenges of the new laws of spectacularization. In a performance almost anticipating Fluxus, Jorn dripped paint from a ladder on which he was seated to demarcate the papers for the collage books.

5. Claes Oldenburg, quoted in Rose, *Claes Oldenburg*, p. 36.

6. In Oldenburg's pamphlet accompanying the first exhibition in 1958, the slogan reads: "The slogan of *Ray Gun* is 'Annihilate—Illuminate.' Ray Gun is both destructive and creative."

7. For example, one could think of Roy Rogers, Colonel Sanders, and Ronald McDonald, as familial (and familiar) emblems of corporate sales strategy disguised as patriarchal benevolence in disseminating products.

8. One of many retrospective comments by Oldenburg on Ray Gun is particularly amusing: "One thing about my alphabet is that I try to have everything equal a 'Ray Gun,' which is a phallic form; and the Ray Gun Manufacturing Company, as I officially entitled my store, of course a place where Ray Guns are manufactured. One interpretation, then, is the phallic manufacturing company, with CO also being my own initials. And 'manufacturing' originally means, if you look it up in the dictionary—things done by hand, as was really the case; and it can also mean 'mother fucking.' On the Lower East Side, 'mfg' means precisely that." Claes Oldenburg, in conversation with Richard Kostelanetz, in *The Theatre of Mixed Means* (New York: Dial Press, 1968), p. 156.

9. Indicating his skeptical reverence toward that quintessential figure of a traditional definition of the studio artist, Oldenburg refers to Picasso in his text "America: War & Sex, Etc.," as "the P," when he compares his own sculpture *Fagends* to Picasso's famous antiwar painting *The Charnel House*: "Fagends equal the P's *Charnel House*." See Claes Oldenburg, "America: War & Sex, Etc.," *Arts Magazine* 41, no. 8 (Summer 1967), p. 27.

10. John Roberts, preface to *The Intangibilities of Form: Skill and Deskilling in Art After the Readymade* (London: Verso, 2007), p. 4.

11. The same would apply to *Woman's Leg*, the *Elephant Mask*, the *Street Head*, and most important, perhaps, *C-E-L-I-N-E, Backwards*, all dating from the same *annus mirabilis* in Oldenburg's career, which will be discussed later in this essay.

12. See Oldenburg, "Extracts from the Studio Notes, 1962–1964," p. 46.

13. Claes Oldenburg, description of *"Empire" ("Papa") Ray Gun*, 1959 (ca. 1970), quoted in *Claes Oldenburg: An Anthology*, ed. Germano Celant (New York: Guggenheim Museum, 1995), p. 36.

14. Claes Oldenburg, "Jackson Pollock: An Artist's Symposium, Part II," *Art News* 66, no. 3 (May 1967), p. 27.

15. See, for example, Oldenburg, in conversation with Kostelanetz, p. 139: "I had earlier read his piece on Jackson Pollock which impressed me." Kaprow's later writings on Pollock seem to have met with a certain amount of critical distance, however, as is evident when Oldenburg states: "This extends to edge of magic procedures of identification with which the stereotype receiving machinery more or less co-operates (for example p. 110–111 in Kaprow's recent book on Happenings). Here I've got the thing down on the floor though usually I had it on end and the paint found its own way through gravity." Oldenburg, "Jackson Pollock: An Artist's Symposium, Part II," p. 27.

16. Claes Oldenburg, quoted in Germano Celant, "Claes Oldenburg and the Feeling of Things," in *Claes Oldenburg: An Anthology*, p. 14.

17. This was, of course, one of the questions Oldenburg's generation was engaged with in general, and it was obviously just as much addressed in Cy Twombly's and Jasper Johns's work in a variety of ways, leading to some responses that were similar and structurally comparable to Oldenburg's and others that were decisively different.

18. See Rose, *Claes Oldenburg*.

19. If one would need to substantiate the argument of a latent link between Pollock's belated Americanized automatism and the irresistible rise of spectacle culture, one would only have to point to the Parisian enactment of that link in the hands of Georges Mathieu or the Italian version of that fusion in the hands of Lucio Fontana, two artists for whom the fusion of the speed of

Clockwise from top:

Notebook Page: Geometric Mouse Study, 1968
Ballpoint pen on paper
11 x 8 ½ inches
The Menil Collection, Houston; Anonymous
promised gift

*Notebook Page: Metamorphic Mouse Heads and
Tooth as Balloons, New Haven*, 1969
Felt-tip pen on paper
11 x 8 ½ inches
The Menil Collection, Houston; Anonymous
promised gift

Notebook Page: Studies for Balloons, 1969
Felt-tip pen on paper
8 ½ x 11 inches
The Menil Collection, Houston; Anonymous
promised gift

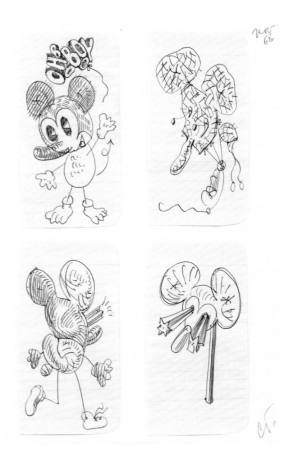

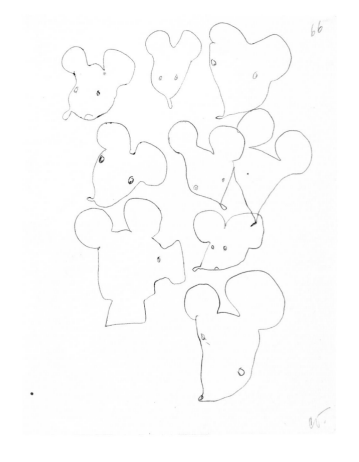

Notebook Page: Metamorphic Studies of Cartoon Mice,
"Ohbobooy," Chicago, 1968
Ballpoint pen on paper
11 x 8 ½ inches
The Menil Collection, Houston; Anonymous promised gift

Notebook Page: Mouse Head Variations, 1966
Ballpoint pen on paper
11 x 8 ½ inches
The Menil Collection, Houston; Anonymous promised gift

Scales of the Geometric Mouse, 1972
Pencil and crayon on paper
23 ⅛ x 29 inches
Collection Walker Art Center; Gift of the artist, 1974

Chronology

MAARTJE OLDENBURG

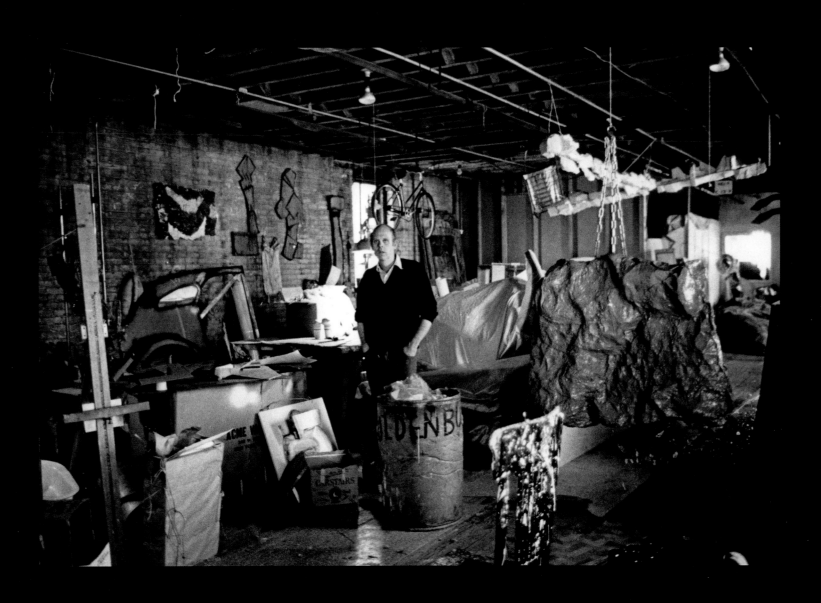

Oldenburg in his Fourteenth Street studio, New York, 1968

Chronology

MAARTJE OLDENBURG

1929–1969

1929–1932

Claes Thure Oldenburg was born on January 28, 1929, in Stockholm, Sweden, to Sigrid Elisabeth Oldenburg (née Lindforss) and Gösta Oldenburg. Her son's Swedish citizenship ensured, Sigrid brought him to New York in September to rejoin Gösta, an attaché at the Swedish Consulate. The family resided in New York City and Rye, New York, through 1932.

1933–1935

The Oldenburgs moved to Oslo, Norway, upon the appointment of Gösta as first secretary of the Swedish Legation. Oldenburg's brother, Richard Erik, was born on September 21, 1933, in Stockholm.

1936–1945

In 1936, the family settled in Chicago where Gösta served first as consul, then as consul general, until his retirement in 1959. On weekends, Oldenburg created an imaginary country called Neubern in the consulate office located on the first floor of the family home at 44 East Bellevue Place. Complete with maps, a mixed Swedish- and English-language newspaper, a domestic film industry depicted in elaborate movie posters, and an air force with an insignia like "a pie with a slice out of it,"[1] Neubern lends support to Oldenburg's tongue-in-cheek claim as an adult, "Everything I do is completely original—I made it up when I was a little kid."[2] He attended the Latin School of Chicago.

1946–1951

Oldenburg graduated from Latin and enrolled at Yale College, where he majored in English literature. Compelled to develop his interest in art, he studied watercolor and perspective drawing at the University of Wisconsin's summer school in 1948; he took studio courses on figure drawing and composition as a junior at Yale that fall. After college, Oldenburg returned to Chicago and took a job as an apprentice reporter covering the police beat for the City News Bureau. He continued his art education by attending night courses at the Art Institute of Chicago.

1952

In January, Oldenburg was called up for military service but was ultimately rejected; the experience left him determined to leave the City News Bureau in order to focus on making art. He took day courses at the Art Institute of Chicago while working as an illustrator for an advertising agency to support himself.

1953

In March, Oldenburg exhibited his work for the first time, contributing satiric drawings of street characters to a group show with Robert E. Clark (aka Robert Indiana) and George Yelich at Chicago's Club St. Elmo. That summer, Oldenburg attended the Oxbow Summer School of Painting in Saugatuck, Michigan. He concentrated on painting in oil and directed a performance set on a lagoon for the school's end-of-summer theater event. He also made the acquaintance of his future wife Patty Mucha (then Pat Muschinski). "Looking for wherever it was happening,"[3] Oldenburg traveled by bus to New Orleans, Houston, and Los Angeles; he eventually spent the fall in San Francisco and Oakland practicing drawing by making studies of figures and landscapes. He went back to Chicago in December for his naturalization as a United States citizen.

1954

In the spring Oldenburg returned to the Art Institute of Chicago. In a painting class taught by Paul Wieghardt, he met H. C. Westermann and younger artists Robert Natkin, Marjorie Oplatka, and Irving Petlin. Oplatka introduced Oldenburg to the writings of Walt Whitman as well as Sigmund Freud, which led to Oldenburg's interests in the subconscious and primitive art. Oldenburg showed drawings and paintings at the Old Town and South Side art fairs. In November, he exhibited at the Tally-Ho Restaurant in Evanston, Illinois.

1955

Oldenburg left the Art Institute of Chicago after the summer session to study on his own, establishing a studio on the Near North Side. He befriended the printmaker and self-styled alchemist Richard O. Tyler and his wife, the painter Dorothea Baer. He met the artists George Cohen, Seymour Rosofsky, and June Leaf, as well as the poet Paul Carroll, who introduced him to the poetry of Rimbaud. That spring, Oldenburg exhibited drawings at 1020 Art Center in a show sponsored by the Chicago chapter of the American-Scandinavian Foundation and took part in "Young Artists among Us" at the Evanston Art Center. Frank Ryan Contemporary Furnishings featured Oldenburg's drawings and paintings in November. To support himself, Oldenburg worked in the music department of the Main Street Bookstore and as an illustrator for *Chicago* magazine.

1956

After participating in the summer group show "Exhibition Momentum 1956," organized by Art Institute students to showcase work by young contemporary artists, Oldenburg moved to New York City and secured a part-time job at the library of the Cooper Union Museum of Decorative Arts. As part of his duties, Oldenburg compiled massive scrapbooks of clippings about decorative arts. In his free time, he took advantage of access to encyclopedias and illustrated texts to study art history and architecture, and he first encountered the works of the eighteenth-century French

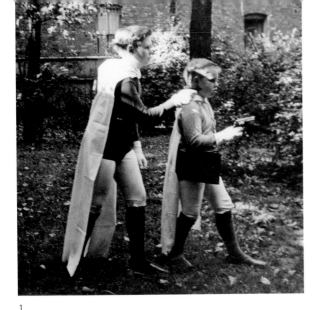

1

1. Oldenburg and his brother Richard, Chicago, ca. 1940
2. *Railroad Shorty*, 1953
3. *Skid Row Figure*, 1957
4. Oldenburg at the Old Town Art Fair, Chicago, 1954
5. Announcement for "Paintings/Drawings: Claes Oldenburg" show at
 Frank Ryan Contemporary Furnishings, Chicago, 1955

2

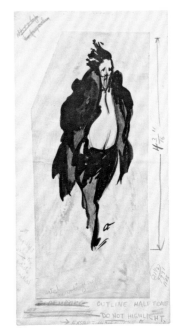

3

4

Paintings / Drawings

CLAES OLDENBURG

NOVEMBER / open house –
Fri., Nov. 4, 7-9 p.m.

FRANK RYAN

contemporary furnishings

1653 north wells street hours 10 to 8 . . wednesday 10 to 6

5

architects Étienne-Louis Boullée and Jean-Jacques Lequeu.

1957

Oldenburg mainly wrote poems and produced collages and assemblages from debris found on the street. In September, he relocated to an apartment large enough to serve as a studio at 330 East Fourth Street, where Tyler was working as superintendent. He avidly walked the streets, taking snapshots and collecting materials, and made his first experimental constructions, including *Elephant Mask* (completed 1959) in wire mesh and paper. The external roaming paralleled a desire to understand the inner life of the self. He read Wilhelm Stekel on ritual and fetishisms and Carl Jung on the collective unconscious, relating each back to his work through primitive art and archetypal structures. He recorded his dreams and created *Strange Eggs*, a series of metamorphic collages made with magazine clippings to which he later added poems.

I like to believe that there is a set of forms that each individual carries and he reads the world through these forms. They're sort of the imprint of his mind and sensibility. And this constitutes his style. Everyone can find out what these forms are if they study themselves and practice creating forms. These are forms in general and they're sort of like a psychological version of the idea that nature is in cubes and solids and squares and so on. I would say that they are more psychological forms. In the superimposition of an object across these forms, you see this image that you want to see enshrined in some kind of object, incorporated in some sort of form. That's the assimilation that interests me.
—OLDENBURG, INTERVIEW WITH PAUL CUMMINGS, 1973

Oldenburg received a 1926 typewriter from Alan Whitney, a reporter friend, on which he composed many subsequent writings.

He initially kept the typewriter on a stand so that during studio activities he could readily walk over and type a few lines or, as he later put it, "stupid thoughts expelled."[4]

1958

Oldenburg reverted to painting portraits and figures in oil. During a May Day party at George Segal's farm in New Brunswick, New Jersey, Oldenburg met Allan Kaprow and other artists represented by the Hansa Gallery. Exhibiting in New York for the first time, Oldenburg contributed drawings to a group show at Red Grooms's City Gallery in December.

1959

Reconnecting in New York, Oldenburg and Mucha began living together at his East Fourth Street apartment. In March, Oldenburg showed figure drawings of Mucha in a one-man show at the Cooper Union Art School Library. Marc Ratliff and Tom Wesselmann, who were then students at the art school, approached Oldenburg about a show in May at the gallery they were starting in the basement of the Judson Memorial Church. Oldenburg decided against showing his figurative work; instead, his first public solo show in New York combined metamorphic paper, wood, and wire constructions with black-and-white drawings and poems. The invitation carried the image of an enigmatic three-dimensional figure, made from paper crumpled around a wooden peg, and the poem: "I see / artists / clumsily duckwalking / all through time / jigging!" Oldenburg and Mucha spent the summer in Lenox, Massachusetts. Mucha worked as a figure model and Oldenburg as the director of the Lenox Art Gallery, which was sponsored by the resort and art school Festival House. Oldenburg returned for the last time to landscape drawing and figure painting. Back in New York, he continued the style of his Judson exhibition in ink and pencil drawings on street life. He attended Kaprow's *18 Happenings in 6 Parts* at the Reuben Gallery and saw Grooms's

Burning Building several times. For the two-man show "Dine-Oldenburg" at the Judson Gallery in November, Oldenburg exhibited constructions of newspaper strips dipped in wheat paste and laid over chicken wire that "satisfied [his] desire for primitive and organic effects."[5] Examples include *"Empire" ("Papa") Ray Gun*, *Street Head I*, and *C-E-L-I-N-E, Backwards*, made after reading *Death on the Installment Plan* by Louis-Ferdinand Céline. He also showed drawings and made a monoprint poster in ink for the exhibition. In December, Oldenburg joined Jim Dine, Lester Johnson, and Kaprow on the panel "New Uses of the Human Image in Painting" at the Judson Gallery and appeared in the Judson's Christmas group show. With *Street Ray Guns*, a wooden box containing eight right-angled objects of assorted found materials, Oldenburg initiated his long-standing practice of collecting "Ray Guns." At the end of the year, several works from "Dine-Oldenburg," including *"Empire" ("Papa") Ray Gun*, were exhibited in the group show "Below Zero" at the Reuben Gallery.

The theme of Ray Gun is perhaps the most important iconographical as well as formal motif in Oldenburg's oeuvre, because it provides the key to his reformulation of sculptural values: his projection of body onto object, permitting the creation of a body-related object of extreme originality.
—BARBARA ROSE, "THE ORIGINS, LIFE AND TIMES OF RAY GUN: 'ALL WILL SEE AS RAY GUN SEES . . .'" 1969

1960

In January, Oldenburg appeared in Kaprow's Happening *The Big Laugh* at the Reuben Gallery; *Girl with Furpiece (Portrait of Pat)*, included in a group show at the Reuben later that month, was Oldenburg's final figure painting. He turned next to "Ray Gun Show," which opened at the Judson Gallery on January 30. The exhibition comprised two environments,

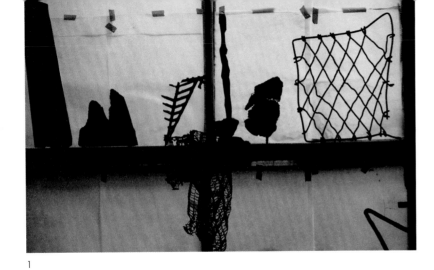

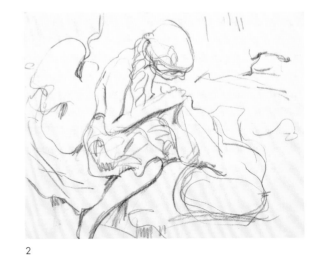

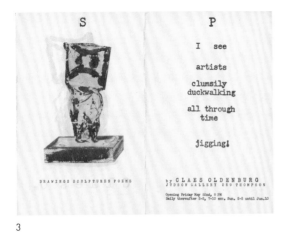

1. Objects found on the street by Oldenburg, New York, 1957
2. *Pat Sewing*, 1959
3. Announcement for "Drawings, Sculptures, Poems" show at Judson Gallery, New York, 1959
4. Oldenburg in Lenox, MA, 1959
5. Announcement of "Dine/Oldenburg" show at Judson Gallery, New York, 1959

The Street and *The House*, constructed in the gallery by Oldenburg and Dine respectively. Oldenburg built a set of street life from paper, cardboard, and burlap—including portions of buildings, vehicles, and figures—and filled the floor with junk.

Time: the present
Place: the city, materials of the city, textures of the city, expressions of the city, of the street: asphalt, concrete, tar, paper, metal . . . etc. natural and manmade effects. Newspapers, comics, scrawls of all sorts, anonymous passages of materials . . . where we always see the face, the visage, the spirit, looking back . . .
　　What are my preferences in the real world: the city and the poor and the miserable; the streets . . . proletariat or common people, their inventions. Popular culture. Present-day primitives: children, madmen, the American cultureless. In general the bleak grey face of things, not pastoral. Modern and citified. This is the setting for my mysticism. The erotic and the intimate, too, form another setting . . .
　　—OLDENBURG, "NOTES," 1959

"Ray Gun Spex," a series of performances held throughout the ample rooms and hallways of the Judson Memorial Church, took place in late February. The series began with Oldenburg's first performance, *Snapshots from the City.* Oldenburg, in underwear and torn canvas strips, and Mucha, dressed as a "street chick" out of Oldenburg's drawings, postured and danced wildly in the environment of *The Street.* Lucas Samaras, hidden from view, simulated a camera taking snapshots by turning the lights on and off seventy times at arbitrary intervals. Dine performed *Smiling Workman,* at the end of which he swallowed paint from a bucket and dove through the scenery. Happenings by Al Hansen, Robert Whitman, and Dick Higgins followed. During the intermission in the church gym, millions of dollars of Ray Gun "cur-

rency," mimeographed by Oldenburg, were generously distributed for the purchase of street trash piled in shopping carts, while Oldenburg, in tattered regal costume, delivered a mock sermon. Kaprow concluded the event with *Coca Cola, Shirley Cannonball?,* in which giant objects, including a cardboard leg and a cloth telephone booth with Oldenburg inside, hopped around the gym. Dine joined Oldenburg in making mimeographed Ray Gun comic books. On April 13, Oldenburg and Mucha were married at city hall in Staten Island. For a solo show at the Reuben Gallery in May, Oldenburg produced more paper, cardboard, and burlap constructions, including *Street Chick* and *The Big Man.* He made drawings in ink and collaged newspaper for the show's announcement. In June, the cardboard construction *Mug* was included in "New Media—New Forms I," the first in a series of groundbreaking shows featuring contemporary artists at the uptown Martha Jackson Gallery. Asked to make the poster and catalogue cover, Oldenburg created an ambiguous profile torn from newspaper with a headdress bearing the names of the many artists in the exhibition. Oldenburg and Mucha spent the summer in Provincetown, Massachusetts, where Oldenburg worked evenings as a dishwasher. He put aside the street theme and during the day made American flags and "postcards" from driftwood, which were shown together with related ink drawings at the local Sun Gallery. Returning to New York in the fall, Oldenburg acted on his ambition to give back as art the colorful wares on display for sale in the shops populating the Lower East Side. In anticipation of *The Store,* he made drawings of goods and clothing and watercolors of store windows, as well as plaster reliefs of common objects in tempera. In December, *C-E-L-I-N-E, Backwards* appeared in the Christmas group show at Richard Bellamy's Green Gallery on Fifty-Seventh Street. Oldenburg made monoprint posters announcing his performance

Blackouts for "Christmas Varieties" at the Reuben Gallery, which had relocated to a larger space more suited to performance at 44 East Third Street. A precursor to the Ray Gun Theater, *Blackouts* consisted of seemingly unrelated acts in four parts titled "Erasers," "Chimney Fires," "The Vitamin Man," and "Butter and Jam."

1961
In January, Oldenburg designed sportswear-like costumes in bright colors, as well as the poster for an Aileen Passloff Dance Company concert. The following month, he staged the ambitious two-part *Circus (Ironworks/Fotodeath)* at the Reuben Gallery. In March, the Provincetown flags were included in a group show at the Alan Gallery. Oldenburg left the Cooper Union Museum Library and focused on developing the "store" theme. Likening *The Street* to drawing and *The Store* to painting, he shifted from black and white to bright colors. Finding tempera lacking sufficient intensity, he began applying enamel bought in a nearby hardware store to his plaster reliefs; he used seven colors that he never mixed, waiting for each layer to dry before adding the next in order to keep the colors pure. To achieve the effect of putting "paint into space,"[6] Oldenburg installed the new plaster reliefs in a mural configuration for the group show "Environments, Situations, Spaces" with George Brecht, Dine, Walter Gaudnek, Kaprow, and Whitman at the Martha Jackson Gallery in late spring; for the catalogue, he composed his statement "I am for an art."[7] In June, Oldenburg relocated his studio to a storefront space at 107 East Second Street and worked further on reliefs of common objects. He posted the name Ray Gun Mfg. Co. on the door and printed stationery and business cards. That summer, Oldenburg developed a close friendship with the Swedish engineer Billy Klüver, who introduced him to the works of Jean Tinguely and European New Realists, such as Arman, Yves Klein, and Daniel Spoerri. In September, *Big Man* and *Street*

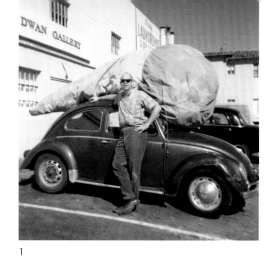

1

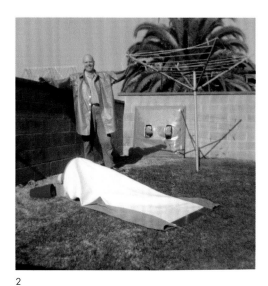

2

1. *Floor Cone* (1962) in front of Dwan Gallery, Los Angeles, 1963
2. Oldenburg with vinyl pieces in his backyard in Venice, CA, 1963
3. *Autobodys*, 1963
4. Studies for announcement for 1963 Dwan Gallery show and final poster design

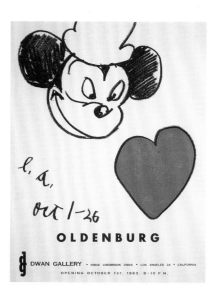

3

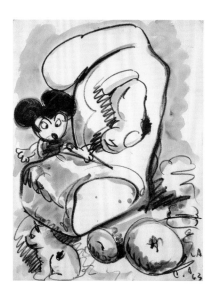

4

a battleground for style. Factory for my style. Since then it has served me as a guide to changes in interest. The drawings in connection with the street bring out the emphasis on line which characterized that period, those preparatory to the store announce the emphasis on color and painting a surface, now I am getting intimations of a voluminar-dominated theme perhaps The Home, in drawings which are clear in line and solid, 3 dimensional, as compared to the disappearing drawing of store-color or the agitated drawing of street.
—OLDENBURG, "NOTES," 1963

Oldenburg made six California Ray Guns cast in plaster, sprayed with enamel, and mounted on Plexiglas sheets. The molds were fabricated from acetate sheets, using the vacuum-forming process of toy-vending machines; Oldenburg later gave the sheets away as souvenirs of Californian technology to Wesselmann and Andy Warhol, among others. *Bride Mannikin* and other *Store* pieces traveled in the exhibition "Amerikansk pop-konst," organized by Pontus Hultén, director of Moderna Museet in Stockholm. In March, Oldenburg and Mucha returned to New York; they lived at the Chelsea Hotel and worked in a loft at 48 Howard Street. Works on the theme of the Home—such as *French Fries and Ketchup*, *Soft Pay Telephone*, *Soft Typewriter*, *Giant Toothpaste Tube*, and *Soft Light Switches*—were shown at the Sidney Janis Gallery in April. Selected by Alan Solomon as one of eight American artists to represent the United States at the Thirty-Second Venice Biennale, Oldenburg sailed with Mucha on May 13 on the Italian liner *Vulcania* for Venice. From June through July, they traveled in Italy, visiting Pisa, Rome, and Varese, where Oldenburg restored *Store* pieces owned by the collector Giuseppe Panza di Biumo. At Ileana Sonnabend's invitation, Oldenburg spent August to October in Paris, working in a borrowed studio on sculptures in the

form of food. Made from plaster of Paris poured into cardboard or canvas forms and painted in tempera and casein, the finished sculptures rest on plates in vitrines and on display counters typical of Parisian shops. The sculptures and related drawings were exhibited in October at the Galerie Ileana Sonnabend in Paris. The filmmaker Michelangelo Antonioni commissioned Oldenburg to work in Rome on object-oriented sets for a film starring Soraya, the former wife of the Shah of Iran. On November 22, Oldenburg and Mucha returned to the Chelsea Hotel; they continued to work at Howard Street while looking for a new studio.

1965
In March, Oldenburg and Mucha moved into a block-long studio with four exposures on the fourth floor of a loft building at 404 East Fourteenth Street. Other occupants eventually included John Chamberlain, On Kawara, Yayoi Kusama, and Larry Rivers. On a set of shelves he found in the studio and painted white to lend an architectural appearance, Oldenburg placed unaltered, altered, and studio objects he had accumulated while moving from studio to studio. Objects included toys, souvenirs, Ray Guns, work studies, and performance props. Along the top of the shelves he stenciled "museum of popular art, n.y.c." Enjoying the scale of his new studio, Oldenburg produced his first Proposed Colossal Monuments.

In 1965, soon after moving into a very long and spacious loft, I found myself making objects in enormous scale—or rather proposing and imagining them. The objects were the same I had been using in more or less "normal" scale, but I now set them into the city as if they were large as skyscrapers (or threw them). Another way of expressing it is to say that the city itself became small, or object-like—especially those parts of it which have object-form such as the

island of Manhattan, Ellis Island, City Island. Like souvenir ashtrays of the USA or Statues of Liberty one buys at Times Square.
—OLDENBURG, "NOTES ON MONUMENTS AND THE LIGHT SWITCH," 1966

The group show "Recent Work" at the Sidney Janis Gallery featured drawings of outsize objects placed in New York settings, such as an ironing board stationed above the Lower East Side and a cement pat of butter blocking the intersection of Broadway and Canal Street. In May, *Washes* was performed at Al Roon's Health Club as part of the First New York Theater Rally, organized by Alan Solomon. All the action took place in the club's swimming pool, whose surface Oldenburg conceived of as a painting. On July 4, the *Washes* cast was transported to the brookside estate of the novelist and screenwriter Rudy Wurlitzer in upstate New York to make the film *Birth of the Flag*. Stan VanDerBeek and Sheldon and Diane Rochlin photographed the film. Samaras played a vampire, preying on other performers. Mucha gave birth to a giant American flag as Samaras slowly twirled a scythe above her. Moving in a circle, cast members lifted and lowered an unfurled parachute around a nude Carolee Schneemann. At the film's conclusion, Henry Geldzahler, playing Rip van Winkle, woke up and walked away in a protracted take. Through August, Oldenburg produced watercolors of Proposed Colossal Monuments, later featured in *Domus* magazine in an article by Pierre Restany; subjects included a teddy bear for Central Park, a fan for Staten Island, and a banana for Times Square. Oldenburg created his first multiple editions, *Baked Potato* in an edition of 75 for Tanglewood Press and the vacuum-formed *Tea Bag* in an edition of 125 for Multiples, Inc. That fall, Oldenburg revived his drawings of female figures in a series of erotic fantasies rendered in ballpoint pen. Concurrently, he worked toward his second solo show at the

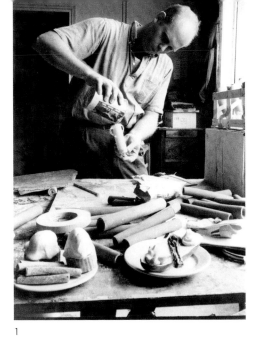

1

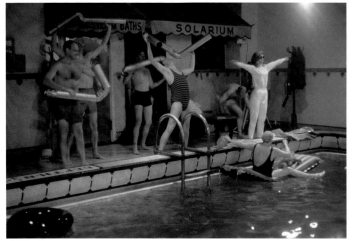

2

4

1. Oldenburg in his Paris studio, 1964
2. *Washes*, 1965
3. Oldenburg with patterns for *Bathtub* (1966) in his Fourteenth Street studio, 1965; photo by Peter Moore
4. *The Bathroom Group in a Garden Setting*, 1965
5. *"Capric"—Adapted to a Monument for a Park*, 1966

3

5

Sidney Janis Gallery, continuing the theme of the Home in drawings and sculptures in the form of bathroom fixtures and kitchen appliances, such as a toilet, a washstand, a medicine cabinet, a bathtub, a scale, a Silex Juicit, and a Dormeyer blender. The sculptures were realized in white, blue, orange, silver, and black vinyl obtained from California. In December, Oldenburg staged *Moveyhouse* at Film-Makers' Cinematheque in New York. The audience was required to stand while the performers occupied the theater seats, some wearing a mask of a mouse head combined with the profile of a movie projector. Oldenburg's stated intention was to supplant film with reality as the focus of the audience's attention. The projector ran without film, its cone of light illuminating the activity of the performers.

1966

In January, Oldenburg initiated the *Airflow* project by visiting Robert Breer's father, the inventor Carl Breer, in Detroit to research the first streamlined automobile, the Chrysler Airflow. Whereas Oldenburg remembered the Airflow from a childhood toy replica, "[Breer] had a super Airflow, which was the biggest Airflow ever made. Special tires were made just for it. . . . We took all kinds of measurements. I used Patty as a sort of ruler. I would have her lie down in front of it and take photographs and everything so that we really took measure of this car."[9] Oldenburg decided to focus on the components of the car's "anatomy"[10] he found most interesting, such as the motor, the radiator, the tires, and the horn. The works were realized in canvas impressed with enamel sprayed on corrugated cardboard panels. Tapping into his fascination with gravity as a creative determinant, Oldenburg for the first time tried rendering an object in different scales, experimenting with smaller versions of the whole car in canvas and vinyl. In March, sculptures on the theme of the Airflow and in the form of bathroom fixtures and kitchen appliances were exhibited in the

show "New Work by Claes Oldenburg" at the Sidney Janis Gallery. The show also included three-dimensional canvas maps of Manhattan postal zones and the New York City subway system, as well as Proposed Colossal Monuments for New York sites, such as a shrimp in place of Ellis Island. Oldenburg selected fifty items from the "museum of popular art, n.y.c." for a group show featuring collections by artists titled "As Found: An Experiment in Selective Seeing," organized by Ulfert Wilke at the Institute of Contemporary Art in Boston. Oldenburg catalogued the objects and treated them as art on loan. In notebooks, he formulated detailed plans for a "museum of popular objects" consisting of two wings, one for unaltered objects, the other for studio objects. His plans called for an acquisitions committee comprising Bellamy, Solomon, and Hansen; a quarterly bulletin; and a movie titled *Tour through the Museum*, in which the objects would be filmed so as to make them appear as large as sculptures in a real museum. Oldenburg produced drawings for a museum building in the shape of a "Geometric Mouse." Based on the *Moveyhouse* mask, the Geometric Mouse consists of a square and two circles to which Oldenburg added an organic appendage identified as "the nose." He also considered renting an abandoned butcher shop bearing the sign "MEATLAND" at Fourteenth Street and First Avenue to house the collection. At intervals, Oldenburg continued his erotic drawings in pencil, combining female figures with objects in large scale. In April, Oldenburg participated with Raymond Parker and Larry Rivers in a symposium moderated by Thomas Hess and sponsored by the San Francisco Art Institute to accompany the exhibition "Six from the East" at the San Francisco Museum of Art. Oldenburg returned to New York via Los Angeles, where he attended the wedding of James and Judith Elliott; as a wedding gift, he distributed a multiple of 250 cake slices cast in plaster at the Santa Monica Pier. In August, Oldenburg trav-

eled to Stockholm to prepare a survey of sculpture and drawing from 1963 to 1966, organized by Kasper König at Moderna Museet. Pontus Hultén, the director, provided studio space in the museum overlooking Niki de Saint-Phalle's formidable structure *Hon (She)*. Oldenburg produced additional work, including drawings and models of Proposed Colossal Monuments for Stockholm, such as a giant wing nut slowly rotating above a traffic circle. He made a cast-iron multiple of knäckebröd (Swedish crispbread) and created a large-scale soft sculpture in the form of a circular Swedish light switch. Banners in the shape of a saw using the colors of the Swedish flag, yellow and blue, were hung outside the museum for the opening. For the catalogue cover, Oldenburg experimented with images of the Geometric Mouse but he ultimately chose the outline of four typical Los Angeles swimming pools. At König's suggestion, the Geometric Mouse appeared on the letterhead of stationery Oldenburg printed for exhibition correspondence. The similarity between the Swedish words for mouse (*mus*) and museum (*museet*) playfully underscored the appropriateness of the image. During the show, colored Jell-O prepared in a ceramic mold of Oldenburg's face was served; titled *Life Mask*, the mold was made by the ceramicist Signe Persson-Melin from a plaster cast taken by the author and performance artist Michael Kirby. Oldenburg staged his final performance, *Massage*, at Moderna Museet on October 3, 4, 6, and 7. Asked to lie down, the audience was blindfolded, covered in blankets, and given warm frankfurters to hold while an amplified recording of Oldenburg typing grew louder and louder. In Oslo, he revisited sites recalled from childhood, such as the giant steel banana marking the pier where bananas are unloaded. From October to November, Oldenburg occupied a studio in London arranged by the Robert Fraser Gallery. He produced London-sited drawings, including *Proposed Colossal Monument for Battersea*

"Claes Oldenburg," Robert Fraser Gallery, London, November 22–December 31

Annual Exhibition 1966: "Contemporary Sculpture and Prints," Whitney Museum of American Art, New York, December 16, 1966–February 5, 1967 (group exhibition; catalogue)

1967

"Scale Models and Drawings," Dwan Gallery, New York, January 7–February 11 (group exhibition)

"Dine, Oldenburg, Segal: Painting/Sculpture," Art Gallery of Ontario, January 14–February 12 (toured to Albright-Knox Gallery, Buffalo, NY; catalogue)

"Projects for Macrostructures," Richard Feigen Gallery, New York, February 11–March 9 (group exhibition)

"Monuments, Tombstones and Trophies," Museum of Contemporary Crafts, New York, March 17–May 14 (group exhibition)

"An Exhibition of New Work by Claes Oldenburg," Sidney Janis Gallery, New York, April 26–May 27 (catalogue)

"American Sculpture of the Sixties," Los Angeles County Museum of Art, April 28–June 25 (touring group exhibition; catalogue)

"American Painting Now," United States Pavilion, Expo '67, Montreal, April 28–October 27 (group exhibition; catalogue)

"Kulch-In," Aspen Center of Contemporary Art, CO, August 15–17 (group exhibition organized with fellow resident artists Allan D'Arcangelo, Les Levine, Roy Lichtenstein, Robert Morris, DeWain Valentine, and Jonathan Williams)

IX Bienal do Museu de Arte Moderna, São Paulo: "Environment U.S.A., 1957–1967," Museu de Arte Moderna, São Paulo, September 22, 1967–January 8, 1968 (touring group exhibition; catalogue)

"Sculpture in Environment," Central Park, New York, October 1–31 (group exhibition sponsored by New York City Administration of Recreation and Cultural Affairs; catalogue)

Guggenheim International Exhibition 1967: Sculpture from Twenty Nations, Solomon R. Guggenheim Museum, New York, October 20–February 4, 1968 (group exhibition)

"Claes Oldenburg, Drawings: Projects for Monuments," Museum of Contemporary Art, Chicago, October 24–November 26 (toured to Krannert Art Museum, University of Illinois, Champaign, December 1–31)

1967 Pittsburgh International Exhibition of Contemporary Painting and Sculpture, Museum of Art, Carnegie Institute, Pittsburgh, October 27, 1967–January 7, 1968 (group exhibition; catalogue)

"Homage to Marilyn Monroe," Sidney Janis Gallery, New York, December 6–30 (group exhibition; catalogue)

1968

"Ars Multiplicata: Vervielfältigte Kunst seit 1945," Wallraf-Richartz-Museum, Cologne, January 13–April 15 (group exhibition; catalogue)

"Dada, Surrealism, and Their Heritage," Museum of Modern Art, New York, March 27–June 9 (touring group exhibition; catalogue)

"Claes Oldenburg," Irving Blum Gallery, Los Angeles, opened June 2

"Sammlung 1968 Karl Ströher," Galerie-Verein Munich, Haus der Kunst, Neue Pinakothek, Munich, June 14–August 9 (touring group exhibition; catalogue)

Documenta 4, Museum Fridericianum, Orangerie im Auepark, Galerie an der Schönen Aussicht, Kassel, June 27–October 6 (group exhibition; catalogue)

XXXIV Esposizione Biennale Internazionale d'Arte Venezia: "Linee della ricera: dall'informale alle nuove strutture," Padiglione Centrale, Venice, June 22–October 20 (group exhibition; catalogue)

"Earth Works," Dwan Gallery, New York, October 5–30 (group exhibition with Carl Andre, Herbert Bayer, Walter De Maria, Michael Heizer, Stephen Kaltenbach, Sol LeWitt, Robert Morris, Dennis Oppenheim, and Robert Smithson)

"Richard J. Daley," Richard Feigen Gallery, Chicago, September–October (touring group exhibition; catalogue)

"The Machine as Seen at the End of the Mechanical Age," Museum of Modern Art, New York, November 25, 1968–February 9, 1969 (touring group exhibition; catalogue)

1968 Annual Exhibition: "Contemporary American Sculpture," Whitney Museum of American Art, New York, December 17, 1968–February 9, 1969 (group exhibition)

1969

"New York 13," Vancouver Art Gallery, January 21–February 16 (touring group exhibition; catalogue)

"Concrete Poetry," Fine Arts Gallery, University of British Columbia, Vancouver, March 28–April 18 (group exhibition; catalogue)

"Superlimited: Books, Boxes and Things," Jewish Museum, New York, April 16–June 29 (group exhibition; catalogue)

"Claes Oldenburg: Constructions, Models, and Drawings," Richard Feigen Gallery, Chicago, April 30–May 31 (catalogue)

"7 Artists: Dine, Fahlström, Kelly, Marisol, Oldenburg, Segal, Wesselmann," Sidney Janis Gallery, New York, May 1–31 (catalogue)

"Pop Art Redefined," Hayward Gallery, London, July 9–September 3 (group exhibition; catalogue)

"Claes Oldenburg," Museum of Modern Art, New York, September 25–November 23 (toured to Stedelijk Museum, Amsterdam, January 16–March 15, 1970, Städtische Kunsthalle Düsseldorf, April 15–May 24, 1970, and Tate Gallery, London, June 24–August 16, 1970; catalogue)

"The Spirit of the Comics," Institute of Contemporary Art, University of Pennsylvania, Philadelphia, October 1–November 9 (group exhibition; catalogue)

"New York Painting and Sculpture: 1940–1970," Metropolitan Museum of Art, New York, October 18, 1969–February 1, 1970 (group exhibition; catalogue)

"Art by Telephone," Museum of Contemporary Art, Chicago, November 1–December 14 (group exhibition; catalogue)

"Dubuffet and the Anticulture," Richard Feigen & Co., New York, November 25, 1969–January 3, 1970 (group exhibition; catalogue)

PERFORMANCES & FILMS

PERFORMANCES 1960–1969

Snapshots from the City, Judson Gallery, Judson Memorial Church, New York, February 29–March 2, 1960
Performers: Patty Mucha, Claes Oldenburg, and Lucas Samaras

Blackouts, Reuben Gallery, New York, December 16–18, 1960
Performers: Patty Mucha and Claes Oldenburg.
Light and sound: Max Baker

Circus (Ironworks/Fotodeath), Reuben Gallery, New York, February 21–26, 1961
Performers: Olga Adorno, Edgar Blakeney, Henry Geldzahler, Gloria Graves, Marilyn Jaffee, Carl Lehmann-Haupt, Chippy McKellen, Patty Mucha, Claes Oldenburg, Lucas Samaras, Claire Selley, Clifford Smith, Judy Tirsch, and Tom Wesselmann.
Light and sound: Max Baker

RAY GUN THEATER, *The Store*, New York, February 23–May 26, 1962

Store Days I, February 23–24
 Performers: Milet Andreyevich, Terry Brook, Lette Eisenhauer, Gloria Graves, Mickey Henrion, Billy Klüver, Johanna Lawrenson, Jean-Jaques Lebel, Patty Mucha, Claes Oldenburg, Lucas Samaras, and Carolee Schneemann
Store Days II, March 2–3
 Performers: Cora Baron, Rachel Drexler, Jackie Ferrara, Henry Geldzahler, Gloria Graves, Patty Mucha, Claes Oldenburg, Lucas Samaras, and Charlotte Tokayer
Nekropolis I, March 9–10
 Performers: Claes Oldenburg, Patty Mucha, and Lucas Samaras
Nekropolis II, March 16–17
 Performers: Milet Andreyevich, Öyvind Fahlström, Irene Fornés, Maricla Moyano, Patty Mucha, Claes Oldenburg, John Rublowsky, and Lucas Samaras

Injun I, April 20–21
 Performers: Terry Brook, Lette Eisenhauer, Patty Mucha, Claes Oldenburg, and Lucas Samaras
Injun II, April 27–28
 Performers: Cora Baron, Lette Eisenhauer, Edward Epstein, Patty Mucha, Claes Oldenburg, and Lucas Samaras
Voyages I, May 4–5
 Performers: Milet Andreyevich, Cora Baron, Barbara Dilley, Irene Fornés, Patty Mucha, Claes Oldenburg, and Lucas Samaras
Voyages II, May 11–12
 Performers: Dominic Capobianco, Jackie Ferrara, Patty Mucha, Claes Oldenburg, and Lucas Samaras
World's Fair I, May 18–19
 Performers: Patty Mucha, Claes Oldenburg, Mia Rublowski, Lucas Samaras, Nickky [—], and Robert [—]
World's Fair II, May 25–26
 Performers: Dominic Capobianco, Lette Eisenhauer, Patty Mucha, Claes Oldenburg, Lucas Samaras, and John Weber

Injun, Dallas Museum for Contemporary Arts, April 6–7, 1962
Performers: Russell Adams, Ronnie Cole, Jim Daugirda, Howard Doolittle, Nancy Ellison, Janie Grisham, Martha Hamm, Carolyn Higginbotham, Joseph Hobbs, Sue Jacobson, Joan Key, Paul Koeppe, Arthur McKnight, Gart McVean, Patty Mucha, Claes Oldenburg, Harold Pauley, Flora Reeder, Dennis Taylor, Peggy Wilson, Scott Wilson, Jim Woodson, Edward Zelenak

Sports, Green Gallery, New York, October 5, 1962
Performers: Patty Mucha, Claes Oldenburg, and Lucas Samaras

Gayety, Lexington Hall, University of Chicago, Chicago, February 8–10, 1963
Performers: Martha Ansara, Ann Bardacke, Harry Bouras, Lorraine Bouras, Peter Butterfield, Mary Davis, Norman Dayron, Barbara Dickerson, Ted Dickerson, Len Frazer, Kurt Hayl, George Kokines, Rosemary Kreinhofner, Dan Lyon, Patty Mucha, Toni Robinson, David Root, David Roth, Dan Russ, Ellen Sellenraad, Johan Sellenraad, John Snowday, Vern Zimmerman, and Roger Zoss

Stars: A Farce for Objects, Washington Gallery of Modern Art, Washington, DC, April 24–25, 1963
Performers: Olga Adorno, Thomas Bartlett, Cathleen Bingham, Michael Booth, Gil Carther, Chris Denney, Jill Denney, Joan Fugazzi, Fred Goldfrank, Gloria Graves, Chris Harris, Grail Hillow, Ed Kelley, Charles Lilly, Joan Mason, Patty Mucha, Alan Raywid, Rette Rickerson, Thomas Roberts, Cindy Warren, and Clarence Wheat

Autobodys, parking lot of the American Institute of Aeronautics and Astronautics, Los Angeles, December 9–10, 1963
Performers: Tony Berlant, John Dagget, Ken Dillon, Tom Etherton, Charles Frazier, Judy Gerowitz, Dejon Greene, Lloyd Hamrol, Nancy Hamrol, Jim Howell, Richard Mathews, Bobbie Neiman, Rolf Nelson, Claes Oldenburg, Patty Mucha, John Romeyn, Deborah Sussman, John Weber, Laurie Weber, and Santos Zuniga

Washes, performance at Al Roon's Health Club, New York, part of First New York Theater Rally, May 22–23, 1965
Performers: Richard Artschwager, Sarah Dalton, Martha Edelheit, Lette Eisenhauer, Helene Faison, Jackie Ferrara, Nancy Fish, Henry Geldzahler, Gloria Graves, Al Hansen, Alex Hay, Deborah Hay, Geoffrey Hendricks, Jon Hendricks, Michael Kirby, Barbara Lloyd, Patty Mucha, Yvonne Mulder, Annina Nosei, Richard Oldenburg, Dorothea Rockburne, Barbara Rose, Lucas Samaras, Raymond Saroff, Marjorie Strider, Elaine Sturtevant, David Whitney, and Rudy Wurlitzer

Piece for Telephone, Program 7, TV Studio, New York, May 24–26, 1965
Claes Oldenburg calls a telephone on the stage to speak to the audience from outside the theater and nobody answers it

Moveyhouse, performance at the Forty-First Street Theatre as part of the Film-Makers' Cinematheque Festival, New York, December 1–3, 16–17, 1965
Performers: Dominic Capobianco, Lette Eisenhauer, Jo Eno, John Jones, Fred Mueller, Patty Mucha, Claes Oldenburg, Ellen Sellenraad, and Johan Sellenraad.
Piano: Liz Stevens

Massage, Moderna Museet, Stockholm, October 3–4, 6–7, 1966
Performers: István Almay, Gabrielle Björnstrand, Olle Granath, Six Maix, Claes Oldenburg, Patty Mucha, Mette Prawitz, and Rico Weber

FILMS

Snapshots of the City, 1960
Film of the performance *Snapshots from the City* at Judson Gallery, New York, 1960, by Stan VanDerBeek
16 mm, black/white, sound, 5 min.
Distributed by Film-Makers' Cooperative, New York

Fotodeath, 1961
Film of the performance *Circus (Ironworks/ Fotodeath)* at Reuben Gallery, New York, 1961, by Al Kouzel
16 mm, black/white, silent, 12 min.
Not distributed

Injun, 1962
Film of the performance at Dallas Museum for Contemporary Arts, 1962, by Roy Fridge; produced by Dallas Museum for Contemporary Art
16 mm, black/white, sound, 12 min.
Not distributed

Pat's Birthday, 1962
Film of events arranged by Oldenburg, Palisades, New York, 1962, by Robert Breer
16 mm, black/white, sound, 13 min.
Distributed by Film-Makers' Cooperative, New York

Scarface and Aphrodite, 1963
Film of the performance *Gayety* at Lexington Hall, University of Chicago, 1963, by Vernon Zimmerman
16 mm, black/white, sound, 15 min.
Distributed by Film-Makers' Cooperative, New York

Autobodys, 1963
Film of the performance, Los Angeles, 1963
16 mm, black/white, silent, 20 min.
Not distributed

Birth of the Flag I, II, 1974
Film of events arranged by Oldenburg, New York state, 1965, by Stan VanDerBeek, Diane Rochlin, and Sheldon Rochlin; edited by Lana Jokel, produced by Rudy Wurlitzer
16 mm, black/white, silent, two parts, 19 min., each
Not distributed

USA: Artists: Claes Oldenburg, 1966
Documentary by Alan Solomon; narrated by Jim Dine, produced by Lane Slate for National Educational Television, Channel 13, New York
16 mm, black/white, sound, 29 min.
Not distributed

Hole, 1967
Film of the project *Placid Civic Monument* in Central Park, New York, 1967, by Claes Oldenburg
Super 8 mm film to be screened at 5 fps, color, silent, 20 min.
Not distributed

Colossal Keepsake No. I, 1969, 1969
Film of the construction and installation of *Lipstick (Ascending) on Caterpillar Tracks*, Yale University, New Haven, 1969, by Peter Hentschel and Bill Richardson
16 mm, black/white and color, sound, 20 min.
Not distributed

Sort of a Commercial for an Icebag, 1969
Documentary by Michel Hugo; camera by Eric Saarinen, edited by John Hoffman, sound by Howard Chesley, produced by Gemini G.E.L.,

Los Angeles
16 mm, color, sound, 20 min.
Distributed by Gemini G.E.L., Los Angeles, and Museum of Modern Art, New York

Possibly a Special for the Bag, 1970
Documentary by Michael Hugo; camera by Eric Saarinen, edited by John Hoffman, sound by Howard Chesley, produced by Gemini G.E.L., Los Angeles
16 mm, color, sound, 30 min.
Distributed by Gemini G.E.L., Los Angeles

The Great Ice Cream Robbery and *Claes Oldenburg Retrospective: Tate Gallery, London, 1970*, 1970
Documentaries by James Scott; camera by Adam B. Mill, produced by Arts Council of Great Britain
16 mm double projection, color, sound, 35 min.
Not distributed

Claes Oldenburg, The Formative Years, 1973–74
Documentary by Michael Blackwood; camera by Christian Blackwood, Nicholas Proferes, and Seth Schneidman, edited by Lana Jokel, sound by James Musser, production manager Stephen Westheimer, produced by Blackwood Productions, New York
16 mm, color, sound, 52 min.
Distributed by Blackwood Productions, New York

Ray Gun Theater 1962, a Film by Raymond Saroff, 1995
Film of Ray Gun Theater performances, 107 East Second Street, New York, 1962, by Raymond Saroff
Video, black/white, silent, ca. 120 min.
Distributed by McPherson and Company, Kingston, New York

SELECTED BIBLIOGRAPHY
CLAES OLDENURG: THE SIXTIES

Books and Catalogues by Claes Oldenburg

Injun and Other Histories (1960). New York: A
 Great Bear Pamphlet, 1966.
Store Days. New York: Something Else, 1967.
Notes. Los Angeles: Gemini G.E.L., 1968.
Claes Oldenburg: Notes in Hand. New York: E. P.
 Dutton; London: Petersburg Press, 1971.
More Ray Gun Poems 1960. Philadelphia:
 Moore College of Art, 1973.
Raw Notes. Edited by Kasper König. Halifax:
 Press of the Nova Scotia College of Art and
 Design, 1973.

Articles and Statements by Claes Oldenburg

Accompanying texts for Fred McDarrah's
 photographs of *Snapshots from the City. Beat
 Coast East: An Anthology of Rebellion*, edited by
 Stanley Fisher, pp. 33. New York: Excelsior
 Press, 1960.
"Portfolio and Three Poems." *Exodus* 3
 (Spring–Summer 1960), pp. 73–80.
"New Talent USA." *Art in America* 50, no. 1
 (January 1962), p. 33.
"The Artists Say: Claes Oldenburg." *Art Voices*
 4, no. 3 (Summer 1965), pp. 62–63.
"Fotodeath/Washes." *Tulane Drama Review* 10,
 no. 2 (Winter 1965), pp. 85–93, 108–18.
"A Statement," pp. 200–3; "Injun: The Script,"
 pp. 204–6; "World's Fair II: The Script,"
 pp. 220–22; "Gayety: The Script," pp. 234–40;
 "Autobodys: The Script," pp. 262–71. In
 Happenings: An Illustrated Anthology, edited by
 Michael Kirby. New York: E. P. Dutton, 1965.
"Extracts from the Studio Notes (1962–64)."
 Edited by Max Kozloff. *Artforum* 4, no. 5
 (January 1966), pp. 32–33.
"The Airflow—Top and Bottom, Front, Back
 and Sides, with Silhouette of the Inventor;
 to Be Folded into a Box." *Art News* 64, no. 10
 (February 1966), cover.
"Afterthoughts." *Konstrevy*, no. 5–6
 (November–December 1966), pp. 214–20.

"Portfolio: 4 Sculptors." *Perspecta*, no. 11
 (1967), pp. 44–53.
"Egomessages about Pollock." In "Jackson
 Pollock: An Artist's Symposium, Part II."
 Art News 66, no. 3 (May 1967), p. 27.
"America: War & Sex, Etc." *Arts Magazine* 41,
 no. 8 (Summer 1967), cover, pp. 32–38.
"Statement." In "Hommage to the Square."
 Edited by Lucy Lippard. *Art in America* 55,
 no. 4 (July–August 1967), pp. 50–57.
"Some Program Notes about Monuments,
 Mainly." *Chelsea*, no. 22–23 (June 1968),
 pp. 87–92.
"About the Famous Toronto Drainpipe."
 Artscanada 25, no. 3 (August 1968),
 pp. 40–41.
"Claes Oldenburg: Fireplugs." *Design
 Quarterly*, no. 74–75 (1969), n.p.
"Statement." In *Dubuffet and the Anticulture*,
 exh. cat., pp. 13. New York: Richard L.
 Feigen & Co., 1969.
"My Very Last Happening." *Esquire*,
 May 1969, pp. 154–57.
"Notes on the Lipstick Monument." *Novum
 Organum*, no. 7 (May 15, 1969), n.p.
"Bedroom Ensemble, Replica I." *Studio
 International* 178, no. 913 (July–August
 1969), pp. 2–3.
"Claes Oldenburg: Postcard 8/23/69." *Art
 Now: New York* 1, no. 8 (October 1969), n.p.
"Statements." *Museumjournaal* 15, no. 2
 (April 1970), pp. 72–76.
"Oldenburg: weicher Golem." *Der Spiegel*,
 April 20, 1970, pp. 212, 215, 218, 219.
"Chronology of Drawings." *Studio International*
 179, no. 923 (June 1970), pp. 249–53.
"Letter to Maurice Tuchman, Jan. 27, 1969."
 In "An Introduction to 'Art and Technology.'"
 Edited by Maurice Tuchman. *Studio
 International* 181, no. 932 (April 1971),
 pp. 176–77.
"Claes Oldenburg: Collecting Ray Guns in
 New York." *Vision* 3 (November 1976),
 pp. 22–25.
"The Double-Nose/Purse/Punching Bag/
 Ashtray." *Tracks* 2, no. 1 (Winter 1976),
 pp. 5–10.

Interviews with Claes Oldenburg

Pincus-Witten, Robert. "The Transformation
 of Daddy Warbucks: An Interview with Claes
 Oldenburg." *Chicago Scene* 4, no. 4
 (April 1964), pp. 34–38.
McDevitt, Jan. "Object: Still Life, Interviews
 with the New Object Makers, Richard
 Artschwager and Claes Oldenburg, on
 Craftsmanship, Art, and Function." *Craft
 Horizons* 25, no. 5 (September 1965),
 pp. 28–32, 55–56.
"Waldorf Panel 2" (discussion between Isamu
 Noguchi, Claes Oldenburg, Phillip Pavia,
 George Segal, George Sugarman, and
 James Wines). *It Is* (Fall 1965), pp. 77–80,
 110–13.
Schilling, Alfons. "'Bau' Interview with Claes
 Oldenburg." *Bau* 4 (1966), pp. 83–87.
Glaser, Bruce. "Oldenburg, Lichtenstein,
 Warhol: A Discussion." *Artforum* 4, no. 6
 (February 1966), pp. 20–24.
Baro, Gene. "Oldenburg's Monuments."
 Art and Artists 1, no. 9 (December 1966),
 pp. 28–31.
Fraser, Robert. "London: Male City."
 International Times, December 12, 1966.
Gablik, Suzi. "Take a Cigarette Butt and Make
 It Heroic." *Art News* 66, no. 3 (May 1967),
 pp. 30–31, 77.
Kostelanetz, Richard. "Interview with Claes
 Oldenburg." In *The Theater of Mixed Means*.
 New York: Dial, 1968.
Coplans, John. "The Artist Speaks: Claes
 Oldenburg." *Art in America* 57, no. 2 (March
 1969), pp. 68–75.
Siegel, Jeanne. "How to Keep Sculpture Alive
 in and out of a Museum: An Interview with
 Claes Oldenburg on His Retrospective
 Exhibition at the Museum of Modern Art."
 Arts Magazine 44, no. 1 (September–October
 1969), pp. 24–28.
"Vielleicht wäre ich so verrückt, Spiegel-
 Interview mit Claes Oldenburg." *Der Spiegel*,
 April 20, 1970, p. 217.
Reaves, Angela Westwater. "Claes Oldenburg,
 an Interview." *Artforum* 21, no. 2 (October
 1972), pp. 36–39.
Rose, Barbara. "New York Is an Oldenburg

Festival." *New York Magazine*, May 6, 1974, pp. 91–95.

Friedman, Martin. "Claes Oldenburg." In *Oldenburg: Six Themes*, exh. cat., pp. 25–95. Minneapolis: Walker Art Center, 1975.

Bach, Friedrich. "Interview mit Claes Oldenburg." *Das Kunstwerk* 28, no. 3 (May 1975), pp. 3–13.

Brown, Kathan. "About California." *Vision* 1 (September 1975), pp. 5–7.

Slavutski, Victoria. "El broche más grande del mundo." *La Opinión Cultural*, September 19, 1976, pp. 2–5.

Beeke, Anna. "Het Formaat van Claes Oldenburg." *Hollands Diep* 3, no. 9 (May 7, 1977), pp. 44–47.

Bourdon, David. "Artist's Dialogue: A Conversation with Claes Oldenburg." *Architectural Digest* 39, no. 6 (June 1982), pp. 164, 168, 170, 172.

Hapgood, Susan. "Claes Oldenburg." In *Neo-Dada, Redefining Art 1958–62*, edited by Hapgood, pp. 123–29. New York: American Federation of Arts/Universe, 1994.

Buchloh, Benjamin H. D. "Claes Oldenburg: A Conversation in 1985." *October*, no. 70 (Autumn 1994), pp. 33–36.

Jocks, Heinz-Norbert. "Claes Oldenburg: 'Hinter meinen Bemühungen steht der Wunsch, auszutesten, wann etwas anfängt, Kunst zu sein.'" *Kunstforum International*, no. 134 (May–September 1996), pp. 268–91.

Sylvester, David. "BBC Interview (1965)." In *Interviews with American Artists*, pp. 203–4. New Haven, CT: Yale University Press, 2001.

Books and Catalogues on Claes Oldenburg

Claes Oldenburg, exh. cat. Paris: Galerie Ileana Sonnabend, 1964. With a text by Otto Hahn; French.

Exhibition of Recent Work by Claes Oldenburg, exh. cat. New York: Sidney Janis Gallery, 1964.

Claes Oldenburg: Skulpturer och teckningar, exh. cat. Stockholm: Moderna Museet, 1966. With texts by Öyvind Fahlström, Ulf Linde, and Claes Oldenburg; English and Swedish.

New Work by Oldenburg, exh. cat. New York: Sidney Janis Gallery, 1966. With a text by Claes Oldenburg.

An Exhibition of New Works by Claes Oldenburg, exh. cat. New York: Sidney Janis Gallery, 1967.

Baro, Gene. *Claes Oldenburg: Drawings and Prints*. Lausanne: Publications I.R.L.; London: Chelsea House Publishers, 1969.

Claes Oldenburg: Constructions, Models, and Drawings, exh. cat. Chicago: Richard Feigen Gallery, 1969. With a text by Claes Oldenburg.

Claes Oldenburg: Proposals for Monuments and Buildings, 1965–1969. Chicago: Big Table, 1969. With an interview of Claes Oldenburg by Paul Carroll.

Claes Oldenburg, exh. cat. New York: Museum of Modern Art, 1970. With texts by Claes Oldenburg and Barbara Rose. Additional catalogues were published at subsequent stations of the touring exhibition: Amsterdam: Stedelijk Museum, 1970. With texts by Alice Legg, and Claes Oldenburg; English and Dutch. Düsseldorf: Städtische Kunsthalle Düsseldorf, 1970. With texts by Gene Baro, Öyvind Fahlström, Alicia Legg, and Claes Oldenburg; German. London: Arts Council of Great Britain, 1970. With texts by Alice Legg and Claes Oldenburg (exh. cat. of Tate Gallery exhibition).

New Work by Claes Oldenburg, exh. cat. New York: Sidney Janis Gallery, 1970. With a text by Claes Oldenburg.

Claes Oldenburg: Object into Monument, exh. cat. Pasadena, CA: Pasadena Art Museum, 1971. With texts by Barbara Haskell and Claes Oldenburg.

Claes Oldenburg: Works in Edition, exh. cat. Los Angeles: Margo Leavin Gallery, 1971.

Johnson, Ellen H. *Claes Oldenburg*. New York: Penguin Books (New Art 4), 1971.

Kerber, Bernhard. *Claes Oldenburg: Schreibmaschine*. Stuttgart: Phillip Reclam, 1971.

Oldenburg's Giant Three-Way Plug at Oberlin, exh. cat. Oberlin, OH: Allen Memorial Museum, 1971. With a text by Ellen H. Johnson.

Maus Museum: Eine Auswahl von Objekten gesammelt von Claes Oldenburg/Mouse Museum: A Selection of Objects Collected by Claes Oldenburg, exh. cat. Kassel: Documenta, 1972. With a text by Kasper König; German and English. (Supplement to Documenta 5 catalogue.)

The Lipstick Comes Back, exh. cat. New Haven, CT: Yale University Art Gallery, 1974. With a text by Susan P. Casteras.

Claes Oldenburg: The Alphabet in L.A., exh. cat. Los Angeles: Margo Leavin Gallery, 1975. With texts by Helen Ferulli and Claes Oldenburg.

Oldenburg: Six Themes, exh. cat. Minneapolis: Walker Art Center, 1975. With an introduction and an interview of Claes Oldenburg by Martin Friedman.

Zeichnungen von Claes Oldenburg, exh. cat. Tübingen: Kunsthalle Tübingen; Basel: Kunstmuseum Basel, 1975. With texts by Götz Adriani, Dieter Koepplin, and Barbara Rose; German.

Claes Oldenburg, exh. cat. Delft: Stedelijk Museum, 1977. With texts by Ank Leeuw-Marcar and Claes Oldenburg; Dutch.

Claes Oldenburg: Mouse Museum, Ray Gun Wing, exh. cat. Chicago: Museum of Contemporary Art, 1977. With a text by Judith Russi Kirshner and a chronology by Claes Oldenburg.

Claes Oldenburg: Tekeningen, aquarellen en grafiek, exh. cat. Amsterdam: Stedelijk Museum; Paris: Musée National d'Art Moderne, Centre Georges Pompidou; Stockholm: Moderna Museet, 1977. With a text by Coosje van Bruggen; respectively English and Dutch; French; English and Swedish.

Claes Oldenburg: Mouse Museum/Ray Gun Wing, exh. cat. Cologne: Museum Ludwig, 1979. With a text by Coosje van Bruggen; English, German, and Dutch.

Claes Oldenburg: Dibujos/Drawings 1959–1989, exh. cat. Valencia: IVAM, Instituto Valenciano de Arte Moderno, 1989. With texts by Coosje van Bruggen and Claes Oldenburg; English and Spanish.

Claes Oldenburg: 8 Sculptures 1961–1987, exh. cat. London: Mayor Gallery, 1990. With a text by John McEwen.

Claes Oldenburg: Multiples in Retrospect 1964– 1990. New York: Rizzoli, 1991. With texts by Thomas Lawson, Claes Oldenburg, and Arthur Solway, and a catalogue raisonné by David Platzker.

Claes Oldenburg: Nur ein anderer Raum, exh. cat. Frankfurt am Main: Museum für Moderne Kunst, 1991. With a text by Coosje van Bruggen; English and German.

Ginsberg, Susan. "Claes Oldenburg: Sculpture 1960–1968; a Catalogue Raisonné." Ph.D. diss., City University of New York, 1991.

Claes Oldenburg, exh. cat. New York: Pace Gallery, 1992. With an interview of Claes Oldenburg by Arne Glimcher.

Claes Oldenburg: Die frühen Zeichnungen, exh. cat. Basel: Öffentliche Kunstsammlung Basel, 1992. With texts by Dieter Koepplin and Claes Oldenburg.

Claes Oldenburg: Multiples 1964–1990, exh. cat. Frankfurt: Portikus; Munich: Städtische Gallerie im Lenbachhaus; Vienna: Hochschule für angewandte Kunst, 1992. With a text by Thomas Lawson; German.

Claes Oldenburg: Multiples and Notebook Pages, exh. cat. Tel Aviv: Tel Aviv Museum of Art, 1994. With a text by Edna Moshenson; English and Hebrew.

Claes Oldenburg: An Anthology, exh. cat. New York: Guggenheim Museum Publications, 1995. With texts by Germano Celant, Dieter Koepplin, Marla Prather, and Mark Rosenthal.

Axsom, Richard H. *Printed Stuff: Prints, Posters, and Ephemera by Claes Oldenburg; a Catalogue Raisonné 1958–1996*. Madison, WI: Madison Art Center, 1997. With texts by Richard H. Axsom and David Platzker.

Distel, Hans. *Claes Oldenburg's Lipstick (Ascending) on Caterpillar Tracks*. Freiburg im Breisgau: Rombach Verlag, 1999.

Claes Oldenburg Drawings, 1959–1977; Claes Oldenburg with Coosje van Bruggen Drawings, 1992–1998 in the Whitney Museum of American Art, exh. cat. New York: Whitney Museum of American Art, 2002. With a text by Janie C. Lee.

Claes Oldenburg: Early Work, exh. cat. New York: Zwirner & Wirth, 2005. With a text by Julia E. Robinson.

Articles on Claes Oldenburg

Burg, Copeland C. "Institute Show Stirs Grumble." *Chicago American*, November 6, 1954.

Dunsterville, Hilary. "Art Reviews: Claes Oldenburg." *Villager*, June 4, 1959, p. 10.

Levin, Eli. "Young Artist's Work Has Intimate Quality." *Patriot Ledger*, November 17, 1959.

Tallmer, Jerry. "Theater(?): Three New Happenings." *Village Voice*, January 13, 1960.

"'Happenings': Art in a New Medium." *Cooper Union Pioneer*, February 11, 1960.

Kiplinger, Suzanne. "Ray Gun." *Village Voice*, February 17, 1960, p. 11.

Seelye, Anne. "Reviews and Previews: New Names This Month: Ray Gun." *Art News* 59, no. 1 (March 1960), p. 18.

Tuten, Frederic. "Up-Beats." *Time*, March 14, 1960, p. 80.

Krim, Seymour. "An Art for Downtown Persons?" *Village Voice*, March 23, 1960, pp. 4, 6.

Sandler, Irving. "Reviews and Previews: Reuben Gallery." *Art News* 59, no. 4 (Summer 1960), p. 16.

Tillim, Sidney. "Claes Oldenburg." *Art News* 59, no. 4 (Summer 1960), p. 53.

Sandler, Irving. "Ash Can Revisited, a New York Letter." *Art International* 4, no. 8 (October 25, 1960), pp. 28–30.

Petersen, Valerie. "Reviews and Previews: 'Varieties' at Reuben Gallery." *Art News* 59, no. 10 (February 1961), p. 16.

Nicholas, Robert. "Entertainment: Ironworks Fotodeath." *Village Voice*, March 2, 1961, p. 10.

Johnston, Jill. "Art without Walls: Claes Oldenburg." *Art News* 60, no. 2 (April 1961), pp. 36, 57.

Johnston, Jill. "'Environments' at Martha Jackson's." *Village Voice*, July 6, 1961, p. 13.

Kroll, Jack. "Reviews and Previews: Situations and Environments at Jackson Gallery." *Art News* 60, no. 5 (September 1961), p. 16.

Johnston, Jill. "Claes Oldenburg." *Art News* 60, no. 9 (January 1962), p. 60.

Tillim, Sidney. "Month in Review: The Store." *Arts Magazine* 36, no. 5 (February 1962), pp. 34–37.

Porter, Bob. "Art Notes: New Yorker Brings 'Store.'" *Dallas Times Herald*, March 28, 1962.

Geist, Sidney. "A Number of Things." *Scrap*, no. 7 (April 6, 1962), pp. 1–3.

Johnston, Jill. "Off Off-B'Way: 'Happenings' at Ray Gun Mfg. Co." *Village Voice*, April 26, 1962, p. 10.

Johnston, Jill. "Reviews and Previews: Happenings at the Store." *Art News* 61, no. 3 (May 1962), p. 55.

Hansen, Al. "New Trends in Art: Ray Gun Theatre." *Prattler*, May 4, 1962, p. 4.

Mayer, Robert. "Strange Things Are Just Happening." *Newsday*, May 7, 1962, section C, p. 1.

Mays, Stan. "Well, for Art's Sake! It's Called a Happening in Crazy Greenwich Village." *Daily Mirror*, May 18, 1962, p. 15.

Askew, Rual. "Reviews: Dallas." *Artforum* 1, no. 1 (June 1962), p. 7.

Lamkin, Marguerite. "New York Newsletter: Hamburger." *Evening Standard*, September 12, 1962.

Fried, Michael. "New York Letter." *Art International* 6, no. 8 (October 25, 1962), pp. 72–76.

Ashton, Dore. "Exhibitions at Green Gallery." *Das Kunstwerk*, no. 16 (November 1962), p. 70.

Johnston, Jill. "Reviews and Previews: Green Gallery." *Art News* 61, no. 7 (November 1962), p. 13.

Preston, Stuart. "Current and Forthcoming Exhibitions: New York." *Burlington Magazine* 104, no. 716 (November 1962), p. 508.

Tillim, Sidney. "Month in Review: Green Gallery." *Arts Magazine* 37, no. 2 (November 1962), pp. 36–38.

Kramer, Hilton. "Art: New Realists at Sidney Janis." *The Nation*, November 17, 1962.

Rosenberg, Harold. "The Art Galleries: The Game of Illusion." *New Yorker*, November 24, 1962, pp. 161–67.

Rudikoff, Sonya. "New York Letter." *Art International* 6, no. 9 (November 25, 1962), p. 62.

Hess, Thomas. "Reviews and Previews: 'New Realists' at Sidney Janis." *Art News* 61, no. 8 (December 1962), pp. 12–13.

Johnson, Ellen H. "Is Beauty Dead?" *Allen Memorial Art Museum Bulletin* 20, no. 2 (1963), pp. 56–65.

Ashton, Dore. "High Tide for Assemblage: New York Commentary." *Studio* 165 (January 1963), pp. 25–26.

Ashton, Dore. "New York Letter." *Das Kunstwerk* 16, no. 7 (January 1963), p. 32.

Kilpatrick, Bill. "Happenings Are Strange Things." *The Dude* (January 1963), pp. 23–24.

Johnson, Ellen H. "The Living Object." *Art International* 7, no. 1 (January 25, 1963), pp. 42–45.

Middleton, Mary. "'Happenings' to Happen Here." *Chicago Daily Tribune*, February 2, 1963, p. 13.

O'Hara, Frank. "Art Chronicle." *Kulchur* 3, no. 9 (Spring 1963).

Seckler, Dorothy Gees. "The Audience Is His Medium!" *Art in America* 51, no. 2 (April 1963), pp. 62–67.

Canady, John. "Art: By Claes Oldenburg; an Exhibition of Food and Other Things at the Sidney Janis Gallery." *New York Times*, April 7, 1964, p. 32.

Canady, John. "Maybe Hopeful: Symptoms in a New Pop Exhibition." *New York Times*, April 12, 1964, section 2, p. 19.

Buchwald, Art. "Anything Can Happen." *New York Herald Tribune*, April 16, 1963, p. 21.

"Happenings: Pop Culture." *Time*, May 3, 1963, p. 73.

"It Happened in Washington—but What?" *Newsweek*, May 6, 1963, p. 25.

Ashbery, John. "Paris Notes." *Art International* 7, no. 6 (June 25, 1963), pp. 76–77.

Restany, Pierre. "Une Tentative américaine de synthèse de l'information artistique: Les Happenings." *Domus*, no. 405 (August 1963), pp. 35–42.

Seldis, Henry J. "In the Galleries: Dial $1-0-0-0 for Plastic Payphone." *Los Angeles Times*, October 11, 1963, section V, p. 8.

Berman, Arthur M. "Venice Artist Spotlights Commonplace Objects." *Los Angeles Times*, November 3, 1963, section C, p. 4.

Canady, John. "Hello, Goodbye: A Question about Pop Art's Staying Power." *New York Times*, January 12, 1964.

Kozloff, Max. "Art." *The Nation* 198, no. 5 (January 27, 1964), pp. 107–8.

Nordland, Gerald. "Marcel Duchamp and Common Object Art." *Art International*, February 1964, pp. 30–32.

Swenson, G. R. "Reviews and Previews: Four Environments at Janis Gallery." *Art News* 62, no. 10 (February 1964), p. 8.

Canaday, John. "Art: By Claes Oldenburg." *New York Times*, April 7, 1964.

Canaday, John. "Maybe Hopeful: Symptoms in a New Pop Exhibition." *New York Times*, April 12, 1964.

Genauer, Emily. "The Large Oldenburgs and Small Van Goghs." *Herald Tribune*, April 13, 1964, p. 30.

Norland, Gerald. "A Succession of Visitors." *Artforum* 2, no. 12 (Summer 1964), pp. 64–68.

O'Doherty, Brian. "Artist as Performer: Which Means New Criteria for Art." *New York Times*, August 23, 1964, section X, p. 18.

Judd, Donald. "In the Galleries: Janis Gallery." *Arts Magazine* 38, no. 10 (September 1964), p. 63.

Bourdon, David. "Claes Oldenburg." *Konstrevy* 40, nos. 5–6 (November–December 1964), pp. 164–69.

Judd, Donald. "Specific Objects." *Arts Yearbook*, no. 8 (1965), pp. 74–78.

França, J.-A. "Expositions à Paris: Claes Oldenburg." *Aujourd'hui*, January 1965, p. 86.

Hess, Thomas. "The Disrespectful Hand-Maiden." *Art News* 63, no. 9 (January 1965), pp. 38–41.

Restany, Pierre. "Une Personnalité charnière de l'art américain: Claes Oldenburg, premières oevres." *Metro*, no. 9 (March–April 1965), pp. 20–26.

Factor, Don. "Los Angeles Drawings by Dine, Oldenburg, Talbert and Whitman at Dwan Gallery." *Artforum* 3, no. 7 (April 1965), p. 9.

Billeter, Erika. "Atelierbesuche bei fünf New Yorker Malern: Claes Oldenburg." *Speculum Artis* 17, no. 9 (September 1965), pp. 34–38.

Geldzahler, Henry. "Happenings: Theater by Painters." *Hudson Review* 18, no. 4 (Winter 1965–66), pp. 581–86.

Restany, Pierre. "Claes Oldenburg 1965 e i disegni di 'Monumenti Giganti' per New York." *Domus*, no. 433 (December 1965), pp. 50–53.

Sontag, Susan. "Happenings: An Art of Radical Juxtaposition" (1962). In *Against Interpretation*. New York: Farrar, Straus and Giroux, 1966.

Rosenstein, Harris. "Climbing Mt. Oldenburg." *Art News* 64, no. 10 (February 1966), pp. 21–25, 56–59.

Mekas, Jonas. "Movie Journal." *Village Voice*, February 3, 1966, p. 21.

Canaday, John. "Gag Man Returns with a Few Bathroom Jokes: Oldenburg's 'Soft' Ware at Janis Gallery." *New York Times*, March 12, 1966, p. 23.

Genauer, Emily. "Art Tour: Critical Guide to the Gallery." *New York Herald Tribune*, March 12, 1966.

Picard, Lil. "Soft Imitations of Hard Objects." *East Village Other* 1, no. 9 (April 1–15, 1966), p. 11.

Berkson, William. "In the Galleries: Janis Gallery." *Arts Magazine* 40, no. 7 (May 1966), pp. 57–59.

Finch, Christopher. "The Object in Art." *Art and Artists* 1, no. 2 (May 1966), p. 21.

Schlanger, Jeff. "Claes Oldenburg—Extension of Drawing, Sculpture, Time and Life." *Craft Horizons* 26, no. 3 (June 1966), pp. 88–90.

Novick, Elisabeth. "Happenings in New York." *Studio International* 172, no. 881 (September 1966), pp. 154–60.

Reichardt, Jasia. "Gigantic Oldenburgs." *Architectural Design* 36, no. 11 (November 1966), p. 534.

Baro, Gene. "Claes Oldenburg, or the Things of This World." *Art International* 10, no. 9 (November 20, 1966), pp. 41–43, 45–48.

Mussman, Toby. "The Images of Robert Whitman." *Film Culture*, no. 43 (Winter 1966), p. 5.

Fahlström, Öyvind, and Ulf Linde. "Claes Oldenburg at the Moderna Museet, Stockholm, Two Contrasting Viewpoints." *Studio International* 172, no. 884 (December 1966), pp. 326–29. Reprinted from *Claes*

Oldenburg: Skulpturer och teckningar, 1963–1966, exh. cat. Stockholm: Moderna Museet, 1966.

Reichardt, Jasia. "Bridges and Oldenburg." *Studio International* 173, no. 885 (January 1967), pp. 20–26.

Bourdon, David. "Immodest Proposals for Monuments." *New York World Journal Tribune*, January 8, 1967, pp. 22–23.

Scott, Patrick. "'Giant Hamburger' a $2,000 Bargain." *Toronto Daily Star*, February 9, 1967, p. 32.

Brown, Gorden. "In the Galleries: Janis Gallery." *Arts Magazine* 41, no. 7 (May 1967), p. 56.

Glueck, Grace. "New York Gallery Notes Janis Gallery." *Art in America* 55, no. 3 (May–June 1967), pp. 115–16.

Willard, Charlotte. "In the Galleries: Metamorphosis." *New York Post*, May 6, 1967, p. 48.

Perrault, John. "Touch of the Scary." *Village Voice*, May 11, 1967.

Rose, Barbara. "Claes Oldenburg's Soft Machines." *Artforum* 5, no. 10 (Summer 1967), pp. 30–35.

Rosenstein, Harris. "Reviews and Previews: Janis Gallery." *Art News* 66, no. 4 (Summer 1967), p. 64.

Lipton, Lawrence, and Art Kunkin. "Store Days: Documents from The Store (1961) and Ray Gun Theater (1962)." *Living Arts: Supplement to the Los Angeles Free Press*, July 1967, p. 1.

Kozloff, Max. "Art" (review of *Store Days*). *The Nation*, July 3, 1967, pp. 27–28.

Flynn, Betty. "You Can Take an Object and Change It from Small to Big to Colossal." *Panorama (Chicago Daily News)*, July 22, 1967, pp. 2–3.

Trini, Tommaso. "Libri: Store Days." *Domus*, no. 453 (August 8, 1967), pp. 45, 51.

Tuten, Frederic. "Books" (review of *Store Days*). *Arts Magazine* 42, no. 1 (September–October 1967), p. 63.

Johnston, Jill. "Three Theater Events." *Village Voice*, December 23, 1967, pp. 11.

Bourdon, David. "Books: Claes Oldenburg's Store Days." *Village Voice*, December 28, 1967, pp. 6–7, 23.

Graham, Dan. "Oldenburg's Monuments." *Artforum* 6, no. 5 (January 1968), pp. 30–37.

Sylvester, David. "The Soft Machines of Claes Oldenburg." *Vogue* 151, no. 3/2193 (February 1, 1968), pp. 166–69, 211–13.

Altman, Jack. "Claes Oldenburg: The Super, Giant, Economy-Sized Fantasies of the King of Neubern." *Midwest (Chicago Sun-Times)*, February 18, 1968, pp. 6, 8, 10–12, 15.

Forge, Andrew. "Store Days." *Studio International* 175, no. 901 (March 1968), pp. 162–63.

Phelan, Charlotte. "Oldenburg in Houston: A Portable, Pliable Art." *Houston Post*, March 7, 1968, section 7, pp. 1–2.

Purdie, Patricia. "A Soft Ghost of a Giant Fan." *Houston Post*, March 8, 1968, pp. 1, 4.

Mark, Norman. "Art Exhibit to Protest Daley Policy." *Chicago Daily News*, September 12, 1968, p. 28.

Bruckner, D. J. R. "The Art World Answers Chicago's Major Daley." *Los Angeles Times*, October 20, 1968, calendar section, p. 59.

Marcuse, Herbert. "Commenting on Claes Oldenburg's Proposed Monuments for New York City." *Perspecta: The Yale Architectural Journal*, no. 12 (1969), pp. 75–76.

Coplans, John. "The Artist Speaks: Claes Oldenburg." *Art in America* 57, no. 2 (March 1969), pp. 68–75.

Bourdon, David. "Groundbreakers in an Art the Ancients Dug." *Life*, April 25, 1969, pp. 85–86.

Darnton, John. "Oldenburg Hopes His Art Will Make Imprint at Yale." *New York Times*, May 16, 1969, p. 37.

Schulze, Franz. "Sculptor Claes Oldenburg: A Wry View of 'The Locked Mind of Chicago' and Its Ruthless, Dominating Edifices." *Panorama (Chicago Daily News)*, May 17, 1969, pp. 4–5.

Rose, Barbara. "Oldenburg Joins the Revolution." *New York Magazine*, June 2, 1969, p. 57.

Gruen, John. "Things That Go Limp." *New York Magazine*, September 1, 1969, p. 57.

Glueck, Grace. "Soft Sculpture or Hard—They're Oldenburgers." *New York Times Magazine*, September 21, 1969, pp. 28–29, 100, 102, 104–5, 107–9, 114–15.

Canaday, John. "Oldenburg as the Picasso of Pop." *New York Times*, September 28, 1969, section D, p. 23.

Finch, Christopher. "Notes for a Monument to Claes Oldenburg." *Art News* 68, no. 6 (October 1969), pp. 52–56.

Bourgeois, Jean-Louis. "New York: Claes Oldenburg, Museum of Modern Art." *Artforum* 8, no. 3 (November 1969), pp. 74–78.

Kokkimen, Eila. "Books" (review of *Claes Oldenburg: Drawings and Prints*). *Arts Magazine* 44, no. 2 (November 1969), pp. 12, 14.

Rose, Barbara. "The Origin, Life and Times of Ray Gun." *Artforum* 8, no. 3 (November 1969), pp. 50–57.

Siegel, Jeanne. "Oldenburg's Places and Borrowings." *Arts Magazine* 44, no. 2 (November 1969), pp. 48–49.

Rosenberg, Harold. "The Art World: Marilyn Mondrian." *New Yorker*, November 8, 1969, pp. 167–76.

Mellow, James R. "On Art: Oldenburg's Scatological 'Soft Touch.'" *New Leader*, November 10, 1969, p. 49.

Ashton, Dore. "Dubuffet and Anticulture: 'Conegidouille,' Said Pere Ubu, 'The Spirit of Anticulture Will Not Be Put to Rest.'" *Arts Magazine* 44, no. 3 (December 1969), pp. 36–38.

Kramer, Hilton. "Hamburger Heaven." *New York Review of Books*, December 4, 1969, pp. 17–20.

Suvin, Darko. "Reflections on Happenings." *Drama Review* 14, no. 3 (1970), pp. 125–44.

Johnson, Ellen H. "Oldenburg's Poetics: Analogues, Metamorphoses and Sources." *Art International* 14, no. 4 (April 20, 1970), pp. 42–45, 51.

Kennedy, R. C. "Oldenburg Draughtsman." *Art and Artists* 5, no. 4 (July 1970), pp. 25–27.

Legg, Alicia. "Claes Oldenburg." *Art and Artists* 5, no. 4 (July 1970), pp. 20–24.

Sylvester, David. "Furry Lollies and Soft Machines." *Sunday Times Magazine*, July 7, 1970, pp. 14–20.

Johnson, Ellen H. "Oldenburg's Giant

Three-Way Plug." *Arts Magazine* 45, no. 3 (December 1970–January 1971), pp. 43–45.

Downs, Linda. "Oldenburg's Profile Airflow and Giant Three-Way Plug." *Bulletin of the Detroit Institute of Arts* 50, no. 4 (1971), pp. 69–78.

Goldman, Judith. "Sort of a Commercial for Objects." *Print Collector's Newsletter* 2, no. 6 (January–February 1972), pp. 117–19.

Hughes, Robert. "Magician, Clown, Child." *Time*, February 21, 1972, pp. 60–63.

Chappell, Sally A. "Films on Sculpture." *Art Journal* 33, no. 2 (Winter 1973–74), p. 128.

Grove, Lloyd. "The Second Coming of Claes." *Yale Daily News Magazine*, April 17, 1974, p. 5.

Loring, John. "Oldenburg on Multiples: Multiples as Concept and Technology in the Work of Claes Oldenburg." *Arts Magazine* 48, no. 8 (May 1974), pp. 42–45.

Wilson, Martha. "Books" (review of Claes Oldenburg's *Raw Notes*). *Art and Artists* 9, no. 3 (June 1974), pp. 47–51.

Judd, Donald. "Claes Oldenburg July 1966." In *Donald Judd: Complete Writings, 1959–1975*, p. 191. Halifax, Nova Scotia: Press of the Nova Scotia College of Art and Design; New York: New York University Press, 1975.

Wohlfert, Lee. "The Bizarre, Colossal Shapes of Oldenburg: 'My Monuments Are a Kind of Theater.'" *People Weekly* 3, no. 25 (June 30, 1975), pp. 54–56.

Taylor, Robert. "Oldenburg's Many Masks." *Boston Globe*, January 18, 1976, section B, p. 1.

Patton, Phil. "Oldenburg's Mouse." *Artforum* 14, no. 7 (March 1976), pp. 51–53.

Zach, B. "Claes Oldenburg—Toronto." *Artmagazine* 7, nos. 26–27 (May–June 1976), pp. 14–17.

Foote, Nancy. "Oldenburg's Monuments to the Sixties." *Artforum* 15, no. 5 (January 1977), pp. 54–56.

Olander, W. R. "Claes Oldenburg." *Arts Magazine* 52, no. 2 (October 1977), p. 2.

Pieszak, D. "Oldenburg: No More Big Macs to Go." *New Art Examiner* 5, no. 3 (December 1977), p. 6.

Kostelanetz, Richard. "The Discovery of Alternative Theater: Notes on Art Performances in New York City in the 1960s and 1970s." *Perspectives of New Music* 27,

no. 1 (Winter 1989), pp. 128–72.

Soutif, Daniel. "Claes Oldenburg ou l'autoportrait à l'object." *Artstudio* no. 19 (Winter 1990), pp. 40–55.

Ashton, Dore. "Claes Oldenburg: 'The Store' New York 1961." In *Die Kunst der Ausstellung*, edited by Bernd Klüser, pp. 148–55. Frankfurt am Main: Insel Verlag, 1991.

Scott Brown, Denise. "Remedial Housing for Architects Studio." In *Venturi, Scott Brown & Associates: On Houses and Housing*, edited by James Steele. New York: Academy Editions, 1992, p. 57.

Banes, Sally. *Greenwich Village 1963: Avant-Garde Performance and the Effervescent Body*. Durham, NC: Duke University Press, 1993.

Drucker, Johanna. "Collaboration without Object(s) in the Early Happenings." *Art Journal* 52, no. 4 (Winter 1993), pp. 51–58.

Leiser, Erwin. "Claes Oldenburg & Coosje van Bruggen." *Frankfurter Allgemeine Magazin* 36, no. 706 (September 10, 1993), pp. 10–18.

Haywood, Robert E. "Heretical Alliance: Claes Oldenburg and the Judson Memorial Church in the 1960s." *Art History* 18, no. 2 (1995), pp. 185–212.

Francis, Mark. "Claes Oldenburg. Washington and Los Angeles." *Burlington Magazine* 137, no. 1,108 (July 1995), pp. 482–83.

Barnes, Julian. "Good Soft Fun." *Modern Painters* 8, no. 4 (Winter 1995), pp. 12–15.

McGee, Celia. "A Pop Art Provocateur Having Monumental Fun." *New York Times*, October 1, 1995, pp. 41–42.

Smith, Roberta. "A Pop Absurdist Who's a Happening All by Himself." *New York Times*, October 6, 1995, section C, pp. 1, 27.

Wallach, Amei. "Claes Oldenburg: Sculpting a Universal Language." *Sculpture* 15, no. 1 (January 1996), pp. 22–25.

Weinstein, Jeff. "Old Softies: Claes Oldenburg in Retrospect." *Artforum* 34, no. 5 (January 1966), pp. 54–59.

Sladen, Mark. "Meet Ray Gun." *Art Monthly*, no. 197 (June 1996), pp. 3–6.

Bois, Yves-Alain, and Rosalind Krauss. "A User's Guide to Entropy." *October*, no. 78 (Autumn 1996), pp. 48–51.

Page, Clement. "Claes Oldenburg: Monuments

to the Imagination." *Transcript* 2, no. 2 (November 1996), pp. 72–78.

D'Souza, Aruna. "'I Think Your Work Looks a Lot like Dubuffet': Dubuffet and America, 1946–1962." *Oxford Art Journal* 20, no. 2 (1997), pp. 61–73.

Fer, Briony. "The Somnambulist's Story: Installation and the Tableau." *Oxford Art Journal* 24, no. 2 (2001), pp. 75–92.

Berrebi, Sophie. "Dubuffet Pilote: Claes Oldenburg regarde Jean Dubuffet." *Cahiers du Musee National d'Art Moderne*, no. 77 (Autumn 2001), pp. 80–91.

Mucha, Patty. "Sewing in the Sixties." *Art in America* 90, no. 11 (November 2002), pp. 79, 81, 83, 85, 87–88.

Ursprung, Phillip. "Plasterman: Allan Kaprows und Claes Oldenburgs Streit um das Erbe der New York School." In *Masterplan: Konstruktion und Dokumentation amerikanischer Kunstgeschichten*, edited by Peter Schneeman and Thomas Schmutz, pp. 85–103. Bern: Peter Lang, 2003.

Rodenbeck, Judith. "Madness and Method: Before Theatricality." *Grey Room*, no. 13 (Autumn 2003), pp. 54–79.

Potts, Alex. "Autonomy in Post-war Art, Quasi-heroic and Casual." *Oxford Art Journal* 27, no. 1 (2004), pp. 43–59.

Shannon, Joshua A. "Claes Oldenburg's The Street and Urban Renewal in Greenwich Village, 1960." *Art Bulletin* 86, no. 1 (March 2004), pp. 136–61.

Berrebi, Sophie. "Paris Circus New York Junk: Jean Dubuffet and Claes Oldenburg, 1959–1962." *Art History* 29, no. 1 (February 2006), pp. 79–107.

Williams, Tom. "Lipstick Ascending: Claes Oldenburg in New Haven in 1969." *Grey Room*, no. 31 (Spring 2008), pp. 116–44.

Shannon, Joshua. "A Neo-Dada City: Oldenburg." In *The Disappearance of Objects: New York Art and the Rise of the Postmodern City*. New Haven, CT: Yale University Press, 2009.

Ward, Lucina. "Soft Sculpture: Don't Touch, Lick or Smell." *Artonview*, no. 57 (March 2009), pp. 20–27.

Kino, Carol. "Going Softly into a Parallel

Universe." *New York Times*, May 17, 2009, p. 30.

Mucha, Patty. "Soft Sculpture Sunshine." In *Seductive Subversion: Women Pop Artists, 1958–1968*, edited by Sid Sachs and Kalliopi Minioudaki, pp. 144–61. New York: Abbeville Press; Philadelphia: University of the Arts, 2010.

Smith, Katherine. "The Public Positions of Claes Oldenburg's Objects in the 1960s." *Public Art Dialogue* 1, no. 1 (2011), pp. 25–52.

Selected Books and Articles

New Forms—New Media, exh. cat. New York: Martha Jackson Gallery, 1960.

Hess, Thomas B. "Mixed Mediums for a Soft Revolution." *Art News* 59, no. 4 (Summer 1960), p. 45.

McDarrah, Fred W. *The Artist's World in Pictures*, pp. 182–83. New York: E. P. Dutton, 1961.

Alloway, Lawrence. "Junk Culture." *Architectural Design* 31, no. 3 (March 1961), pp. 122–23.

Johnston, Jill. "Dance: Aileen Passloff." *Village Voice*, March 9, 1961.

Kaprow, Allan. "'Happenings' in the New York Scene." *Art News* 60, no. 3 (May 1961), pp. 36–39, 58–62.

Constable, Rosalind. "Scouting Report on the Avant-Garde." *Esquire*, June 1961, pp. 83–88.

Klüver, Billy. "Happenings." *Konstrevy* 38, no. 2 (1962), pp. 58–66.

Kozloff, Max. "'Pop' Culture, Metaphysical Disgust, and the New Vulgarism." *Art International* 6, no. 2 (March 1962), pp. 34–36.

Swenson, Gene. "The New American 'Sign Painters.'" *Art News* 61, no. 5 (September 1962), pp. 44–47, 60–62.

Restany, Pierre. "Le Nouveau Réalisme à la conquete de New York." *Art International* 7, no. 1 (January 25, 1963), pp. 29–36.

Kramer, Hilton. "A Symposium on Pop Art." *Arts Magazine* 37, no. 7 (April 1963), pp. 38–39.

Rosenberg, Harold. "In the Galleries: Black

and Pistachio." *New Yorker*, April 15, 1963, pp. 82–98.

Seitz, William C. "Pop Goes the Artist." *Partisan Review*, no. 30 (Summer 1963), pp. 313–16.

Seckler, Dorothy Gees. "Folklore of the Banal." *Art in America* 51, no. 4 (August 1963), pp. 44–48.

Rose, Barbara. "Dada Then and Now." *Art International* 7, no. 1 (September 25, 1963), pp. 23–28.

Gray, Cleve. "Art Centers: Remburgers and Hambrandts." *Art in America* 51, no. 6 (December 1963), pp. 118–29.

Nordland, Gerald. "Marcel Duchamp and Common Object Art." *Art International* 8, no. 1 (February 15, 1964), pp. 30–32.

Klüver, Billy. "Bakelsen som konst." *Vi* 51, no. 9 (February 29, 1964), pp. 11–13, 42, 44.

Kelly, Edward T. "Neo-Dada: A Critique of Pop Art." *Art Journal* 23, no. 3 (Spring 1964), pp. 192–201.

Solomon, Alan R. "The New American Art." *Art International* 8, no. 2 (March 20, 1964), pp. 50–55.

Dienst, Rolf-Gunter. *Pop-Art*. Wiesbaden: Limes Verlag, 1965.

Rublowsky, John. *Pop Art*. New York: Basic Books, 1965.

Pop Art Nouveau Realisme etc. . . ., exh. cat. Brussels: Palais des Beaux-Arts, 1965.

Kirby, Michael. "The New Theater." *Tulane Drama Review* 10, no. 2 (Winter 1965), pp. 23–43.

Geldzahler, Henry. "Happenings: Theater by Painters." *Hudson Review* 18, no. 4 (Winter 1965–66), pp. 581–86.

Amaya, Mario. *Pop as Art: A Survey of New Super Realism*. London: Studio Vista, 1965.

Crispolti, Enrico. *La Pop Art*. Milan: F.lli Fabri, 1966.

Kaprow, Allan. *Assemblage, Environments and Happenings*. New York: Abrams, 1966.

Lippard, Lucy R. *Pop Art*. New York: Frederick A. Praeger, 1966.

Goldin, Amy. "Requiem for a Gallery." *Arts Magazine* 40, no. 3 (January 1966), pp. 25–29.

McGrath, Tom. "Happenings, Events and Activities." *Peace News*, January 28, 1966.

Kempton, Sally. "Beatitudes at Judson Memorial Church." *Esquire*, March 1966, pp. 106–9.

Rosenberg, Harold. "From Pollock to Pop: Twenty Years of Painting and Sculpture." *Holiday* 39, no. 3 (March 1966), pp. 96–100, 136–40.

Swenson, Gene. "New York: The Boundaries of Chaos." *Art and Artists* 1, no. 1 (April 1966), pp. 60–63.

Frankenstein, Alfred. "An S.F. Art Talkfest." *San Francisco Chronicle*, April 18, 1966, p. 53.

Ashton, Dore. "Conditioned Historic Reactions." *Studio International* 171, no. 877 (May 1966), pp. 204–5.

Finch, Christopher. "The Object in Art." *Art and Artists* 1, no. 2 (May 1966), pp. 18–21.

Irwin, David. "Pop Art and Surrealism." *Studio International* 171, no. 877 (May 1966), pp. 187–91.

Sottsass, Ettore. "Dada, New Dada, New Realists." *Domus*, no. 399 (December 1966), pp. 49–50.

Alloway, Lawrence. "Art in Escalation, the History of Happenings: A Question of Sources." *Arts Magazine* 41, no. 3 (December 1966–January 1967), pp. 40–43.

Boatto, Alberto. *Pop Art in U.S.A.* Milan: Lerici, 1967.

Original Pop Art, exh. cat. Gelsenkirchen: Städtische Kunstausstellung Gelsenkirchen, 1967.

Bourdon, David. "Immodest Proposals for Monuments." *World Journal Tribune*, January 8, 1967, p. 22.

Alloway, Lawrence. "Hi-Way Culture." *Arts Magazine* 41, no. 4 (February 1967), pp. 28–33.

Sandberg, John. "Some Traditional Aspects of Pop Art." *Art Journal* 26, no. 3 (Spring 1967), pp. 228–45.

Graham, Dan. "Models and Monuments: The Plaque of Architecture." *Arts Magazine* 41, no. 5 (March 1967), pp. 30–37.

Higgins, Dick. "Against Movements." *Something Else Newsletter* 1, no. 6 (May 1967), pp. 1–4.

Kozloff, Max. "Art." *The Nation* 205, no. 1 (July 3, 1967), pp. 27–29.

Flavin, Dan. "Some Other Comments . . . :

More Pages from a Spleenish Journal." *Artforum* 6, no. 4 (December 1967), pp. 20–25.

Leider, Philip. "Gallery '68: High Art and Low Art." *Look* 32, no. 1 (January 9, 1968), pp. 14–21.

Finch, Christopher. *Pop Art: Object and Image*. London: Studio Vista; New York: E. P. Dutton, 1968.

Kostelanetz, Richard. *The Theatre of Mixed Means*. New York: Dial, 1968.

Kozloff, Max. "The Poetics of Softness." In *Renderings*. New York: Simon and Schuster, 1968.

Ohff, Heinz. *Pop und die Folgen*. Düsseldorf: Droste, 1968.

Forge, Andrew. "Media Crisis." *Studio International* 175, no. 898 (March 1968), pp. 162–63.

Morris, Robert. "Anti-form." *Artforum* 6, no. 8 (April 1968), pp. 33–35.

Kaprow, Allan. "The Shape of the Art Environment." *Artforum* 6, no. 10 (Summer 1968), pp. 32–33.

Rose, Barbara. "Blowup—the Problem of Scale in Sculpture." *Art in America* 56, no. 4 (July–August 1968), pp. 80–91.

Andreae, Christopher. "Art Boycott Falters." *Christian Science Monitor*, September 14, 1968, front page.

Perreault, John. "Long Live Earth!" *Village Voice*, October 17, 1968.

Perreault, John. "Dump. Drop. Drape." *Village Voice*, November 14, 1968, pp. 17–18.

Finch, Christopher. "The Role of the Spectator." *Design Quarterly*, no. 73 (1969), n.p.

Russell, John. *Pop Art Redefined*. London: Thames & Hudson, 1969.

Rose, Barbara. "Problems of Criticism, V: The Politics of Art, Part II." *Artforum* 7, no. 5 (January 1969), pp. 44–49.

Alloway, Lawrence. "Popular Culture and Pop Art." *Studio International* 178, no. 913 (July–August 1969), pp. 17–21.

Russell, John. "Pop Reappraised." *Art in America* 57, no. 4 (July–August 1969), pp. 78–89.

Skelton, Robin. "Pop Art and Pop Poetry."

Art International 8, no. 8 (October 1969), pp. 39–41.

Compton, Michael. *Pop Art: Movements of Modern Art*. London: Hamlyn, 1970.

Kozloff, Max. "The Division and Mockery of the Self." *Studio International* 179, no. 918 (January 1970), pp. 9–15.

Glueck, Grace. "At the Whitney, It's Guerrilla Warfare." *New York Times*, November 1, 1970, part 2, p. 22.

Pierre, José. *Pop Art: Paintings-Sculptures*. London: Methuen; New York: Tudor, 1971.

Forge, Andrew. "Forces against Object-Based Art." *Studio International* 181, no. 929 (January 1971), pp. 32–37.

Glueck, Grace. "Art Notes: No Bones in Their Noses." *New York Times*, April 18, 1971, section D, p. 21.

Alloway, Lawrence. "'Reality': Ideology at D5." *Artforum* 11, no. 2 (October 1972), pp. 30–35.

Seitz, William. "The Real and the Artificial: Painting of the New Environment." *Art in America* 60, no. 6 (November–December 1972), pp. 58–72.

Alloway, Lawrence. *American Pop Art*. New York: Collier Books, 1974.

Erhard, Ernst-Otto. *Pop Kitsch Concept-Art. Aufsätze zur gegenwärtigen Situation der Kunst*. Ravensburg: Otto Maier Verlag, 1974.

Henri, Adrian. *Total Art: Environments, Happenings, and Performances*. London: Thames & Hudson, 1974.

Lahr, John, and Jonathan Price, eds. *The Great American Life Show: Nine Plays from the Avant-Garde Theater*. New York: Bantam Books, 1974.

Wilson, Simon. *Pop*. London: Thames & Hudson, 1974.

Hughes, Robert. "The Instant Nostalgia of Pop." *Time* (April 15, 1974), pp. 80–83.

Shapiro, David. "Sculpture as Experience: The Monument That Suffered." *Art in America* 62, no. 3 (May–June 1974), p. 57.

Baldwin, Carl R. "On the Nature of Pop." *Artforum* 12, no. 10 (June 1974), pp. 34–38.

Alloway, Lawrence. *Topics in American Art since 1945*. New York: Norton, 1975.

Bush, Donald J. *The Streamlined Decade*.

New York: Braziller, 1975.

Pierre, José. *Dictionnaire de Poche. Le Pop Art*. Paris: Fernand Hazan, 1975.

Celant, Germano. "Artspaces." *Studio International* 190, no. 977 (September–October 1975), pp. 115–23.

Von Pop zum Konzept. Kunst unserer Zeit in Belgischen Privatsammlungen, exh. cat. Aachen: Neue Galerie—Sammlung Ludwig, 1975.

O'Doherty, Brian. "Inside the White Cube, Part II: The Eye and the Spectator." *Artforum* 14, no. 8 (April 1976), pp. 26–34.

Kuspit, Donald B. "Pop Art: A Reactionary Realism." *Art Journal* 36, no. 1 (Autumn 1976), pp. 31–38.

Higgins, Dick. "The Origin of Happening." *American Speech* 51, no. 3–4 (Autumn–Winter 1976), pp. 268–71.

Krauss, Rosalind. *Passages in Modern Sculpture*. New York: Viking, 1977.

Adams, Hugh. *Art of the Sixties*. Oxford: Phaidon, 1978.

Goldberg, Rose Lee. *Performance: Live Art, 1909 to Present*. New York: Abrams, 1979.

Banes, Sally. "The Birth of the Judson Dance Theater: 'A Concert of Dance' at Judson Church, July 6, 1962." *Dance Chronicle* 5, no. 2 (1982), pp. 167–212.

Haskell, Barbara. *Blam! The Explosion of Pop, Minimalism, and Performance 1958–1964*. New York: Whitney Museum of American Art, 1984.

Gaggi, Silvio. "Sculpture, Theater and Art Performance: Notes on the Convergence of the Arts." *Leonardo* 19, no. 1 (1986), pp. 45–52.

Gustafson, Donna. "Food and Death: Vanitas in Pop Art." *Arts Magazine* 60, no. 6 (February 1986), pp. 90–93.

Mahsun, Carol Anne. *Pop Art and the Critics*. Ann Arbor, MI: UMI Research Press, 1987.

Leffingwell, Edward, ed. *Modern Dreams: The Rise and Fall and Rise of Pop*. New York: Institute for Contemporary Art, 1988.

Sandler, Irving. *American Art of the 1960s*. New York: Harper and Row, 1988.

Bromberg, Craig. "That Collaborative Itch." *Art News* 87, no. 9 (November 1988), pp. 160–63.

Livingstone, Marco. *Pop Art: A Continuing History*. London: Thames & Hudson, 1990.

Waldman, Diane. *Collage, Assemblage, and the Found Object*. New York: Abrams, 1992.

Rosenthal, Mark. *Artists at Gemini G.E.L.* New York: Abrams; Los Angeles: Gemini G.E.L., 1993.

Hapgood, Susan. *Neo-Dada, Redefining Art 1958–62*. New York: American Federation of Arts/Universe, 1994.

Moore, Barbara. "New York Intermedia: Happenings and Fluxus in the 1960s." In *American Art in the 20th Century*, exh. cat., pp. 99–106. London: Royal Academy of Arts, 1994.

Sandford, Mariellen R., ed. *Happenings and Other Acts*. London: Routledge, 1995.

Bois, Yve-Alain, and Rosalind Krauss. *Formless: A User's Guide*. New York: Zone, 1997.

Madoff, Steven H. *Pop Art: A Critical History*. Berkeley: University of California Press, 1997.

Whiting, Cécile. *A Taste for Pop: Pop Art, Gender and Consumer Culture*. Cambridge: Cambridge University Press, 1997.

Marter, Joan M. *Off Limits*, exh. cat. Newark, NJ: Newark Museum, 1999.

Brauer, David, Jim Edwards, et al. *Pop Art: U.S./U.K. Connections, 1956–1966*, exh. cat. Houston: Menil Collection, 2001.

Harrison, Sylvia. *Pop Art and the Origins of Post-modernism*. Cambridge: Cambridge University Press, 2001.

Boettger, Suzaan. *Earthworks: Art and the Landscape of the Sixties*. Berkeley: University of California Press, 2002.

Harper, Cheryl. *A Happening Place*. Philadelphia: Jewish Community Centers of Greater Philadelphia, 2003.

Francis, Mark, ed. *Pop*. New York: Phaidon, 2005.

Hochdörfer, Achim, and Susanne Neuburger. *Konzept. Aktion. Sprache.*, exh. cat. Vienna: Museum moderner Kunst Stiftung Ludwig Wien, 2008.

Kourlas, Gia. "Judson Dance Theater and the Brave New World of Dance." In *Singular Forms: Art from 1951 to the Present*, exh. cat. New York: Guggenheim Museum, 2008.

Kaplan, Fred. *1959: The Year Everything Changed*. Hoboken, NJ: Wiley & Sons, 2009.

Robinson, Julia. *New Realisms, 1957–1962: Object Strategies between Readymade and Spectacle*. Cambridge, MA: MIT Press; Madrid: Museo Nacional Centro de Arte Reina Sofía, 2010.

CONTRIBUTORS

BENJAMIN H. D. BUCHLOH is Andrew
W. Mellon Professor of Modern and
Contemporary Art at Harvard University and
co-editor of the journal *October*. He is the
author of *Neo-Avantgarde and Culture Industry*
(2000) and the coauthor of *Art since 1900*
(2005). His most recent publications include
essays on Richard Hamilton, Gerhard Richter,
Raymond Pettibon, and Gabriel Orozco.
He is the editor of *October*'s special issue on
Andy Warhol and an anthology of writings
by Gerhard Richter. He received the Venice
Biennale's Golden Lion for Art History
and Criticism.

ACHIM HOCHDÖRFER is curator at the
Museum moderner Kunst Stiftung Ludwig
Wien. His exhibition and publication projects
include "Jeff Wall: Photographs" (2003),
"Cy Twombly" (2009), and "Tacita Dean:
The Line of Fate" (2011). He has written
widely about contemporary art in magazines
and journals such as *Artforum*, *Texte zur Kunst*,
and *Camera Austria*.

BRANDEN W. JOSEPH is the Frank Gallipoli
Professor of Modern and Contemporary
Art in the Department of Art History and
Archaeology at Columbia University and a
founding editor of the journal *Grey Room*.
He is the author of *Random Order: Robert
Rauschenberg and the Neo-Avant-Garde* (2003)
and *Beyond the Dream Syndicate: Tony Conrad and
the Arts after Cage* (2008), as well as numer-
ous scholarly essays and articles in the fields of
contemporary art, music, and cinema.

MAARTJE ELISABETH OLDENBURG is
the executive director of the Oldenburg van
Bruggen Foundation. She earned a Bachelor of
Arts from Princeton University in 1995 and a
Juris Doctor from New York University School
of Law in 2003.

GREGOR STEMMRICH is Professor of
Art History of the 20th and 21st Century
at Freie Universität Berlin and founder
of "Kunst und Kinematographie" for
Medienkunstnetz (www.mediaartnet.org).
His numerous publications include *Jeff Wall*
(1997), the collected writings and interviews
of Lawrence Weiner (with Gerti Fietzek,
2004), *Dan Graham* (2010), and *Robert Morris:
HEARING. Listening to HEARING* (2012).
He has edited the anthology *Minimal Art.
Eine kritische Retrospektive* (1995) and *Eine
andere Kunst—ein anderes Kino* (*The Other
Arts—The Other Cinema*; *Jahresring*, 2006).
He has written widely about contemporary
art in catalogues, anthologies, and journals.

ANN TEMKIN is the Marie-Josée and
Henry Kravis Chief Curator of Painting and
Sculpture at the Museum of Modern Art
in New York. Her recent exhibitions and
catalogues include "Color Chart: Reinventing
Color, 1950 to Today" (2008), "Gabriel
Orozco" (2009), and "Abstract Expressionist
New York" (2010).

PHOTO CREDITS

Works by Claes Oldenburg © 2012 Claes
Oldenburg

We thank all photographers who gave us
permission to reproduce their photographs,
especially Robert McElroy, whose generosity in
allowing us to illustrate this book with numerous
images speaks of both his close relationship with
Claes Oldenburg and his unique understanding
of Oldenburg's work.

Cover, p. 253 left: courtesy Oldenburg van
Bruggen Studio, photo © Ugo Mulas Heirs.
All rights reserved; p. 3: courtesy Oldenburg
van Bruggen Studio, photo © Yale Joel (for Life
Magazine); pp. 4, 22, 23, 24 top, 247–251, 256,
257, 289 no. 4a and b: photo © Museum moderner
Kunst Stiftung Ludwig Wien, Lisa Rastl & Lena
Deinhardstein; pp. 13, 32, 33: courtesy Oldenburg
van Bruggen Studio, photo © I. C. Rapoport;
pp. 18, 36 left, 67, 147, 148, 149, 155, 216, 220,
235, 265 left: courtesy Oldenburg van Bruggen
Studio, photo D. James Dee; pp. 21, 68, 69,
193 top, 206, 212, 291 no. 5: photo © Whitney
Museum of Art, Sheldan C. Collins; pp. 24, 42
left, 48, 49, 170, 185 left, 186 right, 210: photo
© The Museum of Modern Art, New York;
pp. 24 right, 35 left and right, p. 41, 234 left: photo
© Collection Centre Pompidou, Dist. RMN;
pp. 26, 27, 30: courtesy Oldenburg van Bruggen
Studio, photo © Martha Holmes (for Time Life);
pp. 28, 29: photos Claes Oldenburg; p. 35 top:
courtesy Oldenburg van Bruggen Studio; p. 36
right: photo © bpk / Kupferstichkabinett, SMB/
Jörg P. Anders; p. 37: photo © National Gallery
of Art; pp. 14–17, 39, 45–47, 53, 54-55, 56, 57,
73, 76–79, 83, 85, 86, 88–91, 98–99, 100,104,
107–109, 113, 114–121, 122–125, 128–129, 241
left and right, 244–245, 287 no. 1 and 2, 291 no. 2:
courtesy Oldenburg van Bruggen Studio, photo
© Robert McElroy/licenced by VAGA, New York,
NY; p. 40: courtesy Onnasch Kunsthandel, photo:
Gunter Lebkowski; p. 43 left and right: courtesy
Oldenburg van Bruggen Studio, photo Douglas
Parker Studio; p. 51: photo © Ludwig Museum—
Museum of Contemporary Art, Budapest, Jósef
Rosta; pp. 58–59, 61 top, 65 bottom, 71, 74, 80,
103, p. 145 right, 146, 161, 166, 174 right, 179
bottom right, 185 right, 186 left, 189, 193 right,
198, 203, 208, 209, 222, 228 top and bottom,
233 left, 239 left, top right and bottom right,

266 right, 274 bottom, 281, 283, 285 no. 2–5,
287 no. 3 and 4, 289 no. 1–3, 295 no. 1–2 and
no. 4, 297 no. 1 and 3–5, 299 no. 3, 301 no. 1
and 3: courtesy Oldenburg van Bruggen Studio;
pp. 61 bottom, 293 no. 3: courtesy Oldenburg
van Bruggen Studio, photo Geoffrey Clements,
New York; pp. 64, 234 right: photo © The Menil
Collection, Houston; p. 65 top: courtesy Paula
Cooper Gallery, photo Adam Reich; pp. 66 left
and right, 181, 299 no. 1: courtesy Oldenburg
van Bruggen Studio, photo Ellen Page Wilson;
p. 70: photo © Victoria and Albert Museum,
London; p. 81: photo © bpk / Nationalgalerie,
SMB, Sammlung Scharf-Gerstenberg / Volker-H.
Schneider; p. 93 left, 227: photo Claes Oldenburg;
p. 93 right: courtesy Oldenburg van Bruggen
Studio, photo Burt Kramer; pp. 95, 219, 221,
236: courtesy Menil Collection, Houston, photo
Paul Hester; pp. 126, 127, 289 no. 3: courtesy
Oldenburg van Bruggen Studio, photos Julian
Wasser; pp. 131, 157, 262: courtesy Oldenburg
van Bruggen Studio, photo Hans Hammarskiöld;
pp. 132–144, 145 (left), 150–154: photos Cathy
Carver; p. 158: courtesy Oldenburg van Bruggen
Studio, photo Fred McDarrah, New York; pp.
162, 169: photo © The Solomon R. Guggenheim
Foundation, New York, David Heald; pp. 163,
172, 277: photo © Collection Walker Art Center,
Minneapolis; pp. 165 left, 176–77: photo © MMK
Museum für Moderne Kunst Frankfurt am Main,
Rudolf Nagel; pp. 165 right, 174 left: photo
© Whitney Museum of Art, Jerry L. Thompson;
pp. 167, 180: photo © Hirshhorn Museum
and Sculpture Garden, Lee Stalsworth; p. 171:
photo © National Gallery of Art, photo Philip A.
Charles; pp. 173, 213: photo © Collection
Stedelijk Museum, Amsterdam; p. 175: photo
© The George Economou Collection; p. 179 top
left: courtesy Oldenburg van Bruggen Studio,
photo Tom Powel; p. 179 top right: courtesy
Oldenburg van Bruggen Studio, photo Dorothy
Zeidman; p. 179 bottom left: courtesy Oldenburg
van Bruggen Studio, photo Tom S. Powell
for Grant Selwyn; p. 181 top: photo © IVAM
Institut Valenciá d'Art Modern, Spain; p. 182:
Bilbliotheque Nationale de France, Paris. IFN-
7703120; photo: Bibliotheque Nationale de France;
p. 183: photo Dennis Hopper; pp. 184, 207 left,
289 no. 4c, 297 no. 2: photo © Whitney Museum
of American Art, New York; p. 187: photo © Des
Moines, Rich Sanders; p. 190: Courtesy New
York City Parks Department; p. 193 left: courtesy
Oldenburg van Bruggen Studio, photo David
Heald; pp. 194, 195, 197, 291 no. 1, 297 no. 4:

courtesy Oldenburg van Bruggen Studio, photo
Shunk-Kender © Roy Lichtenstein Foundation;
p. 196: © VBK, Wien 2012, photo courtesy The
Menil Collection, Houston; p. 199: © Calder
Foundation New York / VBK, Wien 2012, photo
Mary Ann Sullivan; p. 200: courtesy St. Louis Art
Museum, MO; pp. 207 right, 228 bottom, 233 right:
photo © Kunstmuseum Basel, Martin P. Bühler;
p. 211: photo © Los Angeles County Museum
of Art; p. 215: courtesy Oldenburg van Bruggen
Studio, photo Helaine Messer; p. 218: © Estate
of Marcel Duchamp/VBK Wien / photo: Corbis,
Barney Burstein; p. 224: © VBK, Wien 2012,
photo © Digital Image, The Museum of Modern
Art, New York/Scala, Florence; p. 225: photo
© The Museum of Modern Art, New York, and
Robert McElroy/licenced by VAGA, New York,
NY; p. 226: © VBK, Wien 2012; p. 229: © Estate
of Brassaï / photo: Dist. RMN; p. 231: © photo:
Glenstone, Tim Nightswander/Imaging4Art;
p. 232: © VBK, Wien 2012, photo © Digital
Image, The Museum of Modern Art, New York/
Scala, Florence; p. 237: © Succession Picasso
/ VBK, Wien 2012, photo © Digital Image,
The Museum of Modern Art, New York/Scala,
Florence; p. 240: © VBK, Wien 2012; p. 242:
courtesy Oldenburg van Bruggen Studio, photo
Charles Moore; pp. 253 right, 279: courtesy
Oldenburg van Bruggen Studio, photo Jill
Krementz; pp. 254–255, 266 left: courtesy
Oldenburg van Bruggen Studio, photo Hans
Blezen; pp. 258–261: courtesy Oldenburg van
Bruggen Studio, photos Balthasar Burkhard;
p. 265 right: photo © The Pace Gallery, Joerg
Lohse; p. 269: courtesy Oldenburg van Bruggen
Studio, photo Pieter Boersma, Amsterdam;
pp. 274 top and left, 275 top and bottom: photo
© The Pace Gallery, photo John Behrens; pp. 275
right, 276, 295 no. 3, 299 no. 2: photo © The Pace
Gallery, photos Ellen Labenski; p. 285 no. 1: photo
Time Inc.; p. 291 no. 3: photo © Peter Moore/
licenced by VAGA, New York, NY; pp. 291 no. 4,
301 no. 2: courtesy The Pace Gallery; p. 301 no. 4:
courtesy Rupert Steiner; p. 320: photo © Moderna
Museet, Stockholm.

Every effort has been made to trace copyright
holders and to obtain their permission for the use
of copyrighted material. The publisher apologizes
for any errors or omissions in the above list and
would be grateful if notified of any corrections
that should be incorporated in future reprints or
editions of this book.

EXHIBITION

Exhibition itinerary:
Museum moderner Kunst Stiftung
 Ludwig Wien
 February 3–May 27, 2012
Museum Ludwig, Cologne
 June 22–September 30, 2012
Guggenheim Museum Bilbao
 October 30, 2012–February 17, 2013
The Museum of Modern Art, New York
 April 14–August 5, 2013
Walker Art Center, Minneapolis
 September 14, 2013–January 12, 2014

MUSEUM MODERNER KUNST
STIFTUNG LUDWIG WIEN

Director: Karola Kraus
Curator: Achim Hochdörfer
Project manager, curatorial assistant:
 Claudia Dohr
Production assistant: Katharina Schendl
Conservation: Tina Hierl, Charlotte Karl,
 Katherine Ruppen, Eva Stimm
Press: Eva Engelberger, Barbara Hammerschmied
Marketing and communications: Wofgang
 Schreiner, Florian Moritz, Michaela Zach
Fundraising: Christina Hardegg,
 Bärbel Holaus
Events: Katharina Radmacher
Exhibition design: Wilfried Kühn,
 Thomas Gürtler, Johanna Hoth
Exhibition graphic design: Nicole Six and
 Paul Petritsch
Audiovisual technician: Michael Krupica
Exhibition installation: Oli Aigner and mumok
 team, mu.st
Art mediation program: Claudia Ehgartner,
 Johanna Gudden, Jörg Wolfert & Team
 (mediation concepts: Maria Bucher,
 Maria Huber, Katharina Morawek)
Transport: Kunsttrans, Masterpiece, Dietl

LENDERS

The Museum moderner Kunst Stiftung
Ludwig Wien would like to thank the private
and institutional lenders whose cooperation
and support made this exhibition possible:

Douglas Baxter, New York
Gail and Tony Ganz, Los Angeles
The Helman Collection
Samuel and Ronnie Heyman
Mr. Carroll Janis
Patty Mucha
Ad Petersen
Robert F. and Anna Marie Shapiro

And those private lenders who wish to
remain anonymous

Albright-Knox Art Gallery, Buffalo
Art Gallery of Ontario, Toronto, Canada
Glenstone
Hirshhorn Museum and Sculpture Garden,
 Smithsonian Institution, Washington, DC
IVAM Centro Julio González, Valencià
Kröller-Müller Museum, Otterlo, The
 Netherlands
Kunsthaus Zürich
Kunstmuseum Basel
Kunstmuseum Basel, Kupferstichkabinett
Locksley Shea Gallery
Los Angeles County Museum of Art
Ludwig Museum—Museum of Contemporary
 Art Budapest
Moderna Museet, Stockholm
Musée National d'Art Moderne—Centre
 Georges Pompidou, Paris
Museum Boijmans Van Beuningen
Museum für Moderne Kunst, Frankfurt a. M.
Museum Ludwig, Cologne
National Gallery of Art, Washington, DC
Solomon R. Guggenheim Museum, New York
Stedelijk Museum, Amsterdam
Tate
The Peter Brant Foundation, Greenwich, CT
The George Economou Collection
The Menil Collection, Houston, TX
The Metropolitan Museum of Art, New York

The Museum of Contemporary Art,
 Los Angeles
The Museum of Modern Art, New York
The Pace Gallery, New York
The Cy Twombly Foundation
Victoria and Albert Museum, London
Wadsworth Atheneum, Hartford, CT
Walker Art Center, Minneapolis
Whitney Museum of American Art, New York

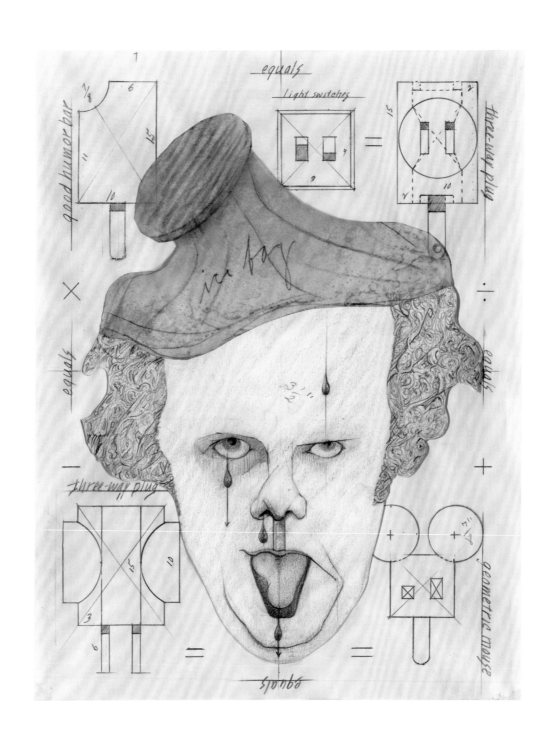

Symbolic Self-Portrait with Equals, 1969
Pencil, crayon, spray enamel, watercolor, and collage
11 x 8 ¼ inches
Moderna Museet, Stockholm

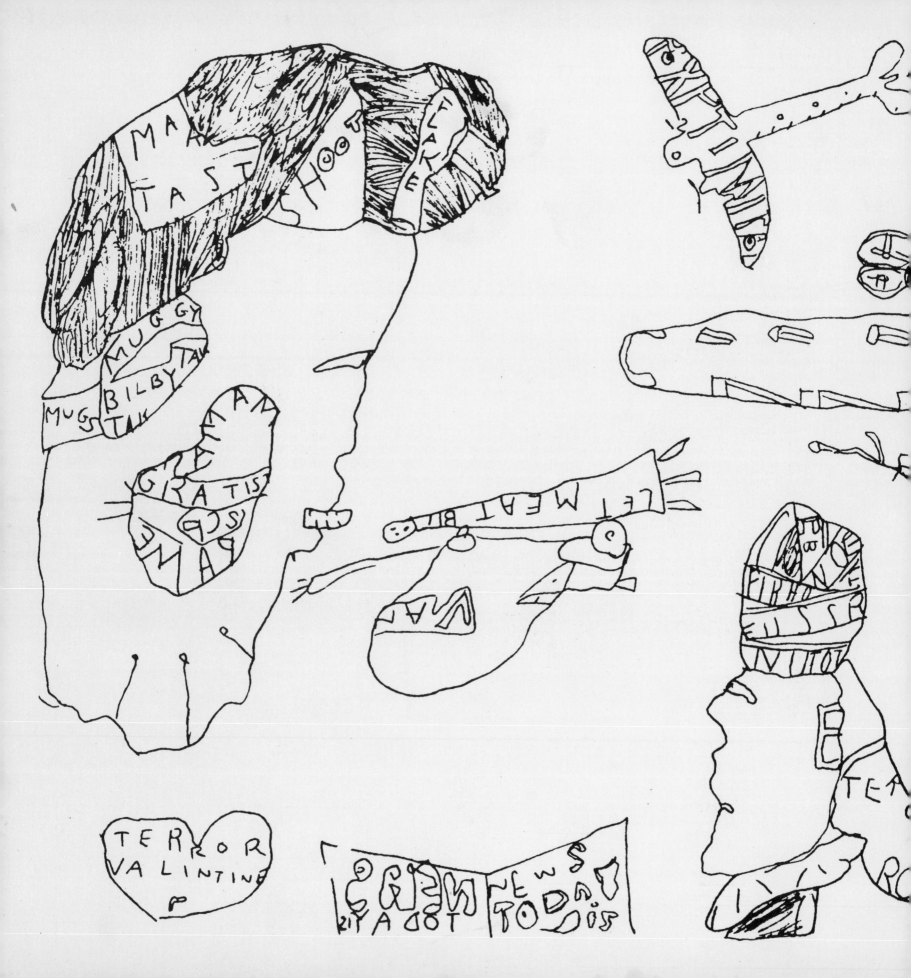